# UNDERWATER PHOTOGRAPHY FOR EVERYONE

# UNDERWATER PHOTOGRAPHY FOR EVERYONE

## FLIP SCHULKE

**PRENTICE-HALL, INC.** □ ENGLEWOOD CLIFFS, N.J.

*To my New Ulm High School teachers,*
*Mary Kayser, Journalism; Alice Steen,*
*English; and Cecile McLaughlin, Librarian.*
*Theirs is the highest vocation—opening*
*up young minds to the wonders of the world.*

*Underwater Photography for Everyone* by Flip Schulke
Copyright © 1978 by Flip Schulke
All rights reserved. No part of this book may be
reproduced in any form or by any means, except
for the inclusion of brief quotations in a review,
without permission in writing from the publisher.
Printed in the United States of America
Prentice-Hall International Inc., London
Prentice-Hall of Australia, Pty. Ltd., Sydney
Prentice-Hall of Canada, Ltd., Toronto
Prentice-Hall of India Private Ltd., New Delhi
Prentice-Hall of Japan, Inc., Tokyo
Prentice-Hall of Southeast Asia Pte. Ltd., Singapore
Whitehall Books Limited, Wellington, New Zealand
10 9 8 7 6 5 4 3 2 1

**Library of Congress Cataloging in Publication Data**
Schulke, Flip
Underwater photography for everyone.

Bibliography: p.
Includes index.
1. Photography, Submarine.    I.  Title.
TR 800.S34    778.7'3    78-9820
ISBN 0-13-936450-1

# CONTENTS

# FOREWORD

All of us who dive have come to love the strange, blue universe lurking beneath the waters that cover 70 percent of our planet's surface. It exists almost as another dimension—one that beguiles the senses with its twilit beauty. When first you discover it, you are Columbus finding a New World—a world of silence but not of solitude . . . a world of brilliant, rock-hard corals and swaying plants that bend to the current as wheat bends to the wind. Fish flash through it like polychrome showers. School upon vivid school, each a darting miracle of choreography.

This particular world bewilders the eye—and the lens of a camera as well. Refraction of the light rays that penetrate water distorts both size and distance. The watchful barracuda that pauses to inspect you is actually magnified by a factor of one-third. Not knowing this when you focus could destroy a dramatic photograph. And color dies with depth. As you descend, red disappears first, then, orange, then yellow. The red snapper that dazzled you at 15 feet becomes a blue-gray shadow at one hundred.

The skilled photographer, however, can compensate for both illusion and darkness. This book is designed to open the wonders of an infinitely lovely and infinitely elusive world to your camera. Its author, Flip Schulke, has gained an international reputation both as a photojournalist and as an innovative explorer of the depths. Underwater he has developed and refined techniques that will enable you to overcome the problems posed by this spectacular environment.

At the *National Geographic* we have fostered underwater photography from its infancy. In 1927 the magazine published the world's first undersea color photograph: A "hard-hat" diver-photographer held a bulky camera and triggered the explosion of a pound of magnesium flash powder on a raft at the surface. Readers of *Underwater Photography for Everyone* can appreciate how the state of the art has improved in the intervening half-century.

Underwater photography has proved of enormous value in marine exploration and research. Probing the bottom of Bounty Bay off Pitcairn Island, Luis Marden—a pioneer underwater photographer and *Geographic* staff member for 42 years—discovered and photographed the remains of Captain Bligh's celebrated vessel. Later he dived into a freshwater cenote in Yucatán to record with his cameras the thousands of Maya artifacts found by scientists at Dzibilchaltún.

Archeologists have since found underwater photography invaluable as a scientific tool to record with permanence and precision the relics of man's past on the ocean floor. Their grids and cameras have faithfully captured *in situ* the remains of vessels as old as a Bronze Age ship that came to grief off Turkey some 32 centuries ago.

In 1962 Danish archeologists salvaged five sunken Viking ships in the Roskilde Fjord. Before taking any action—as good archeologists will—they mapped the site. But they replaced the tedious surveying techniques of the

past with photography. Not only did the scientists save considerable time, but the photographs—showing the crumbled hulks lying on the bottom— assisted in the spectacular restoration of these nearly thousand-year-old maritime masterpieces.

Flip Schulke has been a valued contributor to the *National Geographic* since 1958: For us his cameras have ranged from mountain glens of the Blue Ridge to the brooding depths of Lake Titicaca. But it is beneath the surface of tropic seas that he has gained his widest renown. Teacher as well as artist, Flip will guide you toward underwater expertise. In the end your camera will confer upon each dive a kind of immortality. While the experience may fade, the image will remain.

—Gilbert M. Grosvenor
Editor, *National Geographic Magazine*

# ACKNOWLEDGEMENTS

An instructional book of this type could not be done without the gifts of both time and creative work by many people. I am extremely grateful to my editors at Prentice-Hall, Carol Cartaino who saw merit in my original outline and who juggled my outpourings into a coherent book and Mariana Fitzpatrick who saw the project through its final stages. My deepest thanks to Kim Powell Dugger for supplying the light-hearted drawings which illustrate the text, and to Penny McPhee for all of her help with the glossary. To Howard and Benjamin Chapnick of Black Star Picture Agency for encouraging and supporting this project and all of my underwater ideas and assignments, my thanks because they recognize the need to communicate the undersea world.

To my co-worker, fellow photographer, and wife, Debra Streuber Schulke, who never faltered in her assistance and support during what seemed a never ending task, my deepest appreciation.

A fatherly thank you to Maria Schulke, who graces the book jacket cover, for being a tireless underwater model.

Thanks are due to Phil Kunhardt, who gave me my first significant underwater assignments when he was a young assistant picture editor at *Life* magazine; to Paul Dammann for suggesting the original solution for a corrective dome; to Gomer McNeil for explaining to me the physical and optical problems of underwater corrected optics; and to Hans Hass who inspired a young boy to explore the ocean depths.

A photographic book is dependent on photographic prints of the highest quality. Wolfram Kloetz of Modernage Custom Labs, New York, made that necessary extra effort in printing most of the photographs in this book.

Special thanks to underwater photographers J. Gale Livers, Geoff Harwood, Hans Hass, Rodney Fox and Jeff Nadler who have kindly permitted me to use some of their photographs to illustrate portions of the text.

I am most grateful to the following underwater photographers and cinematographers whom I admire and from whom I have gained much of my own knowledge of underwater photography. These men and women have freely shared their own experiences and discoveries, thereby greatly advancing the art of underwater photography. They include Lamar Boren, Jacques Yves Cousteau, Michel Deloire, Douglas Faulkner, Peter Gimbel, Jerry Greenberg, Hans Hass, Jordan Klein, Bates Littlehales, Peter Stackpole, Ron Taylor, Valerie Taylor, and Stanton Waterman, who share honors as the best in underwater photography.

Finally, I would like to thank all of the manufacturers who provided me with information and in many cases loaned me equipment so that I could test and evaluate it for the book. These firms are listed in the appendix.

# INTRODUCTION

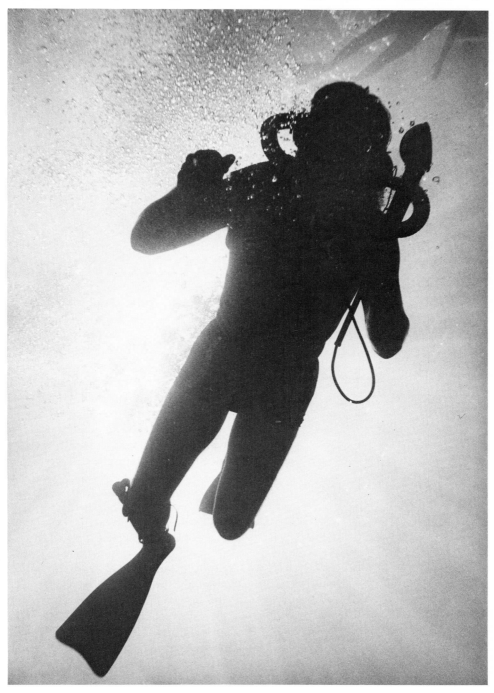

How many times have you set out to indulge in a new hobby and been discouraged by the seeming complexity of it all before you ever hammered the first nail or inserted part A into part B? If you've actually mastered a skill from a "how-to" book, I unreservedly admire your determination and perseverance. But chances are you're at least a little like me. You learn best by watching an old hand, and then going home to practice in the privacy of your own mistakes. Also, if you're anything like me, you get frustrated and lose interest if you're forced to read about the intricate musculature of your shoulder and wrist when all you want to do is learn to play tennis.

That's why in writing this book I want to take you underwater personally, guide you through my realm, show you some of the tricks I've learned in 20 years of underwater photography, and point out some tried and

true exercises that will help you master each stage in the easiest possible way—when you're ready.

Underwater photography can be as simple or as complex as you want it to be. But as a professional underwater photographer and surface photojournalist, I am convinced that at every level the primary goal is fun. It is the thrill of bringing home—to show family and friends—what you, as a diver, see beneath the surface.

With this in mind, I would like to help the average underwater swimmer have fun while taking excellent photographs, whether he or she is snorkeling in a pool with the simplest and most inexpensive camera or scuba diving on coral reefs with the most advanced single-lens-reflex 35-mm camera. Underwater photography as a hobby and part-time vocation has grown in gigantic leaps within the past 10 years. Two million sport divers now enjoy the delights of the world beneath the sea, and all of them long to share the mysteries they've discovered. The ability to take photographs underwater is no longer limited to accomplished scuba divers with hundreds of dollars of photographic equipment. Nor is it as complicated as most articles and books make out. With the advent of molded plastic camera housings (watertight cases that protect the "surface" camera), underwater photography for fun is well within the reach of every swimmer with face mask and flippers.

To dispel the "mystique" of the extreme difficulty and exorbitant cost of taking subsurface photographs, this book begins with easy, basic underwater photography that can be accomplished with a simple still or movie camera—often the type you are already using in your everyday surface photography. In subsequent chapters, I'll explain the use of more complex underwater cameras and housings, as well as natural and artificial lighting and other advanced techniques as I know and use them.

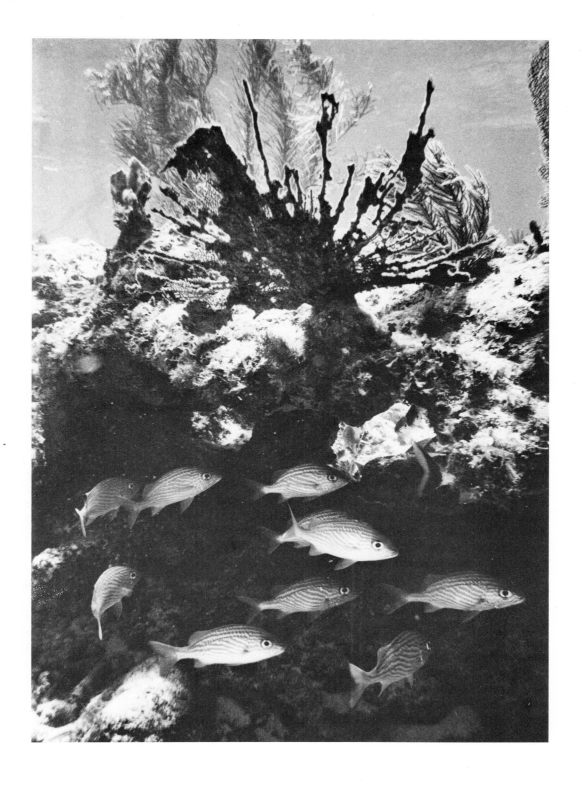

Few photographers were making a living underwater when I first took the plunge, so in many cases I had to develop or modify the tools and techniques myself. What you will read is based on my first-hand experience and that of other people who have advanced underwater photography, such as Jacques Cousteau's team, led by engineer Jean de Wouters, who developed the *Calypso* camera now known as the Nikonos; Hans Hass, who designed the Rolleimarin, the camera housing most used by professional photographers of marine life; and Bates Littlehales, whose career with *National Geographic* magazine has covered underwater sights all over the world.

Most of my underwater photographic knowledge has been gained through trial and error—which I hope this book will enable you to avoid. I have tested the equipment and techniques described and found them to be excellent for the task at hand. I shall, I admit, be quite dogmatic in my advice at times. For although there are various methods of accomplishing a given result in underwater photography, I am presenting those which have worked for me and which I know will work consistently for you. You will very likely come upon other sources and other approaches. Some of these, while good in the past, have been improved upon recently. Others are workable on the surface, and by extension seem plausible underwater, but they just do not give the best results. And in still other areas, there is honest disagreement among advanced underwater photographers on which method is best. As you progress in underwater photography, you will undoubtedly discover new methods to solve your own particular pictorial problems. Meanwhile, what you will find in this book works, and works on a dependable basis.

Both the beginning underwater photographer and the advanced professional need to develop an awareness of what is photogenic in the dramatic subsea world around them. As your sense of "seeing" photographs develops underwater, so too will your desire to advance from the simple camera to more advanced techniques in your effort to put onto film those marvels that you see below. Throughout the book you will find photographs taken with cameras and using techniques described in the text. For example, the photographs in the chapter dealing with Instamatic cameras were actually taken with Instamatic cameras, as were photos in the color insert. Indeed, more and more photographers, amateur and professional alike, are working in color today, thanks to advances in technology, thereby doing justice to their subject matter.

*Underwater Photography for Everyone* is intended to be a continuing, progressive workbook. Start with Chapter 1, which discusses underwater snapshots—the easiest and least costly way to take subsurface photographs. Even if you are an accomplished underwater photographer, you may pick up some helpful tips in these pages or reacquaint yourself with basic information in order to help a member of your family or a friend begin to bring back his photographic impressions from the underwater world.

The exercises at the end of selected chapters will enable you to put into practice the skills discussed in that chapter. The most important part of photography is taking pictures. The most costly equipment is wasted unless you know how to use that equipment. And then you must shoot, shoot, shoot. The more you shoot, the better you will become. Master the simple techniques and equipment first, and then graduate to more difficult techniques. Trying too many different techniques at once will only confuse you and result in poor photographs. Crawl before you walk, and walk before you run, and the resulting underwater photographs will be the envy of all your diving friends.

# WHERE TO FIND IT

## Glossary

To keep this book simple yet informative, I have adopted a "need-to-know" approach. Too often semitechnical books are so cluttered with peripheral theories and information that the novice is scared off before he or she begins. At the same time, the advanced amateur or professional photographer may wish to review photographic theories or obtain a more scientific explanation of complicated principles such as underwater optics or the mechanics of cameras. To satisfy both kinds of readers, selected photographic words and theories are printed in italics, indicating that they appear in the Glossary.

## Manufacturers

I have attempted in this book to cover the latest underwater photographic techniques and specific practical equipment wherever possible. With the exception of certain amphibious equipment (which can be used both in air and in water), most underwater photographic equipment must work in conjunction with current models of surface cameras, that is, the housings are designed to fit a particular camera. As a result, commercially manufactured housings often change. Many models offered one year are discontinued the next. Therefore, I have tried to concentrate on those models of surface cameras and underwater housings made by reliable manufacturers who have consistently produced items that give good results and that can be replaced and re-paired easily. I have included a list of the major manufacturing companies with their current addresses in Appendix I.

## A WARNING

One final note before we begin. I cannot stress enough that good underwater photography is dependent upon the photographer's ability to swim, snorkel, and scuba dive. With a face mask alone, you can take excellent pictures in a swimming pool or lake-side swimming area. Venturing into the ocean, onto reefs, and deeper into lakes or underwater caves calls for professional instruction, and if you are snorkeling or using scuba equipment in any underwater environment, certification.

Four major associations offer courses in scuba (self-contained underwater breathing apparatus) and certification in skin and scuba diving. These are the YMCA, The National Association of Underwater Instructors (NAUI), the Professional Association of Diving Instructors (PADI), and the National Association of Scuba Diving Stores (NASDS). Courses are offered through local dive shops, the best place to obtain current information on diving safety and instruction.

Remember the cardinal rule of diving—which applies to all underwater photography—**NEVER dive alone.** Always dive with a partner and stay within visual distance of your "buddy" at all times, both above and beneath the water.

Now get your mask and flippers and let's go.

FLIP SCHULKE, *Miami, Florida*

# 1·GETTING STARTED WITH YOUR CAMERA UNDERWATER

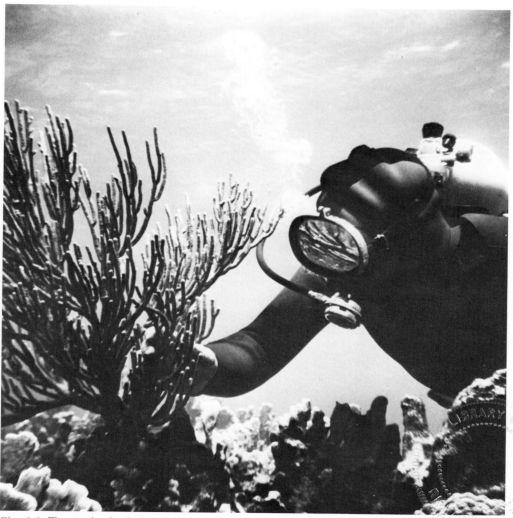

***Illus. 1.1*** The simplest kind of camera can take good UW photographs on a sunny day, in shallow water. Here a diver examines a piece of soft coral. Taken with Instamatic X-15 camera in an Ikelite UW housing. Automatic exposure. Converted to black and white from 64 ASA color slide film. *Photo by Flip Schulke*

# UNDERWATER SNAPSHOTS

Diving is one of the few healthy addictions I can think of, but it's an addiction nonetheless. As soon as any swimmer puts on a face mask and sees the underwater world for himself, he can't help but be impressed with the mysterious realm of the deep. When seeing the delicate multicolored reef fish or an intricately shaped coral formation alive with multifarious sea life for the first time, you can hardly refrain from feeling yourself part of a Jules Verne fantasy. The experience is intoxicating, and the urge to "capture" a fragment of that world and bring it to the surface is almost universal. In the early days of diving, that urge was frequently satisfied by spearfishing. But today—like the photographic safari in Africa, which has eliminated much of the needless killing of nearly extinct animals—UW photography is taking the place of spearfishing. As diving has become more popular and as protection of the environment and awareness of ecology have gained importance in the public's mind, many divers are turning to photography to capture what they see underwater. And they're finding the challenge of hunting down a fish with a camera even greater than with the new power spear guns. The photographer can't get away with just any photograph of his fish. He wants to get a good photograph, one that is aesthetically pleasing. He must get much closer than the spear fisherman; he must find an effective angle. And most importantly, even after he succeeds, the fish is still there for others to enjoy seeing.

This chapter presupposes that you have not had a lot of experience using a diving mask, flippers, and snorkel. But you've tried skin diving and enjoyed it. You may have already decided to take snorkeling lessons or a scuba certification course. As an inexperienced diver, you'll probably be surprised to learn that you can start taking UW photographs right now! You can actually begin taking simple photographs below the surface with nothing but a face mask in a backyard swimming pool and then advance right along as you progress in skin and scuba diving.

As a professional photographer and UW photography instructor, I am often asked by novice divers how to begin UW photography and what type of equipment to purchase. Almost always these would-be UW photographers fear that they must have costly equipment and a great deal of knowledge to be able to return from beneath the sea with acceptable photographs.

This may have been the case a few years ago, but it certainly isn't true today. The best advice I can give is to start with simple, yet reliable equipment. In the United States, this almost invariably means a camera made by the Eastman Kodak Company.

Begin with a camera you already own. Kodak has sold more than 50 million Insta-

***Illus. 1.2*** A good place to begin your UW photography is in a swimming pool. The water is clear and subjects usually handy and cooperative. Taken with Instamatic X-35 camera in an Ikelite UW housing. Automatic exposure. Black-and-white film. *Photo by Flip Schulke*

**Illus. 1.3** The EWA-Marine or Spiratone Aqua-Case. A dependable soft vinyl housing that is safe to depths of 30 feet or less. This purselike Aqua-Case encloses an Instamatic X-35 camera including flash cube. The diver's right hand fits into a built-in glove, enabling his fingers to work the camera's controls and shutter release lever. *Photo by Flip Schulke*

**Illus. 1.4** Capturing colorful photographs of sea creatures can be accomplished with inexpensive camera and housing combinations. The scuba diver pictured here is about to photograph a banded reef fish with her Kodak Trimlite Instamatic 38 camera in an Ikelite housing. *Photo by Gale Livers/Ikelite*

matic cameras in the 126 (or square) film cartridge size and several million pocket or Trimlite Instamatic cameras in the miniature 110 film cartridge size. It is very likely that you too own one of these cameras—or that you can borrow one from a relative or friend. If so, you're already halfway toward taking your first UW picture, because easy, inexpensive UW photography begins with pocket Instamatics or Trimlite Instamatic cameras encased in a rigid molded plastic housing, or a good soft vinyl housing. The prices of such housings will please you. They range from as little as $30 to $50, depending on the model of Instamatic camera you have. This price also includes a UW flash gun for flash bulbs or flash cubes, or in the case of the soft housing, room for a small strobe (electronic flash) unit.

The largest manufacturer of molded plastic housings for Instamatic cameras is Ikelite Underwater Systems. The only brand of soft vinyl housings that I have tested extensively and found to be completely safe down to 30 feet is manufactured by EWA-Marine/Goedecke & Co. (Some models of the EWA-Marine housings have been imported for sale in the United States by Spiratone.)

As a novice, with a face mask and your own Instamatic camera inside a housing, you can go right out and take photographs of your children and friends in a neighborhood or backyard swimming pool. You'll soon find that a UW portrait can be far more prized than a snapshot taken above water.

Perhaps you're planning a vacation at a nearby lake or resort. Again, let your family and friends be the subjects of serious or comical UW portraits. In fresh-water lakes all you need is a face mask to stalk and capture on film the many fish that abound at shallow depths.

If you're lucky enough to vacation at the seaside, the opportunities for UW photographs are endless. Depending upon your location, you may discover shallow reefs or grass gardens close to the shore. You'll find coral, starfish, a wide variety of fish, and hundreds of growing things that can be your subject matter. In many areas, large group-diving charter boats take day-long excursions to shallow reefs, where professional guides can show you the underwater sights.

**Illus. 1.5** Practicing correct UW framing (composition) through your viewfinder is easily done in a swimming pool. The better you get to know how your camera and housing operates in controlled conditions, the easier it will be for you to get good photographs when reef diving in the open ocean, or in lakes and rivers. Taken with Kodak Trimlite Instamatic 38 camera, in Ikelite housing. "Near-focus" setting (3 to 6 feet). Automatic exposure. Black-and-white 64 ASA film. Sunlight. *Photo by Flip Schulke*

You may be enchanted by a school of the tiniest fish imaginable, brightly adorned in irridescent colors, or be privy to a large grouper dining on a sea urchin. If you're lucky, the area may boast a shipwreck to which you can dive—all the stuff of which exciting UW pictures are made, with nothing but your Instamatic camera and a housing. These group charters are very reasonable in cost, and they are an exciting and educational experience. What's more, you can return home with color photographs documenting everything you saw.

Anyone in good physical condition with face mask, flippers, and snorkel can participate in all the diving activities I've men-

tioned thus far, **as long as you stay in shallow water.** Beyond a maximum depth of 12 feet, you must have instruction, even when you're snorkeling. And, of course, at any depth you must always dive with a partner, or "buddy," who remains clearly within sight of you at all times.

Now let's pick up our Instamatic cameras and get to work.

## COLOR FILMS

Undoubtedly you will want to shoot color film once you've seen your first coral reef. The subsea world is like a jewel box, spilling over with brightly colored gems—shades of topaz and amethyst and sapphire, deeper and richer than you've ever seen on land. But even when you're taking pictures in a swimming pool, I advise shooting color film.

Remember that a photographic processing laboratory can always make black-and-white prints from your color photographs, but the reverse is impossible.

The question I am most often asked is, "What color film should I use underwater?" In extensive personal tests and photographing in color on many professional UW assignments I have found that positive color or transparency film (slides) is far superior to using negative or color-print film (such as Kodacolor).

The best current choices are
1. Kodak Ektachrome 64 ER (E-6 process) in both 110 and 126 Instamatic camera sizes. Both come in 20-exposure cartridges.
2. Kodak Kodachrome 64.

These films will give you color slides that you can project. If you want color prints for your album, the color lab can also make color prints from slides.

Color-print films such as Kodacolor II do not give good UW results generally, because of the large amount of blue tinging caused by the water in all UW photographs. (For further explanations see Chapter 2 and *Films* in the Glossary.) UW photographs taken with positive Ektachrome or Koda-

chrome slide film will be far superior when your subject matter is in the red color range—and this includes "pink" human skin.

## KODAK INSTAMATIC CAMERAS

Instamatic cameras fall into two general categories, based upon the amount of control you have over the camera's focus, shutter speed, and the amount of light that enters the lens, that is, the *f*-stop.
- Instamatic cameras that are totally preset in the factory for "general sunny light conditions."
- Those with limited manual or automatic control, which differ from the many past and present Kodak Instamatic models manufactured but which permit some adjustment of the exposure—usually automatic depending upon the outdoor light conditions—and some sort of change-of-focus capability.

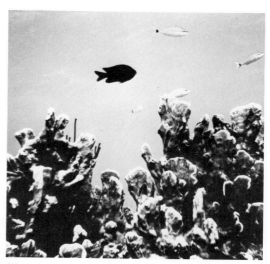

**Illus. 1.6** An interesting UW photograph is usually more dependent on what the diver-photographer sees, frames in the camera's viewfinder, and then captures on film—than on the equipment used. This underwater seascape was photographed with the Instamatic X-15 camera, one of Kodak's least expensive models, and was converted from a 64 ASA color slide film to a black-and-white photograph. *Photo by Flip Schulke*

Of the totally preset Instamatic cameras I shall describe three models, the first two of which are slowly being discontinued. Kodak continues to introduce new models, but because the improvements have been primarily in flash equipment, comments about these two major types of Instamatic cameras should also apply to the new Instamatic cameras.

**Totally Preset Instamatic Cameras**
- Instamatic X-15 and X-15F (126 film cartridge size)
- Pocket Instamatic 20 (110 film cartridge size)
- Trimlite* Instamatic 18 (110 film cartridge size)

These Instamatic models are the least expensive cameras that will give you acceptable results in shallow UW photography. They must be used only in bright sunlight. You will achieve the best snorkeling photos

*Trimlites are the current series of 110 models from Kodak.

5 or 6 feet beneath the surface, though acceptable photographs can be obtained as deep as 12 feet in very clear water on a bright, sunny day. Any deeper, not enough sunlight will reach the film, and flash must be used.

These cameras have a very simple lens that cannot be controlled by the user for exposure, that is, the amount of sunlight allowed to enter the camera. They are preset by Kodak to give the best results in bright sunlight. The shutter speed of these three models is set at 1/90 of a second. The lens is set at $f/11$. When a flash cube is inserted

*Illus. 1.7* An array of Instamatic 126 film size and Instamatic 110 film size cameras and matching UW housings by Ikelite. Both flash bulbs and flash cubes can be used with these cameras in various UW flash guns. Most past and present models of Instamatic cameras can be housed for UW photography. Not all can be adapted for UW flash. A UW equipment catalog should indicate whether flash can be used.

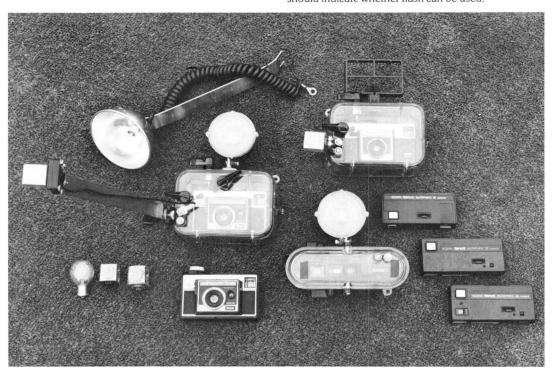

into the camera's flash socket, the shutter speed is reduced to 1/40 of a second, or in other words you will get twice the amount of sunlight.

### A Tip

When using these three models (or older models like them) underwater, remove the base of a flash cube and insert it into the camera's flash socket before putting the camera into the UW housing. This will double the normal amount of light going into the camera and thereby give you sufficient exposure for good color and black-and-white photography—taken by sunlight—in shallow water (down to 12 feet). **Note**: some UW housings have a flash adapter which plugs into the camera's flash socket. Using this adapter plugged in place, *without* actually using a flash cube in the UW flash, will function like the base of a flash cube—the shutter speed will be 1/40 of a second, and your resulting photographs taken underwater will be properly exposed.

**Focus /** These preset models are also prefocused. Only subjects that are 5 feet away from the camera and beyond will be in sharp focus. Anything closer than 5 feet will become less sharp owing to improper focus. It is both possible and desirable to take sharp (or in-focus) photographs at a close range with these preset cameras. To photograph objects that appear to be 2 to 5 feet from the camera, beg, borrow, or buy a plus-3 *diopter* supplementary close-up lens, series 7 size, available at most camera stores. Tape the plus-3 diopter lens on the outside of the UW housing in front of the camera's lens with waterproof adhesive tape. This supplementary diopter lens will change the factory-preset focus range of these Instamatic cameras to give you sharp photographs in the 2-to-5-foot UW apparent distance range. Anything that looks as if it is between 2 to 5 feet away underwater will be in good focus. If you don't move the camera, and if your subject does not move either, you will get a sharp photograph.

**Illus. 1.8** It is often confusing to try to understand the apparent magnification caused by refraction underwater. This photograph was taken with a camera behind a flat port (like your face mask) held so that half of the lens sees underwater and the other half sees above the water. It shows the girl's waist as a third larger below the water than above. This is due to refraction, which makes an object appear closer by 25 percent and larger by 33⅓ percent than it really is. Taken with an Instamatic X-35 camera in an Ikelite housing. Automatic, sunlight exposure. Black-and-white 64 ASA film. *Photo by Flip Schulke*

### Refraction: Why Things Appear to Be Closer to You Underwater

Objects seen underwater, both through a face mask and through the UW housing, seem to be closer than they actually are—closer by 1/4. This *apparent distance* is what we and the camera see, as contrasted with the *actual* (or measured) *distance*.

For example, if an object "looks" through your face mask to be 3 feet away from you (apparent distance), it is really 4 feet away from you (actual distance), that is, if you took a tape measure

underwater and measured the distance from the object to you, it would be 4 feet away.

The camera underwater "sees" in the same way that your eye does; it sees apparent distance, not the actual distance. Therefore a camera-distance, or focus, scale must be set for the distance an object appears to be—not the actual measured distance from the camera. Should you set the distance (focus) scale at the measured distance you would not achieve correct focus.

If you want to find out the apparent distance, you multiply the actual, or measured, distance by .75. For example, the apparent distance of a 4-foot actual distance is .75 × 4 = 3 feet.

There is an exception in more advanced UW photographic lens-correction systems. If you want to learn more about this exception now, see *port* in the Glossary.

This apparent distance is also called by many divers magnification, because when an UW subject appears to be closer, it then also looks ⅓ larger, or magnified.

**Illus. 1.9** Taping a plus-3 diopter supplementary closeup lens onto the front of an Instamatic UW housing.

### A Tip for Estimating Apparent Distance: The UW Measuring Stick

Simple cameras such as the Instamatics have no mechanical means of measuring either actual or apparent distances underwater. You can "guess" the distances if you are relatively good at it, and of course the more practice the better you get. But those of you who aren't too good at guessing should make yourself a measuring stick for UW measurement. I have found this very practicable. You mark off the apparent distances by measuring a 14-inch segment from one end of a 48-inch stick and label this distance "1 foot"; next you measure 32 inches from the end and label this distance "2 feet"; then you mark the end of the 48-inch stick "3 feet." Underwater, 14, 32, and 48 inches will become 1, 2, and 3 feet of apparent distance.

---

**Viewfinders** / Being able to view what the camera sees is very important to good UW photography. The modern molded (hard) plastic housings such as the Ikelite line of UW housings and the EWA-Spiratone soft vinyl housing enable the diver-photographer to press his face mask close enough to the rear of the housing to see directly through the normal viewfinder of the camera.

A simple accessory viewfinder of the sports finder, or open, type can also be utilized (see Illustration 3.4), but I find that looking through the normal viewfinder of the Instamatic camera gives better results in framing my photographs underwater.

**Flash Bulbs/Flash Cubes** / Both the cube and bayonet types can be used in conjunction with these simple cameras underwater to add sufficient light for good color photographs when you are diving deeper than 12 feet or when it is cloudy or hazy. Flash is a must with these models at any depth if the day is completely overcast. Clouds filter out the reddish colors of the spectrum; this causes all colors to appear bluish, even at very shallow depths. Therefore flash serves two purposes underwater; it better illuminates your subject, and it also restores the bright colors by adding back the red tones which have been filtered out by both the clouds and the water. For proper exposure with flash bulbs and cubes underwater, refer to Table 1.1.

### Instamatic Cameras With Limited Manual or Automatic Exposure Control
- Instamatic X-35 and X-35F (126 film cartridge size)
- Pocket Instamatic 40 (110 film cartridge size)
- Trimlite 38 (110 film cartridge size)

My first choice, when asked to recommend a camera to a beginning diver-photographer, has been the 126 film size Instamatic cameras. (UW housings are still available for most of the older 126 models.) Count yourself lucky if you have an Instamatic X-45, with its spring-wound film-advance motor, which was my favorite model, but the X-35 will do the same things underwater that the X-45 will do, as it has a standard film-advance lever in place of the spring-wound motor. The newer X-35F (utilizing a flipflash flash socket) is difficult to convert to UW flash. However, all three of the small, low-cost cameras listed above can do amazing things in UW photography, and each of these models will give you sharp, clear color slides, and/or color prints. Of course, use color slide film (Ektachrome 64 or Kodachrome 64).

Both the older pocket Instamatic 40 and the new Trimlite 38 feature an electronic shutter which is controlled automatically by sunlight via an electric eye. The shutter will adjust to the existing sunlight scene to give you a perfect exposure. The automatic shutter speeds range from 1/225 of a second to 5 seconds or longer. This automatic exposure feature insures that on a sunny day your color slides will be properly exposed from just beneath the surface of the water to as deep as 30 feet. Photography in deeper water is not practicable, for as the light dims and the camera adjusts for the proper exposure, the shutter speed will be so slow that your pictures (without flash) at that depth cannot be sharp. A red indicator light comes on when the required exposure becomes slower than 1/30 of a second. Therefore when the sky is dull or too overcast, the red indicator light will remind you to use flash bulbs or cubes (see Table 1.1).

**Closeup Capability** / The three Instamatic cameras listed also feature a two-position changeable focus slide, which allows you to adapt the camera for closeup pictures for a 3-to-6-foot distance. You can manually switch the focus slide while underwater to the closeup position setting, which allows you to shoot in the distance range best suited to UW photography, the 3-to-6-foot apparent distance range.

The closeup capability is particularly im-

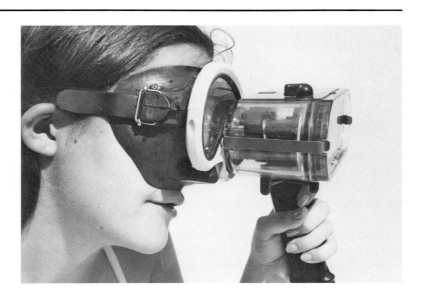

**Illus. 1.10** Even when the Instamatic camera is enclosed in a UW housing, it is possible to frame photos effectively by using the viewfinder built into the camera. The secret is to press your face mask tightly against the rear of the UW housing. By shifting the camera and your eye a bit, you will be able to see the whole viewfinder frame.

portant for UW color photographs for two reasons. First, as you move farther away from your subject underwater, you must shoot through more water. Water acts like a blue filter—just like a pair of blue sunglasses—and the color of your subject will consequently be modified. For example, a yellow fish will appear blue-black, not yellow. Naturally, the farther you move away from your subject, the more blue water you will be shooting through, so the filtering effect will become proportionately more extreme. Secondly, the density of suspended particles in the water can degrade the brightness of the natural colors and cause your photographs to look muddy and unsharp. If these particles are particularly dense, taking pictures underwater is much like shooting through an early-morning fog. Nothing is very clear. So the first rule of UW photography is **Get close to your subject.** The closeup focus feature of these particular Instamatic cameras (X-35, Pocket 40, and Trimlite 38) allows you to do just that.

As you continue diving and taking pictures, you may find that you would like to shoot pictures even closer than the 3-to-6-foot range permitted by these Instamatic cameras. You're fascinated by the colorful stripes on a tiny tropical fish; you'd like to capture the convoluted texture of a small patch of coral.

For closeups with the X-35, Pocket 40, and Trimlite 38, set the focus slide to the 3-to-6-foot setting on the camera. Take a plus-3 diopter supplementary closeup lens, series 7 size. (Spiralite coated closeup lenses of this size cost about $4.50.) Tape the closeup lens to the outside front of the UW camera housing (see Illus. 1.9). This supplementary lens in combination with the lens on the camera will give you an apparent distance range of 3/4 to 2½ feet. Use tape to attach the supplementary lens to the outside of the housing, so that it can be easily removed, even when underwater, if longer

focus distances are desired. When the plus-3 diopter closeup lens is removed, your camera will revert to the 3-to-6-foot focus-slide setting.

## Other Advanced Pocket 110-film-format cameras

In addition to Kodak 110-film-format cameras, two advanced camera-housing combinations that work well underwater are:

**Guppy Marine Housing** / Manufactured by Actsfilm, this extremely simple-to-operate molded plastic housing is designed specifically for the AGFA pocket 110 line of cameras, models 2000, 3000, 4000, 2008, 3008, and 4008. The Guppy housing will also take the AGFA-built strobe flash units designed for these specific AGFA pocket cameras. The strobe flash and camera are housed together, giving you a 110 camera plus strobe flash all in one very compact unit. Distribution of the Guppy in the United States is spotty; therefore the quickest way to find this housing combination is to write to Actsfilm or AGFA-Gevaert, Inc.

**Minolta 110 SLR Camera** / The first *single-lens-reflex* camera to use 110 film. The camera lens is unique in its zoom-to-macro-focusing capability. A UW housing, providing all controls, is manufactured for this camera by Ikelite Underwater Systems.

## Instructions for Using Cameras

When in question about the operation of your particular camera consult the instruction booklet that comes with the camera. Poor photographs almost always result from the misuse of a camera by the photographer, not from a fault in the camera itself. Re-read your instruction booklet before you take your camera underwater. If you follow the instructions carefully, you will get good, sharp, well-exposed color slides and black-and-white prints every time. If you have lost

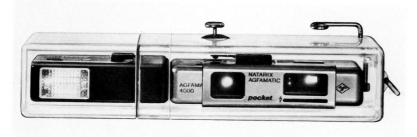

*Illus. 1.11* The Guppy marine housing enclosing an AGFA pocket 110 model 4000 camera and matching AGFA strobe.

the booklet that came with your camera, your local camera dealer will be glad to get a new one from the manufacturer. I cannot stress enough the importance of following the directions; they are easily understood and graphically illustrated. The only exception to following the manufacturer's instructions would concern the type of flash bulbs to use with a particular Instamatic camera. These instructions are for surface flash photography only. (See "Using Flash with Instamatic Cameras," pp. 11–14. You will also find additional information on flash bulb and cube choice in the instruction sheets that come with UW flash guns and UW housings.)

## What Happens to Color as You Go Deeper

So far I have been concerned primarily with using Instamatic cameras in shallow water—water which will permit the sun's rays to penetrate it and illuminate your subject matter. At these shallow depths in bright sunlight, you can expect to get good color. Your reds, yellows, greens, and purples will be bright and strong. But as sunlight penetrates deeper into the water, red, pinks (skin tones), oranges, and yellows are absorbed, attenuated, and scattered. All you really need to know now is that below 20 feet on a sunny day in clear water, red disappears. Orange is absorbed at about 35 feet and yellow at 65 feet; and at 100 feet everything appears bluish-greenish-gray. If you want to know

more about what causes this phenomenon, look up Absorption in the Glossary. The point is that warm colors disappear as you go deeper underwater. Your major problem is how to restore the bright natural colors that exist at any depth but can only be seen when illuminated—essentially with artificial light. With simple cameras, such as the Instamatics, flash bulbs are the answer.

## USING FLASH WITH INSTAMATIC CAMERAS

The first thing to remember, no matter what model Instamatic camera you have, is that the instruction sheets accompanying your flash bulbs and film are written for surface photography. The surface instructions call for "X" flash cubes or flipflash arrays. However, the batteries provided inside your UW housing enable you to use normal or standard flash cubes or bulbs. Disregard the information offered in the instruction booklet, as it does not apply underwater. **Do not use "X" bulbs.** Manufacturers of housings for Instamatic cameras have devised attachments inside of the housing that plug into the "X" flash-cube or flipflash holder of the camera. A UW flash gun using standard flash cubes or bulbs is then plugged into the housing; when the shutter release is pushed, the camera will fire the UW normal flash cube or bulb.

## Flash Tips

For nearly all flash Instamatic camera photography underwater, use clear flash bulbs or flash cubes. The exception to this general rule is in closeup (1 foot or closer camera-to-subject distances), or *macrophotography*. Then you should use blue bulbs.

Though blue flash bulbs or cubes are designed for surface photography with daylight-balanced color films (Ektachrome 64 professional, Ektachrome 64, or Kodachrome 64), if you use blue bulbs when your UW subject is farther away than 1 foot from your flash bulb or cube, your resulting color photographs (slides) will always have an overall blue cast.

Nearly all of your photography with Instamatic cameras underwater will fall in the 1-to-5-foot range from your subject; therefore be sure to use clear flash bulbs or cubes—bayonet-based GE 5 or Sylvania 25 flash bulbs or regular cubes (not X cubes), either clear or high-power clear cubes. Clear flash bulbs and cubes give the best skin-tone color rendition.

The farther away the flash bulb is from the housing, the better your flash photographs will be underwater. Use longer, not shorter, UW flash holders.

Correct color rendition and exposure with the Instamatic cameras in UW photography depends on the distance between the camera and the subject. When the flash-cube adapter of the UW housing is plugged into the flash socket of the camera, the lens and shutter are permanently set (as long as you keep the flash-cube adapter plugged into the camera). Your only remaining variable is the distance you and your UW camera are from your subject. Therefore, to obtain good color you must enjoy weaker or more powerful flash bulbs, or vary your camera distance; varying the distance is easier.

*Illus. 1.12* Inexpensive flash guns for UW photography. These units are designed to use bayonet flash bulbs, either blue or clear (upper right) or flash cubes (upper left). Electrical connections will vary depending upon your particular housing. Most connectors can be adapted for any manufacturer's UW camera housing.

Table 1.1 will show you the best apparent distance range and bulb to obtain properly exposed color slides with the Instamatic cameras (X-35, pocket 40, Trimlite 38) and also the pre-set Instamatic cameras (X-15, pocket 30, Trimlite 18) with Ektachrome X, Kodachrome 64, or any other brand of cartridge color-slide film with a speed of ASA 64. Note that there is a different set of apparent distance ranges in the guide for Instamatic cameras that can be set in the near-focus, or 3-to-6-foot-focus-slide position, in order to get proper color exposure when the camera is set in this mode underwater. Each brand and type of flash, which is easily obtained locally or while you are traveling, has been carefully tested by me.

**Illus. 1.13** Two flash guns mounted on Ikelite Instamatic camera housings. The flash gun on the right is preferable because of its greater distance from the camera's lens. A short flash gun such as the one on the left will emphasize backscattering of suspended sediment in the water.

**Illus. 1.14** The flash cube helps to light up a "sergeant major" as it swims through the coral on a shallow tropical reef. The use of flash will bring out the rich, bright colors of undersea animals when using color film, and add contrast to black-and-white photographs. Taken with Instamatic X-35 camera in an Ikelite housing. 3-to-6-ft closeup setting. GE high-power flash cube. 64 ASA color film (converted to black and white). Shot in sunlight at about 12-foot depth. *Photo by Flip Schulke*

**Table 1.1. Flash Bulb and Cube Guide for Instamatic Cameras**

| Bulb/Cube | Best UW Exposure Range: Cameras Set at 6 ft and Beyond Measured in Apparent Distance (or How Far It Looks to Your Eye) | Best UW Exposure Range: Cameras Set at 3 to 6 ft on Focus Slide Measured in Apparent Distance (or How Far It Looks to Your Eye) |
|---|---|---|
| Bayonet base General Electric press 5 flash bulb or Sylvania press 25 flash bulb<br><br>Clear | 3 to 5 ft | 1 to 3 ft |
| General Electric High-power flash cube (not X) or Sylvania "High-Power" flash cube (not X)<br><br>Clear | 3 to 5 ft | 1 to 3 ft |
| General Electric flash cube (not X) or Sylvania flash cube (not X)<br><br>Clear | 2 to 4 ft | ½ to 3½ ft |

I prefer the bayonet-based, clear, press 5 or press 25 flash bulbs because they give the best color rendition underwater. My next choice is the "high-power" flash cube because it gives a little more light than do the regular flash cubes. All flash cubes give a slight bluish tinge to skin tones, when compared with color slides taken with clear bayonet flash bulbs.

Roughly estimate the number of pictures you will be taking during a given dive. Take only that number of flashbulbs, plus a few extra to allow for misfiring. Chapter 7 illustrates some good methods for holding spare flashbulbs or cubes when you go underwater.

Although any type of flash bulb or flash cube will fire when immersed directly in water, you will be assured better electrical contact when you fire your camera if you scrape the soft lead contacts on the base of each flash bulb with your diving knife before entering the water.

Try to use up all the flash bulbs you take into the water each day because the water will often soften the plastic coating which protects the glass bulb and eventually will corrode the base, causing misfiring.

Occasionally after firing, a flash bulb will "pop" with a bang underwater. Although such explosions are harmless, it is advisable to wear a glove when you remove the shattered bulb from the flashgun.

Don't litter the undersea world. Be sure to take your used flash bulbs or cubes back to the surface in your UW flash-bulb or cube holder for disposal. Leave the reef exactly as you found it for the next diver or photographer to enjoy.

## BLACK-AND-WHITE PHOTOGRAPHY

If you decide to try black-and-white photography underwater, the best film to use is Kodak Verichrome-pan (ASA 64), which comes in 126 and 110 cartridges. Flash cubes and bulbs used with black-and-white film are the same as with color film, since all Instamatic cameras listed here utilize 64 ASA films. You can use Table 1.1 to calculate

the proper apparent-distance range for your black-and-white photographs.

Remember that black-and-white film has a greater *exposure latitude,* so you do not have to be as precise in selecting the distance range for optimum flash exposure as you have to be with color film. A black-and-white negative that is slightly overexposed or underexposed can still make a good enlargement. Color film offers no leeway. Exposure must be correct to get good, rich colors.

Some UW subject matter lends itself more effectively to black-and-white than to color photography. (See Chapters 9 and 10.)

## Photo Tips

Wear some sort of protective clothing when either skin or scuba diving. A regular Neoprene wetsuit certainly is best, since it has been specifically designed for diving. But for beginners, or the occasional diver-photographer, a long-sleeved sweatshirt, an old pair of blue jeans, and a heavy-duty pair of cotton work gloves will protect you

from being scratched by objects on the bottom, the bottom itself, or coral. Such protective clothing also enables you to kneel, lie, or hold on to the bottom by wrapping your arms or legs around coral or whatever is there. This holding position will help to minimize camera movement. Protective clothing also keeps you warm.

Color results are the best when the sun is shining. When the sun is clear of clouds, you will get the best color between 9 A.M. and 4 P.M., in shallow water (not deeper than 15 feet).

When shooting underwater, hold the camera tightly against your face mask. Push the shutter release slowly so that you do not move the camera when you depress the shutter button. Learn to squeeze off your shots, much the same as squeezing the trigger on a pistol or rifle in target practice. *Squeeze*—don't push or pull. Most bad UW photography is due to camera movement, which causes un-sharp photographs. Breathing can also cause camera movement and bubble (from scuba regulator) interference. Hold your breath an instant before releasing the shutter. As lengthy breath-holding can cause carbon dioxide buildup, hold your breath only long enough to stop moving while the photograph is being taken. Brace your arms against your body or against some other solid object. I prefer to wear a heavy-duty cotton work glove on one hand so that I can steady myself while I take the photograph with the free hand.

With simple or automatic cameras with which you have no control over the speed of the shutter, like the Instamatic cameras, it is important to move the camera (pan) with a moving object. If the camera is panning, that is, moving at the same speed as your subject and in the same direction, your resulting photograph will "stop" the moving action of the subject.

Remember to look around at your diving companions and photograph their activities. The resulting photographs make great mementos of the day's dive, and you will find that people in the sea can be as interesting as sea creatures. (See Chap. 10 for tips on effective UW photography of people.)

*Illus. 1.15* Always protect yourself against coral scratches and "fire" coral when reef diving. *Photo by Flip Schulke*

**Fig. 1.1** Panning means moving your camera in the same direction your subject is moving, and at the same rate of speed.

**Illus. 1.16** Try to compose your UW photographs so that the whole film area is used. Your partner moving about the reef provides an excellent subject. Coral is always a good prop, and taking the photograph when your partner is exhaling (which causes rising bubbles) will emphasize the fact that your photographs were actually taken beneath the surface. Taken with Instamatic X-35 in an Ikelite UW housing. 3-to-6 ft closeup setting. 64 ASA color film (converted to black and white). Automatic, sunlight exposure. About 15-foot depth. *Photo by Flip Schulke*

Aiming the camera down with the bottom beneath your subject does not usually result in good UW photographs. The subject tends to blend in with the mottled bottom, unless you happen to be shooting in a swimming pool or on a white sandy ocean bottom. Therefore swim either beneath or at a lower angle to your subject, which will then be silhouetted against the surface, or just above the horizon line of the bottom, to allow the subject to stand out clearly.

Try lying on your back underwater and looking directly up toward the surface. During the middle of the day you can get the sun along with your subject, into your photographs, giving many interesting and artistic silhouette results. (See Chap. 9 for further information on this technique.)

When using a UW camera housing for the first time, it is always safest to take the housing underwater without the camera inside. Water leakage can be caused by many factors, the most common being a grain of sand in the O-ring seal. But whatever the reason, it may be too late to save a camera from ruin, or at least very costly repairs, if your housing develops a leak. Therefore it is just good preventive practice to test the housing by taking an empty housing 10 to 15 feet down. Most leaks show up when very little pressure is being exerted against the housing's water seals. If no leaks appear at 15 feet you have a 95 percent chance that none will at greater depths.

Always soak your housing with the camera inside by immersing it in clean, warm fresh water after each use in saltwater. The dissolved salt in ocean water will form solid crystals if not washed away by soaking and will eventually cause leakage past the rubber O-ring seals. Housings should be soaked for at least 15 minutes. Washing with running water is not sufficient.

## MOVING UP

This chapter has outlined the easiest and least expensive way to begin to take UW photographs: with Instamatic cameras enclosed in a UW housing.

There are a number of manufacturers of UW housings, a few of which have a large variety of models to fit the many different Instamatic cameras, both current and older models. Some of these housings have been illustrated in this book. Except for the advanced hobbyist who has the knowledge and tools to construct a precision UW housing out of Plexiglas, I suggest that the best way to both learn to do this and to protect your camera is to invest in a commercially available housing from a reputable manufacturer. Manufacturers of UW photographic equipment have often been short-lived, however. Moreover, their addresses may change, but current addresses can always be found in the monthly magazine *Skin Diver,* which is always available in dive shops and at larger newsstands.

As you begin to take more and more photographs underwater, you will find that the Instamatic type camera will begin to limit the type and quality of UW photographs that you are able to take.

First, you will find that the lenses that are affixed (and cannot be interchanged) to the Instamatic cameras are relatively narrow in their *angle of coverage* and that you must back away from many subjects just to be able to get them into your viewfinder. Backing away creates problems in image sharpness and color rendition. A wider-angle lens would enable you to stay close to your subject, thereby creating a sharper picture and much better color.

Second, you will find that you can only guess focus; and because of this, when you misjudge the distance or do not have enough time to use the UW measuring stick, your photographs may be unsharp because they are out of focus.

Third, the *shutter speed* with these cameras cannot be controlled by the diver-photographer, which may limit your ability to take photographs that require a fast shutter speed. Panning to stop action when using a camera with an automatic or slow shutter works only when the subject is moving smoothly at medium or slow speed in one direction. Fast, erratic speed on the part of the subject calls for a fast shutter speed, which cannot be achieved with Instamatic cameras.

Fourth, you are limited to a maximum of 20 exposures per camera load. Of course you must get back into the boat to change film cartridges.

Fifth, since the cameras are quite inexpensive, the lens cannot be fast enough to enable you to take photographs in low light conditions (i.e., overcast weather, extremely cloudy conditions).

*Illus. 1.17* If you shoot downward on a subject, you will find that your subject will tend to blend into the distracting jumble of the sea bottom. Instead, get as low as possible and shoot upward so that your subject is outlined against only a water background. This will add both drama and effectiveness to your UW photographs. Taken with Instamatic X-15 in a Spiratone Aqua-housing. Sunlight exposure. About 15-foot depth. *Photo by Flip Schulke*

Last, since you do not have control over the shutter or lens and since the lens is slow, flash photography is limited to the distances listed in Table 1.1.

When you find it difficult or impossible to photograph desired scenes and subject matter underwater, then you are ready to consider "moving up" to cameras with which you can control both shutter speed and lens light-gathering power, in other words, cameras with standard speed selection dials and $f$-stop settings on the lens.

These better cameras can also be placed in housings. The amphibious camera is designed to be placed in water without the need for a protective housing. The body of this camera itself is a watertight housing.

The next chapter will give you the basic mechanical and optical information that applies when these more sophisticated cameras are used in UW photography.

### Suggested Assignments with Instamatic Cameras

1. Photograph someone—friend, family, or any unsuspecting swimmer, in a swimming pool. Practice holding the camera still—squeezing the shutter button—holding your breath for a few seconds before, during, and after you squeeze the camera button.
2. Pose your subject in the pool in a stationary position underwater. If a blurred picture results, you moved the camera when you pushed the shutter button.
3. Have your subject swim or dive, so that you can practice panning to capture fast-action subjects with the rather slow shutter speeds of the Instamatic cameras.
4. Take some photographs with the sun shining and some with the sun behind clouds so that you can see the resulting changes in colors underwater in these two most common shooting conditions. A red bathing suit (or international safety orange diving vest) on your subject will give you the necessary red for these test photographs.
5. Make a test of exposures by utilizing a flash bulb of your choice, using Table 1.1 as a starting point. If you make the test in a swimming pool, note the clarity of the water and make your test late in the afternoon so that the daylight does not overpower the flash exposures.
6. Read Chapter 6 to learn more advanced lighting techniques which may also be used with Instamatic cameras.
7. Read Chapters 8 and 9 for further ideas of what to shoot when diving.

# 2·MOVING UP WHILE DIVING UNDER—OPTICS AND LIGHT TRANSMISSION

*Illus. 2.1*  Photo by Flip Schulke

This chapter will deal primarily with the theory of how and why the camera "sees" underwater. I have found that there are two general types of learners—those who need to know how and why things work as they do and those who prefer to learn by doing. If you have a hard time understanding the explanations that follow, skip them and go on to the next section. At a later time, perhaps after some practical experience with the problems of photographing in water, you will better understand how this chapter on theory works. This chapter includes an extensive examination and illustration of concentric dome ports, a significant, rather new method for correcting many of the optical problems of UW photography with lenses dsigned for surface or in air photography. A full understanding of how domes actually work in correcting optical *Refraction* problems will greatly aid the advancing UW photographer in obtaining brighter, clearer UW color photographs.

If you are a more advanced photographer, either amateur or professional, you already have a working knowledge of the basic theory of photography and the mechanics of standard camera operation. I have often felt when reading UW photography books that so much general photographic theory was included in detail that the information unique to taking photographs underwater was often slighted.

Therefore, once you have graduated from the Instamatic, or inexpensive, automatic cameras, if you do not already have a basic knowledge of photography, the following books would be helpful.

For the novice with a new *single-lens-reflex* camera (by far the most common 35-mm-film-size camera) Nikon Educational Services publishes a booklet of only 31 pages, entitled *Beginner's Guide to the Single-Lens-Reflex Camera* (revised 1976), by Rick Smolan. You can order one of these booklets from Nikon School, Dept. NS, 623 Stewart Avenue, Garden City, N.Y. 11530.

In it you will find short, easy-to-understand explanations of how to operate SLR cameras.

A second, longer book, which is easily the best basic text-workbook for self-instruction that I have ever seen is *Learning Photography: A Self-Directing Introduction* (revised edition) by Walt Craig, Ohio State University, available by writing to Grid, Inc., 4666 Indianola Avenue, Columbus, Ohio 43214. This is the first book— really a softcover combination of reading and workbook—that I have been able to give to people with no previous knowledge of basic photography who, after following the directions and diagrams, are able to master the basic techniques of camera operation.

For the advanced photographer who feels he can take the best photographs by having a full theoretical understanding of photography, I suggest a hardcover book called *Photography: A Handbook of History, Materials and Processes* by Charles Swedlund, Southern Illinois University, published by Holt, Rinehart and Winston, Inc. Commonly used photographic terms are defined in a glossary, for those who may need a quick glance to remember forgotten terms.

## ADVANCED CAMERA EQUIPMENT USED UNDERWATER

The major types of advanced camera equipment to be examined in subsequent chapters are:

- 35-mm cameras (those using 24 x 36 mm film, commonly known as 35-mm film). These are by far the most popular cameras in use today and, in particular, the *single-lens-reflex,* so called because both the eye "views" and the film "takes" through the same single lens.
- *Viewfinder* cameras, in which the lens is used only to take the photograph and a separate system must be used to view the scene (Chapter 3).
- The amphibious 35-mm camera, designed primarily for UW photography (Chapter 4).

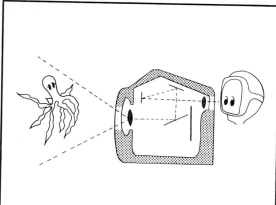

**Fig. 2.1** Single-lens-reflex (SLR) camera, in typical UW housing.

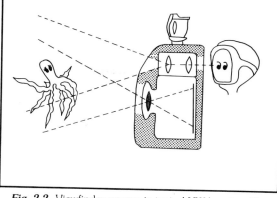

**Fig. 2.2** Viewfinder camera in typical UW housing. This type of camera almost always requires an accessory UW viewfinder—preferably of the "optical" type.

**Fig. 2.3** Twin-lens-reflex (TLR) camera in a typical UW housing.

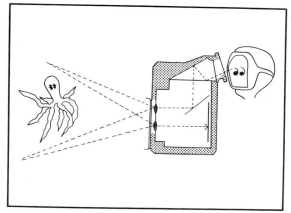

- Large-format cameras (those cameras using 120 or 220 film). The most popular cameras for UW photography in the 1950s, they were largely replaced by the 35-mm cameras used in UW photography today. These cameras can be of the single-lens-reflex type, or of the *twin-lens-reflex type,* whose use was pioneered by Austrian scientist-diver-inventor, Hans Hass (Chapter 5).

Regardless of the type of camera you choose to use, you must understand the peculiar characteristics of light underwater—how it behaves differently from light on the surface—in order to achieve optimum photographic results.

# HOW LIGHT BEHAVES IN UW PHOTOGRAPHY

Light rays from the sun or sky striking the water's surface produce a number of phenomena which you need to understand in order to take more advanced photographs underwater.

## Reflection

Some of the sunlight is reflected back into the air. The rest penetrates through the surface of the water. The lower the sun is in the sky (early in the morning or late in the afternoon), the more light is reflected back into the sky and the less light reaches underwater. The amount of reflected light is also dependent on the condition of the surface of the sea. The waves of rough seas reflect back into the air a much greater amount of light than a calm, flat sea, principally because of the greater surface area presented to the sunlight by the wavy, irregular config-

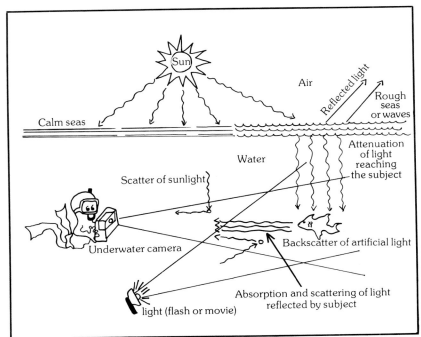

Fig. 2.4 Factors affecting light underwater.

uration of the water. Underwater, about 85 percent of the light is direct light from the sun; the rest is diffused light—light that is scattered by clouds, water vapor, and dust in the atmosphere. When the sun is low in the sky or when there is a heavy cloud cover, 90 percent or more of the UW light is diffuse. Light that is reflected back into the atmosphere can return and penetrate the water surface as diffused light. Therefore it is possible to take photographs early in the morning and late in the afternoon. The light level or intensity will be much lower than when the sun is high, but the diffused light is softer and often more penetrating underwater than harsh, direct sunlight.

## Refraction

The light rays that do penetrate the water undergo a change of direction. They are refracted, or bent, because of the difference in density between air and water. You can observe this when you place an oar into the water. It appears to be bent at the place where it enters the water. It is obvious that the water itself acts like an additional lens in the UW photographic system. *Refraction* ultimately is the source of most of the problems distinctive to UW photography. In order to correct them we must compensate for such effects.

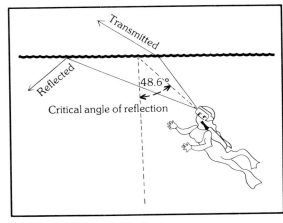

Fig. 2.5 Critical angle of reflection.

## Refraction Problems in UW Photography. / The four main optical problems in UW work due to refraction are:

1. An apparent change in object position. (Objects appear to be ¼ nearer.)
2. A visual increase in image size. (Objects appear to be magnified by ⅓.)
3. A reduced angle of coverage of lens.
4. Some increase in general optical *aberrations*.

The above problems and their correction will be discussed in detail later in this chapter.

## Dispersion

When sun or sky light is refracted, the white light is broken up into the color spectrum like a rainbow. Thus white light is separated into its colored components by the phenomenon called *dispersion*. Because of dispersion, some of the sunlight is scattered, which affects both exposure and color.

## Absorption

The main reason why water appears blue at greater depths is *absorption*. Water absorbs light selectively, absorbing red in the greater proportion, through the spectrum to blue at greater depths, until all light is absorbed and everything becomes black. Red disappears within 20 feet (6 m) of the surface. Orange goes next at about 35 feet (10 m), and yellow is gone at 65 feet (20 m). At 100 feet (30 m) everything is blue or grayish blue-green. This is the sequence of absorption in what are called the "clearwater conditions" seen in the Florida Keys or the Bahama Islands. Exact absorption rates will vary with various water conditions, but the above rates give you something to start with when dealing with color absorption in your own diving areas.

The absorption of warm colors as depth increases creates a color-balance problem in UW photography. It is as though one were completely surrounded by a light-blue filter, which gets deeper and deeper blue as one moves farther and farther away from the subject. This particular problem causes pho-

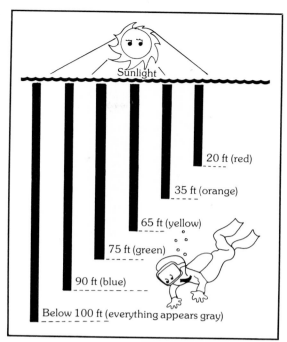

*Fig. 2.6* Color absorption in water.

tographs taken in all but quite shallow water (deeper than 15 feet on a sunny day—at any depth on an overcast day) to be completely blue overall. Brightly colored fish that may still show some color to your eye will come out blue-gray in color photographs. This problem can partly be overcome by the following techniques:

**Closeup and Wide-Angle-Lens Photography** / Shoot with as little water as possible between the camera and the subject—close-up photography for small objects and wide-angle-lens photography for larger subject matter. Obviously the closer you can get to what you are shooting, the less water you are shooting through, and the less the blue-filter effect. You may notice somewhat the same effect when you take photographs in the deep shade in surface photography. Your resulting color photographs will also look very blue or blue-green because the red rays of the sun are being filtered out.

**Artificial Light** / Utilize artificial light to restore the reds, oranges, and yellows to the scene and subject matter. The artificial light most often used for still UW photography is flash bulb or electronic flash (strobe). Battery-powered *movie lights* commercially produced with a maximum of 350 watts can also be used. The most cumbersome method is to use large UW floodlights (1000 watts per light), which must be powered from an electric 110-volt generator in a surface boat. These lights receive their power through thick electric cables, which must be long enough to come down through the water from the boat to the UW photographer. These methods of movie lighting to restore true colors by using constant artificial light are covered in Chapter 8.

**Colored Filters** / Use colored filters in front of the camera's lens to change or compensate for a loss of color or a color shift. Made by Kodak and called *Color compensating (CC) filters,* these come in glass-mounted and gelatine configurations. Many UW photographers have utilized quite a variety of CC filters to try to bring proper color tones back to their natural- or sun-lighted photographs without resorting to artificial light. I am not a great advocate of CC filters in UW daylight photography because I find that the quality of both sun and sky light varies so much, necessitating different filters at different depths, under different sky conditions, and with different water-tint conditions. It is quite difficult to change filters when a camera is inside an UW housing. The only practical camera that has this feature is the Rolleimarin/Rolleiflex UW housing-camera combination.

I have used some of the CC filters in the red range—CC-R—and have found them to be effective in warming up the overall blue tones in shallow-water daylight photography. The CC-M (magenta) range of filters and the Kodak Wratten conversion filter 85 have been advocated by a number of divers in books and articles on color-filter use in UW photography. I have not found these filters, used alone, to be very successful. Color-correction options are broader with the CC-R (red) filters. Check Table 2.1 for approximate filter and depth combinations. Try them out for yourself to see whether they meet your particular UW color-correction needs.

---

**Table 2.1. Recommended Color-correcting (CC) Filters**
(For use in most clear oceanic water,* clear day, sun shining—10 A.M. to 3 P.M.)

Subject-to-camera distance is assumed to be about 5 feet. The depth at which each filter best compensates for the selective attenuation of the water path is shown. A depth range is also shown for which the resulting photographs (on daylight color film) will more or less match what the diver sees. In greenish coastal water the filter compensation should be provided with CC-M (magenta) filters instead of the CC-R (red) filters. (Substitute a CC20R-CC20M combination filter for a CC40R filter.)

| Filter | Best Compensation for Water Path | To Match Approximately What the Eye Sees at |
|---|---|---|
| CC20R | 5 feet | 10–20 feet |
| CC30R | 8 feet | 15–25 feet |
| CC40R | 12 feet | 20–30 feet |
| CC50R | 15 feet | 25–40 feet |

*From *In-Water Photography, Theory and Practice,* by Lawrence E. Mertens, © 1970. Reprinted by permission of John Wiley & Sons, Inc.

---

You can see from Table 2.1 that to get the best correction for color balance, you must use four different CCR filters for depths ranging from 5 to 15 feet. I feel that in general UW photography this is impracticable. I would rather use one or two filters and "live" with the color balance. But color correction really depends upon the photographer's needs and desires, plus the time he has to spend in the water, the variety of situations and depths he plans on encountering, and his tolerance of a color that is not "true." Again I must remind you that

filtration works best on clear, sunny days when you are not using artificial lighting sources. Overall scenic photographs and photographs of large objects underwater cannot be successfully lit by artificial light, and therefore filtration is about the only solution to restoring pleasing UW colors, especially the reds, oranges, and yellows.

Absorption depends, of course, also on the degree of purity of the water. Impure fresh water or seawater can assume the coloration of impurities suspended in it. If there is a lot of vegetation present the water will take on a distinct green coloration. Once while shooting a story for *National Geographic* magazine, on the recovery by paleontologist Dr. S. David Webb of the skeletal remains of Aucilla mammoths from a river in northern Florida, I found the water to be deep reddish brown. This condition was caused by tannic acid from the bark of the many trees that fall into the river and rot. In this case it was impossible to correct for the red color of the water, and the resulting photographs have an overall red-brown cast. There was so much coloration in the water that visibility was very poor, and I had to use extremely wide-angle lenses to get any usable photographs of the recovery of the large "hairy elephant" bones.

## Scattering

Another problem of UW photography is the reduction or lessening of light intensity (*attenuation*) due to scattering of light rays. In other words, the light rays reflect off substances in the water and do not penetrate completely. Both absorption and scattering reduce not only the intensity of light but also the saturation (brightness) or intensity of colors. Scattering can be caused by suspended minerals, decayed organic matter, air bubbles, plankton, minute sea animals, and microscopic vibrations within the water. A diver-photographer has almost no control over discoloration and scattering caused by impurities, or over matter suspended in the water. Reflection of artificial light off suspended particles toward the observer and camera's eye is known as backscattering; it is the effect familiar to those who have driven with headlights on in a heavy rainstorm, fog, or snowstorm. Backscattering can be minimized by the proper placement of artificial light sources relative to the camera. We shall return to this in greater detail when discussing UW artificial lighting in Chapter 7. But one rule to remember about backscattering is that the closer your light source (flash bulbs, strobe, etc.) is to your camera, the more its light will reflect off particles suspended in water and result in a snowflake effect. Therefore flash guns that are mounted on very short arms will cause the most backscattering (see Illus. 1.13.)

## LENSES AND LENS PORTS FOR SOLVING UW OPTICAL PROBLEMS

We have seen in this chapter that many inherent problems in UW color photography can be solved by artificial lighting, and/or color-compensating filtration. These are partial solutions to the problems caused by the refraction of light when it penetrates water.

The next major technique for correcting discoloration, lack of sharpness caused by suspended matter in the water, and refraction-magnification is the use of *wide-angle lenses*, combined with a lens-correction system.

### Refraction Magnification

These problems were touched on in Chapter 1. Let us examine the problems of the *flat port* used in front of the camera's lens underwater in greater detail. First look at Table 2.2, which shows the angles of coverage of common lenses when used in air (on the surface) and those of the same lenses used underwater behind a flat port. The lenses are for interchangeable-lens cameras.

Photographers who are accustomed to thinking in terms of surface angle of coverage must make adjustments when using camera lenses underwater. The figures in the table show the differences due to refraction: an object photographed will appear closer as the angle of coverage of the lens underwater no longer "sees" as it does on the surface, but loses 25 percent or one fourth of the in-air angle of coverage. A 50-mm lens has an angle of coverage of 46° when one is photographing on the surface; through a flat-port window its angle of coverage is reduced to 34.5°. No longer is the 50-mm lens a normal lens; it is now a semi-telephoto lens. Consequently you must move one fourth of the distance from your subject farther away to include the whole subject. And of course you are then shooting through one quarter more water, with increased lack of clarity as well as reduced color saturation and intensity (brightness of color).

You can see by looking again at the table that in order to get the "normal" angle of coverage of 46° you must in fact use a 35-mm lens through a flat-port window. In other words, a 35-mm lens equals a 50-mm lens underwater through a flat port. To re-store the surface angle of coverage you must back away from your subject underwater more than the apparent distance when underwater.

Going down the table, you see that you need a 24-mm lens to approximate the angle of coverage of a 35-mm surface lens. You need a 17-mm lens underwater to approximate the angle of coverage of a 28-mm surface lens.

Therefore, practically speaking, you must take this adjustment into consideration when choosing lenses that will give you the ability to remain closer to your subject—and thus shoot through less water—but still retain the angle of coverage of a wider-angle lens.

A point of clarification on the use of the word magnification in diving. As we have stated, objects as seen through a flat port appear through refraction to be closer to you than they really are (one fourth closer). Therefore they appear to be larger (magnified) by one third. The object is not really larger or magnified, it only appears larger because the apparent distance brings it closer, and any object that moves closer to an observer "grows" in size. Again, as I have said, all the diver-photographer has to do to

### Table 2.2. Diagonal Angle of Coverage of Commonly Used Camera Lenses*

| Lens Identification (Focal Length) 35-mm Lenses (24 x 36) | Lens Coverage in Air | Lens Coverage Underwater When Photographing Through a Flat Port |
|---|---|---|
| 50 mm: considered the normal-focal length lens in a 35-mm camera | 46° | 34.5° |
| 35 mm: semi-wide-angle lens | 62° | 46° |
| 28 mm: medium-wide-angle lens | 74° | 54° |
| 24 mm: wide-angle lens | 84° | 60° |
| 20 mm: very wide-angle lens | 94° | 66.5° |
| 17 mm: extremely wide-angle lens | 103° | 72° |

*Coverage angles are generally calculated in relation to the image diagonal.

restore the true size of an object is to move back away from the subject by one fourth and the object will decrease in size by one third—or return to its normal relationship and angle of coverage of any particular lens size. Therefore, though there has been much misinformation written about this, a lens does not change *focal length* underwater, it is solely the effect of the shorter apparent distance from the object which leads one to "see" the object magnified.

Moving back from the subject forces the

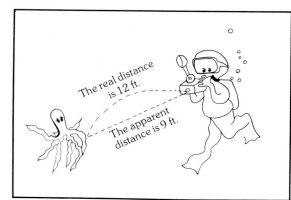

**Fig. 2.7** Apparent decrease in camera-to-subject distance caused by refraction. Objects appear to be ¼, or 25 percent, closer.

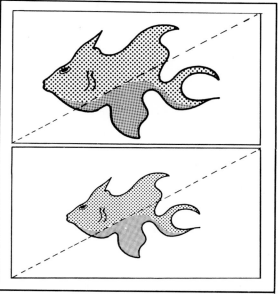

**Fig. 2.8** Apparent increase in size (magnification) caused by refraction. The bottom figure is the actual size of a fish. The top figure is the size the fish appears to the camera lens underwater, that is, ⅓, or 33⅓ percent, larger.

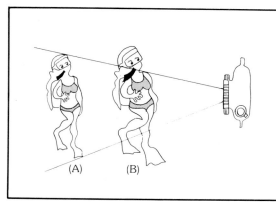

**Fig. 2.9** Because of refraction your camera sees figure A—on the surface—far enough away from the subject so that the full figure is recorded on film. When you take the camera underwater, remaining the same actual distance away from your subject, the UW camera will now see the subject at position B. Since the figure is now ⅓ larger, your lens will cut off the head and legs as seen in this drawing. In order to photograph the full figure, you must back away from the subject.

Barrel distortion          Pincushion distortion

**Fig. 2.10**

camera to view the subject through 25 percent more water, and this complicates the problems of sharpness of image and color brightness. Thus, the prime reason for preferring wide-angle lenses in UW photography is that these lenses enable the photographer to get as close as possible to the subject being filmed. By permitting you to get closer to your subject while retaining the full image within the frame, a wide-angle lens enables you to shoot through fewer particles and less water, resulting in a clearer picture.

## Other Optical Problems Caused by the Flat Port

In addition to causing the shorter apparent distance changes described, a flat port also produces undesirable *aberrations. Chromatic aberration,* or aberration of color, degrades the sharpness of the photographic image, that is, it reduces *resolution.* This is especially noticeable toward the *edges* of an image. This aberration is most apparent when the recommended wide-angle lenses are utilized in UW shooting through a flat port. It also degrades the color saturation of the UW photograph.

The last major aberration with a flat port is *distortion.* Distortion affects the shape of the photographic image. Pincushion distortion results when magnification of the outer portions of the picture are greater than that of the center portions, and barrel distortion results when it is less. A flat port produces pincushion distortion primarily—again more noticeable with wide-angle lenses. Such distortions are less distracting, of course, if natural subjects with no straight lines or square corners are being photographed.

It should be noted that the term "distortion" is often used with quite different and incorrect meanings by many photographers. At times it is used incorrectly to describe the elongation of shapes and the exaggerated perspective (often put to good artistic use) that result when a wide-angle lens is used very close to the subject being photographed. This effect, however, is properly called "forced perspective" and is an exaggeration caused, not by the lens itself, but rather by the photographer's proximity to his subject. Optical, or lens, distortion is caused by the lens (in surface photography) and the lens-port combination in UW photography and is most accurately called "curvilinear distortion." I like to draw the distinction between optical and perspective distortion only because so many photographers blame the camera's lens for the exaggerated shapes that they themselves cause by getting too close to their subject with that particular lens.

*Illus. 2.2* A graphic example of forced perspective with a wide-angle lens used underwater. Because the photographer has moved in close, the barrel of the dart pistol looks abnormally long in relationship to the true length of the pistol, and also out of scale with the diver's head. When forced perspective is understood and applied with thought, it can add drama to your UW photographs. Taken with Nikon F, 35-mm SLR, 28-mm lens. Harrison/Atlantic Plexiglas housing. Tri-X black-and-white 400 ASA film. Sunlight, exposure determined by using a Sekonic light meter. 20-foot depth. *Taken for* Life *magazine by Flip Schulke*

Now that we have seen the advantages of using a wide-angle lens underwater and have also seen the optical problems caused by the refraction of water in using them, the next step is to look at some of the various methods of correcting the difficulties.

## UW OPTICAL LENS CORRECTION SYSTEMS

Because of the many optical problems inherent in the use of flat ports in UW photography, several approaches have been tried in order to resolve them. The following are some of the leading approaches and solutions:

1. The concentric, or Dome, port
2. The Ivanoff corrector
3. The Cousteau dome
4. Water-contact UW designed lenses

### Concentric, or Dome Ports

Before I go into explaining dome ports, I would like to tell you how I began experimenting with corrected optics. I had progressed from using my first home-made Plexiglas housing for a Leica 3f 35-mm lens, which I borrowed from a photographer friend, Carroll Seghers II, in 1955, through other Plexiglas housings of my own design until I had devised a housing for the Nikon F single-lens-reflex camera in the early 1960s. Utilizing a three-sided prism from an old Rolleimarin housing, I was able to enlarge the viewfinder screen of the Nikon F SLR. This was in the days before the Nikon and Canon Sports or Speed finders, five-sided prisms that greatly enlarge the ground-glass viewing screen of Nikon and Canon SLRs. This primitive viewing system for the Nikon F camera enabled me to see the complete ground-glass viewing screen while underwater. Up to that point (about 1963) the widest-angle lens that was practicable in the SLR housing was the 28-mm lens. Of course I had a flat port on the front of my Plexiglas housing. The corners of photographs taken with even the 28-mm lens were not sharp. I did not know how to correct for this problem.

Nikon had produced an 8-mm f/8 fisheye (a lens "seeing" 180° and giving a circular image on 35-mm film). I had been contemplating photographing some research submarines underwater and was trying to figure out how to use the widest angle lens possible underwater. The problem with the Nikon fisheye lens—which by the way was the only fisheye lens commercially available at that time—was that its front element was curved like half a baseball.

If you place a flat port in front of this particular lens, the lens will see the whole inside front of the UW housing. A diver-assistant and friend, Paul Dammann, suggested that perhaps the circular concentric covering of a boat's compass might work in covering the curved fisheye lens and also act as the port. This way the curved front element of the fisheye lens could fit into a slightly larger concentric compass cover. I found various-sized glass and Plexiglas compass covers in a large Miami boating supply store, where they were sold as replacements for cracked compasses. They looked like domes to me, so Paul and I called them "domes" from the beginning.

I took a few different-sized Plexiglas domes to photographer-designer Jordan Klein of Mako Engineering in Miami. He cut a circular hole in the flat front of my housing and glued on the Plexiglas dome so that the camera's fisheye lens protruded into and nearly filled the dome. Taking it underwater, I found that it worked! I later learned that Klein had been doing the same thing, at the same time, for a young marine biologist-photographer, Dr. Walter Starck III.

In 1964 I made my first photographs with the fisheye plus dome UW housing. In 1965 I went to Seattle, Washington, to photograph Namu, the Killer Whale (see Chapters 4 and 10). While doing some further testing of this equipment, soon after fabricating it in 1964,

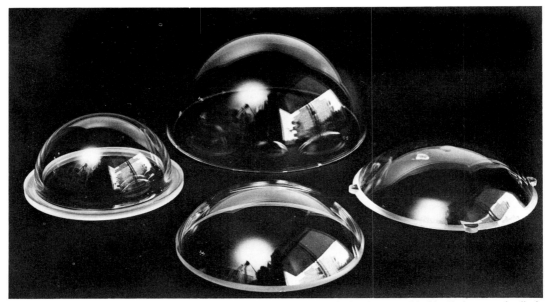

***Illus. 2.3*** Plexiglas concentric dome lens ports. The dome on the right has been molded by Ikelite specifically for UW-housing lens correction. The other three are replacement domes for boat compasses manufactured by Ritchie and Danforth White. These replacement compass domes can be obtained from most yachting or boating instrument sales outlets. *Photo by Flip Schulke*

***Illus. 2.4*** My original 1964 Plexiglas Harrison/Atlantic UW housing for the Nikon F 35-mm SLR camera which featured a Ritchie compass dome port glued onto the face of the housing in place of the normal flat port. It had been modified many times to incorporate early prism finders, and the controls have been used again on subsequent housings. These glued Plexiglas UW housings have been superseded by commercially manufactured cast aluminum and molded Lexan[tm] plastic housings. Nearly all UW housings up until the middle 1960s were built at home or made to order on a one-of-a-kind basis.

I took a photograph in a swimming pool, half underwater and half out of water. Instead of getting the magnification of the lower half of my subject's body under the surface of the water, I discovered that the part of my subject underwater was the same size as the top half. I realized that the dome had somehow corrected for the refraction of the water and that the lens underwater was

"seeing" actual, not apparent, distance. I made a patent search and discovered that the principle of utilizing a curved concentric covering over a lens was patented in the 1920s and that therefore no enforceable patent could be received. At the same time E. M. Thorndike and optical engineer Gomer McNeil were doing separate projects for the U.S. Navy in which concentric dome ports were utilized to correct the problems of refraction in UW photography.

When I communicated with Gomer Mc-Neil, he was able to explain to me the theory behind the use of corrective optical domes in UW photography. I showed the results of my corrected dome optics for both Nikonos and SLR cameras at the International Underwater Film Festival, held in Santa Monica, California, in 1966. There I conferred with other UW photographers and an optical designer, Greg Morris, showing them the technical aspects of dome correction. Soon the California UW housing manufacturers were offering dome optical correctors for SLR housings and corrected wide-angle lenses for the amphibious Calypso/Nikonos camera. Dome correctors have become the accepted and least expensive method for correcting the major problems inherent in UW photographic optical systems worldwide. The question is: How do they work?

**Dome Ports: Theory and Practice** / One of the most elementary and least costly methods of restoring the full coverage angle of an in-air lens used underwater and of avoiding many of the aberrations of a flat UW port is to use a hemisphere with concentric inner and outer surfaces. The majority of these domes are made of Plexiglas, which has very good optical properties. The main suppliers for such domes are the manufacturers of Plexiglas covers for marine compasses, the type of dome I used for my prototype. Glass domes are also used and can be obtained from optical supply houses. Before discussing the advantages and disadvantages of each, let us consider the general optical principles on which they work.

In order to gain the full corrections that the dome port affords, the normal in-air lens and the dome must be so placed that the entrance pupil of the lens and the center of curvature of the dome coincide. From Fig. 2.11 it can be seen that the light rays enter directly (in a straight line) through the dome and camera lenses and hit the film inside the camera, that is, any light ray traveling along the normal continues without deviation and therefore is not refracted (bent). The original in-air angle of coverage of the lens is thus preserved.

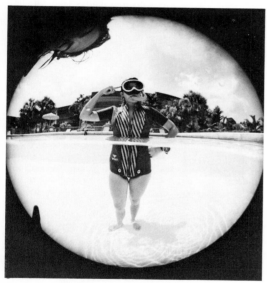

*Illus. 2.5* The best way to prove a theory is to demonstrate it. Here you see a photograph taken in a swimming pool (see Illus. 1.8), this time with an 8-mm Nikkor fisheye lens which gives a 180° angle of coverage on the surface. The fisheye lens is protected from the water by a concentric dome port (see Illus 2.4). The camera and housing are held half in and half out of water. You can see that the model's waist is the same thickness both above and below water. The concentric dome port in conjunction with a lens underwater has corrected for refraction—the underwater portion of the subject and the above-water portion remain exactly the same actual and apparent distance from the camera underwater and on the surface. Proof that the dome principle does correct for refraction in UW optics. *Photo by Flip Schulke*

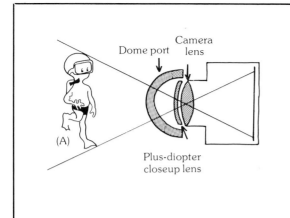

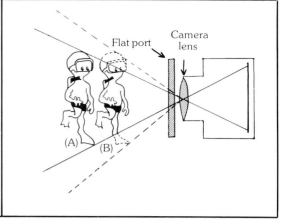

**Fig. 2.11** The image as seen through a dome port. Because the dome port corrects for the effects of refraction, the angle of coverage remains the same underwater as it does on the surface, in air. (Compare with Fig. 2.12.)

**Fig. 2.12** The image as seen through a flat port. Because the flat port does not correct for refraction, the angle of coverage is narrowed. Instead of seeing the diver at position A, the lens and flat port combination sees the diver at position B. Unless you increase the camera-to-diver distance (by backing up), you will cut off the head and feet of your subject in the finished photograph.

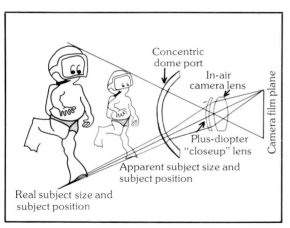

**Fig. 2.13** This drawing (not to scale) shows you the effect of the dome port with regard to the apparent distance of subject to camera. The dome port in contact with the water forms a strong negative lens element, thereby reducing the subject in size and seeing this reduced subject very close to the camera. In order to properly focus on this "closeup" subject a plus-diopter closeup lens is often needed—unless the lens is designed for a 1 foot near focus point.

As discussed previously, a flat port reduces the apparent object distance by 25 percent from the real or actual object distance. A dome port in conjunction with an in-air lens reduces the apparent object distance even more, but it does not magnify the object. This is due to the fact that the dome port in contact with the water forms a strong negative lens element. Just as a rough example: with a dome with a radius of 4⅓

inches and an actual in-water distance of 8 feet to your subject, the dome port causes the camera's lens to see your subject—reduced in size—apparently 15.6 inches away from the UW camera. The exact apparent object distance varies, depending on the radius of curvature of the particular concentric dome port used, and the reduction in apparent distance is greatest for the smallest domes.

What the UW photographer is confronted with, in effect, is closeup photography, only as far as focusing the lens is concerned. Closeup photography, of course, can be managed either by using a plus-diopter supplementary lens (called portura lenses by some optical manufacturers) or by using an extension shim or extension tube to move the film plane farther from the lens. Which of these means is used depends on the particular camera and in-air lens combined with the dome port. I find that the plus-diopter supplementary lenses, which are obtainable at low cost, are preferable.

Table 2.3 gives examples of supplementary plus-diopter lenses to be utilized with specific domes. Many current wide-angle lenses now focus close enough so that no plus-diopter supplementary need to be used.

## Table 2.3. Dome Ports

| Radius of Curvature of Dome Port | Diopter lens |
|---|---|
| 3.5 inch (89 mm) | +5 |
| 6 inch (152 mm) | +3 |
| 8 inch (203 mm) | None, if the in-air lens being used can be focused to within 2 ft (610 mm) |

It is thus evident that the dome port as such, used with or without a plus-diopter lens, will affect the accuracy of the camera lens's engraved focus or footage scale. This scale cannot be used accurately in dome-port UW applications. The focusing scale must be recalculated, either through optical mathematics or by making tests underwater. Naturally, if focusing is done via the ground glass of an SLR camera, one does not have to refer to the footage scale at all, because if the subject is sharply focused on the ground glass in the camera's reflex viewfinder, then the photograph will be sharp.

The main points to remember about dome versus flat ports are these.

1. A camera seeing underwater through a flat port has its angle of coverage reduced by 25 percent, causing the UW photographer to move back from the subject 25 percent in order to restore the normal in-air angle of coverage of any particular lens.
2. A camera seeing underwater through a dome port in effect retains the normal in-air angle of coverage. Therefore the photographer can remain closer to the subject.
3. The dome-port system also exhibits very good correction of pincushion distortion, as can be seen by the two test-pattern photographs (Illus. 2.6 and 2.7). Edge sharpness is not totally corrected, but in actual UW photographs loss of edge sharpness can barely be detected.
4. Dome-port systems do exhibit a slight difference in focus from the center of the frame to the edge of the frame. The reason is that the dome port focuses on a curved aspheric surface, but the camera's film plane is flat. It is completely compensated for, however, by the depth of field of wide-angle, in-air lenses.
5. The dome-port combination also gives good correction of chromatic aberration (color brightness). When a photograph is taken with both flat ports and dome ports under the same UW lighting conditions, the dome-port photographs will have much brighter colors in wide-angle photography.
6. Dome-port systems also correct for angle of coverage in fisheye lenses, restoring the in-air angle of such lenses (See Fig. 2.8). Remember, the extreme curvature (barrel distortion) is caused by the fisheye lens design, not by the dome port, which retains the lens's in-air angle of coverage.

**Plexiglas versus Real-glass Domes** / Let us now briefly consider the merits and drawbacks of Plexiglas and real-glass domes. Glass ports, fabricated to the proper shape, size, and thickness, can have good strength and rigidity. However, glass domes are much more costly, and they are difficult to cut to the proper size for a housing. Moisture (fogging and droplets) forms more

**2.6**

**2.7**

*Illus. 2.6, 2.7* Another way to demonstrate the refraction-correction capabilities of concentric dome ports is to photograph a test pattern underwater with the same lens behind different ports. On the left, *Illus. 2.6*, the 5-foot-wide test pattern was shot from 3 feet distant with a 20-mm Nikkor lens behind a flat port. You will note that there is strong "pincushion" distortion of the straight lines in the test pattern. The geometrical shapes of the pattern are stretched and out of focus as you look toward the edges of the film format. The test pattern also is closer than in the photograph on the right, *Illus. 2.7*, though this photograph was taken from exactly the same camera test-pattern distance as the left photograph and with the same 20-mm lens, but now the 20-mm lens is behind a *concentric dome lens port*. The dome-corrected photograph exhibits straight test-pattern lines, even geometric patterns over the whole film format, and nearly sharp focus throughout. In a like color-test-pattern photograph the dome-corrected lenses also exhibit superior color brightness (saturation). *Photos by Flip Schulke*

*Illus. 2.8* UW test-pattern photograph taken with a Minolta-Rokkor-OK MC fisheye lens, 16mm, $f/2.8$ behind a corrected dome lens port. It gives 180° angle of coverage in air and the same angle of coverage underwater. *Photo by Flip Schulke*

readily on the inside of a glass dome, especially in cold water. Plastic, on the other hand, is cheaper and more easily fabricated, but it scratches easily. Plastic domes can be protected from scratching when not in use by lens covers. They show almost no fogging or interior condensation of water vapor. All

in all, plastic domes seem best at the depths we have been working at, that is, surface down to 150 feet.*

Condensation can become a real problem when the surface air temperature is much warmer than the water and the air humidity is high. This warmth and humidity enter the UW camera housing when it is opened to change film. When the housing is then closed and submerged in cold water, the temperature change is transmitted quickly through glass and condensation starts. The resulting photographs look as if they were shot through mist or fog. **A tip:** When condensation is noticed on the interior of whatever type of port is being used, the heat from an UW light can often be enough to warm up the port, and the condensation will evaporate. Inserting a silica-

*I am well aware that scuba divers photograph deeper than 150 feet with compressed air. I do not advise it. Any diver-photographer venturing deeper than 150 feet with compressed air is seriously risking *nitrogen narcosis* or, even worse, the *bends*. He must be fully aware of his own limitations regarding the buildup of nitrogen in his bloodstream which can lead to the narcosis or *decompression sickness*. (See Glossary.)

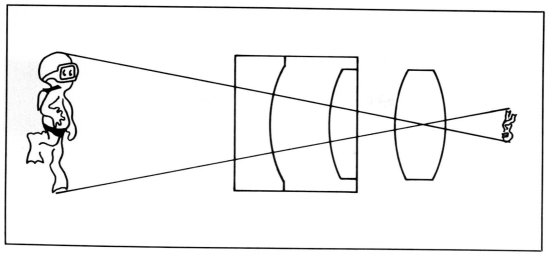

**Fig. 2.14** The Ivanov corrector port. (Lens-elements are not drawn to scale.)

gel packet into the housing before diving may also help.

Housings currently available with dome corrected ports are listed, along with their manufacturers' names and addresses, in the Appendix.

## Other Lens-Correction Systems

Since the interest in UW photography is growing so quickly—both for personal and scientific-industrial use—refraction correction systems will continue to proliferate. Three of such systems, about which I have personal knowledge, will now be examined.

## The Ivanoff Corrector Port

One of the first optical designs to reduce the aberrations inherent in the flat port is the *Ivanoff corrector port,* invented by Professor Alexandre Ivanoff in France. It is basically a reversed Galilean telescope, in which the front plano-concave lens is used as the watertight port. This negative element is combined in the corrector with a positive lens positioned behind it.

The Ivanoff corrector port was designed to be afocal, and it therefore can be used in conjunction with an in-air camera lens of any focal length as long as no vignetting of the corners of the film frame occurs. It completely corrects for the UW magnification effect; and thus the focal length, image scale, and angle of coverage of the camera lens is the same in water as it is in air. Pincushion distortion, chromatic aberration, and other flat-port aberrations are fully corrected. Although the Ivanoff corrector is afocal, in practical applications, where in-air lenses physically change in size and where it is necessary to focus the in-air lens underwater, a separate Ivanoff corrector port must be designed, constructed, and matched to each individual in-air focusing lens it is intended to be combined with. Its full range of UW corrections make it a superior choice when undertaking exacting UW mapping.

Manufacturing and patent rights to the Ivanoff corrector port are held by Dimitri Rebikoff, and the port can be obtained only from him. The high cost of this corrector port has limited its use primarily to government and industry, since it is sold by Rebikoff only as part of a variety of camera-plus-corrector units.

*Illus. 2.9* One of Jacques Cousteau's divers looks through the Cousteau dome port. Note how this optical system reduces the diver's head. *Photo by Flip Schulke*

## The Cousteau Dome Port

The specifically designed and built UW cameras—both still and movie—that Jacques Yves Cousteau's team of UW photographers use for their theater and TV documentaries have an in-air lens used in conjunction with a different type of glass dome port. It differs from concentric dome ports in that the dome element is thinner in the center and thicker at the edges (that is, the radius of the curvature of the second surface is shorter than that of the first surface, thus forming a negative meniscus lens). Through one of these Cousteau domes, the scene or object appears to be reduced in size. A separate glass dome is optically ground for each different focal-length lens that the Cousteau photographers use in their UW

cameras. To my knowledge, Cousteau has never published the specifications of this dome corrector, nor has he made them commercially available.

## The Water-Contact Lens

The ultimate in correction of aberrations, distortion, and magnification can be found only with camera lenses designed—from the beginning—for UW usage. Utilizing high-speed computers and glass that meets the requirements of total UW optical correction, lens manufacturers are beginning to produce fully corrected—some of the early models are partially corrected—water-contact lenses. These lenses cannot be used for in-air (surface) photography, since the front element of the entire lens is designed to be

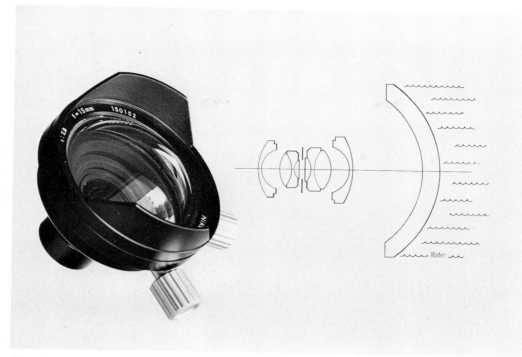

**Illus. 2.10** Nikkor UW 15-mm, $f$/2.8 water-contact corrected lens for the Nikonos/Calypso amphibious cameras. The effective focal length underwater is 20 mm.

in direct contact with the water in order to obtain the desired optical properties. These lenses differ from in-air lenses used in combination with corrector ports, though interestingly enough all except one of the water-contact lenses employ a curved or dome-type front water-contact element.*

The pioneer of water-lens development has been Nikon Optical of Japan. It has made a partially corrected 28-mm lens and a fully corrected 15-mm lens for its 35-mm Nikonos UW still camera (amphibious). These lenses will be discussed fully in Chapter 4.

A series of completely corrected in-water lenses, for both still and movie use, is currently manufactured by Ernst Leitz Canada Limited. Marketed as Elcan lenses, they have been designed for use with both 2½ by 2½ inch (6 by 6 cm) and 35-mm still cameras as well as for 16-mm and UW TV cameras. Since these lenses are in very limited production—being purchased for specially designed government and industrial UW usage—the cost of these superb UW lenses is quite high.

*The first commercially available water-contact lens, the 28-mm Nikkor UW lens for the Nikonos amphibious camera. Though corrected for all other UW aberrations, it is not corrected for magnification, and gives an angle of coverage of a 36-mm lens when underwater.

# 3 · THE 35-mm CAMERA UNDERWATER

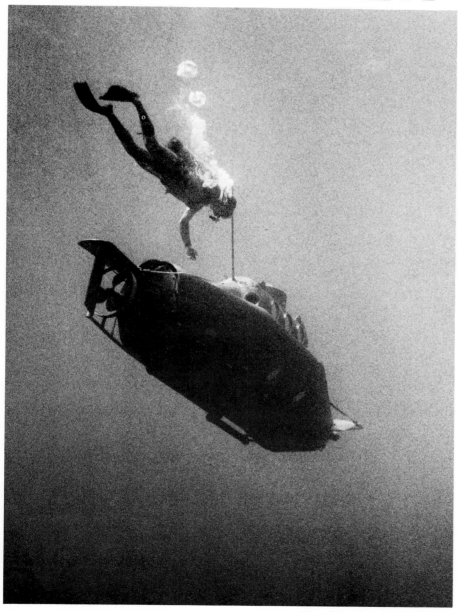

**Illus. 3.1**  *Photo by Flip Schulke*

Numerous books have been written on the care and feeding of 35-mm cameras, since they are by far the most popular "advanced" camera.

It wasn't always that way. Because of the level of the technology, larger-format cameras were the rule until the early 1950s. Indeed, the early Rolleimarin housing designed by Hans Hass for the German-made Rolleiflex camera caused UW photographers to concentrate on this particular camera and housing and 2¼ x 2¼ size roll film format for years.

The real breakthrough in the popularity and acceptance of the 35-mm camera came about with the single-lens-reflex 35-mm camera. Focusing and viewing could be done through the same viewfinder, allowing the photographer to see exactly what the camera lens would record on film. This system made framing and focusing easier and eliminated parallax problems. At first the mirror that enabled the viewer to see through the same lens that took the photograph would black out the viewfinder by remaining up, covering the prism/viewfinder, as the shutter button was pushed. This problem was solved by the Asahi-Pentax Company of Japan, who designed the first instant-return mirror, which would automatically pop back into viewing place as soon as the exposure was made. All the other SLR manufacturers followed, and the boom for SLR 35-mm cameras began—a boom which has not slowed.

*National Geographic* and *Life* magazines used 35-mm color almost entirely. *National Geographic,* with its continued interest in Jacques Cousteau, and subsequently many other UW photographers, used 35-mm color underwater and showed that the color and sharpness indeed were retained.

The resolution (sharpness) of a larger negative or color transparency cannot be surpassed because it does not have to be enlarged as much to get the same size print

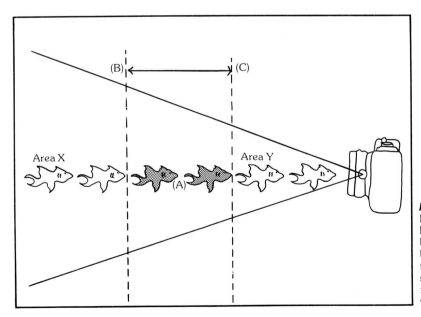

**Fig. 3.1** Depth of field. If you focus your camera's lens on point A, everything between point B and C will be in sharp focus. Depth of field is regulated by both *f*-stop and point of camera focus (A). Areas X and Y will be out of focus.

*Illus. 3.2* A typical black-and-white 35-mm contact sheet from a roll of film shot with the Nikonos camera and the 28-mm UW Nikkor lens (effective focal length underwater is 38 mm). *Photo by Flip Schulke*

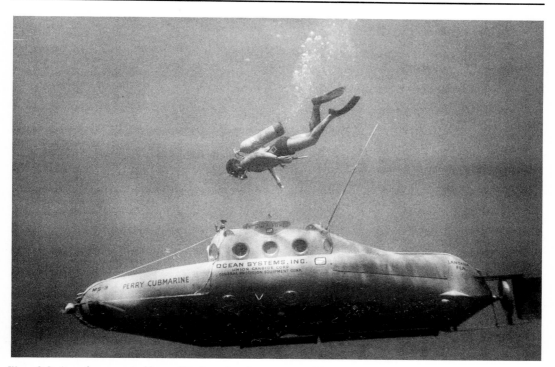

*Illus. 3.3* An enlargement of frame 19a from the above contact sheet. From an assignment on research submarines for *Life* magazine. *Photo by Flip Schulke*

or printed engraving. But there are some major advantages to using 35-mm cameras that I feel far outweigh cameras of the larger format.

## Advantages

1. The wide gap in overall cost of both camera and housing, vis-à-vis 35-mm and 2¼ x 2¼ inch. The 35-mm equipment is much less expensive, especially in the cost of a UW housing and all accessories.
2. The ability to interchange lenses easily at less cost than with 2¼ x 2¼-inch cameras.
3. The availability of macro- (for closeup photography of fish and coral), wide-, and extremely wide-angle lenses (for getting in close with larger UW subject matter.)
4. The much greater *depth of field* inherent in 35-mm lenses over 2¼ x 2¼-inch lenses, giving equal angle of coverage.
5. The ability to look directly through the SLR prism, which helps the photographer attain sharp focus and accurate composition of subject matter.
6. The greater variety of film available to the photographer in the 35-mm size. (See *Film* in the Glossary.)
7. The 36 exposures per cartridge of 35-mm film, versus 12 exposures for 120 film and 24 exposures for 220 film (2¼ x 2¼)—a distinct advantage, because of the difficulty of returning to a boat or dry area, drying the UW camera housing, opening the camera, changing the film, and then returning to the water for more UW photography.
8. The smaller physical size of the 35-mm camera, which allows for a smaller UW housing and subsequently a lighter-to-handle housing on the surface or in a rocking boat.
9. The ease of swimming with a smaller housing.
10. The ready availability of 35-mm slide projectors, to show UW color slides. Have you ever tried to find a 2¼ x 2¼ slide projector? Yes, they do exist, but in very small numbers.
11. Availability of motorized film advance 35-mm accessory attachments for a number of 35-mm SLR cameras which will fit into some UW housings.

## Disadvantages

1. The 35-mm camera must be handled with greater care in composing the photograph, that is, you must fill the frame to the edges to reduce the amount the photograph must be enlarged. Processing and film handling must be extremely careful: The smallest scratch or speck or dust will be exaggerated on a 35-mm negative because it must be enlarged more.
2. The Rolleiflex camera (2¼ x 2¼ inches) in the Rolleimarin housing has a between-the-lens shutter instead of the *focal-plane* (curtain) *shutter* found on most 35-mm cameras and all SLR 35-mm cameras. Therefore electronic (*strobe*) flash used underwater can be synchronized at shutter speeds *above* 1/60 of a second, the limit of most 35-mm focal-plane-shutter cameras. This is an advantage for those photographers specializing in photographing fish.
3. Owing to the small pentaprism viewfinder on 35-mm cameras, it is very difficult for the diver wearing a face mask to see through the 35-mm UW housing the complete frame in the prism viewfinder of the SLR cameras. This difficulty can be corrected in only two 35-mm cameras, Nikon and Canon, which have greatly enlarged accessory viewfinder prisms, called Sports or Speed viewfinder prisms, which slip into place when the normal viewfinder pentaprism of these cameras is removed.

# SOME PERSONAL OBSERVATIONS ABOUT THE 35-mm CAMERA IN UW PHOTOGRAPHY

In my opinion the 35-mm camera is presently the most versatile camera for top quality UW photography, the next most versatile being the Nikonos amphibious camera. Next in line would be the 35-mm cameras with noninterchangeable lenses, such as the Olympus 35 RC, the Rollei 35 and 35 S, and the Konica Auto-S 2 and C 35.

Professionally I prefer 35-mm cameras in UW picture taking. I utilize a number of Canon and Nikon cameras in housings, along with a few Nikonos and Calypso amphibious cameras which I use primarily with wide-angle and extreme wide-angle lenses. This battery of UW cameras gives me a lot of "shooting power" per dive.

When I need to use a larger-format camera underwater I prefer the Asahi Pentax

6 x 7 (120/220 film size) in the Pentax marine housing (see Chapter 5). If you already own, or favor larger-format cameras, stick to them underwater. But for the beginning UW photographer, I suggest examining the vast variety of 35-mm UW gear available. You will find them easier to use underwater and much easier on your pocketbook.

## What You Need to Know about 35-mm UW Housings

Later in this chapter I shall discuss specific UW housings for 35-mm cameras. I have used all the housings that I shall discuss in detail. Some are not now manufactured, but can be obtained in the second-hand market. If you are looking for a particular housing no longer manufactured, a classified ad in the newspapers of a large city, especially New York, Chicago, or Los Angeles, should bring you results. Many times photographers with an older housing—the very one you may be looking for—want to get a different housing for a different camera or for a different purpose and so are looking for a buyer. I shall list which housings are no longer manufactured and which are available. Many manufacturers of UW photographic equipment run small businesses, but the majority of them, though they produced very good equipment, have in the end failed.

Consequently I try to concentrate on the few UW manufacturers who are either connected with large photographic manufacturing companies or who have been able to survive manufacturing and selling UW photographic equipment for a reasonable number of years. A few of these companies are constantly updating their housings to match the constant changes that camera manufacturers make in their cameras. The recurring problem of UW housings is that quite often a minor model change, either in positioning of camera controls or in the physical size of the camera, will necessitate a newly designed housing. This is an inconvenience in UW photography, something we just have to live with.

Before deciding on any particular housing, it is best to get all the available information from the manufacturer or dealer who is selling UW photographic gear. Talk to other UW photographers about their experiences with any equipment you might think you are interested in. You will find many "horror" stories, about certain housings and UW strobes that are difficult to handle underwater, that leak, and that just don't stand up to the corrosive effects of saltwater.

You must also be wary of many salespersons in both dive and photographic stores. In dive shops, where most UW photo gear is sold, the salesperson may not be as knowledgeable as he tries to appear—and may simply try to sell you whatever he happens to have, without concern for your specific needs. In photo shops, the salesperson may be well versed in surface photography but know little about the problems of diving photography or UW photographic equipment. He, therefore, may not be equipped to give you intelligent advice on purchasing a housing.

As with all types of technical gear—radios, hi-fi's, CB units, etc.—you must learn as much as possible about the items you're seeking. You'll find that if you have some idea of what you are trying to accomplish with your UW photography, the dive shop employee can find out the answers to your questions.

You will also find that, because each camera needs its own particular housing, stores stock only a minimal selection of models. (Helix Limited in Chicago is one exception.) But stores usually have good illustrative catalogs, which will show you in pictures what you may be looking for.

Again, *Skin Diver* magazine is a good place to learn about new photographic gear

***Illus. 3.4*** A typical open-type viewfinder, often referred to as a sports finder.

***Illus. 3.5*** An optical viewfinder of my own design.

for UW photography, since photography now is the largest single hobby of both snorkelers and scuba divers. In *Skin Diver* you will find articles on most of the new UW photo products as they are seen, used, or tested by that magazine's writers. A bit of caution is needed, though, when reading their articles, for I have found them to be a bit optimistic when describing the virtues of new gear and a bit lax in describing the things the gear won't do.

It is impossible to discuss in great detail exactly how each housing that I will talk about works. **Read the directions that come with each housing carefully.** If the dive shop or photo store has the item in stock, ask to read the directions before buying; they will give you a better idea of how it will work underwater.

In this book you will find that much of the specific information that I give on named UW housing models will also apply to other models that appear on the market after this book has been published.

## Viewfinders for Use Underwater

Since viewfinders are utilized with many UW housings, I will next discuss viewfinders, and in particular some individual models. Different camera-housing combinations require certain types of viewfinders to make it possible for the UW photographer to best compose or see as closely as possible what the camera will actually record on film. There are three major types of viewfinders for UW use:

1. Sports finder (or open viewfinder)
2. Optical viewfinder
3. The camera's optical viewing system (direct viewing)

The first type (sports finder) seems to be at

best a poor compromise; it gives only a very rough estimation of the exact framing of a UW camera's lens. These open sports finders were the first type widely used in UW photography, and the most simple and least expensive. The optical finder, the best of the supplementary finders, was originally very costly. Today, thanks to plastic molded lenses, it is quite low in cost. Both of these viewfinders must be attached to the outside top of the respective UW camera housing. Because the viewfinder is a few inches away from the lens of the camera, when you look through the viewfinder, you are seeing the subject matter from a slightly different perspective. This is called by photographers *parallax*. The line of sight through the viewfinder is offset from the line of sight of the lens because the bulky UW housing does not permit the viewfinder to be any closer. The nearer the subject to the camera, the more drastic is the parallax displacement. Both open viewfinders and optical viewfinders have provided for compensation for parallax.

The third method of viewing is directly through the lens of an SLR camera, or directly through the viewing lens of a twin lens reflex, of which the Rolleiflex/Rolleimarin combination is the best known.

The *twin lens reflex* has been popular with photographers who like to photograph fish or coral, because the larger format of the film (120/220) calls for a larger camera and therefore a much larger integral viewing screen, which is then enlarged by the integral viewing system of the Rolleimarin UW housing. The one problem is that the integral viewing system of the Rolleimarin is a three-sided prism, which shows the viewer the scene in reverse. In other words, a fish swimming actually right to left, will look to the photographer viewing through the twin-lens UW optical viewing system to be swimming left to right—something which takes a lot of practice to master in trying to follow moving objects, especially underwater.

The single-lens-reflex (SLR) cameras, on

**Fig. 3.2** Parallax
The displacement of an image when viewed through an accessory viewfinder. The diver looks through a viewfinder mounted on top of an underwater camera in figure A. Since the viewfinder is mounted above the camera lens, its angle of coverage will be above the camera's. Figure B is what the viewfinder sees. Figure C is what the camera lens sees, *unless* the photographer compensates for the parallax by tilting the viewfinder downward. Correcting for viewfinder parallax underwater is usually a matter of trial and error.

the other hand, have five-sided prisms which show the viewer the scene with left and right on the same sides as the actual scene. The problem with 35-mm SLRs, though, is that the integral viewing screen is designed for the eye of the photographer to be pressed directly against the circular viewing window of the SLR cameras. To date no one has devised a system of enlarging the viewing screen of a 35-mm SLR camera with the SLR's original prism. In fact, the prism of the majority of SLRs cannot be removed.

Therefore viewing through a normal prism of a 35-mm SLR permits the diver to see only a small portion of the total frame of the viewing screen—except with the "soft" vinyl housings described on p. 48, which have

**Illus. 3.6** Two enlarged accessory viewfinder prisms. Left, the Nikon Sports Finder prism and right, the Canon Speed Finder prism.

severe depth limitations. The solution to this problem for most 35-mm SLR cameras inside rigid housings is for the diver to use the camera's integral prism viewfinder to focus on the subject, and then to use a supplementary optical viewfinder mounted on top of the UW housing to compose his picture.

There are, however, two camera manufacturers who have made special large five-sided prisms which are used in place of the normal prism that comes with their cameras. In Illustration 3.6 you see the Nikon Sports Finder prism and the Canon Speed Finder prism. These special accessory prisms will fit the F model cameras of both manufacturers. With one of these enlarged viewfinder prisms in place, the diver-photographer can see the full frame of the camera's viewing screen, and can easily focus and compose the exact

photograph by looking through this system inside of a rigid housing, with face mask on, of course. Another advantage is that the diver can also see the built-in light-meter display inside the Canon F-1 camera, thereby making a UW light meter unnecessary.

Until some inventive genius devises a method of enlarging the normal prism screen on other 35-mm SLR cameras, the above system, utilizing the Nikon Sports Finder prism or the Canon Speed Finder prism on their respective F model cameras is the ultimate in enabling the diver-photographer to obtain perfect focus and exact composition. As you will see when we discuss housings for these particular 35-mm cameras (the Fs with large prisms), prices range from $50 for soft vinyl cases for shallow water (down to 30 feet) to $150 for molded rigid plastic

housings on to $500 to $1000 for cast aluminum housings, the Rolls Royces of UW housings.

Since we have mentioned an integral light meter in the Canon F-1 camera, this seems to be a good place to examine the subject of light meters in UW photography.

## UW LIGHT METERS, BUILT-IN AND ACCESSORY

Since the intensity of sunlight (both bright and overcast) varies depending on the clarity and depth of the water, the surface waves, and the time of day, it is quite difficult to guess the proper exposure when taking UW photographs. Some of the newer 35-mm cameras have built-in light meters. If you can see the meter display inside the SLR viewfinder screen, you can utilize it to obtain correct exposure.

If your camera is one of the latest fully automatic cameras, which selects the proper f-stop and/or shutter speed for you by "reading" the light coming into the camera, again, your worries about proper daylight exposure are quite simple. You may have to set the ASA setting on your automatic camera slightly lower or higher than the actual ASA of the film you are using—an underwater test will show you whether you need to do this (and how much). The automatic light-meter sensor may read light lower or higher underwater, since such meters were designed to set exposures automatically in air, not underwater.

But if your camera is not an automatic-exposure-setting model and you cannot see the integral light-meter display in order to manually set the proper f-stop and/or shutter speed, then you need to use an accessory light meter underwater.

The Sekonic Marine Meter II, Model L-164B, is the only available amphibious light meter designed especially for UW photography. If you are considering purchasing a meter for UW use, save your money until

**Illus. 3.7** Meter bracket by Farallon/Oceanic Products for the Sekonic Marine II light meter bolts directly onto UW camera.

you can purchase one of these exceptional and accurate meters, built to stand the stresses of the UW environment. If you get one of these meters I strongly suggest that you also get a Sekonic Marine Meter II bracket-holder, which can be bolted directly onto your camera housing, keeping your meter in sight for constant consultation. The meters come with a lanyard cord, but before I made my first bracket-holders (they are now commercially available from Farallon Oceanic Products and Glenn Beall Industries), I broke a few meters when they smashed against a bobbing boat. This particular meter reads reflected light; therefore you will not get an accurate exposure reading if you point it at a black wet suit. I try to read the meter against skin tones, which will give you a good average for proper color exposure.

If you already own a light meter, you can most probably find a small, compact meter housing from Ikelite, which manufactures a large line of plastic housings especially for in-air light meters. One of the best and smallest meter-housing combinations is the Weston 5 (now known as the Weston Euromaster) in an Ikelite housing. Another good bet is the

Sekonic Auto-Lumi model 1-86 meter housed in a Nikonos (EPOI) plastic UW housing, distributed by Nikon. This L-86-Nikonos meter-housing combination is best used mounted in a meter bracket (made by Farallon Oceanic Products or Glenn Beall Industries). Many diving accessories are luxuries, some nice to have, many impractical or unnecessary. The meter bracket-holder is a necessity if you don't want to have your light meter broken underwater.

The important point to remember is that you do need a light meter underwater, unless your camera is completely automatic (something I don't suggest for UW photography) or if it contains a built-in meter and you are able to utilize it through the viewfinder. Proper exposure via a light meter really makes the difference between color slides with bright (saturated) colors and well exposed subject detail. It will also improve the technical quality (exposure) of your black-and-white UW photographs.

## 35-mm-CAMERA HOUSINGS

### The "Soft" Vinyl Housing

In my testing of UW housings, I have found only one manufacturer that makes a reliable soft vinyl housing that can be trusted to keep the camera dry and to operate smoothly (if the manufacturer's directions are followed). These are the EWA-Marine/Goedecke Aqua housings (20.00–50.00). Information about the availability of this housing can be obtained from Spiratone, who imports it, or from your local dive shop. EWA/Goedecke in Germany should be able to give you the names of specific U.S. dealers.

These EWA housings are excellent choices for the shallow-water diver—snorkeling fans, or those who like to scuba in depths down to 30 feet. They are safe from leakage (if all directions are followed) to 35 feet. I have taken them down to 45 feet without any trouble, but to be safe 30 feet is a good maximum safe depth for these soft vinyl cases.

You will find that most models of 35-mm cameras fit inside these thick vinyl bags that simply snap shut like a purse, keeping the water out. You can perform all the normal camera functions—changing speeds and f-stops, focusing, advancing the film, and pushing the shutter button—with your right hand enclosed inside the built-in "glove." Because the vinyl is clear, you can see inside the housing to set the proper f-stop numbers and speed dial. The camera's lens shoots through an optically clear glass flat port. A similar porthole on the backside of the housing provides direct viewing through the camera's finder. Because the housing has been designed for viewing through SLR prism viewfinders, viewing through other 35-mm cameras is not completely satisfactory.

Before testing the EWA-Marine Aquahousing, I had not had very good experiences with flexible plastic vinyl soft housings. I was amazed with both the ease of operation underwater and the resulting photographs that this housing gave me. I must admit that when I first saw the plastic bag I was very leery and unimpressed, but after taking photographs in the open ocean, I was surprised, especially with the edge sharpness of the 28-mm lens, considering that the housing uses a flat port. The reason for this is that the lens port can be pressed right up against the front element of the camera's lens, at any focus length, as the case is flexible. I also was amazed at being able to see the complete viewfinder through the housing's porthole and at the resulting exact focusing and composition of subject matter in my photographs.

I found that I could see the full frame of the viewfinder through my face mask and housing viewing porthole if I pressed my face mask hard against both the camera and

**Illus. 3.8**
EWA/Aqua-housing by Spir-
tone will take almost any
35-mm SLR camera safely
to a maximum depth of 30
feet.

porthole. Because the camera is loose inside the vinyl housing, the viewfinder can be pressed firmly against the flat glass viewing port. This cannot be done in hard housings (molded plastic or aluminum), because in those housings the camera is mounted inside in a rigid position. The only other SLR-housing combinations that offer the full frame of the viewfinder require utilizing accessory sports/speed viewfinder prisms (Nikon and Canon only).

With this housing it is easy to set the speeds and advance the film lever, but it is difficult to feel and then depress the shutter release button with a hand encased in the plastic glove. I suggest that a soft-release button be used on any camera inside this housing. These accessory buttons are quite large and are easy to feel with the gloved hand.

Electronic (strobe) flash can be fitted inside the EWA-Marine Aqua-housing, and works very well for closeup photography, 2 feet and closer. You can see how the strobe flash fits inside the housing in Illus. 3.8. If your SLR camera has a built-in manuaual light meter, with the meter readout

visible in the viewfinder, you can also then use this meter to set the proper exposure for a sun-sky illuminated scene, because you can easily read the scale in the camera's viewfinder through the porthole of the Aqua housing.

On the negative side: Since the flexible housing contains a considerable volume of air underwater, the housing is very buoyant—like a small balloon. To reduce this effect I attached a lead weight belt to the bottom of the flash arm. This made the housing just slightly positive in buoyancy, and much easier to handle and operate underwater.

Since it is flexible, the housing is quite easy to pack and carry along on a trip, taking up much less space than a rigid UW housing does. But these housings shouldn't be allowed to come in contact with sharp objects. All in all the flexible housing is a good choice for the beginning shallow water diver/snorkeler.

**Remember,** however, that there are depth limitations (30 feet), and care must be taken to follow directions for closing the housing so that no leaks develop.

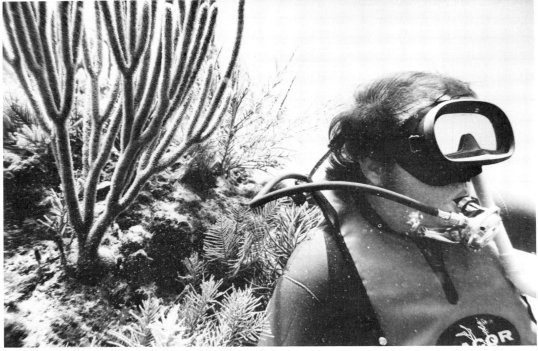

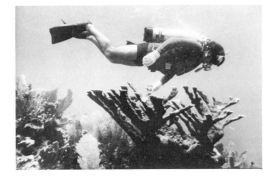    

*Illus. 3.9, 3.10, 3.11* These three photographs were taken on a 20-foot deep reef in the Florida Keys, with the soft vinyl EWA/Aqua-case by Spiratone. Spiraflex 35-mm SLR camera, 28-mm Spiratone *f/2.8* lens, flat port (glass), effective UW focal length of lens 38 mm. Tri-X 400 ASA film. Edge sharpness is quite good for an uncorrected port system and wide-angle-lens combination. *Photos by Flip Schulke*

## 35-mm RANGEFINDER OR GUESS-FOCUS CAMERAS

Almost all the currently available 35-mm cameras that utilize an integral *Rangefinder* for focusing and an integral separate view- finder come with lenses that cannot be interchanged. In other words, most come with 50-mm lenses (which is considered the normal-length lens for a 35-mm-camera— the 35-mm in such a camera refers to the

film size, not the lens focal length.) The Leica 35-mm rangefinder camera is the prime exception to this; it does have interchangeable lenses.

A few rangefinder 35-mm cameras come with a 35- or 40-mm lens attached, which does give you a wider angle of coverage than the 50-mm lens cameras. All commercial housings for this type of camera (rangefinder or "guess-focus") utilize flat ports through which the lens sees. If you remember the explanation of the 25 percent loss of angle of coverage with a flat-port housing underwater, you can readily see that this combination in UW photography would not permit you to photograph larger objects (such as people) underwater unless the water were extremely clear.

Since it is nearly impossible to utilize the rangefinder to focus this camera underwater, you must resort to guessing distances for focus, or use the measuring-stick technique (see p. 8).

On the credit side, these cameras are very compact, which means they can be placed in very compact UW housings. Most of them have a full range of shutter speeds up to and including 1/500 of a second for UW action photography. They can be used with strobe flash or flash cubes or bulbs for artificially lighted photographs. Controls in most UW housings available for these cameras include shutter release, film advance, shutter speed, aperture, and focus. If the particular camera has both automatic and manual exposure control, a UW control rod is provided in the housing.

It would be impossible to list all the rangefinder or "guess-focus" 35-mm cameras that can be adequately housed for UW photography. Ikelite manufactures by far the largest range of housings specifically designed for these types of 35-mm cameras—such as the Olympus range of cameras, the 35RC, the Rollei 35 and 35S, and the Konica C-35.

# SINGLE-LENS-REFLEX 35-mm CAMERAS IN UW HOUSINGS

The single-lens-reflex camera (see Fig. 2.1) enclosed in a housing solves a great many of the UW photographer's problems. Many of these assets have already been listed but, to summarize, they are:

1. Ability of the diver-photographer to see exactly what he or she is going to get on the film through the viewfinder-prism-lens system of the SLR.
2. Ease of focusing through the same viewfinder-prism-lens system.
3. Interchangeability of lenses. Availability of extremely wide-angle lenses.
4. Total control by the photographer over the exposure, via f-stop and shutter-speed UW control rods.
5. Availability of both strobe and flash-bulb artificial light capability.
6. Choice of 20 or 36 exposures. (I advise always shooting 36-exposure rolls.)
7. Availability of an electric motorized film-advance camera attachment, which also permits the photographer to take sequential photographs.
8. A built-in light meter, which can be overridden for manual operation.
9. Interchangeability of housing ports, corrected dome ports for wide-angle photography, and flat ports that can be utilized with normal lenses and for macrophotography.
10. The availability of close-focusing lenses for macrophotography. This includes photography of very small animals, corals, sea anemones, sponges, hydroids, and other such comparatively immobile forms of marine life.

## Camera-Housing Combinations Recommended for Their Versatility

As you have already seen, the UW photographer's life is complicated by the fact that
- Established camera manufacturers constantly modify their cameras and add new models.
- UW photography, though growing by leaps and bounds, is only a small portion of photog-

raphy as a whole. Therefore it is not feasible economically for the manufacturer of UW housings to design and construct new housings for the hundreds of 35-mm SLR cameras on the market, not to mention the dozens of models of rangefinder 35-mm and large-format (2¼ x 2¼-inch) cameras.

The solution to the problem caused by this multiplicity of camera models can be overcome for shallow-water diving by use of the soft-vinyl housing, since almost any camera model can be housed in one of the soft housings discussed earlier. But what about housings for deeper diving? Or a housing that allows using the SLR camera to its best advantage? **A tip:** The best way to keep up with current housings is to order the catalogs from the UW equipment manufacturers, most of which are listed, with addresses and telephone numbers, in the Appendix.

It would be impossible to give a complete description of the available SLR camera-housing combinations here. I will concentrate on those that I have used and consider superior in use underwater, the most versatile, and those from manufacturers who have been in business long enough to lead me to believe they will be making new housings, new models, and stocking a full inventory of parts for both their current and older models for some time to come. Since I have no control over sales philosophy of the manufacturers, please understand that some of the equipment that I describe could be difficult to obtain in some sections of the United States.

## Molded Plastic (GE's Lexan) Housing

Ikelite SLR 35-mm case, Ikelite Underwater Systems (under $200), accommodates (among others) the Nikon F and F-2 cameras and the Canon F-1 camera. Any of these three cameras can be fitted with respective interchangeable enlarged viewfinder prisms that enlarge the reflex viewing screen sufficiently to enable the photog-

rapher to both compose and focus with ease underwater. Mentioned before, they are known as the Nikon Sports-finder Prism Finder and the Canon Speed-finder Prism Finder.

The Canon F-1 system combination also enables you to see the integral light-meter display on the viewfinder screen while underwater. These cameras, of course, have a full range of lenses from longer macrolenses for closeup work, through interchangeable housing ports that will accommodate any lens you would want to utilize in the housings, except for fisheye lenses (both circular and full-frame).

You have full control over focus via a large focus knob, which engages a focus ring that is universal to all lenses. Speed is by a direct-drive control rod and knob. You must look through the clear plastic (Lexan) housing to view the various speed settings. Lens diaphragm control, or f-stop, works by knob-operated direct-drive gear, but you also have to view the f-stop you want through the plastic case. This means that you need a UW flashlight to illuminate the speed and f-stop dials in order to regulate them when photographing at night.

Both flash bulbs or cubes and strobe flash can be used. There is a BC power pack inside the housing, powered by a dry-cell battery. The strobe is connected with Ikelite's own pluggable-unpluggable connection system. (EO connections are available.) A solid-state triggering (SST) device inside the housing fires surface strobe units housed in Ikelite strobe UW housings (more on this in Chapter 7). Amphibious strobe units manufactured by other companies can also be used via the strobe connections that go through the rear wall of the housing.

Dome correction lens ports are available for wide-angle lenses, including a special macrolens port which will handle any macrolens.

The housing can be handled comfortably underwater; the angled handle makes verti-

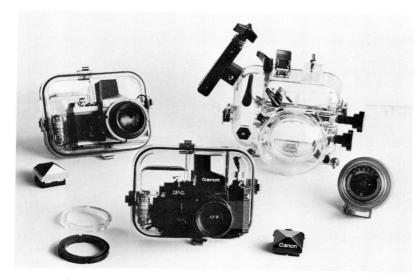

**Illus. 3.12** The Ikelite SLR UW housing for the Canon F and Nikon F camera models. These housings will accept the accessory enlarged prisms that Canon and Nikon offer. The *f*-stop is changed by means of a plastic gear. Focusing is by a notched ring.

**Illus. 3.13** Interchangeable ports add to the versatility of SLR housings. These from Ikelite include dome, macro, and extension ports. *Photo by B & L Photographers, Inc.*

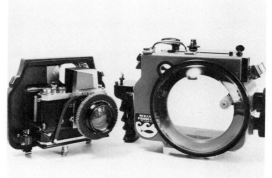

**Illus. 3.14** Hydro-35,<sup>tm</sup> cast-aluminum housing for the motorized (36-exposure) Nikon F SLR camera with 8-inch dome port by Farallon/Oceanic Products. *F*-stop by mechanical arm, gear focusing.

cal or horizontal photographs easier to take when one is working and swimming. The depth rating for these housings is limited to 300 feet. (Some commercial diving exceeds this depth.)

Since all parts are molded, interchanging them is easy. Molding necessitates a sameness of parts, a great convenience if a diver owns more than one of these housings. One set of ports can be utilized with more than one housing, as can flash equipment, control rings, etc.

Though the GE Lexan molded plastic material exhibits tremendous strength, it can be scratched easily and is not as strong as a cast-aluminum metal housing. Viewing through the clear-plastic housing is a bit slower in actual operation underwater than through the more expensive aluminum housings, because the opaque nature of metal

construction calls for dials on the exterior of the case for *f*-stop and speed settings which can be operated more quickly. On the plus side, though, molded plastic housings do not exhibit the condensation and corrosion problems common to aluminum housings. Any water leaking into the housing can be readily detected in a plastic housing. Above water a molded-plastic housing is also lighter in weight than an aluminum housing is.

In sum, this housing is the least expensive available rigid SLR housing that has been designed with nearly all available professional features. A good choice, when you first want to try your hand at SLR UW photography.

## Cast-aluminum Housing

The Hydro-35 SLR case, Farallon/Oceanic Products (under $800) will accommodate the Nikon F camera, with or without 36-exposure motor drive, the Nikon F-2, with or without 36-exposure motor drive, and the Canon F-1 camera.

These housings will accept the interchangeable enlarged prism viewfinders (Nikon Sports and Canon Speed finder prisms.)

The Canon F-1 integral light meter can be utilized with this housing.

Focus is very easy and in a good position on the left side of the housing. It engages with a toothed gear which fits around the lens-focusing ring. A separate toothed gear ring must be used with each different lens used inside the housing. Both the *f*-stop control and the speed-dial control have matching dials on the outside of the housing, so that it is easy to see exactly where you have set either the *f*-stop or the speed dial.

An Electro Oceanics female connector comes as standard equipment on the reverse side of the housing, into which many types of UW electronic flash strobes can be plugged.

Farallon/Oceanic Products makes its own housing for strobes and also manufactures its own amphibious strobe units designed

*Illus. 3.15* F-stop control knob on the exterior of the Hydro-35 SLR housing.

entirely for UW strobe photography. Further illustrations and explanations of the Farallon/Oceanic Products UW strobes can be found in Chapter 7.

A UW light meter encased in a housing can also be bolted onto the hydro-35 housing.

This housing comes with an optically corrected dome port for normal lenses through the 24-mm lens. Farallon/Oceanic has a larger fisheye dome port as an accessory for use with extremely wide-angle lenses and a flat port for divers using telephoto and other special focusing lenses for macrophotography.

The design of this housing is very compact and thus comfortable to use and swim with underwater, where it is almost weightless. On the surface it is considerably heavier than a molded plastic housing.

One of the prime advantages of this hous-

ing is that it can accommodate the 36-exposure motor drives of both Nikon models. This installation utilizes a battery pack located inside the housing rather than the standard Nikon battery packs that are normally used with the motorized F cameras. A kit that permits operation of shutter wind lever and shutter release by manual controls rather than by the motor of the camera can also be installed. This is quite handy, for motorized cameras are not very reliable underwater (usually owing to high degrees of moisture found in all diving situations); with the manual overide one can continue to take photographs.

The advantage of the motorized camera underwater is the capability of instantly taking another photograph, if the action is good, without having to take the housing away from your eye and manually advance the film-advance lever. Underwater this manual operation takes more time, and is more clumsy by far, than it does on the surface. A second advantage of the motorized camera is that it allows the photographer to take a sequence of photographs one right after the other, as fast as he can push the release button. **A word of caution**: A motor on a 36-exposure camera can use up the roll very quickly if you are not judicious in its use. You must keep yourself from getting trigger happy, or you will be spending most of the day getting in and out of the boat, drying yourself and the camera housing and changing film cartridges. A remote control system including cord is available for motorized models.

## SOME CONCLUSIONS

As with almost all machinery and most other things in life, one gets what one pays for. Though less expensive housings can equal some of the features of the Hydro-35, this housing is probably the most professional camera housing rig commercially manufactured and available today. The aluminum construction allows for a lot of knocking

around in a rocking boat. Domes, though, are acrylic plastic and must be protected from scratching. The port is the most vulnerable part of this housing, but if it is protected, especially when it is out of the water and being transported, the Hydro-35 is extremely rugged. In the last analysis, ease of operation is the number one virtue of any piece of UW photographic equipment. No matter how much experience you have underwater, it is still a difficult, often very cold, alien environment. Any design in photo gear that makes it easier to physically operate underwater is the superior choice, if it is designed and manufactured to stand the salt water and the knocking about in rough seas, often in small boats. The Hydro-35 is easy to use underwater. The only equipment that would be easier to handle would be an amphibious single-lens-reflex camera that had interchangeable lenses.

**"Used" SLR Housings** / I have described two major camera housing systems, from two manufacturers. Two additional housings have had much success in the past and though no longer manufactured, can be bought in the second-hand market. Both are very good cast-aluminum housings, and both allow for use of the enlarged prism viewfinders.

### Niko Mar Housings

The Niko Mar housings were designed for the Nikon F and F-2 cameras and the Nikon F 36-exposure motor, by Giddings/Felgen undersea products. The Niko-Mar housings for the Nikon F came in models I and II, and the latest model, III, which will also house the Nikon F-2 camera. These housings are well designed, though a bit larger than the Hydro-35. They come with flat and dome ports. Parts, service, and repairs are now handled by Farallon/Oceanic Products.

### Oceaneye 100

The Oceaneye 100 housing was designed by *National Geographic* photographer Bates Littlehales and Gomer McNeil of the Photogrammetry Division of Mitchell Camera Corp. The Nikon F

*Illus. 3.16* Niko-Mar cast-aluminum 35-mm housing for the Nikon F motorized (36 exposures) camera. No longer manufactured, but a good buy on the used housing market since Farallon/Oceanic handles service, repair, and parts for these housings. *Photo by Flip Schulke*

*Illus. 3.17* Oceaneye 100 cast-aluminum housing for the Nikon F motorized 36-exposure camera. *Photo by Flip Schulke*

and Nikon motorized F-36 can be used in this housing. Probably one of the best designed UW 35-mm housings, it was completely designed around a large dome, which could be used with all lenses. If a new model of this housing were made, it would probably be the Rolls Royce of SLR dome corrected-optics housings.

## Macrophotography with the 35-mm SLR-housing Combinations

One of the greatest advantages of the SLR camera is that you see exactly what the film will see. Because of this, the SLR in a housing has been a favorite among photographers who want to "get in close" to their subject matter, which is often very small. All the housings described in this chapter can be utilized for macrophotography.

In macrophotography with the SLR housing you can use the macrolenses, usually in the 50-mm range, manufactured by the camera companies for that specific purpose. This of course brings your camera very close to the subject, which is fine in smooth water and with inanimate objects. But if the sea is surging, you may bash your camera against bottom, coral, or rocks.

The alternative is to use telephoto lenses (usually in the 100-mm range) with extension tubes, so that you can focus the lens closely. Most telephoto lenses won't focus closer than 3 feet without extension tubes or plus-diopter closeup supplementary lenses attached to the prime lens. There are macro flat ports available for SLR housings that enable you to encase the longer 100-mm length lenses with extension tubes attached.

If you are using the 100-mm-length lenses, you must plan ahead for the object that you wish to photograph, for with extension tubes or closeup supplementary lenses attached, the 100-mm lens will not have a very large focus area. The advantage of the longer lens used in macrophotography is that it gives you some room to work in relationship to your subject.

Artificial light, usually flash bulb or cube or strobe, is almost always necessary for macro UW photography to light up the subject and to bring out the usually bright colors of both tropical fish and inanimate objects.

## Tips for 35-mm SLR-Housing Photography

These housings must be protected while traveling and while in a dive boat. Even as all housings are fragile, certainly the cameras inside of them are. Do not travel with the 35-mm camera inside the housing. Constant jarring can throw controls and gears out of alignment. For air travel it is best to invest in a solid case, either a plywood or molded plastic case designed especially for delicate instruments. Fiberbuilt makes very strong cases, designed for movie-camera equipment, which are quite large and lined with foam rubber. I do not suggest the less expensive models as the walls are too thin and can be easily dented.

When near my home base, I wrap my cameras and housings in foam rubber and place them in large heavy-plastic, carefully marked garbage cans for easy handling in the dive boat. (See Chap. 9.)

On a calm day, I use a long nylon rope with a series of brass snap fasteners to lower my UW housings into the water. (See Chap. 9.)

Check out a new housing to see how it handles underwater. I always suggest with a new housing, or one that hasn't been used in some months, that you take it down 10 to 15 feet to test it for leaks **without the camera inside.** This may take a little more time, but it could save your camera from irreparable damage. A housing could have a bad O-ring seal or O-ring control seal or a bit of sand or grit blocking the O-ring seal; this will become readily apparent when you take the housing down. If the camera were inside, you could have major repair or replacement problems. I know this sounds conservative, but, considering the costs of the 35-mm camera with a lens and viewfinder, it's better to be safe than sorry. If you do have a leak, first try to discover the source and then send the housing to a reputable dealer for repair. (See more on this, pp. 214–15.) Meanwhile, if you have been diving in fresh water, dry the housing thoroughly. If you have been diving in salt water, submerge and soak the housing in fresh water before drying it.

In ocean diving, salt build-up can be a major problem in corroding controls, and causing leaks. With a new aluminum housing I always unscrew all the metal screws that contact metal and are exposed to the water. I coat each screw with O-ring grease and replace them in the housing. Since most of the screws and bolts are stainless steel or brass and the housing itself is aluminum,

you will get a corroding electrolysis action caused by the action of the salt water interacting with the two dissimilar metals in contact. The coating of O-ring grease will keep this from happening. Salt crystals also build up in O-ring groove areas. The only way to get rid of this salt-crystal build-up is to soak the housing in fresh warm water for at least half an hour. Rinsing with a hose will not get rid of the salt crystals that have penetrated into screw threads and around the O rings. I would dare say that 90 percent of all leakage damage to cameras inside housings is caused by inadequate washing (soaking) after a dive in the ocean.

Keep your camera housings out of the sun while in the boat. Otherwise heat will build up and cause moisture fogging inside the housing. That kind of heat and moisture won't do your expensive 35-mm camera any good. I keep mine wrapped up in towels and in the plastic garbage can (see Chapter 9.) until just before I take them into the water. I know that you will see many diver-photographers leaving their housings, especially aluminum ones, resting on the back deck of the boat on the ride home. Don't imitate them, unless you have the money to replace your housing or camera often.

Check out your whole system—camera, housing, lenses, lens gears, flash, or strobe—the night before you go on a photo dive. Check especially batteries, the one in your 35-mm camera if it uses one and the battery in the housing that works the flash-bulb or cube flash gun. Be sure that the strobe has charged or has fresh batteries, depending on the type of strobe. Make sure that you have the proper film and in sufficient quantities. Be sure that whatever system of lens-gear focusing ring your housing utilizes you have the proper gears for the lenses you plan to use. Check to see that you have the proper f-stop gear or control for your particular 35-mm camera. Don't forget a small tool kit, so that you can turn all nuts and screws, whether slotted, Phillips head, or Allen socket—UW manufacturers seem to delight in using all three systems in one housing—since it is impossible to turn the screw or bolt without the proper tool.

The first time you go diving with a new housing and camera rig, you will have to go into the water with the complete rig to see if it is positive in buoyancy or negative. (If it floats, it's positive; if it sinks, it's negative.) There are many arguments for having either a positive, or a negative buoy-

*Illus. 3.18* **No!** The wrong way to wash your photographic equipment after use in salt water. Rinsing with a hose is not enough.

*Illus. 3.19* **YES!** The correct way to wash the salt water off your equipment. Completely submerge the housing in fresh water.

ancy. Positive housings will float to the surface if you should happen to let them go. Negative housings will sink, which can result in a total loss if you are diving in very deep water, say, near a reef wall or cliff. It is much easier to handle a housing that is slightly negative. Turn the housing in different positions. If it wants to right itself, or turn itself into an awkward position, you need to add small weights (lead) inside the housing. These weights can be attached to the inside of the housing by using glue, tape, or screws and bolts, depending on the particular housing. This is called "trimming off" a housing. You will see that if the housing is balanced in almost all directions, it will stay in almost any position you put it, much like the way objects in a weightless state in spaceships "hang" suspended in air. So will your housing, if you spend some time trimming it off. If it happens to be very negative, attach pieces of styrofoam to the housing to give it the needed lift to make it comfortable for you to use. Styrofoam is usually attached by using tape, the best tape for this purpose being ducting tape, also called gaffer's tape, silver-tape, or gray tape, which can be found in most hardware stores or photographer's supply houses.

Wear a wet suit even in warm water. It will make you more comfortable and will protect you from coral scratches as you brace yourself to hold the housing and camera steady.

Always use a cylinder pressure gauge on your regulator when scuba diving; this way you can measure your film supply against your air supply. It is always frustrating to have film to expose and run short of air. Since it is often difficult to swim with a housing and strobe plus arms, be sure to always give yourself sufficient air to swim slowly back to your boat.

I do not believe in neck cords around any type of camera gear underwater. I did use them in the past, but since the wearing of safety vests or buoyancy compensator (BC) vests is nearly universal now, cords around the neck can easily interfere with their operation.

Further, they will just add more loose ropes to get tangled up. I hold on to my camera and housing with one hand, use the other for gripping and changing bulbs and controls, and use my legs for swimming. Because of my aversion to neck cords underwater, I have tried to mount all the accessory equipment directly onto the camera housing. That is why in the housing photographs you see in this chapter, a light meter is

bolted into the housing. In the chapter on artificial lighting, you will see different types of extension arms to hold flash and strobe. I often detach the flash and hold it at arm's length, but I can then easily affix it back onto the housing, again freeing that hand. Another reason for the housing to be trimmed off is that the more easily it is balanced in water, the easier it is to both hold and work the film release trigger with one hand.

Those little white numbers—lens name and other miscellaneous information often painted on the front ring of your lens—will often reflect back from the port of the housing, and you will find all this information as part of your resulting color slide or black-and-white photograph. These words and numbers will reflect back into your lens even worse when you are using a dome port in your UW housing. The solution is to take a small paint brush and some black enamel and paint them out. I use model airplane paint because it comes in such small quantities and dries quickly. You will often be painting over the serial number of the lens, which is important to know, but these words and numbers are engraved and painted on by the camera manufacturer, so you can still read the serial number by letting light reflect off the painted-over number.

For those divers who have vision problems, such as those who wear bifocal eyeglasses, here is a suggestion for focusing on closeup objects. When you look through the viewfinder prism of an SLR, you are looking at the focusing screen, which,

owing to the optical problems of SLR prisms, is quite close. The solution is to buy a correction lens from your optician and tape it inside the viewing port of your SLR UW housing. You will then find that focusing underwater is much easier. The only problem is that other divers cannot use your housing as they won't be able to focus the camera properly. If it is taped in place, however, it can be removed when you open the housing for someone with normal vision. (For additional information for eyeglass wearers, see Chap. 9.)

## Suggested Assignments with 35-mm Cameras in Housings

Take your camera and housing into a swimming pool.

- Take action pictures of people diving and swimming from underwater. You will have to use high shutter speeds for this. Try slower shutter speeds also to see the difference.
- If you have a 35-mm camera housing that is not an SLR, try practicing "framing" with your accessory viewfinder to learn how to correct for parallax at different distances from your subject.
- Take a UW portrait. Compose the photograph on the SLR viewing screen and try various lenses to see the effects a wider- or narrower-angle lens gives you underwater.
- Practice closeups with your SLR in the pool. Put pennies or other small objects on the bottom.

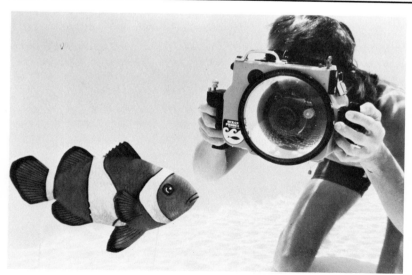

**Illus. 3.20** Practicing closeups in a swimming pool. New techniques are best perfected before going into the open ocean. I use a brightly colored wooden fish for a prop, about the only practical way to bring a fish to a swimming pool. *Photo by Flip Schulke*

- Try to use an accessory viewfinder (either open or optical type that is mounted on the top of the housing) on your SLR. See how close you come to the same composition when you use the SLR viewing system through the lens, especially with a fast-moving swimmer. Often action photographs are easier to shoot with an accessory viewfinder, hence the name "sportsfinder" for so many of them.

In the ocean, try the following:

- Take a subject (your safety diver or buddy diver) down on a shallow reef. See if you can take a UW portrait with either you or him kicking up so much sand that you cannot see the action. If you cannot see it clearly, neither can the camera. Practice stirring up as little sand as possible when you move. Then wait until the sediment settles before shooting.
- Lie on your back on the bottom and shoot silhouettes of divers (or larger fish) swimming overhead. See if you can blot out the sun with the diver's or fish's body. This is much easier to do with an SLR housing, since what you see is exactly what you get.
- Try one or more of the color filters listed on page 24 to make a color test (without using artificial light) for the particular water that you usually dive and photograph in.
- Make a depth color test of natural light with your own camera again without using artificial light.

Try exposures at 5, 7, 10, 12, 15, 18, 20, and 25 feet beneath the water's surface on both a bright, sunny day and on an overcast day. **Tip:** At a well-stocked art-supply store you can get opaque acetate sheets, which you can cut up to manageable size (I use 4-by-5-inch sheets), staple them together and attach a cord and regular lead-pencil; you can keep notes of your speed and exposure settings by writing, underwater, on the acetate sheets.

- With a normal (50-mm lens) take close-ups of the fish and coral—or cans and bottles, old tires, junked cars, algae, and catfish, found on the bottoms of lakes and rivers.
- If you have macro-closeup capability, try extreme close-ups, utilizing some sort of flash (either bulb or cube or electronic strobe). Remember that in macrophotography in order to get a truly sharp photograph you must focus very accurately and that the flash will enable you to close the f-stop (diaphragm) to a very small opening, increasing your depth of field and insuring further sharpness of your subject matter.

# 4 · THE AMPHIBIOUS STILL CAMERA – Calypso, Nikonos I, Nikonos II, Nikonos III

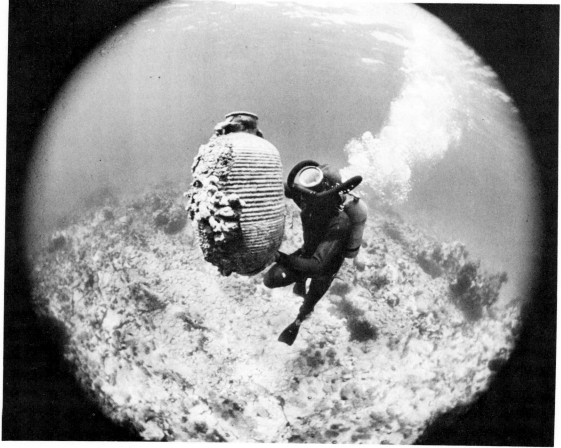

***Illus. 4.1*** An underwater archeologist rising to the surface of the Mediterranean holding an amphora from a fourth-century Byzantine wine carrying ship. Underwater discovery is one of the lures of the sea. Taken for *Newsweek* and *National Geographic* magazines. *Photo by Flip Schulke*

Heretofore we have covered the most common method of taking UW photographs—placing a camera that was designed for photographing in air into a watertight housing incorporating control rods to work the surface camera settings. No matter how small you design a housing it must be larger than the camera it surrounds. It also must have O-ring seals for all the controls and for the opening and closing of the housing. A housing is thus a compromise, since it is an adaptation of a surface camera for UW photography.

Not so the amphibious camera. This camera is designed specifically for UW photography. With certain lenses it can be used, of course, on the surface, in rain, snow, and high humidity, but it was originally designed to withstand the pressure of the depths and comes with lenses that correct, in one way or another, the effects of light underwater. Currently there is only one such camera widely available.

## HISTORY OF THE AMPHIBIOUS CAMERA

### The Calypso-phot

The Calypso camera, as it was known when it first appeared upon the American diving scene in the late 1950s, was conceived by Jean de Wouters, a Belgian engineer, and developed in collaboration with Jacques Yves Cousteau. It was originally manufactured in France and was called the "Calypso-phot" (*Calypso* after the famed research vessel of Commandante Cousteau). The camera was cast aluminum, had an ingenious film advance and shutter trigger combined in one lever—you pressed it once to snap the shutter and again to advance the film. As a news photographer, I have yet to see a faster working manual advance and triggering system.

The Calypso and later Nikonos cameras consist of three components which fit together snugly to make a self-contained, watertight camera without any need for a separate bulky UW housing.

1. The outer housing, which is die-cast from thick aluminum alloy.
2. The interior body, which contains the shutter, film advance lever, and other moving parts, and is removable for film loading.
3. The lens, which when mounted in place, locks the entire camera assembly together and prevents it from being accidentally jarred loose.

The camera is watertight only when completely assembled. The components are susceptible to damage individually. If the interior body or lens were accidentally dropped into salt water they could be ruined if not quickly soaked in fresh water and repaired.

All joints of the camera are sealed by means of O-ring gaskets. These synthetic rubber rings insure absolute water tightness and can withstand water pressure at depths down to 160 feet (50 m)—as deep as you should dive with scuba equipment. As pressure increases, the seal becomes even tighter.

The first model Calypso was a 35-mm camera using 36-exposure cartridges. It came with only one lens at first, a 35-mm SOM Berthiot *f*/3.5 lens. Since it was covered with a flat port, the lens angle of view underwater approximated a 50-mm lens. A few flash guns for bayonet-based flash bulbs were also produced by the manufacturer. The camera had shutter speeds ranging from 1/30 of a second to 1/1000 of a second with a focal-plane shutter. It had an optical viewfinder built in, which was fine for surface use of the camera but couldn't really be used underwater. An accessory open sports-finder viewfinder was available for the 35-mm lens and was designed to be clipped on top of the body of the camera via an attachment shoe. There was no built-in system of focusing the camera, such as a coupled rangefinder, which was customary in 35-mm non-SLR cameras of that period.

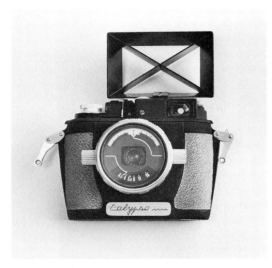

*Illus. 4.2* The original Calypso amphibious 35-mm camera.

Focus was by guess. The focus scale was in meters.

But this French import, like the French-designed Gagnan/Cousteau scuba regulator, revolutionized UW still photography. The camera was very small and easy to swim with. It was a simple matter to dry the small exterior and change film.

The amount of UW photography done in the late 1950s and early 60s was still quite limited, and the French Calypso organization did not have the sales or distribution organization to market the camera worldwide. Manufacturing rights were acquired by Nikon.

Before I begin the Nikonos story—for that was the new name that Nikon gave to its model of the Calypso UW camera—I want to congratulate Jean de Wouters, the Calypso designer, and the craftsmen who made this camera in France. Though two Calypsos that I have owned have been stolen, I still own and use six of the original models. All are in good working order, only one has had a mechanical breakdown, and not one has ever leaked a drop of water. Luckily, the

lenses that Nikon subsequently manufactured will fit into the Calypsos, as will the flash guns and strobes made for the Nikonos I and Nikonos II models. These original Calypso cameras were entirely crafted of metal and have withstood the wear and tear of difficult professional UW usage. U.S. Divers Company was the American distributor for the Calypso camera and discontinued selling Calypsos when the Nikonos appeared on the scene.

## Nikonos Model I

This camera was delivered with a 35-mm, $f/2.5$ lens, which could be used equally well both under and above water. Like that on the Calypso, this lens was protected from the water by a flat port, so it, too, gave the approximate angle of coverage of a 50-mm lens underwater. Of course the fact that the lens was a half a stop faster than the Calypso's 35-mm lens was a help in dim-light photography. A model I Nikonos can be recognized because only the word "Nikonos" was engraved on the front of the camera body, it was black (the Calypsos were primarily gray), and the film-pressure plate was not hinged, as it would be in Nikonos models II and III.

An excellent flash gun using bayonet flash bulbs appeared with the Model I as an accessory, and soon after, Nikon-Japan produced a second lens, the 28-mm $f/3.5$ UW Nikkor lens. The UW meant that the lens had been designed for underwater photography. The front element, or what we would call the "port," was an integral part of the lens system, and in fact this 28-mm UW Nikkor lens was no longer a surface lens, protected from the water by a flat piece of glass (port), but instead a true "water-contact" lens, in which the front element in contact with the water was corrected for certain UW optical problems. Though probably the 28-mm $f/3.5$ UW lens exhibits the sharpest edge definition (resolution) of any

lens or lens combination that is in current use in UW photography, a certain confusion has grown up around the word "corrected." At present, when the word "corrected" is used in connection with a UW lens, most UW photographers mean that a lens has the same angle-of-coverage underwater that it does on the surface. In the case of the 28-mm UW Nikkor lens, though technically a 28-mm lens, which in air has an angle-of-coverage of 74° (diagonal), this lens under-water—the environment for which it was specifically designed—has an angle-of-coverage of 59°, which is roughly a little longer in focal length than a 35-mm lens in-air. This can be quite confusing, because photographers, being used to thinking in terms of the in-air angle-of-coverage of lenses, gets the wrong idea of the actual UW angle-of-coverage of this lens. The manufacturer is technically right in calling the lens a 28-mm; just remember that it gives you a 35-mm lens angle-of-coverage UW.

The 28-mm UW Nikkor, because of its water-contact-designed front element, cannot be successfully focused above water and therefore cannot be used in surface photography as the original 35-mm Calypso/Nikonos lenses can.

## Nikonos Model II

This camera followed the Model I with minor external changes. It had a rewind lever replacing the small rewind knob on the earlier model and on the Calypso, which was a bit difficult to turn with wet hands and took a long time to rewind after exposing the cassette. It also had a hinged pressure plate, making it easier to load film, but more difficult to load the camera mechanism back into the body casing. This difficulty was caused by the placement of the hinge at the top of the pressure plate. Consequently one had to hold the pressure plate with a finger when replacing it in the body, which photographers with large fingers found a bit difficult to do. Changes were also made in the in-

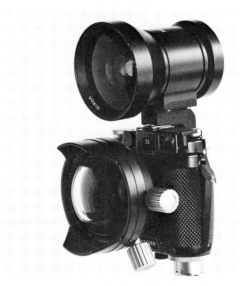

*Illus. 4.3* 15-mm UW Nikkor f/2.8 lens. Effective UW focal length 20 mm. Nikonos UW 15-mm optical viewfinder, mounted on a Model II Nikonos camera. *Photo by Flip Schulke*

terior mechanism, especially in the film transport system, which had caused some problems in some individual models of Calypso and the Nikonos I.

At this time, a long-rumored super-wide-angle lens issued forth from Nikon: a 15-mm UW Nikkor f/2.8, which came with its own UW optical viewfinder. Though quite expensive, it was superbly corrected for edge sharpness, contrast, and color aberration. Like its predecessor, the lens was called a UW 15-mm lens and was designed for UW use only. But as with the 28-mm, the new 15-mm took in a UW "angle of coverage" of 94°, which corresponds to the angle of coverage of a 20-mm surface lens. So what we had was a truly great fully corrected 20-mm UW lens.

I make these distinctions in true angle of coverage underwater, because one can take the 15-mm surface Nikkor f/5.6 SLR lens, use it with a dome corrector, and actually get the full 15-mm angle of coverage of 110° underwater.

A dome corrector will not give one the refined optical qualities of the UW-designed "15-mm" lens, however. I rather suspect that Nikon, if it should desire, could design a UW lens that would be fully corrected and give 110° of coverage. But in actual usage, a 94° or 20-mm lens is more practicable in most UW photography. I have found in my work that while a 110° lens would be helpful (for example, in photographing large objects such as small submarines), the wide angle does create forced perspective distortion—the result of the camera being very close to the object being photographed. So I feel the 15-mm 94° lens was a good design choice.

Nikon also came out with an 80-mm Nikkor lens for the Nikonos cameras, which can be used both above and below water. It has a flat port, thus enabling one to use it in both environments. Since the depth of field of an 80-mm lens is very small and a lens with such a focal length must be accurately focused, I have not seen much use for it in UW photography. There is no internal focusing system in any Nikonos model and an 80-mm lens is very hard to accurately focus by guess. It can be used successfully underwater as a closeup lens, when objects of measured distances are photographed. Since there are many closeup attachments for both the 35-mm and 28-mm Nikonos lenses available, which are discussed on pp. 66–67 and 73–74, I have not found this particular lens very practicable in UW work. As an aside, the 80-mm lens was often used in surface photograhic coverage of the Vietnam war. They were mounted on Nikonos cameras, which were a favorite of combat photographers because of the wet climatic conditions of Vietnam. I suspect that the decision to manufacture this 80-mm lens grew out of that demand for a watertight lens because of rain rather than a real need for it underwater. It is said that the famous photojournalist David Douglas Duncan, who greatly helped to popularize the Nikon camera during the Korean war, influenced Nikon to produce the 80-mm Nikonos UW lens. This may explain why the 80-mm Nikonos is so difficult to use underwater.

## NIKONOS MODEL III

Available in 1975, it has a number of major changes from previous Nikonos or Calypso models:

1. The camera is slightly larger than previous models; therefore handle brackets for previous models will not fit the Model II.
2. The speed dial has been enlarged, which makes it much easier to grasp and the speed-setting numbers much easier to read; the dial is black and the numbers, larger than previous models, are etched in white.
3. The female lens mount in the body of the camera is now made from stainless steel instead of aluminum as in previous models.
4. The built-in optical viewfinder is larger and brighter and has etched framing marks (along with parallax correction marks) for the 35-mm and 80-mm lenses. **Note:** I still find, though, that the built-in viewfinder can be used only in surface photography with this camera. Because one's face mask keeps the eye too far away from the built-in viewfinder underwater, one cannot begin to see the whole frame.
5. A more positive safety lock for the shutter advance and release lever.
6. A tripod socket (1/4 by 20 thread) located directly in line with the center of the lens on the base of the camera body. This is a great improvement, since the tripod socket was a part of the flash-synchronizer socket on previous models, which meant that if a flash was plugged into the flash-synchronizer socket, one had no tripod socket. The tripod socket is not needed so much for use on a UW tripod but to enable the diver to bolt on strobes and handle brackets. Heretofore all the stress of these units attached to the camera body was borne by the flash connector cord—something that caused a great many problems, as the stress was just too great for the small synchronizer socket. It also meant that the attachments would come off whenever one removed the flash-synchronizer connector from the body.
7. The film frame counter was transferred from the bottom of the case (one had to turn the camera upside down to see the counter in previous models) to the top of the case body, where it is easily seen by the diver.
8. The film pressure plate is now hinged from

the bottom of the inside portion of the camera, which makes it much easier to replace the insides into the casing or lower part of the camera, a vast improvement over the hinged pressure plate of earlier models.

## SUGGESTIONS FOR PERFECTING AMPHIBIOUS CAMERAS

The Nikonos camera would be greatly improved if shutter speeds went slower than 1/30 of a second. It is possible to mount the camera underwater and take photographs of inanimate objects, especially with the closeup devices; however, I would like to see at least 1/15, 1/8, and 1/4 of a second shutter speeds added to subsequent models.

The fact that a mechanical means of accurately focusing the lens has not been designed is a major drawback. This could be accomplished by either a rangefinder large enough to see through the diver's face mask or the ultimate—a single-lens-reflex Nikonos type UW camera. This would most probably do away with 35-mm housings altogether, except for less expensive 35-mm SLR cameras. Such a camera is possible—UW photographers want it—and perhaps Nikon, who has the lead via the Nikonos cameras, will find it economically feasible to produce such a camera. We need it, and as UW photography grows, I am sure that the camera manufacturers will design a UW single-lens-reflex camera with interchangeable lenses. Then getting sharp focus would not be the problem it now is with the Nikonos.

Because of the focus problem, I utilize Nikonos/Calypso cameras with wide-angle lenses only, the greater depth of field of wide-angle lenses compensating for my incorrect guesses in exact camera-to-subject distances. I don't find the 35-mm lens very practicable for this reason, except for use in combination with a closeup attachment for closeup photographs, where the distance is or can be actually measured.

## VIEWFINDERS BY NIKON

Nikon produces an open sports-type viewfinder that clips on the top of all three models of Nikonos cameras for the 80-mm, 35-mm, and 28-mm Nikkor lenses. As I have mentioned, the 15-mm UW Nikkor has an accessory optical viewfinder manufactured by Nikon that is excellent. The open sports-finder type viewfinders for the other three lenses leave much to be desired, since they give only a very rough approximation of the view that the camera is seeing. The trend in UW photography in accessory viewfinders is to optical viewfinders designed for UW usage. Optical viewfinders for the other three lenses are manufactured by independent companies to meet some of the needs of Nikonos users and will be described later in this chapter.

## CLOSEUP LENS ACCESSORY BY NIKON (Macro)

Nikon also makes a closeup device that utilizes three different closeup frames. This consists of a supplementary lens that at-

*Illus. 4.4* Nikonos (Nikon) closeup attachments and wire focus-distance, subject-composition frames. Model III Nikonos camera.

taches to the 80-mm, 35-mm, and 28-mm Nikonos lenses, with corresponding closeup frames for each lens. A general note about closeup photography with the Nikonos camera utilizing closeup frames: This procedure is perfect for subjects underwater that don't swim away. These closeup frames are extremely difficult to use in photographs of fish because the fish just won't "pose" neatly enclosed in the metal frame. Rather, the frame scares the fish, and for that reason closeup photography of fish is best with either SLR cameras in housings or twin-lens-reflex cameras or the Rolleiflex camera in the Rolleimarin housing, because frames are not needed with these UW rigs. Nikon also makes a holder for the Nikonos UW flash gun especially designed to hold it in the proper position for the Nikonos close-up lens accessory kit. As with viewfinders, a few other closeup systems are on the market for the Nikonos and will be described on pp. 73–74.*

Nikon has never manufactured an electronic (strobe) unit for their Nikonos cameras. They do supply an accessory light meter (mentioned before), the Sekonic Auto-Lumi Model L-86 meter encased in a plastic housing. It's a good meter but is not as sensitive as the Sekonic Marine II (amphibious) designed specifically for UW photography.

Nikonos cameras are imported into the United States by EPOI-Ehrenreich Photo Optical Industries, Inc. and they are the best people to direct questions and inquiries about the Nikonos cameras.

Since the manufacturers of the Calypso camera are out of business, repairs are best handled by: Professional Camera Repair, N.Y.C.

---

*Everything manufactured by Nikon is described in great detail, with many illustrations, and lens diagrams in *Nikon/Nikkormat Handbook,* Joseph D. Cooper, Amphoto, Pub. 1974.

## FLASH GUNS BY NIKON

An excellent flash-bulb gun is manufactured by Nikon. There are two models: A flash-gun unit for the Nikonos I and Nikonos II (which will also work with the Calypso camera) and a new flash gun for the Nikonos III, which has a different flash gun to camera connector. **Beware:** the Model I flash gun will not work with the Nikonos III. The Model III flash-gun unit is called the "Flash-Unit P."

Both units are powered by photoflash battery type BC, 22.5 volts, which is located in the handle of the flash gun. It takes bayonet-based flash bulbs, and an accessory for AG flash bulbs is available. With FP (focal-plane) flash bulbs, GE 6 or Sylvania 26 (clear), one can use flash as a "fill-in" light to restore the UW colors and still set the shutter speed so that the natural sunlight will be exposed in balance with the flash exposure on the UW subject. This is one of the advantages of flash bulbs over strobe units. Strobe cannot be synchronized with Nikonos cameras beyond 1/30 of a second. Therefore the camera's shutter must go off at 1/30 with strobe; but at times, in shallow water, this will overexpose the natural-lighted background of UW photographs.

## EQUIPMENT AND ACCESSORIES FOR THE CALYPSO AND NIKONOS CAMERAS MANUFACTURED BY INDEPENDENT COMPANIES

Since the advent of the Calypso/Nikonos amphibious cameras, numerous diver-photographers and engineers interested in UW photography have invented and designed equipment and accessories for these cameras. This has mostly been done on a very small scale, and much of the gear is not presently available new. Much is available in

a used condition, but as with all used equipment, it should be examined carefully before it is bought. Some of this equipment, which I feel meets many needs of the photographer using the Calypso/Nikonos cameras in UW photography is listed below. See Appendix I for more information about the manufacturers.

## Fisheye Lens Adapters

**The Super-Eye** / A water dome corrected housing adapter designed to adapt fisheye lenses for use on the Nikonos cameras. It adapts the Nikkor 8-mm, Accura, and Spiratone fisheye lenses, giving a UW angle of coverage of 180°. These are still being manufactured by Seacor.

**The FE-5 Fisheye** / A supplementary lens to be attached to the 35-mm standard Nikonos lens. It gives a picture angle of 150°; the cost is reasonable, but sharpness (resolution) is lacking unless the camera lens is stopped down to $f/11$ or $f/16$. The more you stop the 35-mm lens, the sharper the resulting wide-angle fisheye picture will be. Usage is thus limited to bright days and clear waters primarily. It is still available, new at Green Things/Aqua-Craft.

**Schulke Fisheye Adapters** / Machined aluminum adapters. Model I was designed for the Nikkor 7.5-mm and Nikkor 8-mm fisheye lenses only. Accura and Spiratone $f/5.6$ and $f/8$ 12-mm fisheyes in Nikon mounts can also fit into the Model I adapter. Model II was designed specifically for the Accura and Spiratone $f/5.6$ and $f/8$ 12-mm fisheye lenses. These were the first commercially available "fisheye" adapters, manufactured before some of the newer wide-angle lenses, such as the 15-mm UW Nikkor lens, the 16-mm Minolta Rokkor OK MC fisheye lens (which fills the full 35-mm frame—the older lenses gave a circular image), the Sigma-Filtermatic fisheye lens 16-mm, and the Pentax 17-mm and Nikkor

**Illus. 4.5** Schulke Model I Nikonos adapter for the Nikkor 7.5-mm Fisheye $f/5.6$ lens, mounted on a Nikonos Model I camera. *Photo by Flip Schulke*

**Illus. 4.6** Left, Schulke Model II Nikonos lens adapter. Right, Spiratone/Sigma 12-mm Fisheye $f/8$ lens.

16-mm fisheye lenses, which also fill the full 35-mm film frame, became available. Now almost all major lens manufacturers make "film-frame" fisheye lenses. These Schulke adapters for the fisheye are no longer being manufactured, because of the proliferation of fisheye lenses and the constant discontinuation of older fisheye models. Since each adapter must fit a particular lens, it became difficult to change adapter models. Fisheye lenses still give effects and angles of coverage (up to 180°) which cannot be dupli-

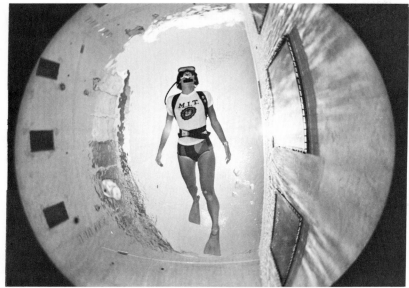

**Illus. 4.7** The extremely wide angle and lens curvature can lend drama to a simple picture situation. A beginning diver is shown in a special teaching pool at the Freeport, Bahamas, Underwater Explorers' Club. The fisheye shows the viewing windows located on both sides of this deep tank. Some fisheye lenses give only a partial circular format on the 35-mm frame, as can be seen with this Spiratone/ Sigma 12-mm $f/8$ lens. The lens was used in a Nikon F/Niko-Mar UW housing combination so that the subject composition could be viewed through the lens. *Photo by Flip Schulke*

**Illus. 4.8** The fisheye lens enabled me to photograph the Tektite underwater laboratory and get the whole complex in one picture. Taken for *True* magazine originally, it has been published worldwide. Nikonos I camera, Nikkor 7.5-mm fisheye $f/5.6$ lens in my own adapter, 64 ASA color film, converted to black and white, sunlight exposure, limited visibility. *Photo by Flip Schulke*

**Illus. 4.9** A 29-foot killer whale (Orca) is too large to photograph with anything but a fisheye lens. Taken for *National Geographic* magazine, with a Harrison/ Atlantic Plexiglas 35-mm UW SLR housing, Nikon F camera, Nikkor 7.5-mm Fisheye $f/5.6$ lens, Tri-X black-and-white film rated at ASA 1600, dome port, murky water conditions. *Photo by Flip Schulke*

cated by any other "normal" wide-angle lenses in UW photography. On pp. 69 and 105 you can see examples of UW problems solved by the fisheye lens. Because of the numerous fisheye lenses on the market, the trend is toward using these lenses in SLR cameras in UW housings. A separate view-finder, described on p. 71, had to be utilized with the original fisheye lenses.

I have a fond feeling for the early fisheye lenses in UW photography, for at the time they enabled me to take photographs that would be impossible with any other lenses in UW photography. Because they enabled me to get so close to my subject matter, I could photograph in extremely murky water. The study of the fisheye lens led me directly into devising dome correction systems and the restoration of the true angle of coverage of a lens used in UW photography.

## Lens-Adapter Combinations for the Nikonos

**Sea-Eye 21-mm f/3.3** / This corrected UW lens for Calypso/Nikonos cameras has a 92° angle of coverage (the same as a 21-mm in surface photography) and focus and f/stop controls. It plugs into the Nikonos cameras just as the Nikon manufactured lenses do and has an optical-glass view-finder accessory. This lens combination is available new at Seacor.

**Schulke 21-mm Nikkor f/4** / A corrected UW lens for Calypso/Nikonos cameras, with a 92° angle of coverage, plugs into the Nikonos camera just as Nikon UW lenses do, and has focus and f-stop controls. This was the first commercially manufactured 21-mm corrected UW lens. More than 100 models were produced, but it is no longer

*Illus. 4.10* Color photographs of the twin Cousteau mini-subs exploring the bottom of 12,000-foot-high Lake Titicaca, Bolivia. Taken with Nikonos II, 7.5-mm fisheye lens, 160 ASA color film, sunlight, 100-foot depth, below-average clarity for fresh-lake water. *National Geographic. Photo by Flip Schulke*

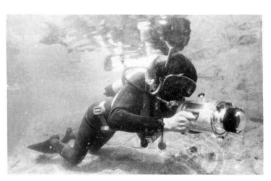
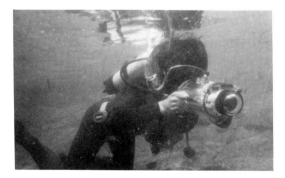

*Illus. 4.11* Left, a photograph taken with the Viz-Master 20 supplementary lens, in conjunction with the Nikonos UW Nikkor 28-mm lens. With the Viz-Master the 35 mm gives an effective focal length of 20 mm. Right, the same subject taken without using the Viz-Master 20. Here the UW 35 mm is giving an effective focal length of 50°. *Photo by Geoff Harwood*

manufactured since Nikon discontinued the Nikkor 21-mm *f/4* wide-angle lens. It is available only in the second-hand market.

## Supplementary Wide-Angle Lens System

**The Viz-Master 20** / The English designed and manufactured Viz-Master 20 is another very well designed supplementary lens that fits onto the 35-mm Nikonos lens and increases its angle of coverage to approximately 94° (approximates a 20-mm angle of coverage). Designed by Geoff Harwood in England, the Viz-Master 20 is not a fisheye lens, as it covers the entire 35-mm film format. There is minimal barrel distortion with this lens. A supplementary viewfinder is needed in order to see the full 94° coverage. The advantage of this sort of wide-angle supplementary lens to the diver is the ability to remove it underwater, when you want to use the normal 35-mm coverage of the Nikonos lens, and to replace it underwater in front of the 35-mm lens, when you again want to take wide-angle photographs. Great care is taken in the grinding and manufacture of this lens, and it gives by far the sharpest image of add-on wide-angle lenses of this type.

## Optical Viewfinders

**Ikelite/Schulke Optical Viewfinder** / A molded plastic optical viewfinder giving fast and accurate aiming for the 15-mm, 28-mm, 35-mm, and 80-mm Nikonos lenses. The image one sees through this viewfinder is 140° circular. A series of framer masks corresponding to the above four lenses can be changed, depending on the lens being used in a Nikonos camera. Most optical viewfinders show only what is to be photographed. The important concept of a good optical type viewfinder is to show considerably more than is actually being photographed. This is to aid one in composition by showing

what one is missing or what might be just about to swim into one's photograph. The design of this optical finder grew out of my need as a professional to see exactly what my composition would be. My prototypes utilized glass elements. Ikelite was able to reproduce the quality of the glass elements in molded plastic lenses at a reasonable cost. See Illus. 3.5.

**Seacor Sea View IV Universal Viewfinder** / A wide-angle optical viewfinder, plastic lens elements. It utilizes masks for 21-mm, 28-mm, and 35-mm lenses.

**Schulke/Klein 180° Optical Viewfinder** / I designed this optical viewfinder in collaboration with noted UW cinematographer and Academy Award winner (*Thunderball*) Jordan Klein. Originally designed for the fisheye lens, Klein designed interchangeable masks so that any angle of view can be accommodated by this viewfinder. Its large size makes it the UW viewfinder of choice in professional UW cinematography. Because of the size of professional movie camera housings, a small optical viewfinder will not permit the diver to get his eye close enough to the viewfinder to see the complete frame. It is available from Mako Engineering.

*Illus. 4.12* Schulke-Klein 180° optical viewfinder.

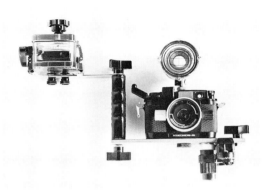

**Illus. 4.13** The Ikelite Nikonos handle unit (bracket). With this and other handle units, SST, strobe and flash arms, and accessory light meters can be easily attached.

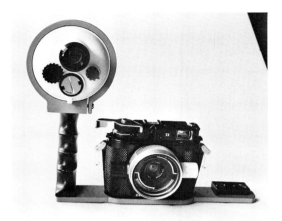

**Illus. 4.14** The Farallon/Oceanic Nikonos handle unit, with Sekonic Marine II meter in holder, attached.

## Handle-bracket Units

It was obvious to UW photographers from the outset of the use of the Calypso and Nikonos cameras that, owing to the very small size of the cameras, it was difficult to hold the unit, even more difficult if the diver had cold-water gloves on.

For this reason many diver-photographers designed and had built various forms of trays that the camera could be bolted to, with a sturdy extending handle that could be easily grasped, in order to work the camera's shutter and advance lever with a thumb—a one-hand operation. These brackets also permitted the attaching of light meters and various brands of flash and strobe units. All such brackets will fit the Calypso and Model I and Model II Nikonos cameras. A variation had to be developed for the Nikonos III because of the physical changes made by Nikon in this newer model.

I can only say that for any serious Nikonos UW photography a handle bracket is a **must.** All one's equipment is attached together, all can then be held with one hand when you need the other to hang on to the boat's bobbing ladder or to coral underwater to steady one's self and at the same time change flash bulbs or camera settings. The thumb advance system works more easily than the finger system of the Nikonos without a handle bracket. But most of all, it makes swimming and photographing less physically taxing, which can only help one concentrate more on taking pictures.

Many handle-bracket units designed for the Nikonos cameras are available on the commercial market. As with flash units, one model of handle bracket will fit the Nikonos I, II, and Calypso cameras, and a different handle-bracket unit is needed for the Model III Nikonos camera. When you are buying a handle-bracket unit, be sure to specify which model you own. The illustrations show two units that I have found particularly well designed and easy to use underwater.

## Strobes for the Nikonos Camera

Most strobes manufactured for UW photography will fit or connect to Nikonos cameras via either direct connections on some models or by connector systems, such as those of Electro Oceanics and Ikelite. I shall fully cover various types and brands of strobe

units in chapter 7. Illus. 7.2 shows you the Nikonos flash-gun unit, two amphibious strobe units, and a housing for a surface strobe that can be connected to a Nikonos camera.

A new UW amphibious electronic (strobe) flash unit, called the TM-1, has been designed and manufactured by Toshiba (Elmo Mfg. Corp., importer). It operates off four alkaline manganese penlight batteries (1.5 volt AA), and you can get approximately 250 flashes with one set of batteries. One of the advantages of this unit is the availability of 1.5-volt penlight batteries worldwide. The unit comes with the connector cable for the Nikonos I, II, and Calypso. An adapter is available for the Nikonos III.

## Accessories for Macro, or Closeup, Photography

Besides the closeup supplementary lens accessory unit manufactured by Nikon for the Nikonos cameras, some models from independent manufacturers offer very good competition. Besides the supplementary closeup lens system there is a second system, using extension tubes, which moves the camera's lens farther away from the film plane, and thus enables the camera to focus

**Illus. 4.16** Flash units for the Nikonos camera: including the Nikonos flash gun (Nikon), an Ikelite Lexan housing for a Braun strobe, amphibious strobe model 2001 (Farallon/Oceanic), and amphibious strobe model AE 100 Graflex Subsea.

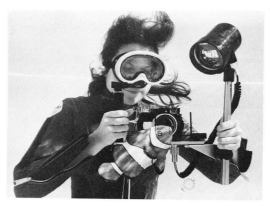

**Illus. 4.17** The Toshiba TM-1 UW amphibious strobe.

**Illus. 4.15** Three common Nikonos plug systems. Left, Nikonos flash gun (Nikon). Middle, EO Nikonos adapter. Right, Ikelite adapter.

at very close distances. The extension tube, I find, gives a higher resolution (image sharpness) than do supplementary lenses, but both have their good points. The supplementary closeup lens system can be removed while one is underwater. On the other hand, one cannot remove an extension-tube closeup unit underwater. Being able to remove the supplementary closeup lens unit allows the diver-photographer to take macrophotographs and then to remove the supplementary lens and resume taking photographs with the regular lens at its normal focus distances.

**Extension Tubes** / The extension tubes made by Farallon/Oceanic Products and Graflex Subsea Products give you the capability of various degrees of macrophotography. I feel that these are the best designed and easiest to use extension-tube units that are consistently easy to obtain through your local dive shop throughout the United States. These tubes work with both 35-mm and 28-mm lenses, though a separate extension tube is necessary for any particular macrodistance with either of the two Nikonos lenses. The extension tube plugs into the Nikonos body like the lens, and the lens is then plugged into the front of the extension tube. This must be done with the camera dry, and above water, of course.

**Close-up Supplementary Lenses** / These also give you various degrees of UW macrophotograph and are made by Farallon/Oceanic Products and Green Things, Aqua-Craft. Again, except for the Nikon closeup lens set, supplementary closeup lens systems for macrophotography **with the Nikonos camera** do not exhibit the edge-to-edge sharpness that using extension tubes for macrophotography do. The great advantage is that the supplementary closeup lens can be attached and removed underwater. Many times this advantage far outweighs the added sharpness afforded by the extension tube, which can't be removed

underwater. Therefore the type and amount of macrophotography that you do underwater should be the deciding factor in purchasing either type of macrosystem for your own use. See *Plate 5.*

## Flash Guns for Flash Bulbs and Cubes

Until recently the only commercially available flash bulb gun for the Nikonos line of

*Illus. 4.18* A macro extension tube for the Nikonos 28-mm UW lens by Farallon/Oceanic.

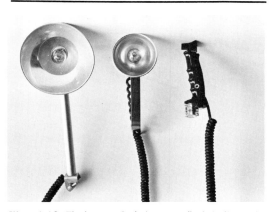

*Illus. 4.19* Flash guns. Left, bayonet flash-bulb gun by Rollei (for Rolleimarin UW housing). Middle, bayonet flash-bulb gun. Right, cube-flash gun, both by Ikelite.

amphibious cameras was the flash gun sold by Nikon (EPOI). Ikelite has marketed what it calls the Nikonos power pack; this is a solid state triggering (SST) system. The power pack incorporates a 22½-volt battery, which fires flash bulbs or cubes through inexpensive flashguns plugged directly into the power pack, which in turn, plugs directly into the Nikonos camera. The power pack comes in two models, one for Calypso, Nikonos I, and Nikonos II cameras, and another for the Nikonos III. The power pack is designed to be used with this manufacturer's Nikonos handle unit. The same power pack can be used to trigger strobe units, and is described in Chapter 7.

*Illus. 4.20* Solid state triggering (SST) Nikonos power pack by Ikelite.

## CAMERA MAINTENANCE

I disagree strongly with the Nikonos instruction manual accompanying each camera on one major aspect. The manufacturer suggests (and actually shows a photograph) the owner rinse off the camera after a dive. This is fine in fresh water; but in salt water, where an increasing number of people are diving, merely rinsing will not dissolve the salt that would have already dried during the time the camera was brought up from underwater and transported home. You must submerge the camera in fresh water, slightly warm, and add a little baking soda. Your camera will then last a long time, and corrosion due to salt crystals will not damage the camera or the camera's O-ring groove. I base this belief on the fact that my own cameras, submerged in water for 30 minutes to an hour after every dive, do not show any signs of corrosion (even cameras more than 10 years old, in constant use in salt water). On the other hand, I am constantly being handed a Nikonos to change film for other divers; and although the camera may be very new, I often find salt crystals caked around the lens O-ring seating groove. Salt crystals are also caked around all the con-

trols, and metal corrosion is evident. I learn from questioning the diver that he or she merely rinses the camera in running water.

I have not discussed repairing your Nikonos because I am a firm believer in camera repairmen; they know what they are doing, and taking a camera apart is like taking a watch apart. Some people can do it, but most can't. If your camera lens or body is accidentally dropped into salt water, when it is being loaded, or if it leaks, follow the procedure outlined in Appendix 3, and ship your camera to the Nikon Service Center or a professional camera-repair center as soon as possible.

### Nikonos Care Hints
(Courtesy of Capt. Bill Crawford, Tropic Isle Dive Shop, Key Largo, Florida)

- Use a light coating of O-ring grease on O rings before dive; clean off excess grease. (Use only recommended silicone grease.)
- Clean grit and sand off O rings. (Cotton swabs are useful.)
- Assemble camera and camera housing components carefully, don't force.
- Don't jump into the water with camera in hand. Have someone hand it to you or use a camera safety line and lower it into the water.
- Rinse camera with fresh water and air blow dry before reloading when planning another photo-dive on the same trip.

- Rinse hands, face, and hair with fresh water before changing film. **Keep saltwater out.**
- Be sure to replace plug in Nikonos body when shifting from flash to natural light photography.
- Keep a spare set of O rings and replace them every year for best service.
- Don't take a camera from an air-conditioned environment out into the sun. Give it time to acclimatize so that moisture won't form on the lens or inside the lens ports.
- Never leave a camera in the sun, as heat will cause the film to shift color and cause possible water leakage through O-ring extrusion.
- A good preventive maintenance check will insure against floodings.
- When not sure about watertightness, take your housing underwater without the camera or strobe in it and check for possible leaks.

**Tips for Calypso and Nikonos Users**

Read the instruction manual that comes with each Nikonos camera. If you have lost yours or have purchased a used camera, your camera dealer can write for one for you, or you can write to Consumer Services, Nikon (EPOI). Detailed, well illustrated instructions come in these manuals. Since the various models have different features, it would be pointless to try to cover such technical instruction in a book of this sort. At least until you become familiar with your own model of Nikonos or Calypso, carry the instruction manual along (wrapped in a plastic bag) in your dive bag or UW photographic equipment case. You can then refer to it wherever you run into a difficulty that you don't know how to overcome. Even after all the years that I have been using these cameras, I still carry the instruction booklets around with me in my equipment case, and they have proved useful many a time.

With any 35-mm camera, remember that the negative or slide area is small—1 by 1½ inches—one scratch or a finger pressed too hard on the surface of the film will ruin a good negative or slide. Care in handling the film is the first prerequisite. Clean the insides of the camera to keep intruding dust or grit from marring your film. Film quality, both black and white and color, is high enough today that you will get sharp, clear pictures if you are careful.

Filling the frame (see Illus. 1.16) is another prerequisite of 35-mm photography. The frame area is already so small you don't want to waste any of it. If you must enlarge your subject from a little image in the middle of the 35-mm frame, you will lose a lot of sharpness and clarity, not to mention color tones. That's why I feel so strongly about the use of optical viewfinders with these amphibious cameras. You must be able to frame correctly in order to fill the frame, and only an optical viewfinder can do this for you.

Since you must estimate (guess) the subject-to-camera distance with the Nikonos camera, practice judging distances on the surface. Make a game of seeing how close you can come to guessing various distances—1, 2, 3, 4, 5, 6, feet—from yourself. The more practice you will become at judging distances. The UW measuring stick, p. 8, is very useful with these cameras to get the exact distance. Obviously, because the measuring stick won't work too well with moving objects, you should practice guessing distances.

Use the depth-of-field indicator located on the distance scale of the lens to help you know what will be sharp in front of and behind the object that you have actually focused the lens scale at. As you change aperture (f-stop) settings, two red pointers move over the distance scale automatically to indicate the limits of sharpness at each f-stop setting. For example, with the 35-mm lens focused at 10 feet and set at f/16, the pointers show that the depth of field extends from about 5 feet to infinity.

You will get better exposure if you use a light meter with these cameras.

Flash-bulb and electronic-flash-exposure information and tips can be found in Chapter 7. Flash technique is basically the same for SLR and Nikonos type cameras.

These cameras will synchronize with class M and class MF flash bulbs at 1/30 of a second only. But class FP (focal-plane) flash bulbs will synchronize at 1/60, 1/125, 1/250, and 1/500 of a second. Use clear flash bulbs except for macrophotography. Electronic flash (strobe) will synchronize at 1/60 and 1/30 of a second only.

A good handle bracket and an attached light meter plus flash or strobe will be a great help in operating the camera underwater.

For night photography, you will need a small UW flashlight to enable you to read the settings and dials on the Nikonos camera. The numbers are extremely small, though easier to read on the latest model, III. A small plus-diopter closeup lens glued to the front of your face mask, like a bifocal eyeglass lens, will enlarge the camera numbers. This lens will be a must if you already wear bifocal glasses on the surface.

Clean and lubricate with O-ring silicone grease the O-ring gaskets at the top edge of the interior body, and the one around the lenses before each diving trip. The gaskets should be protected from cuts or scratches caused by sharp objects or grains of sand. Whenever they appear the least bit worn, they should be replaced. New O rings can be obtained from dive shops and camera stores selling Nikonos cameras, or from Nikon (EPOI).

Remember to submerge your Nikonos or Calypso in fresh clean water for at least 30 minutes after using in saltwater. Rinsing is not enough to dissolve dried or caked salt crystals.

# WHY I LIKE THE NIKONOS AND CALYPSO AMPHIBIOUS CAMERAS

I have stopped counting the times I am asked by other diver-photographers if I use the Nikonos or Calypso cameras in my professional work. For some reason, probably because of their small size and their popularity among amateur UW photographers, they are not considered professional calibre UW cameras.

As mentioned previously, 35-mm color slides were considered unprofessional not too many years ago, and this lack of confidence has persisted, with the result that many UW photographers look upon the Nikonos and Calypso as expensive toys.

Because they are small, easy to dive with, easy to use with attached flash gun or strobe, numerous UW photographers utilize

***Illus. 4.21*** Author and Nikonos.

these cameras for taking "UW snapshots" only. They are not snapshot cameras, however. Of course you can use them that way, but what a waste of a very versatile piece of photographic machinery, fully capable of providing top notch results. Their very smallness can be a great asset.

One day while working off an oil-drilling platform I was confronted with huge waves crashing around the ladder at the base of the platform. Fortunately my Nikonos fit easily into one hand and I was able to enter the water without mishap. It would have been impossible to use a UW camera in its housing that day.

I have taken my Nikonos and Calypso cameras so seriously as a professional photographer that from the start I began trying to fit them with other lenses. The adapters for the fisheye lens, the Nikkor 21-mm, the Pentax-Takumar SMC 17-mm wide-angle lens, the Minolta-Rokkor-OK MC fisheye 16-mm lens (full frame), and the Sigma-filtermatic fisheye 16-mm lens (full frame) all came into being because I recognized that these little cameras could be easily carried both in and out of water, no matter what the weather. Thanks to their small size, I could conserve my energy to move about and capture the images seen by my eye and imagination.

Illus. 4.22 shows the lens-adapter system that I designed, along with a handle bracket that preceded most of the commercially available handle brackets currently on the market.

Such systems are becoming more common today. As the market grows and UW photography becomes increasingly popular, the price of manufacturing accessory systems for the Nikonos and Calypso cameras decreases.

The lenses mentioned above provide a range of wide-angle optics to suit any occasion. They have often solved very difficult UW photographic situations for me.

## Suggested Assignments with Nikonos/Calypso Amphibious Cameras

These cameras have variable shutter speeds. Therefore take the camera without flash into a swimming pool, outside, and do the following:

Lying on the bottom, using the measuring stick, focus on a subject 3 feet away, take exposures at 1/30, 1/60, 1/125, and 1/250. (Shooting in black and white saves money in this sort of test.) Have the various negatives enlarged, or inspect the negs with a magnifying glass. See if your photographs taken at higher shutter speeds are sharper. If they are, practice holding the camera in a steadier manner and release the shutter-release button with a "squeezing" motion—don't shove it.

Repeat the same sequence of shutter speeds, but this time suspend yourself in the water so that you don't have anything solid to lean on or steady yourself with. Again inspect the various speed exposures. You will get a better idea of what is the slowest speed at which you can hold the camera when swimming or suspended in water rather than lying on the bottom.

Have your subject move, swim, or dive into the water so that you have some fast action. Again, use shutter speeds all the way from 1/30 to 1/500. You will get an idea of what slower and faster shutter speeds do to the resulting photograph. Sometimes a "blur" photograph can be artistically pleasing, but most times, stopping the action with a high shutter speed will bring the results that you are looking for if you are trying to communicate what you see underwater to the viewers of your photographs.

As a part of the above, try to catch the complete composition or placement of subjects and subject matter in the frame via the optical viewfinder. If you have both an open sports finder and an optical finder, see which one suits your shooting style best by trying them both out in this action shooting situation. This is very good practice for open-water photography, because if you are shooting fish or even fellow divers, they usually won't wait until you can get the photograph composed properly.

Shoot film. I don't mean waste it on meaningless exposures without a purpose, but it is an axiom of all photography that "the more you shoot, the better you will get." But remember, each time you release the shutter button, your mind should

be telling you, "Now, that looks good!" If the subject suddenly turns, hold your finger until it looks right again. Patience is a must for UW photography. For when you are in the ocean you must conserve film; each shot must count. Changing film is a time-consuming business in open-water photography; very few of us have assistants to do this in the boat, and fewer still have more than one camera to take down. The conditions of the sea will not always permit me, even as a professional, to take down more than one or at the most two cameras at a time. You will find, as I have, that it is very difficult to talk someone into going diving with you and then asking him to stay in the boat to change film for you. Every assistant that I have had has ultimately ended up in the water working as a UW assistant (with lights, or as my safety diver).

In the ocean try the following:

Run a test of your distance-guessing ability. Shoot both guessed and measured distances, using the measuring stick to make exposures at exact distances. Also shoot photographs by utilizing the depth-of-field indicators (the red pointers) on the distance-scale portion of the camera's lens. Because these cameras have no internal focusing system, depth-of-field photography will give you the best system for getting photographs with multiple subjects at different distances in sharp focus. This is also one of the reasons why I have stressed learning how to hold the camera still while taking photographs; the stiller you hold the camera, the slower the shutter speed you can use to get sharp photographs. The slower the shutter speed, the more you can stop down (close down) the f-stop; and the more stopped-down the f-stop the wider your range of depth of field will be.

Pick a UW diving site where there is a mild tidal flow or surging from surface winds. Practice holding on to a stationary object with one hand and taking photographs with the other. You will really understand the necessity of a handle bracket in Nikonos photography. Wearing a wet suit or other protective clothing, try wrapping your legs around coral (not fragile coral that will break off from grasping it) or other objects that you find on the bottom. Often I find that I can wedge myself between rocks and get a good solid hold with just my body and/or legs, leaving both hands free for photography.

Run a color test by taking exposures (metered if possible—otherwise the test cannot be very accurate) at 5, 8, 10, 12, 15, 20, and 25 feet down, by natural light. A good test is to try Ektachrome 64, Ektachrome 200, and Kodachrome 64. Do not use artificial light. Be sure that it is a sunny day, and you will learn at what depths colors fade to blue-gray, and which film gives the most pleasing colors to your artistic tastes. I find that the international safety orange diving jackets are the best for my subjects. They give you a color subject that is consistent throughout all your test photographs. See *Films* in the Glossary.

Try shooting directly upward (lying on your back, while gliding along with scuba); this experiment will show you the problems of parallax, and you will learn how to compensate (move the camera slightly off center) when using the open sports finder or the optical viewfinder.

**Illus. 4.22** A Nikonos I camera with Pentax-Takumar 17-mm full-frame-fisheye f/4 lens, f-stop control, French 17-mm optical viewfinder. I always remove camera body neck straps. If I have to attach a cord to the camera, I attach it to the handle bracket only. All my optical viewfinders are modified to attach to the handle bracket also—a much more secure system than using the accessory shoe located on top of the Nikonos/Calypso cameras. An accessory shoe is a surface camera design that should never have been incorporated into a camera for UW use. It just isn't strong enough. *Photo by Flip Schulke*

# 5·LARGER-FILM CAMERAS

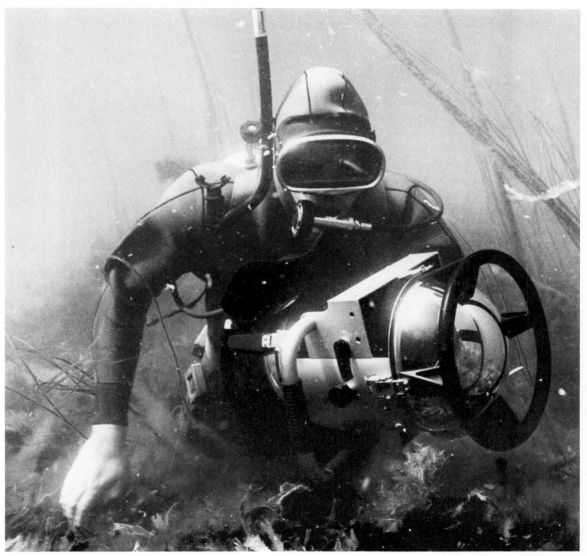

***Illus. 5.1*** *Photo courtesy Braun North America*

In Chapter 3, I touched on the fact that as larger-format camera use underwater has declined, 35-mm camera acceptance has risen. "Larger format" is a term applied to cameras using 120 or 220 size film, of which the format is 2¼ x 2¼ inches (6 x 6 cm) or 2¼ x 2¾ inches (6 x 7 cm).

I have given much more emphasis to 35-mm cameras in housings and the 35-mm Nikonos/Calypso amphibious cameras because the cost of using the larger cameras in UW photography is much greater. That added expense does not, in my opinion, translate itself to UW photographs of significantly higher quality, except in a few instances that satisfy the technical needs of specialized photographers.

The choice of the larger-format camera is very personal. If you are more familiar with the operation of these cameras already or if you currently own one that can be housed, you may want to stick to this equipment when venturing underwater.

## THE ROLLEIMARIN/ ROLLEIFLEX COMBINATION

The larger-format camera played a pioneer role in opening up the undersea world to photography. Designed by the world-famous Austrian scientist-diver-photographer, Hans Hass, this beautiful, practical Rolleimarin housing and twin-lens-reflex Rolleiflex 120 camera comprised what was unquestionably the most popular UW camera-housing unit for many years.

Manufactured by Franke & Heidecke, the Rolleimarin housing, made of cast aluminum and machined to a very high degree of tolerance, has been the standard for excellence. It is especially good for closeup work at about 3/4 to 2 feet. It has a magnified reflex viewer, which gives you almost the exact area the camera lens is taking, via the second, or upper, lens of the Rolleiflex twin-lens-reflex camera. One of the reasons that

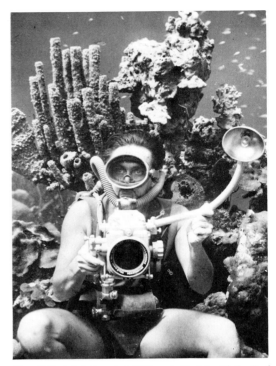

**Illus. 5.2** A light-hearted UW portrait of the "father" of the Rolleimarin housing, Hans Hass, holding the camera system that brought UW photographic capability to divers worldwide. *Photo courtesy Hans Hass*

this camera-housing rig is so popular with closeup photographers, especially fish photographers, is the size of the image that you see via the magnified prism viewfinder. One of the world's finest UW photographers specializing in marine life, Douglas Faulkner, has Rolleimarin housings as the mainstay of his equipment locker.

The larger the image you see, the easier it is to see details in the subject matter, and the easier it is to focus accurately. The Rolleimarin prism is three-sided; thus you see the subject in reverse. If a fish is in reality swimming from left to right, the camera will show the fish on the viewfinder screen to be swimming from right to left. Therefore composing takes a bit of practice.

The great advantage of the twin lens reflex is that the view through the viewing lens is also continual. With SLRs, since you both view and take through the same lens, there is a blackout period just after you release the shutter, for the mirror blocks out the viewing screen for the instant of the exposure. Because fish turn about quickly, you can take an SLR photograph of a fish, and in the instant of the blackout of the viewing and exposing lens, it can turn. You then get a photograph of the turn, not the fish as you saw it just before you released the shutter button. Using a stationary mirror and viewing lens, the Rolleiflex lets you see exactly what your subject looks like at the instant of exposure.

Another advantage of the Rolleimarin/ Rolleiflex is the front between-the-lens-shutter in the camera, which can synchronize with strobe flash right up to 1/500 of a second, versus 1/60 of a second in SLRs in housings and Nikonos cameras. This enables you to balance your strobe artificial light at any shutter speed with the existing sunlight, and the resulting photograph will often look more natural.

The Rolleimarin can use strobe or flash bulbs. Rollei manufactures a very good flash-bulb gun to go with its housing. Because the BC unit that fires the bulbs is located inside the housing, wiring outside to the flash gun is simple and can be plugged and unplugged at will underwater. Douglas Faulkner, who travels to many far places in pursuit of his UW color photographs, favors flash bulbs, because very little can go wrong with a UW flash gun and bulbs are available all over the world. Trying to repair an electronic strobe in remote areas can be impossible. For dependability flash bulbs have much in their favor over strobe in UW usage; though the use of strobes, especially with better cameras and housings, is vastly outstripping the use of flash bulbs in contemporary UW artificial light photography. They are handier to use, the overall cost is lower, and the bulk of carrying both flash bulbs and the litter afterward is done away with. Again, the choice depends upon your own working conditions and problems.

If your total interest in UW photography is photographing fish, then the Rolleimarin/ Rolleiflex combination may be the best for you. Remember, though, it is difficult finding projectors to show 2¼ x 2¼ slides. Reducing them to 35-mm is expensive and defeats the purpose of having the larger format with the larger film area. Because interest in the Rolleimarin has increased recently, it isn't easy to find bargains in used housings. Franke & Heidecke still manufactures these housings, which are available through Rollei of America.

## HASSELBLAD

These Swedish 2¼ x 2¼ cameras, which have gone to the moon and walked in outer space, can also be used in UW photography.

The manufacturer makes housings for its three major cameras:

**The SWC (super-wide-angle) camera /** With its 38-mm Biogon lens, this camera is housed in an aluminum casing that comes with a dome port that restores the normal angle of coverage, which is 90°. The viewfinder supplied with this Hasselblad housing is of the wire open sports-finder type, since the SWC camera is not a reflex camera. In surface work, the SWC is used with an optical viewfinder. An optical viewfinder for underwater work would be a great improvement over the currently available open viewfinder or sports finder from Hasselblad.

**The 500 C/M camera /** The Distagon 50 mm and the Planar 80 mm are the most popular lenses for UW work with the 500 C/M camera, a SLR type. The UW housing manufactured by Hasselblad for these cameras features a magnified viewfinder, giving

you a view of the camera's ground-glass screen which is right side up but reversed, since like the Rolleimarin the housing utilizes a three-sided prism. (Remember that you need a five-sided prism to get the picture right side up and directions left to right on the proper side.) Both flat ports and corrected dome ports are available for this housing. For closeup photography, supplementary closeup lenses called Proxars are necessary.

**The 500 EL/M** / A motorized camera featuring a special magazine that will accept 70 exposures, the 500 EL/M housing features a magnified three-prism viewfinder, and the front portion of the housing is a concentric dome corrector. (Actually there are two interchangeable domes at the front and rear of the housing which are attached by stainless steel snap fasteners.) These domes enable you to obtain the best optical results with different lenses. Heavy-duty grip rings protect the domes and, used in conjunction with the hand grips, make it easy to carry the camera on land and in the water. The 500 EL/M will also accept 12-, 16-, and 25-exposure film magazines, besides the 70-exposure magazine. It is quite large, approaching a 16-mm movie professional housing in size. Certainly it is the Rolls Royce of housing and camera combinations. I have not tested this housing, but it would be interesting to compare it with motorized 35-mm housings.

Housings for the Hasselblads are also made by independent UW photographic equipment manufacturers.

**Hasselblad EL housing** / From Ikelite Underwater Systems, molded plastic (lexan) housing, controls; accommodates all Hasselblad magazines, including 70-exposure pack. Optional interchangeable ports are available, including dome correctors, for all lenses from 50 mm through 135 mm. It has a removable magnifying viewer. You must look down into the viewer, as it is mounted directly above the camera's viewing screen. No prism is involved since viewing is directly down into the viewing screen. It is very compact and motorized.

**Hasselblad 500 C/M models** / From Ikelite Underwater Systems, the same as above, but smaller, since these models are not motorized.

**Hasselblad Super-Wide-Angle (SWC)** / It takes an optional optical viewfinder, since the SWC camera is not an SLR. Otherwise all specifications are the same as the housings above, from Ikelite Underwater Systems.

# OTHER LARGE-FORMAT CAMERAS AND UNDERWATER HOUSINGS

**Bronica S2A** / A 2¼ x 2¼ SLR camera, housing by Ikelite Underwater Systems. Molded plastic (lexan) housing, all controls, optional interchangeable lens ports including dome-correcting ports. The housing will accommodate lenses from 50 mm to 135 mm and has a removable magnifying viewer for direct downward viewing of the screen. This camera is distributed in the United States by EPOI.

**Pentax 6/7 camera** / Using 120-size roll film, with a format of 6/7 cm or 2¼ by 2¾ inches, this large-format SLR with an instant-return mirror is a rather new camera for UW photography. Asahi Pentax manufactures a UW housing for this camera, which it calls the Pentax 6/7 Marine. It is a high-quality seawater-proof coated aluminum alloy housing and therefore quite expensive. It utilizes an accessory magnifier which screws into the standard eye-level prism viewfinder of the camera itself. Accessory items include semi-corrected ports for the wide-angle 55-mm lens and fisheye 35-mm wide-angle lens, plus a standard flat port for the normal lenses (75 mm and 105 mm). For macrophotography, there is an additional flat port

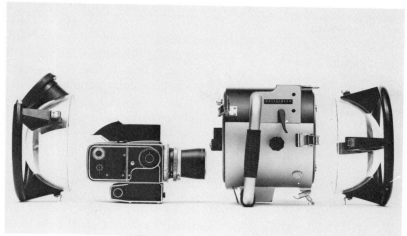

*Illus. 5.3* The Hasselblad 500 EL/M UW housing for the 70-mm EL motor-driven SLR camera, which will take 120-, 220-, or 70-exposure 70-mm film magazines. Hasselblad makes three UW housings that will interchange with any Hasselblad camera made since 1957 and with all future Hasselblads. *Photo courtesy Braun North America.*

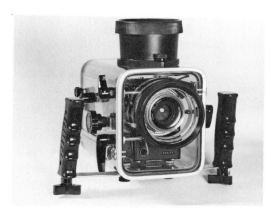
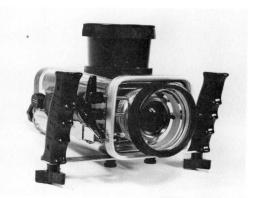

*Illus. 5.4, 5.5* Ikelite UW housings for Hasselblad cameras. Left, housing for the model EL/M (motordriven). Right, housing for the model 500 C/M. *Photos by J. Gale Livers/Ikelite*

---

housing for the macro 135-mm lens or the 150-mm and 200-mm lenses used with the standard closeup extension rings (or tubes). Watertight terminals are provided for flash bulb and cube connector cords and a separate terminal for strobe (electronic) flash connector cords. This marine housing compares well in workmanship with the marine housings made by the camera manufacturers themselves for the Hasselblad and Rolleiflex cameras.

To purchase the Pentax 6/7 camera and lenses, plus the Marine-housing, would be

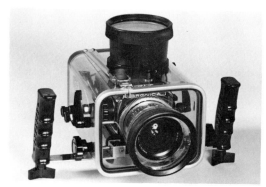

*Illus. 5.6* Ikelite UW housing for the Bronica 6/6 (EPOI) camera. *Photo by Gale Livers/Ikelite*

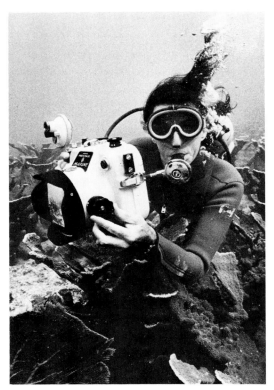

***Illus. 5.7*** UW use of an Asahi Pentax marine housing for the Pentax 6/7 (6- by 7-cm film format) camera. *Photo by Debra Streuber Schulke*

very expensive. Thought must be given to your own pocketbook; or if you are a professional, to whether the resulting large-format photographs would justify the much higher cost of this system in UW photography. If you already own the Pentax 6/7 camera, purchasing the marine housing would then make sense.

**Polaroid SX-70 camera** / 3 x 3 inch color prints, a molded plastic (lexan) housing, manufactured by Ikelite Underwater Systems, with shutter release plus "lighten-darken" and focus controls. Accurate focusing can be accomplished in viewing through the camera's SLR viewing system, but it is not possible to see the full frame through the integral viewfinder. Your face mask will per-

mit seeing the rangefinder focusing system only. Therefore an optional optical viewfinder is necessary to obtain accurate framing (composition). Because the SX-70 is able to focus to within inches of a subject, without the addition of supplementary close-up lenses, it is excellent for macrophotographs underwater.

The exposed and processed print is automatically ejected into a storage compartment inside the housing. You must wait until you return to the surface to open the housing, remove the prints from the storage compartment, and see the results. A flash gun using clear flash bulbs is a great help in restoring the colors of your UW subjects. For an illustration of a Polaroid photograph taken underwater, see color insert, *Plate 40.*

The housing is large, and it takes some intensive practice to learn how to focus through the camera's rangefinder system while underwater. When you master that, the resulting photographs are very sharp.

This is a very specialized camera for most divers, purely a "fun" camera for UW photographic use. The housing allows an entire roll of film to be exposed, and each roll gives a maximum of 10 shots. Polaroids are frequently used underwater by diving instructors to record a student's first dives. They are also used for family snapshots in the backyard swimming pool.

There is an industrial use which makes sense. Engineers and UW contractors have found it an inexpensive device (compared with UW closed-circuit TV) for photographing UW engineering problems, closeup, by UW construction divers. Topside engineers can see a UW photograph within minutes of exposure, and make immediate decisions based on what they see. For example, a UW recovery team used the SX-70 in an Ikelite housing to photograph an anchor and chain that had been lost off the coast of Turkey. Photographs were taken by the divers showing the exact position of the anchor, which

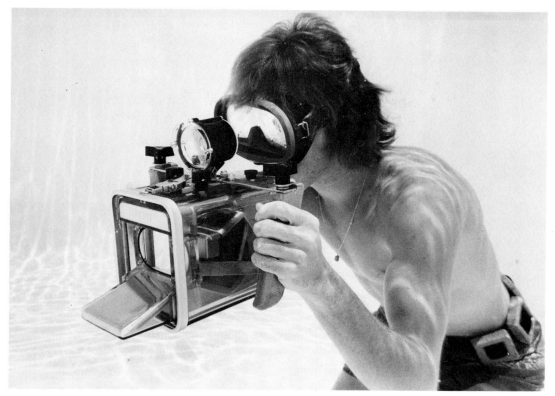

*Illus. 5.8* Ikelite UW housing for the Polaroid SX-70 instant color print camera. The diver is sighting through an accessory optical viewfinder. It is possible to focus through the SLR system of the SX-70 underwater, but you cannot view the full film format, making an optical viewfinder a necessity. The camera deposits the finished prints in the watertight compartment in front of, and below, the lens.

---

weighed many tons. This enabled the surface recovery engineers to make decisions about the UW positioning of lifting cables with regard to the anchor's position on the bottom.

## WHERE THE LARGER-FORMAT CAMERA MAKES SENSE IN UW PHOTOGRAPHY

I said I could not resolve the debate between large and small camera enthusiasts at the beginning of this chapter, but I can relay the arguments of friends who use the larger cameras, along with my personal reasons against general UW usage.

There is no question that in a survey or mapping of the ocean's floor, the larger-format camera is the scientist's best choice, and 70-mm film-format cameras are made for that purpose by Hydro Products. These are highly specialized instrumentation cameras used by UW archeologists and oil companies.

As a generalization, the larger the film, the sharper (see *Resolution* in the Glossary) the resulting film image. Whether or not the added sharpness of image can actually be distinguished by the viewer's eye depends

**Illus. 5.9** A coral reef study taken with the Pentax 6 x 7 camera, 35-mm full-frame fisheye Takumar $f$/4.5 lens, Pentax marine housing, dome corrector. *Photo by Flip Schulke*

upon the individual's visual perception and the format in which the final photograph will be presented.

For the photographer who likes or needs to make enlarged color prints on photographic color print paper (color coupling prints, Cibachrome prints, or dye transfer prints, to mention a few processes) the larger film size will result in enlargements of greater sharpness and fineness of detail. When comparing a larger-format print with a print made from 35-mm film, this greater detail is apparent.

I must admit that when 6 x 6-cm color slides are projected through a 6 x 6-cm slide projector, the image on the screen is breathtaking. A good comparison is the difference in image sharpness and grain between a normal commercial 35-mm movie film and one shot in 70 mm. Because of this striking projection effect, UW photographers who like to display their work at film festivals and photography competitions favor the larger-format camera. You must decide whether the difference matters enough in the kind of photography one is most interested in. When you choose between 35 mm versus the larger-format cameras, one needs to take into consideration financial, aesthetic, and/or professional demands.

The larger-format camera has its technical advantages, but these may be offset by the bulk (volume) of this camera in its marine housing and the resulting greater weight out of water. Lenses for these cameras are limited in variety of focal length. The depth of field of larger camera lenses is much narrower in comparison with a 35-mm lens giving the same angle of coverage underwater. Swimming with a bulky housing is, of course, more difficult.

You must frame your composition just as carefully with the larger camera as with the small, so that your subject fills the whole film area. All too often photographers with larger cameras tend to feel that they can crop and enlarge in the darkroom, since they have a large film area to begin with. The result can be enlarging only a 35-mm-sized area of the much larger film format, thereby losing all the sharpness of the increased film size.

Aesthetics depend primarily on you, the viewer. The large-format cameras do give beautiful results in the photography of fish

**Illus. 5.10** Fine details are enhanced by the use of a larger-format camera in UW photography. This can be seen when photographing a huge piece of brain coral. Edge sharpness is also excellent owing to dome correction. Taken with the Pentax 6 x 7 camera, 35-mm full frame fisheye Takumar $f/4.5$ lens, Pentax marine housing. *Photo by Flip Schulke*

and coral. A look at the books of marine photographer Douglas Faulkner, who uses a Rolleimarin 6 x 6-cm system as his primary UW camera, will attest to the aesthetics obtainable with the larger-format camera in UW photography.

## CONCLUSIONS

For the record, I own a Pentax 6 x 7-cm camera and use it when the diving conditions and subject matter seem tailor-made for the larger film size. I grew up with larger cameras and worked my way down to 35 mm. I like to do my own darkroom enlarging and fully appreciate the visual beauty that can be obtained from using larger film—but the 35 mm remains my workhorse underwater.

You make your choice and take your chances. Weigh carefully the advantages and disadvantages of large versus small before putting your money on the line. After all, it is the slide or print, in black-and-white or color, that will show your results. Any photographic tool, no matter how costly, is only as good as the person who operates it.

Whenever I discuss photographic equipment and the person behind that equipment, I am reminded of photographing the great professional golfer Sam Snead once when he was on vacation. Early one morning while he was practicing, an amateur golfer strode up. He had a "professional" golf bag, full of the highest priced clubs his pro shop had to offer. Snead, who enjoys gambling just a wee bit, asked the other golfer if he wanted to play a little game, with perhaps, a small side bet. Of course the man declined (he had recognized Snead). Then Sam laughingly suggested that he would play the whole game with a tree branch that he would cut then and there off a nearby tree. The other golfer looked at his bagful of high-priced, shiny clubs and agreed. Needless to say, Snead won!

Remember this story when you buy UW photographic equipment. It's not the equipment that will insure good photographs. Only the experienced coordination of eye, brain, and trigger finger will get you those prize-winning UW photographs.

**Assignments**
The same assignments for Chapter 3 can be done with your larger-format camera underwater.

# 6·SUNLIGHTED UNDERWATER PHOTOGRAPHY

**Illus. 6.1** A beautiful sunlit reef in the Glorieuses Islands in the Indian Ocean north of Madagascar. Photographed while on a filming expedition with Jacques Cousteau for *National Geographic* magazine. *Photo by Flip Schulke*

The sun is our primary source of light. On the surface during daylight hours we need little artificial light for photo illumination. Sunlight can also be the primary source of illumination for photography underwater. There are problems, however, and this chapter is intended to expose you to what is good about using sunlight to light your subjects and what special problems exist when you do this underwater.

I prefer to use the sun as much as possible as my major source of UW illumination. Artificial light, which we will examine in the next chapter, must be used in many UW photographic situations; otherwise there just wouldn't be enough light to expose the film in the camera. But artificial light misused—used where it is neither needed nor necessary—will make the resulting photograph look artificial. Sunlight tends to make photographs look more realistic and natural. A good understanding of what you can and can't do with sunlight will increase your ability to take good UW photographs.

In order to discuss sunlight, one must understand commonly used terms for such illumination, for they are used interchangeably by many photographers and do not always mean the same thing.

Some call sunlight photography, "natural light," but this term can be misunderstood, for it can mean "light *natural* to the situation," and at night or in an office building without any windows to permit daylight to enter that means illumination by artificial light.

"Available light" is also used, but again this could mean "any light that is *available*" to the photographer in order to expose his film. It too can mean sunlight illumination or any light that is available inside an enclosure (artificial light).

"Ambient light" is another, more technical term meaning "the light permeating the environment in which you are photographing." I shall use both *sunlight* and *ambient*

*light* to describe the type of illumination I am talking about in this chapter—sunlight photography—whether the sky is clear or cloudy.

Chapter 7 will also be concerned with flash-bulb and strobe (electronic) flash artificial light. Since constant artificial lights are primarily used in movie photography, they are covered in Chapter 8. Movie lights, which can also be a very good source of artificial illumination for still photography underwater, are one of my favorite methods of lighting. You will find them fully described in Chapter 8.

Sunlight is the most readily available lighting source in UW photography. It can also be the most natural and pleasing type of illumination if understood and used properly.

In Chapter 2, a full explanation of what happens when sunlight penetrates into water was given, as well as the optical correction systems and the water-corrected lenses that can help overcome some of these problems and restore bright colors to sunlighted UW photographs. Since such technical information is covered in Chapter 2, this chapter will deal with specific sunlight UW shooting problems and solutions.

## DAYLIGHT SHOOTING CONDITIONS

The most important feature of utilizing sunlight in color photography underwater is learning that the color rendition (the way colors will appear in your finished color slides) and exposure varies depending upon the following major conditions:

1. Bright sun, clear atmosphere.
2. Bright sun, haze or pollution present.
3. Bright sun, covered and uncovered by moving clouds.
4. Bright overcast sky (light cloud cover—no distinct shadows).
5. Dull overcast sky (much deeper cloud cover).
6. Calm seas.
7. Rough seas.

8. Color of surrounding water.
9. Suspended particles in the surrounding water.
10. Depth at which sunlight photography is attempted.

In color photography, all these items affect both the color and exposure of your photographs. In black-and-white photography they affect only exposure. Therefore the UW color photographer has many more variables to take into consideration in sunlight UW photography than the black-and-white photographer does.

For those of you interested in black-and-white photography, the following comments on *exposure* and how to control it will be important. UW color photographers will want to pay attention to *color rendition* (also known as "color balance") as well as exposure problems and techniques.

The major conditions affecting sunlight photography underwater are explained in following chart.

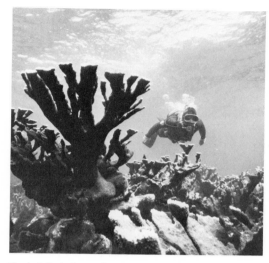

***Illus. 6.2*** A diver always adds an additional point of interest in a UW reef photograph. Taken with Nikonos III, 64 ASA color converted to black and white, 15-mm UW Nikkor lens (effective focal length 20 mm). *Photo by Flip Schulke*

| SUNLIGHT UW CONDITIONS | COLOR rendition correction techniques | COLOR exposure techniques | BLACK/WHITE exposure techniques |
|---|---|---|---|
| a. Bright sun, clear atmosphere, clear water | Below the surface to 15 ft. no correction needed. Greatest light intensity, excellent color rendition, 10 A.M. to 3 P.M. 1 hour after sunrise to 1 hour before sunset good color rendition. Below 15 ft., use artificial light or color correction filters | Light-meter (amphibious or surface model in UW housing) a must for proper color exposure. Internal light meter (inside camera) can be used if equipped with visible readout, enabling setting manually shutter speed and/ or *f*-stop. Totally automatic exposure control cameras provide good *average* exposure UW, but prohibit bracketing, since automatic system selects "average" exposure density. Models with *manual override* permit choosing this mode for UW operation when metering exposure. UW photographers must be able to deliberately *over* or *under* expose for desired color mood | Employ light meter to obtain correct *f*-stop or shutter speed. B/W film has greater exposure latitude so bracketing is less important than in calculating UW color exposures |
| b. Bright sun, atmospheric haze or pollution present | Results same as condition *a* down to 15 ft., with slight loss of "warm" colors | Use same techniques as condition *a*. Light intensity will be less, necessitating more exposure | Use same techniques as condition *a* |

| | | | |
|---|---|---|---|
| c. Bright sun, occasionally obscured by moving clouds | Watch for moving clouds. When the sun is not obscured use techniques of condition *a*. Beware of change in color due to clouds cutting off direct sun's rays. Adjust shooting techniques accordingly, or wait until clouds pass | Exposure can vary 2 to 3 *f*-stops when sun is obscured by passing cloud. Use same techniques as condition *a* to determine exposure | Use same techniques as condition *a* |
| d. Bright overcast sky, light cloud cover | Necessitates restoring color rendition. Use artificial light or CC 10-R filter over camera lens | Use light meter to determine exposure | Use light meter to determine exposure |
| e. Dull overcast sky, deep cloud cover | Same techniques as *d*. Artificial light or use of CC 20-R or 30-R filter on lens absolute necessity | Strict usage of light meter obligatory since eye will adjust to UW light intensity, making it appear overly bright | Strict usage of light meter to determine exposure |
| f. Calm seas | Follow suggestions for *a,b,c, d,e* | Follow suggestions for *a,b,c, d,e* | Follow suggestions for *a,b,c, d,e* |
| g. Rough seas | Since rough seas break up warm rays of bright sunlight entering water interface, follow suggestions for *c,d,* and *e* | Follow suggestions for *a,b,c, d,e* | Follow suggestions for *a,b,c, d,e* |
| h. Color of surrounding water | Artificial light *or* color filtration can help partially to counteract color of surrounding water. See *b,c,d,e* | Follow suggestions for *a,b,c, d,e* | Follow suggestions for *a,b,c, d,e* |
| i. Suspended particles in surrounding water | Poor visibility results in poor photos. Film records suspended particles more intensely than human eye. "Clear" water generally means that details in objects 30 ft. away are visible to eye. Camera shouldn't be more than 10 ft. distant. Suspended particles will degrade color photos taken with artificial light since light reflects off floating particles | Suspended particles may give overly bright (false) meter reading, causing overexposure. Try underexposing on bracketing basis, one and two *f*-stops, from meter reading. Under these conditions automatic exposure-controlled cameras will result in overexposed color photo | Follow suggestions for *i* color exposure techniques |

# HOW TO GET GOOD SUNLIGHT EXPOSURES UNDERWATER

## Shutter Speed and *f*-Stops

Inasmuch as this book is not intended to be a general photo-technical guide, I am assuming that you have read the instruction manual that comes with your camera and that you understand that you can vary the amount of light exposing the camera's film by regulating (choosing) a shutter speed and *f*-stop opening. If you choose a faster shutter speed, you must let more light into the camera by choosing a correspondingly larger *f*-stop (or diaphragm) opening. Probably the most confusing aspect of this is that with a larger *f*-stop opening (where the diaphragm is open wider) the actual *f*-stop number is smaller (i.e., *f*/2 is larger and lets more light into the camera than *f*/16). So when I, and most photographers, talk about using a

smaller *f*-stop, or "stopping down," we are talking about decreasing the diaphragm size. Using a larger *f*-stop or "opening up" means increasing the diaphragm size. A "fast" lens means a lens with a large maximum diaphragm opening.

A faster shutter speed is chosen because of the movement of the object you are photographing, or if the photographer is a beginner, the fear that unsharp photographs will result because he moves the camera during exposure. Generally speaking, I find that if I am swimming, I do not shoot at a speed less than 1/125 of a second. If I am positioned on the bottom and am able to brace myself and camera, then I will shoot at 1/30 and 1/60 of a second. My general shutter speed seems to be consistently 1/125 of a second.

Since shutter speed and diaphragm opening are tied to each other, you must set the *f*-stop to match your speed. The dial on a light meter gives the various shutter speeds and their corresponding *f*-stops. It won't take too many rolls of film for you to find out what is your best "normal" shutter speed underwater.

Here are a couple of tips with regard to shutter speeds. One of the most common reasons for unsharp UW photographs is camera movement. In other words, if you move the camera when you depress the shutter release, this camera movement cannot be compensated for by the slower shutter speeds—1/30, 1/60, and 1/125 of a second. You can assure yourself of a steady camera by trying the following:

1. Press the camera housing or amphibious camera viewfinder tightly against your face mask. This will brace the camera with the bulk of your body, which does not move about in the water as easily as a small camera housing can. Perhaps it is because the camera is weightless underwater that very often UW photographers hold the camera

*away* from their body, causing the camera to move when they depress the shutter trigger. Pressing the viewfinder against your face mask will also assure more perfect visual composition, since in this way, you will be able to see the whole viewfinder.

2. Just an instant before releasing the shutter trigger, **hold your breath**; then the act of breathing won't move the camera. **A word of caution** about doing this. Since I hold my breath for long periods doing surface photography, I naturally used to also hold my breath for long periods underwater in order to keep the camera still. I also had blinding headaches after diving. As certification procedures became more stringent leading me to attend certification classes, I learned that I was getting a classic case of carbon dioxide buildup, which caused the headaches. I used to brag that I could last longer than any fellow diver on one tank at any given depth, but I no longer do this. I now make a conscious effort *not* to hold my breath except just before I take a photograph. Of course, **never hold your breath** if you are photographing while rising to the surface, in scuba diving. UW photography should never cause you to break any of the rules of safe diving that you learn during certification.

If you are shooting a wide expanse of coral, you need the depth of field that a small *f*-stop will give you. The small *f*-stop emits less light, and your meter will tell you that you must select a slow shutter speed. Since moving subjects (fish, people) look better with the background thrown out of focus, you can select a faster shutter speed with its correspondingly larger *f*-stop. Large *f*-stops have a very shallow depth of field, meaning that your background will be out of focus.

All of this the light meter will tell you at a glance if you read the directions that come with it, practice using it on the surface, and

apply this experience when you dive with it. Remember that the meter is a tool and is only as good as your ability to use it.

## Understanding and Using the Light Meter

All photography—and certainly UW photography, in which one is not only trying to choose subject matter but also to set one's camera and follow normal diving procedures in an alien environment—requires that the photographer be able to interpret the lighting conditions to obtain the best possible exposure.

Just as I always use a light meter in surface photography I certainly always use one underwater. Although of course I can "shoot from the hip," guessing the exposure, but I prefer not to. A good light meter takes the guesswork out of most exposure problems. It gives you a positive starting point from which to bracket. Otherwise, though you may get a properly exposed photograph, most probably you won't, no matter how much experience you have.

Use a light meter and you've got daylight exposure problems licked. Of course, the light meter reads the ambient light available. It does not assure perfect exposure, for that perfection can mean different things to different people. As I have mentioned before in this book, what may be pleasing to your eye may not be as pleasing to someone else's. The light meter is a technical tool. It gives you a technical reading of light intensity. Your subject matter may be light or dark. It might look better to you if it appeared lighter in your photograph, thereby emphasizing subject detail. Or it may appear better darker, emphasizing the shape or form of the subject. This visual judgment the light meter cannot make. It will give you only a middle point from which to start.

The light meter will provide you with a range of shutter speeds and *f*-stops to enable you to choose the right combination to fit a particular type of photograph.

## Housing a Light Meter for Underwater Use

If you already own a light meter, find out whether a housing is made for it by checking catalogs such as that of Ikelite. When you buy a light meter, you get what you pay for, usually. An inexpensive light meter may be easily damaged from slight impacts. An inexpensive light meter will not be as sensitive to low light levels as one that costs more. Light levels in UW photography fall in the lower levels on the average, because the deeper you go, the darker it gets.

There are two types of light meter: the incident-light meter, which measures the light falling on the subject, before it is reflected, and the reflected-light meter, which measures the light reflected from the subject.* Reflected-light meters are misnamed. They read any light—reflected or emitted—that comes from the subject, and thus they give more specific information than incident meters. Reflected-light meters are of two basic types:

**Selenium photoelectric cell** / Produces a current when excited by light, activating an indicator needle on the light meter's display dial. The Weston V or Weston Euromaster light meter is an example of the selenium meter.

**Cadmium sulfide (CdS) cell** / Wired to a battery, this cell functions as a resistor blocking the flow of current. When light falls on the resistor, its resistance decreases, resulting in a current which activates an indicator needle. A CdS meter should be more sensitive than a selenium meter in dim light. The disadvantage is the need for a battery to power the meter, and CdS meters tend to

---

*See "Light Meters and Metering" by David Vestal. Reprinted from *Popular Photography,* August 1977. Copyright © 1977 Ziff-Davis Publishing Company. All rights reserved.

be larger in physical size than selenium meters are. A popular example of the CdS meter is the Gossen Luna-Pro. The Sekonic amphibious UW light meter (Marine-II) is a CdS battery-powered meter.

If you inquire about which type of meter is best, you will find photographers who swear by either type. I have found that the reflected-light type is best for UW photography, because the subject matter varies so much from dark to very light. Only a reflected-light meter can give you accurate measurements under these widely varying conditions, but they require more intelligent use. The wrong use of an accurate reflected-light meter can lead to poor exposure, since different interpretations are needed for light and dark subjects and for high-contrast and low-contrast subjects. You have to know more.

Another consideration is the physical size of the numbers on a light meter's dials. Since you will have to read the dials and numbers on the meter underwater and possibly in poor light conditions, large, easy-to-read dials and numbers are a necessity. Some meters have LED lighted readout numbers. If you select one of these meters, be sure that the LED displays can be read in bright sunlight conditions underwater. Some LED displays wash out in bright light and must be shaded to be read, an obvious handicap in UW use.

Surface light meters in UW housings must be pre-set for the ASA film speed before diving underwater. I am not aware of any UW light meter housing that has a control rod for changing the ASA film rating of an enclosed light meter. The light-meter housing should be attached by a bracket bolted to the camera housing, or to the amphibious camera in some convenient to see location.

Two amphibious Sekonic light meters are discussed in Chapter 3, which also lists the commercially available Sekonic meter brackets by manufacturer.

## Light Meters Built into the 35-mm SLR Camera

Almost all the 35-mm SLR cameras currently sold have built-in light meters, which operate either manually or automatically. All are of the reflected type.

**Manual** / "The most common type in the 1970's . . . uses CdS or silicon cells. In general the best of these are "behind-the-lens" meters that read the light that forms the picture after it has passed through the lens. Manual cameras require matching two needles in the SLR prism-viewfinder—or an equivalent procedure—by setting the f-stop or the shutter speed, or both, on the camera."*

**Automatic** / "With automatic exposure cameras, you set either the f-stop (aperture priority) or the shutter speed (shutter priority) and the camera sets the other control automatically to provide a shutter-speed f-stop combination that will give correct exposure [on the surface]. As with any photographic light meter, the film speed must be set correctly in advance; it is usually given in ASA (in the United States) DIN (in Europe)."*

I do not find automatic exposure cameras very successful in giving properly exposed photographs underwater. The camera sets the exposure according to the light, as read automatically by the built-in meter, of the whole picture area. The water surrounding the subject tends to reflect too much light into the camera's meter, and the camera will give you underexposures. It "thinks" the subject is brighter than it actually is and automatically sets the camera exposure incorrectly. There may be some subject matter (close-ups) for which the automatic meter would set the camera correctly, but you would limit yourself with such a UW SLR camera-housing system. A few automatic

---

*From "Light Meters and Metering," by David Vestal.

models can be also set for manual, and these would work underwater.

## Things You Need to Know about Using Cameras with Built-in Meters

"Both manual and automatic exposure cameras usually have meters designed mainly for color-slide film, and they tend to produce underexposure with black-and-white negative film when set at the film's recommended ASA speed. The solution is to reset the film-speed dial to a lower number to offset this tendency; for an ASA 400 film, try ASA 200—half the speed the manufacturer recommends; for ASA 124, try ASA 64, and so on. To avoid confusion, think of them as *exposure indexes,* and when you make notes, use the prefix E.I."*

"*Match-needle readings for 'manual' built-in meters*: For accuracy, move the camera close to the subject so that the tone (reflected-light) you want to read fills the whole SLR prism-viewfinder."* Underwater, move in on your subject, take your reading, set the shutter and *f*-stop according to the match-needle-reading, and move back to properly compose your photograph, including the subject—which may not, then, fill up the whole frame.

"This is like using the built-in meter like a separate, hand-held meter [or meter mounted on your camera housing] except that instead of reading the results off the light dial and the calculator dial of a hand-held meter, you read it, in each case from the *f*-stop shutter-speed setting on the camera itself."*

**Take note:** Not all match-needle displays contained within the SLR prism viewfinder can be seen through both your face mask and the UW housing. The Canon F-1

*From "Light Meters and Metering," by David Vestal.

models, with the accessory speed-finder enlarged-prism viewfinder does enable you to see the metering system. With other cameras and housing combinations all you can do is take them underwater and see if you can distinguish the match-needle display. If you cannot, you will have to resort to the amphibious or housed reflected-light meters.

## Using a Light Meter Underwater

I have suggested previously that you use a reflected-light meter underwater. (Both the Sekonic amphibious meters are of this type.) But a problem can develop when you use a reflected-light meter, because this meter will also read the light reflecting back to the meter from particles in suspension in the water. This exposure problem is like the backscattering effect you get with light reflected off suspended particles when you use an artificial light for illumination. In this case, though, the sunlight or ambient light is scattered back to the light meter, giving a false reading, which is converted into an overexposed photograph because the light meter will "see" or measure too much light.

The solution to sunlight-reflected backscatter is to take the light meter very close to the subject matter being metered. This way you will be measuring the reflected light from the subject through very little water, thus eliminating an equivalent number of suspended particles. The result will be a much more accurate exposure measurement.

I try to move as close as possible to my subject matter whenever I take a reflected light-meter reading underwater, even when the water is crystal clear. Hold the meter with its cell aimed at the part of the subject you want to read and close enough so that no other light affects the meter. Avoid accidentally reading the shadow of the meter or of any other obstacles or reading bright reflections. Avoid also overexposure caused by bright, white sandy ocean-floor bottoms. They

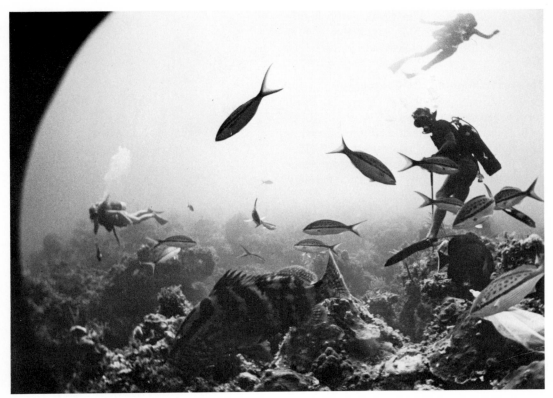

**Illus. 6.6** Sunlighting is the only practicable way to take pictures that show wide vistas underwater. It is simply not possible to artificially light areas beyond 10 feet during daylight hours. A wide-angle lens enables you to make the water appear clearer, since you are encompassing objects that are actually quite close to your camera. Taken with Nikon F-1, Ocean Eye housing with 8-inch dome port, Sigma 12-mm f/8 fisheye lens, 60-foot depth, converted from color, cropped in printing to lose the circular fisheye format. *Photo by Flip Schulke*

same distance of 2 feet from each other. But the wide angle lens makes the octopus closer to the camera lens appear to be much larger than the second subject. This enlargement in apparent size relative to a more distant subject is caused by the proximity of the camera to the subject, a phenomenon called forced perspective. You *force* the camera to see at an extremely close perspective, and because the lens has an extremely wide angle of coverage, it can take in the whole subject at the close distance.

Wide-angle lenses appear to make near subjects larger and closer, and change the shapes somewhat by elongating or stretch-

ing them—a circle in the corner of a wide-angle photograph will appear to be egg-shaped if you are extremely close. On the other hand what we call "normal" or longer-focal-length lenses (50 mm and longer for a 35-mm camera) make subjects seem to be smaller and farther away. Because you have a more distant perspective with these lenses, shapes appear more normal, and that is why the slang term "normal" was originally applied to lenses that appeared to see an object as your eye does in most everyday visual situations.

Subjects taken with wide-angle lenses appear clearer because you are photographing

through less water. The background is farther away due to forced perspective, giving the impression of greater water clarity.

### Tips for Sunlighted UW Photography

In Chapters 8 and 9 I will describe some reliable ways of taking good UW photographs in both sunlight and artificial light. The following are important general tips for your UW photography and some random techniques and suggestions specifically for daylight-illuminated UW photography.

Moving About Underwater: Being a good swimmer and an accomplished scuba diver are great assets to the UW photographer. The better you can move your body underwater and the ease with which you swim, turn, back up, and go forward—all without stirring up bottom sand or sediment—will add immensely to the quality of your UW photographs. No matter how good a photographer you may be on the surface, your UW photographs cannot be consistently good if you are a clumsy swimmer and diver.

Learn to move vertically and horizontally in water by practicing breath control. Because I learned to dive before the invention of the Buoyancy Compensator Vest (BCV) I learned to weight myself according to my dive suit thickness and the approximate depth at which I planned to do most of my photography. Once at that depth I would float neutrally with half a lung of air. By breathing shallowly I would slowly sink toward my subject matter; by breathing more deeply I would rise up away from the subject. Modern diving techniques enable one to "trim-off" at any given depth by using of a Buoyancy Compensator Vest (BCV). Then you can use the deep and shallow breathing techniques described above to move in and back from your subject.

Breath control gives one up and down movement without having to resort to using flippers, which in turn minimizes the amount of bottom sediment kicked up, clouding the water. Indiscriminate use of flippers near the bottom stirs up so much sediment that successful UW photography is nearly impossible. It is useful to talk over this technique with your diving buddy before a UW photographic dive so that he or she practices the same movements when acting as your UW model or assistant.

Since you will lose the reds and oranges of fish and coral if you go too deep, when making a sunlight-illuminated photo dive, concentrate on

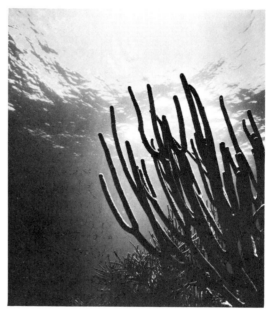

**Illus. 6.7** Shooting UW subjects with a clean, or unobstructed background will emphasize your foreground subject matter. Shooting from a very low angle is the best way to do this. Good UW photographers quickly become adept at hugging the bottom. *Photo by Flip Schulke*

the shallower depths. There may be more undersea water movement caused by surface waves at these shallow depths, though. Learn to use your legs, arms, and extra hand (the one not holding the camera), to steady yourself so that your photographs will not exhibit unsharpness due to camera movement.

The best color balance and light intensity are obtained on a clear, cloudless sunny day from 9 A.M. to 3 P.M., when the surface of the water is calm. A completely clear blue-sky day is a sunlight photographer's dream come true. You can shoot as quickly as you want, and the exposure (light intensity) will remain constant, relieving you of constant light-meter readings to confirm the proper exposure settings for your camera.

Keep your eye on the changing cloud conditions, especially during shallow-water dives—1 to 20 feet. Both the light intensity and the color balance change when the sun goes behind a cloud. You can usually tell when this happens when you are underwater because suddenly everything becomes slightly darker and the water appears much bluer to your eye. The only solution, un-

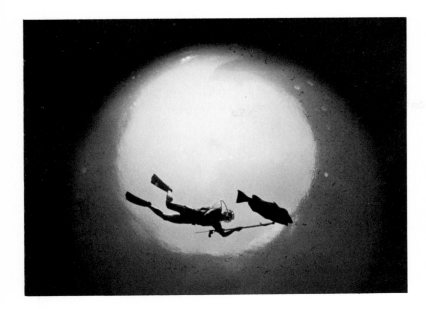

**Illus. 6.8** Spearfishing is outlawed in most beautiful reef areas. Occasionally outside the restricted areas, I spot a graphic shot like this —a spearfisherman swimming over my head with his catch. Visually pleasing, the picture is spoiled from a diver's standpoint because he is using scuba gear, which isn't considered sporting by even the most avid spear diver. The circle is caused by the skylight bending after reaching 45°; it is not a fish-eye photograph. Taken with Calypso camera, 28-mm UW Nikkor lens, converted from color, sunlight exposure determined by UW meter reading surface. For *Argosy magazine, photo by Flip Schulke*

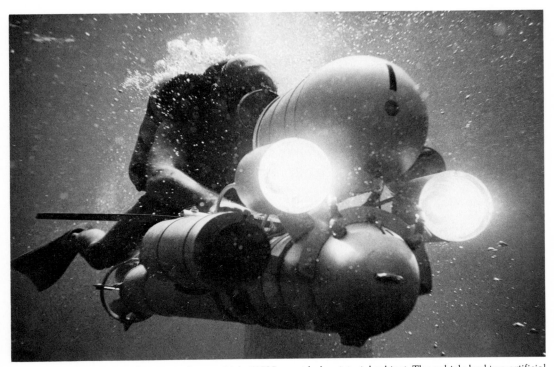

**Illus. 6.9** A diver riding a diver propulsion vehicle (DPV) provided a pictorial subject. The vehicle had two artificial lights in front, so by taking him deep enough to begin to lose quite a bit of sunlight illumination, I could choose an exposure that would emphasize the surreal quality of the scene and show the headlights. Taken for *Life* magazine with Calypso camera, 28-mm UW Nikkor, exposure determined by light meter and then underexposed one stop, Tri-X 400 ASA film, 75-foot depth in clear Bahamas water. *Photo by Flip Schulke*

less you want to switch to artificial light for illumination, is to wait for the cloud to pass. On such shallow dives, it is quite easy to surface—obeying all normal scuba-diving surfacing instructions—and look at the sky; you will soon learn to estimate how long a cloud will cover the sun.

Sunlight illumination is the only way to take UW photographs of large schools of tropical, reef, and other schooling fish. Concentrate on photographs which show larger vistas of the undersea world. Artificial illumination just isn't practicable more than 5 to 8 feet from your subject matter under daylight conditions.

Use faster (higher ASA rating) films early in the morning or late in the afternoon when the sun is lower in the sky.

Check the low and high tide tables. Excellent diving areas abound in cuts in ocean reefs which are extremely difficult to swim in when the tide is flowing in or out. But at the hour or so of slack tide, everything is still, and you can drift about snapping photographs without having to fight against a raging tidal current.

In the ocean, a sudden clouding of the water could be due to plankton. Schools of these minute organisms resemble a cloud of sand and will obscure your subject matter. Don't give up the photo dive, wait a few minutes. In most cases the cloud will pass you by and the water will clear up again.

**A safety tip.** It is easy to swim for great distances away from your boat on a nice day, when you are doing sunlight UW photography. Keep track of where you and your diving buddy are with relationship to your dive vessel. Make sure that you keep watch on your air supply so that you always have sufficient air for the swim back to the boat. One solution to this problem is to bring along a nondiving buddy to remain in the boat when you and your diving partner are photographing underwater. The surface buddy can keep an eye on your air bubbles, and bring the boat over to you when you surface. Be sure that you work this procedure out with the surface buddy **before** you make your UW diving excursion.

You can shoot a lot more photographs on a diving trip if you are able to teach the surface buddy how to reload your camera. It takes a lot of time and energy to get into the dive boat and divest yourself of diving gear and wet-suit jacket so that you can change film yourself. If you have to change your own film (like most of us), be sure to dry your hair and hands and remove your diving jacket, so that water from these things does not drip into your opened camera housing or camera interior.

## Suggested Assignments on a Sunlight Photo Dive

Make a test, keeping track of your exposure, shutter speed, depth, and sky light condition on a UW plastic-page logbook, shooting the same general subject matter without a filter and then with CC-R filters to give yourself a series of slides that will show you which strength CC-R filter does what in the way of correcting or modifying the color of your resulting slide.

In shallow water (not deeper than 10 feet) on a clear, sunny day try some closeup and macrophotographs of flora and fauna. Use supplementary plus-diopter lenses or extension rings. You will find that sunlight gives a look to an undersea subject totally different from that obtained with artificial illumination. I feel that closeup and macrophotography using sunlight as the illumination souce have been virtually ignored. Flash can produce a terrible "sameness" of picture color and quality in UW closeup and macrophotography.

Select a subject about 1 foot in front of your camera, but include another object a few feet away in the background. Now vary the f-stop, which will vary your depth of field. Focus on the near subject, then focus in the middle between the two, and then focus on the far subject. This experiment will give you a much better idea of the variations that selective focus or knowing approximately what a given f-stop with a given focal-lens will give you for a depth of field.

Shoot at various shutter speeds to see the artistic effects of fish and subject movement at slow shutter speeds. Remember to hold the camera steady at slow speeds.

Shoot some UW portraits, both posed and unposed, of your diving buddies. When you photograph them doing something—looking, exploring, searching with a UW light, spearfishing, working, or playing—instruct them before the dive to refrain from looking into the camera's lens when you point it at them. Though mugging photographs are funny, most of the time the photographer's camera should be the unseen witness. Mugging into the camera destroys the reality of the diving situation.

# 7·AN INTRODUCTION TO ARTIFICIAL LIGHTING

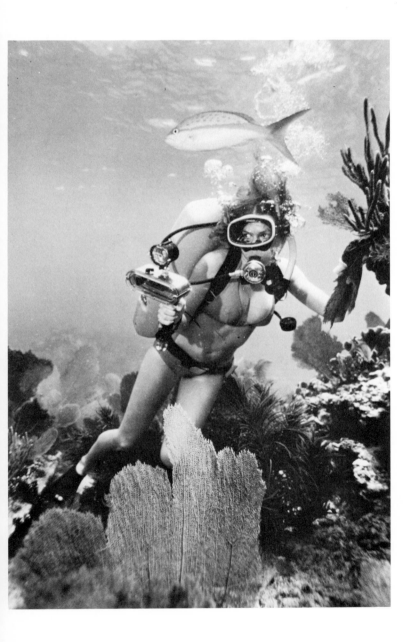

**Illus. 7.1** Cover for *Newsweek* magazine to illustrate a long article on "Life Underwater." The magazine's art director had specific requirements for the photograph, so a professional diving model was used and posed on a shallow (12-foot) reef. The fish swimming by was a lucky accident. Taken with Canon F-1, 24-mm Canon *f*/2 lens, 8-inch dome port, Hydro-35 housing by Farallon/Oceanic, 64 ASA color slide film, one strobe held by an assistant. *Photo by Flip Schulke*

You have read a great deal in Chapter 6 about getting good exposures under what we call sunlight, or ambient-light, conditions. You are well aware now of the limitations of sunlight in color photography below 12 to 20 feet. Throughout this book the various conditions needing artificial light have been mentioned. In this chapter we delve deeper into the problems and solutions of UW artificial lighting. (Movie lighting can be found in Chapter 8.)

You need artificial light when you want to

1. Restore colors absorbed by the water environment.
2. Light up a subject that isn't receiving enough natural light during daylight diving hours.
3. Light up a subject at night, when no natural light is present.
4. Light up a macrophotography subject, so that you can close down the *f*-stop of your lens to obtain maximum depth of field.
5. Illuminate more evenly a subject that may be half in sunlight and half in shade. If you expose for the sunlighted area, then the shade area will be black; on the other hand, if you expose for the shade area of the subject, the sunlighted area will appear overexposed, or washed out. Artificial light can balance the two areas.

Why shouldn't all UW photographs be artificially lighted? First of all, light intensity is cut by about a factor of 4 underwater. In other words, any light is only about 1/4 as strong or as bright as it is on the surface, and that is in *clear* water. The more particles or coloring in the water, the more the light source is lessened in intensity. Artificial lights are cumbersome, heavy (especially electronic strobe lights), difficult to swim with, fragile, time-consuming, difficult to switch from one camera to another, and currently have a massive variety of connector systems. It's like the mind-boggling array of electrical connection systems you run into when traveling in the various countries of Europe. Happily, standardization has begun among major manufacturers, but a variety of connectors is still the rule. In addition,

there is a natural unreliability of electrical or battery-operated devices in a wet, humid environment, especially saltwater. Such conditions conspire to cause your artificial light, which worked so well at home the night before the dive, to refuse to fire underwater. Nothing is more frustrating. I've filled my face mask with underwater epithets on many an occasion.

But we do need artificial light for all the reasons listed. What do we do? What sort of artificial light is best? Is there any one *best* type of artificial light?

I can say without hesitation that your choice of artificial light depends upon your photographic goals underwater, your camera (amphibious or housed), your style of swimming and photographing, and primarily, your pocketbook.

So let's start our examination of artificial light with the least expensive method—considering cost of the light itself—flash bulbs and cubes. You will see as we progress from flash bulbs to strobe equipment that the initial cost of flash bulbs is lower, but if you take a great many photographs, then the initial higher cost of a strobe unit would prove to be less expensive over a long period of time.

## FLASH BULBS AND CUBES

When I refer from now on to flash bulbs, I mean single-contact bayonet-based flash bulbs, which are made primarily by General Electric and Sylvania. To be rather dogmatic I find this type of bulb (either M or FP, focal-plane, model) to be vastly superior in UW flash-bulb photography. They emit at least 2 to 8 times the light intensity of the smaller flash bulbs, cubes, or arrays. Not only that, bayonet-based bulbs have proved to be much brighter in UW tests than any currently available UW electronic strobe. So if it's light you want, this type of flash bulb is the place to find it.

Focal-plane (FP) bulbs are the best to use,

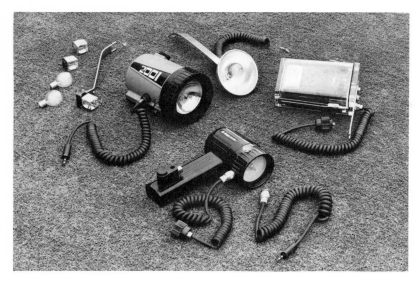

*Illus. 7.2* A representative selection of flash-bulb and cube guns, amphibious strobes, and surface strobe encased in a housing.

for they give a choice of shutter speeds, since focal-plane flash bulbs synchronize at all speeds with most 35-mm cameras having focal-plane shutters or any larger-format camera with a focal-plane shutter. Rolleimarin photographers can use M-class bayonet-based bulbs, GE 5 or Sylvania 25. These bulbs are designed to synchronize with between-the-lens shutters. I discourage the use of blue flash bulbs for anything other than closeup or macrophotography. For this you will find blue-coated bulbs in both M- and FP-class flash bulbs.

Bayonet bulbs are still widely used and sold. You will not find them in a camera shop, unless it sells better (more expensive) cameras. I do not advise flash cubes for 35-mm SLR, Nikonos, or larger-format UW cameras in housings. Even the "Hi-Power" cubes just don't give off enough light. Again, the exception is in macrophotography, in which your flash is so close to your subject that a flash cube may be more convenient.

## UW FLASH UNITS

The initial cost of a UW flash gun is very low for most of this type of unit. Nikonos (EPOI) distributes a UW flash gun for its camera. You must be sure which model of Nikonos camera you have when you purchase a Nikonos flash gun, since the connector-cord plug is different on the Nikonos III camera from that of the Calypso, Nikonos I, and Nikonos II. The Nikonos flash gun has a battery-capacitor unit in the handle of the flash gun, and the whole unit is quite expensive.

Ikelite makes inexpensive flash guns that plug into a universal connector-plug system. You can use all its flash guns on SLR housings that contain the female Ikelite connector plug. This female connector plug can be purchased separately to be mounted in any other type of SLR housing, plastic or metal. It also manufactures a Nikonos power pack, which is part of its solid state triggering (SST) system. The power pack incorporates a selector switch for X (electronic flash) and M (flash bulbs) plus a 22½-volt battery. Therefore with this power pack (which plugs into the bottom female connector of the Nikonos cameras) you can use either strobe or flash bulbs, the power pack supplying the necessary electrical charge to definitely set off the flash bulbs underwater. The power

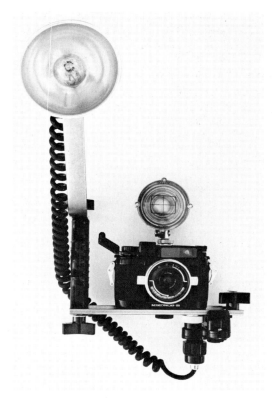

**Illus. 7.3** Typical inexpensive flash gun, mounted for use with the Nikonos III SST system by Ikelite.

**Illus. 7.4** Flash connector systems. Top, Ikelite. Middle, Electro Oceanics (EO). Bottom, Nikonos I and II, with adapter for model III, Toshiba.

pack also comes in two models, one for the Calypso, Nikonos I, and Nikonos II, and a second model for the Nikonos III.

The four main systems of connecting plugs for flash guns or for electronic flash units are:

1. Ikelite connector system (ICS)
2. Rolleimarin dual plug system
3. Nikonos (EPOI) connector system
4. Electro Oceanics Inc. (EO) Enviro Mate system

The main point I should like to stress is that when you are planning a UW camera lighting system be sure to look at these different

**A Tip**

Toshiba (Elmo Mfg. Corp.) distributes a small adapter so that owners of older flash guns can fit them into the female connector plug of the new Nikonos III. I hope that this most popular of UW camera will stick to the model III plug system for some time. Manufacturers are notorious for making changes that cause all the accessories one may have collected for a previous model to become obsolete. Nevertheless the Nikonos III is an improvement in design over the previous model, and of course, the improvements only benefit the diver-photographer. Fortunately, other manufacturers usually devise an adapter. One should always check the pages of *Skin Diver* magazine, for it carries the news and advertisements about all the adaptive devices that can accommodate model-change modifications.

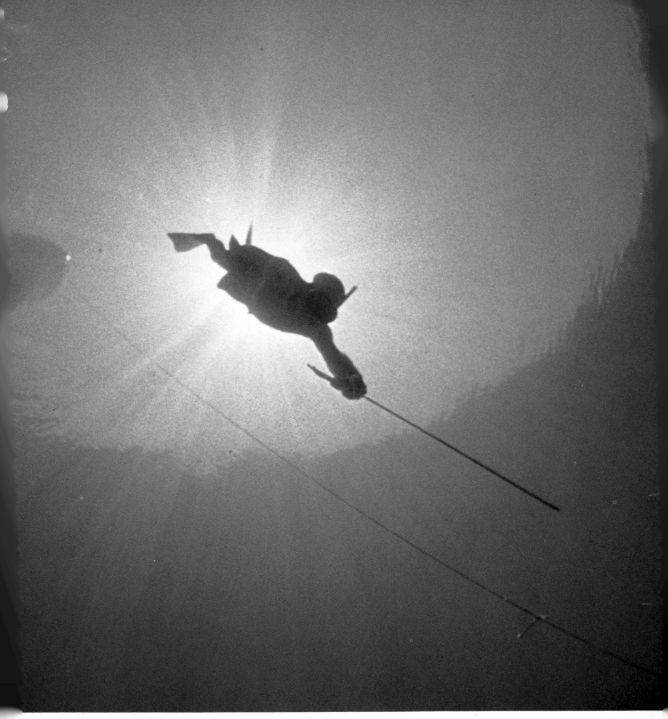

**Plate 1**  A skin diver enters the undersea world. Calypso camera, 28-mm Nikonos lens. Photo by Flip Schulke.

**Plate 2**  As a scuba diver glides toward my camera, his air bubbles add to the feeling of "being underwater." Canon F-1 in Ikelite housing, 24-mm Canon lens through corrective dome. Photo by Flip Schulke.

**Plate 3**
The underside of a starfish is captured here in vivid detail by a Nikonos camera and extension tube.
Photo by Jeff Nadler.

**Plate 4**
Coming in very close reveals the beauty of nature's design. A Nikonos camera and extension tube were used to get this anemone photograph.
Photo by Jeff Nadler.

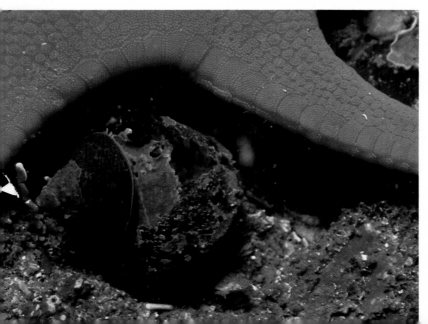

**Plate 5**
This close-up taken with a Nikonos camera and extension tube contrasts the shapes and colors of a blood starfish and a turban snail. Visually exciting subjects such as these abound underseas.
Photo by Jeff Nadler.

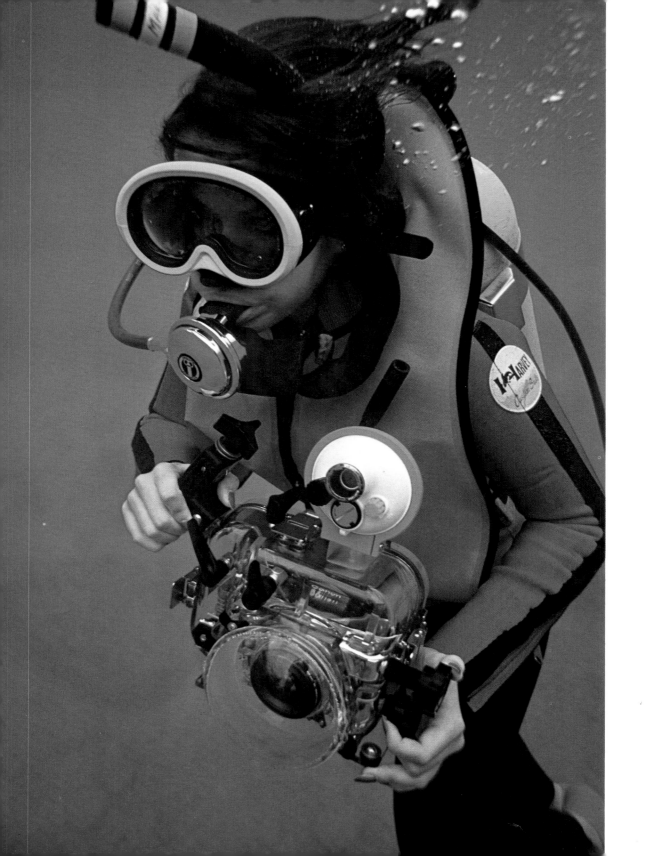

**Plate 7**   An extremely wide-angle lens, such as the 21-mm Nikkor lens, enables you to capture large objects in a single photograph. This research submarine was over 20 feet long.
Photo by Flip Schulke.

**Plate 6**

You can get bright colors without resorting to artificial light if you photograph near the water's surface. This photo was taken by sunlight at a depth of 10 feet. Ikelite SLR housing, 24-mm Canon lens, dome corrector.         Photo by Flip Schulke.

**Plate 8**
While photographing activities at the Naval Undersea Center, San Diego, California, I used an underwater magnesium flare to illuminate the scene and restore pleasing colors. Photo by Flip Schulke.

**Plate 9**
This UW fashion photograph was taken with a 24-mm lens in SLR Ikelite housing, with additional illumination from a 1000 watt Birns & Sawyer constant light. Taken for London *Telegraph* color magazine. Photo by Flip Schulke.

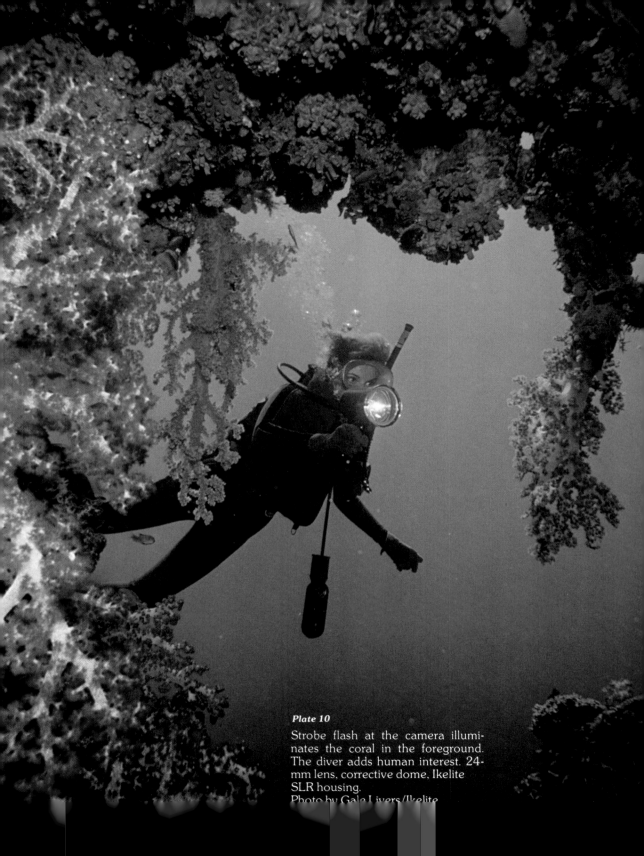

**Plate 10**
Strobe flash at the camera illuminates the coral in the foreground. The diver adds human interest. 24-mm lens, corrective dome, Ikelite SLR housing.
Photo by Gale Livers/Ikelite

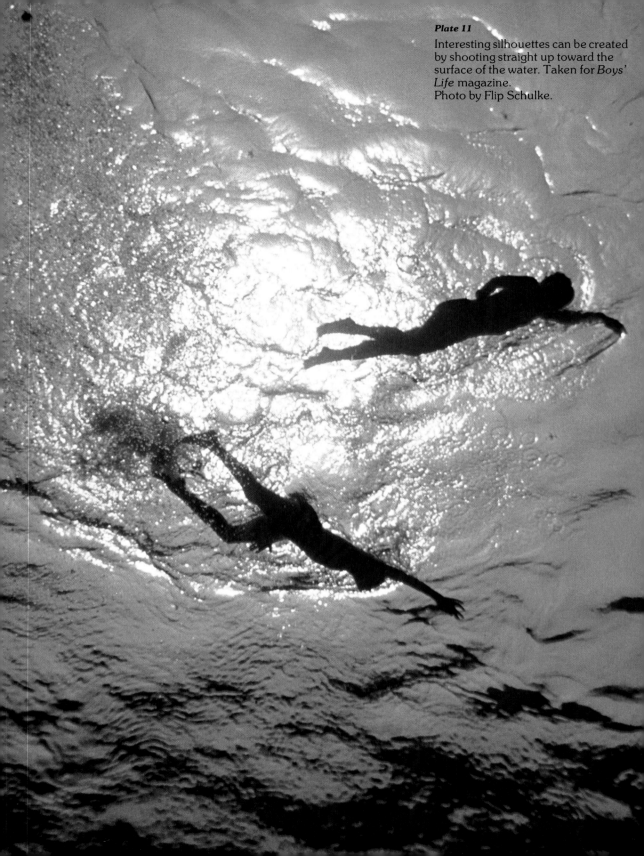

**Plate 11**
Interesting silhouettes can be created by shooting straight up toward the surface of the water. Taken for *Boys' Life* magazine.
Photo by Flip Schulke.

**Plate 12** The fisheye lens enables you to get so close to your subject that the effect is almost like shooting through crystal clear water. Taken for *Life* magazine.    Photo by Flip Schulke.

**Plate 13** The fisheye lens with its 180° angle of coverage can focus on extremely tight areas. Here it permitted me to show old coins being uncovered, yet include the surroundings. Taken for *Argosy* magazine. Photo by Flip Schulke.

**Plate 14**  Sunlight, shallow reef (10 foot depth) photography taken with an Instamatic X-35 camera (126-film size) close-focus setting, Ektachrome slide film. An Ikelite housing was used.        Photo by Flip Schulke.

**Plate 15**  High-power flash cube illuminated coral and reef fish photograph, taken with an Instamatic X-35 camera (126-film size) close-focus setting, Ektachrome slide film. The Instamatic was in an Ikelite housing.
Photo by Flip Schulke.

**Plate 16**    Underwater flash portrait with the Instamatic X-35 camera in Ikelite housing. Excellent  framing of the subject was achieved by viewing through the camera's built-in viewfinder. Photo by Flip Schulke.

**Plate 17**

Even the least expensive Instamatic X-15 camera can give you sharp, colorful portraits. Here, a plus-3-diopter closeup lens was taped onto the front of the Ikelite housing. Photo by Flip Schulke.

**Plate 18** When shooting a 2000-year-old Roman wreck 150 feet below the surface, there is no practical way to correct for the blue-gray tones. Taken with a Nikonos, with 24-mm Nikonos UW lens, for *Newsweek* magazine. Photo by Flip Schulke.

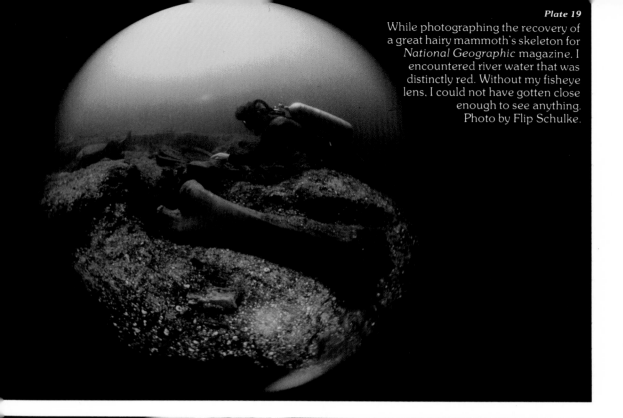

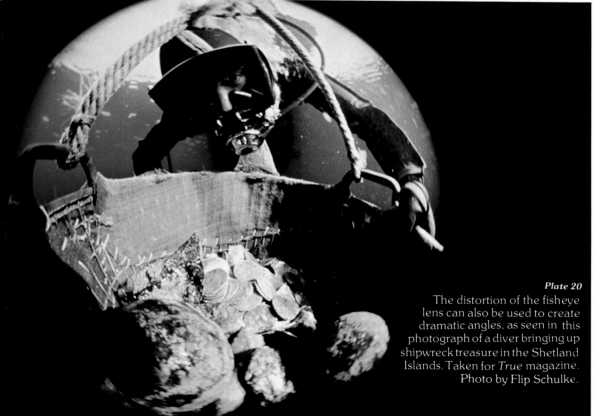

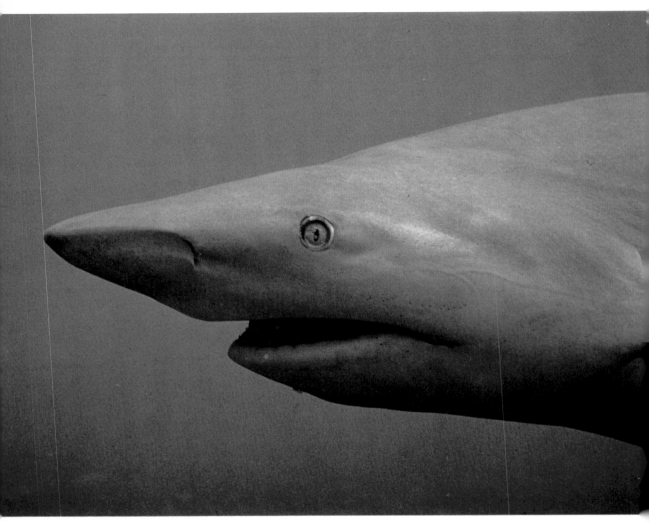

**Plate 21** A close-up of a black-tipped shark. Taken for *Life* magazine.
Photo by Flip Schulke.

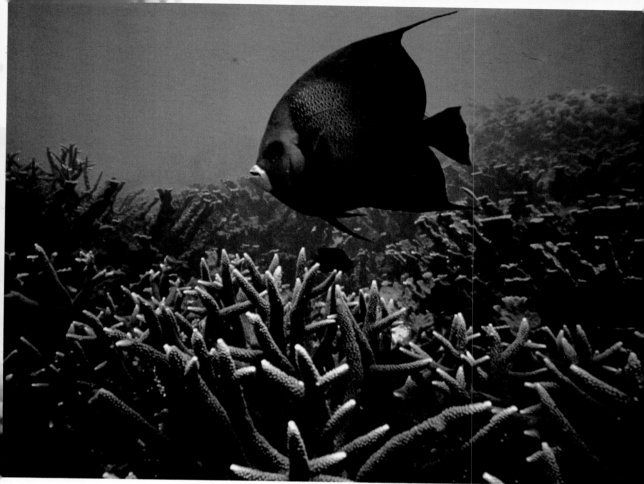

**Plate 22** A gray angelfish glides over staghorn coral in the Florida keys. Nikonos camera, 15-mm Nikonos UW lens, sunlight. Taken for *Exploring* magazine. Photo by Flip Schulke.

**Plate 23**
A squid is caught by the sharp light of a strobe flash. SLR Ikelite housing. Photo by Gale Livers.

***Plate 24*** The brightly colored clown fish half-hidden in a swaying clump of anemone tendrils is an *effective* subject. UW photographers often make the mistake of coming in too close to fish, eliminating its natural habitat. Using a wide-angle lens for some of your fish photography will remedy this. Photo by Gale Livers/Ikelite.

**Plate 25**
Close-up of the lion fish, taken with a macro lens in an Ikelite SLR housing. Photo by Gale Livers/Ikelite.

**Plate 26**   Close-up of a golden tail moray eel. Nikonos, 28-mm lens with an extension tube.     Photo by Jeff Nadler.

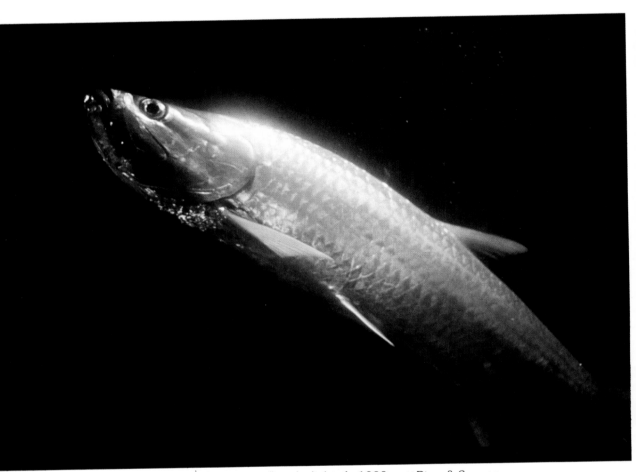

***Plate 27*** The silver scales of a tarpon reflect the light of a 1000-watt Birns & Sawyer floodlight. Photo by Flip Schulke.

*Plate 30*   Photo by Gale Livers/Ikelite.

*Plate 31*   Photo by Jeff Nadler.

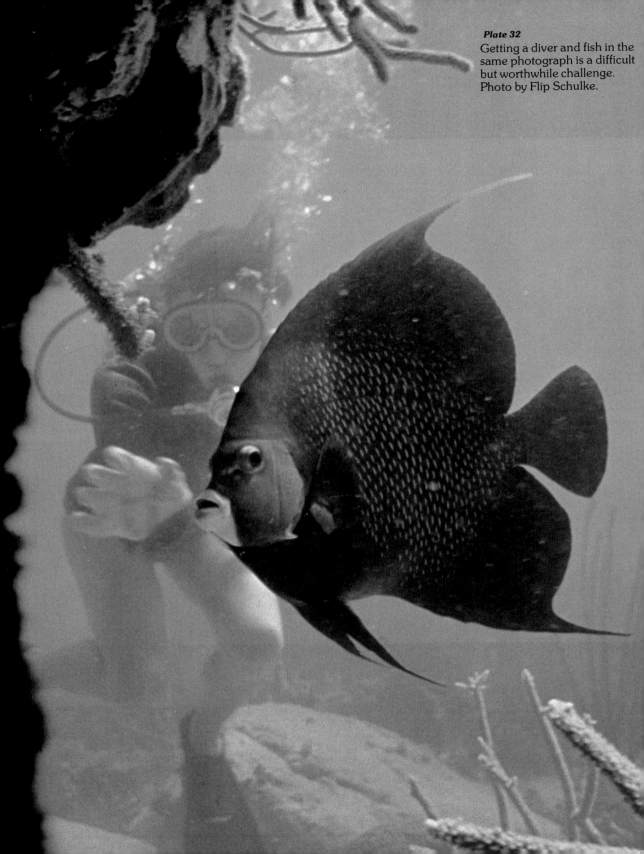

**Plate 32**
Getting a diver and fish in the same photograph is a difficult but worthwhile challenge. Photo by Flip Schulke.

**Plate 33**    Try photographing another  photographer hard at work.
Photo by Gale Livers/Ikelite.

**Plate 34**    Shooting out through the mouth of a coral encrusted cave is another good UW
photographic technique. Strobe-flash was used to light up the inner rim of the cave.
Photo by Gale Livers/Ikelite.

**Plate 35**    Color contrast enhances UW color photographs. Brightly-hued dive suits on your subjects create more exciting slides. Assistant diver Paul Dammann holds my favorite artificial lighting tool, the 1000-watt Birns & Sawyer Snooper floodlight. Photo by Flip Schulke.

**Plate 36**  U.S. Navy aquanaut from the Naval Undersea Center swims with a  magnesium flare.        Photo by Flip Schulke.

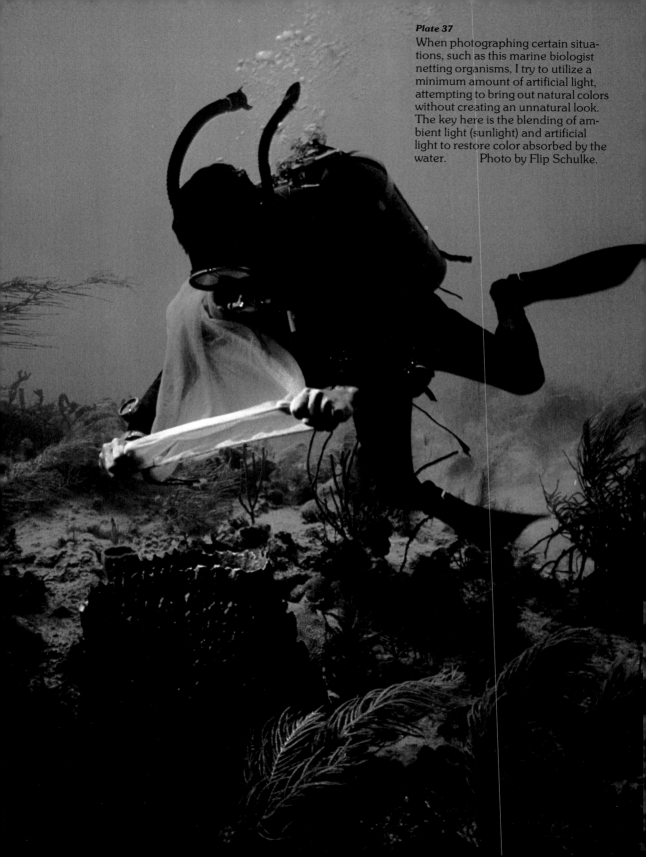

**Plate 37**
When photographing certain situations, such as this marine biologist netting organisms, I try to utilize a minimum amount of artificial light, attempting to bring out natural colors without creating an unnatural look. The key here is the blending of ambient light (sunlight) and artificial light to restore color absorbed by the water.        Photo by Flip Schulke.

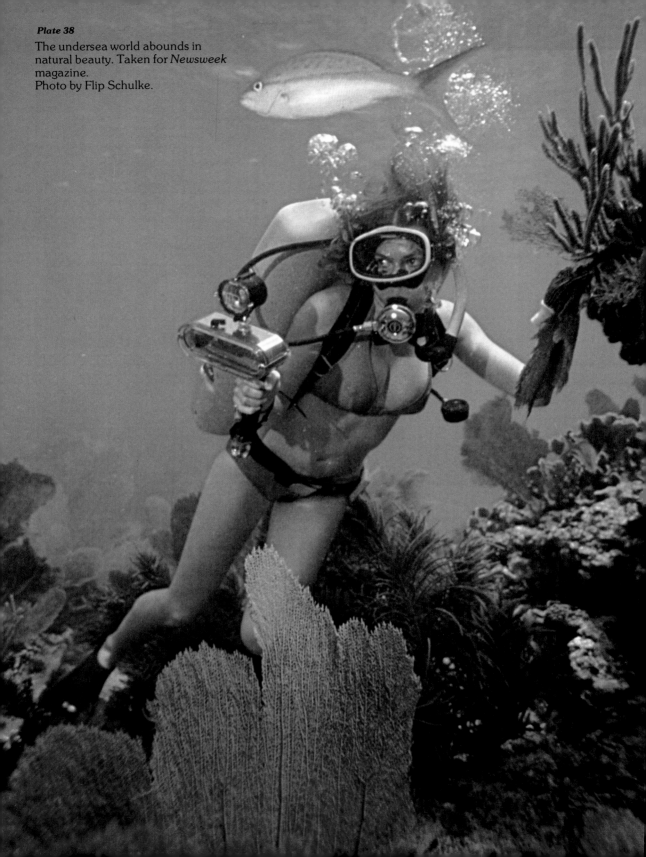

**Plate 39**   Diver Bernard Delmotte, the chief diver of the Jacques Cousteau exploration team, recovers a rare variety of frog from the bottom of Lake Titicaca, Bolivia, 12,000 feet up in the Andes. Not all UW photography is done at sea level! Taken for *National Geographic* magazine. Photo by Flip Schulke.

**Plate 40**

Even the SX-70 Polaroid camera can be used underwater. The Ikelite housing designed for this camera stores each color print as it is ejected by the Polaroid camera. Nearly perfect framing can be obtained by using an accessory optical viewfinder. See page 86 .        Photo by Flip Schulke

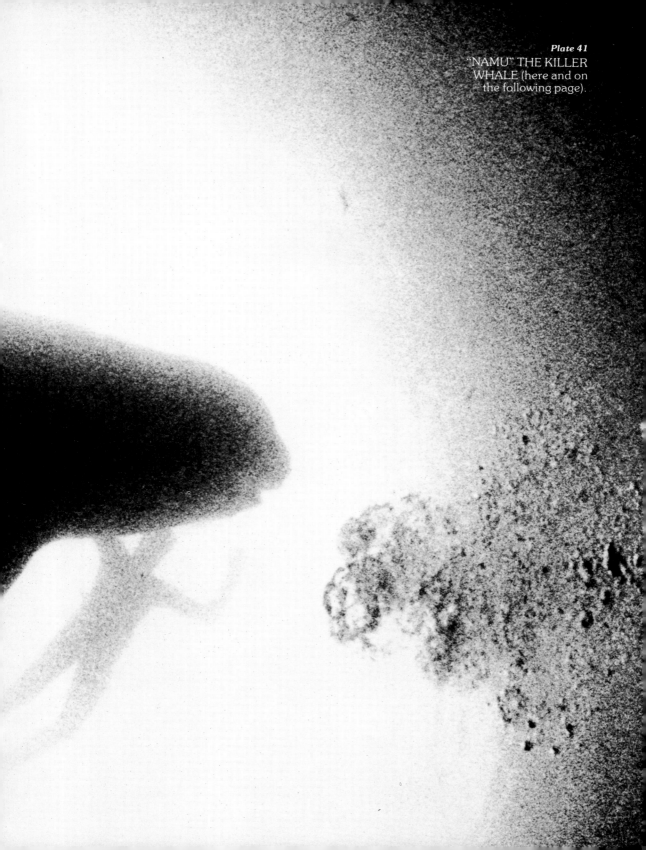

*Plate 41*
"NAMU" THE KILLER
WHALE (here and on
the following page).

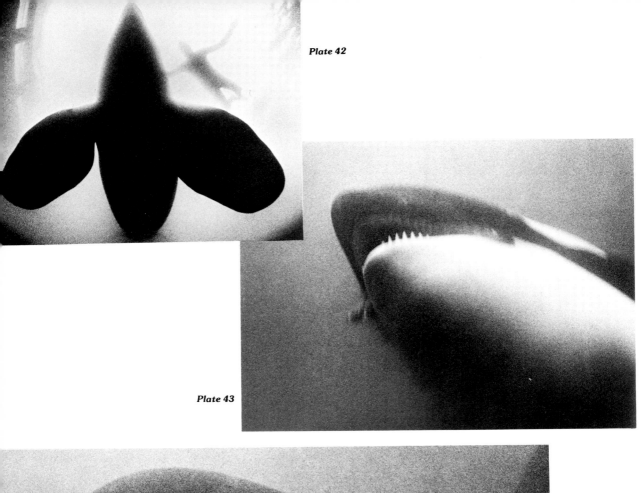

Plate 42

Plate 43

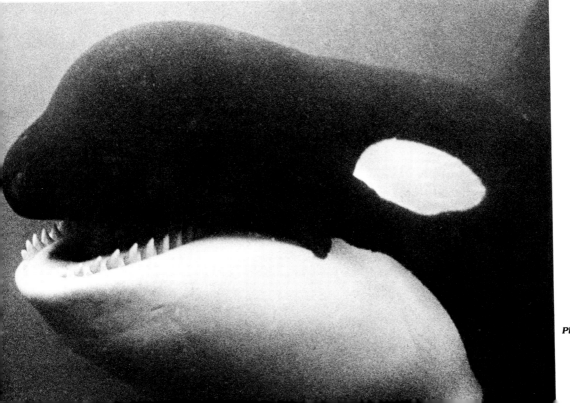

Plate 44

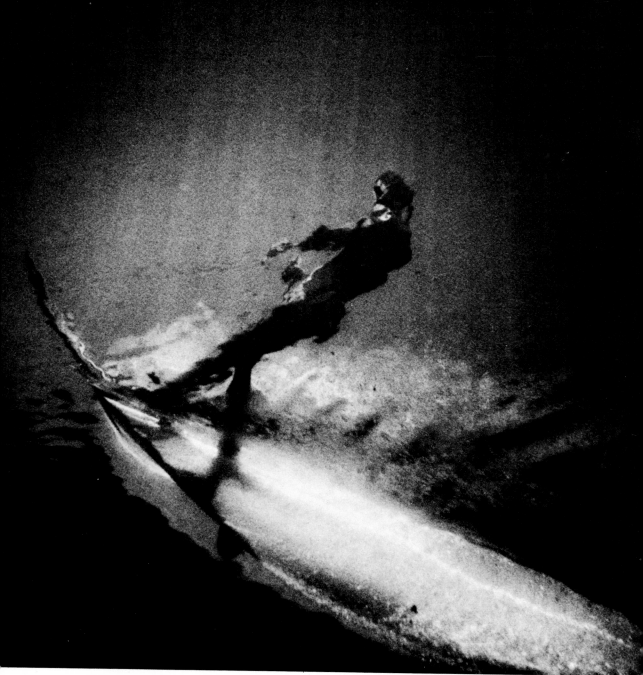

*Plate 45* An underwater look at waterskiing (here and on the following page).

Plate 46

Plate 47

Plate 48

systems and decide on one. Then purchase equipment with it, or have the system mounted in *all* units that you buy. Then if you are far out to sea taking photographs and trouble develops with one unit, a second unit will be compatible with your flash-connector plugs.

The Rolleimarin system is now hardly used in the United States, as it does not work well with electronic flash units, being designed originally for flash-bulb synchronization cable use.

The Nikonos (EPOI) system works *only* with the Nikonos camera, but can be converted with adapters to the Ikelite system.

The Ikelite system was designed to meet the problems of cable connection of all strobe units and was devised to be compatible with both Nikonos, SLR, and electronic UW strobe-flash housings and amphibious electronic strobe-flash units.

The EO system is an adaptation of a sophisticated UW connection system, devised primarily by the manufacturers for industrial and military UW electrical cable connections. It is by far the most costly of the connector systems, and I don't feel that the sophistication of design and manufacture is worth the price, since UW photography is primarily done down to depths of 150 to 200 feet, and this connection system was designed to make watertight electrical connections to extreme depths (the reason for the high cost).

### Tips for Using Flash Bulbs Underwater

Surprisingly enough, flash bulbs will fire *in* water. They can withstand great depths, though they sometimes implode (explode inward with a loud bang) after the shutter is released. Implosions are not a cause for worry, unless you get the flash gun too close to your ear, which can be injured by the implosion's resulting water-pressure waves. The power pack (battery capacitor, BC) is housed safe from water inside the UW camera housing. When you push the shutter release with your finger underwater, you activate an electrical contact inside your camera, which closes a contact in the BC unit and the 22½-volt battery current goes out through the connecting

cable to the UW flash-bulb gun. Once the electrical current is outside the watertight housing, it does not have to be shielded or protected from the surrounding water. The electric current travels along the cable and ignites the flash bulb while the bulb is also surrounded by water. Simplicity itself. About all that can go wrong is a weak battery, which is easily replaced if you remember to carry a spare one. A flash bulb can refuse to ignite (fire), but this is rare.

Try to judge the number of flash bulbs you think you will use when going into the water, and take only that number plus a few extra to allow for misfiring. I find that most misfiring happens because bulbs are taken into the water a few times before they are actually used. This is especially a problem in salt water. The base of the bayonet is metal tipped with lead. The lead can oxidize just from lying around on the surface in the carton in which they were purchased. Oxidation will certainly occur if a bulb is submerged in salt water and then taken to the surface and stored before again being used. Just before a photo dive I take an emery board or fingernail file and scratch the lead tip of all bulbs that I am going to use underwater. Then I can be assured of a good electrical contact and thus a very high probability of the bulb going off when I release the shutter button.

Carrying flash bulbs underwater: This can be done in a number of ways. The easiest method is to take a strip of neoprene dive-suit material, punch a lot of holes in the rubbery material—the holes can be very small—and shove the bayonet

**Fig. 7.1** Methods for carrying flash bulbs and cubes underwater.
(A) A strip of neoprene dive-suit material.
(B) A net bag.

base through the hole. Since they are buoyant, they will float at the end of a short nylon cord tied securely to the strip of dive-suit material and to the back side of the reflector part of your flash gun. This way they are always out of the way of your picture taking, but in easy reach. Little net bags are also sold for this purpose. Just one word of caution, don't litter the bottom of beautiful coral reefs with spent flash bulbs. Put the used ones back into the carry-holder. The ocean is big; but if you shoot off a lot of flash bulbs in a small area of a pretty reef, it's not much different from throwing empty beer cans all over the landscape above water. Another caution: sometimes the bulb will break off from the base after firing, so it's a good idea to wear one glove for removing these sharp broken ends; they can easily cut bare fingers.

## EXPOSURE WITH FLASH BULBS

There are a great many theories about how to determine flash exposure. I shall give here some generalized information from which you can base some tests with your particular flash gun, reflector, housing, and camera-lens combination. There is no magic guide table for UW photography. The conditions of clarity and equipment combinations vary so greatly that one cannot honestly come up with one table that would give you exact guide numbers.

For a base to start at, you can divide the surface flash-bulb guide number (FGN) for the film you are using by 4. Example: If the FGN is 200, your UW FGN would be 50. Keep track of your speeds and f-stop combinations and the distance from subject matter. It is also important to keep track of the surroundings. A white, sandy bottom will reflect light. No bottom or a dark bottom will create no reflection and therefore a little less light intensity.

Personally I feel that guide numbers, since they involve dividing the distance from camera to subject to get the approximate f-stop, are just one more complicated operation underwater. I have seen many diver-photographers miss really good photographs because they are fiddling with their camera gear or trying to figure out the right speed or f-stop combination by using guide numbers.

A much better method is to run a group of tests around one type of flash bulb and at one shutter speed. Then you can mark the proper f-stop for various distances on a piece of tape affixed to the rear of your Nikonos or camera housing. As a suggestion see Table 7.1.

**Table 7.1. Flash-Bulb Guide for Clear-Water**

- Ektachrome-X or Kodachrome 64 (both 64 ASA films).
- Shutter speed, 1/125 of a second. (This will stop most of your unsteadiness with the housing and will stop slowly moving objects.)
- Focal-plane bayonet-based flash bulbs (FP), clear.
    GE 6
    Westinghouse PH/6
    Sylvania FP/26
    Philips PF 24
    Dura 6
    Amplex 6

| • Distance (apparent) | f-stop |
|---|---|
| 1½–2½ feet | 16 |
| 3–3½ feet | 11 |
| 4–4½ feet | 8 |
| 5–7 feet | 5.6 |
| 8–9 feet | 4 |
| 9–12 feet | 2.5 |

When making your initial test, have your subject wear a bright color, either a red or orange bathing suit or dive jacket, in order to evaluate the color rendition. A black diving suit will not give you any clue to your color exposure and the face behind the face mask is too small to let you know.

Remember, though the Nikonos camera, and other SLR cameras containing "focal-plane shutters" will synchronize with bayonet-based class M flash bulbs at 1/30 of a

second, it is more practicable to use class FP clear flash bulbs. Blue bulbs should be used only for close-ups (2 feet and nearer). These FP bulbs are designed to synchronize with the focal-plane shutter at shutter speeds ranging from 1/60 of a second up to 1000 of a second. This gives you a much greater variety of shutter speeds to pick from, the most important advantage of which is being able to stop moving subjects at high speeds.

## STANDARDIZE

I cannot overstress the importance of standardizing your equipment and artificial light (in this case-flash-bulbs) and settling on one kind of color film—at least until you have mastered that group of elements. Underwater is not the place to be faced with choices that take a lot of concentration. The alien environment saps your energy, and your time is spent on mechanics rather than on finding and taking good photographs.

## BRACKETING

Bracketing applies to artificial-light, as well as to natural-light photography. Shoot one stop over and one stop under what you think the exposure should be. After all, a little more film shot may cost a bit more, but not as much as the initial expense of both time and money involved every time you go on a diving excursion. Film and flash bulbs are really the cheapest part of photography. Would you buy a new car to travel cross country and then purchase only 10 gallons of gasoline? Remember this when you are filming, then bracket.

## STROBE (ELECTRONIC-FLASH) PHOTOGRAPHY

*Strobe* lighting has become one of the most popular methods of artificial lighting underwater in recent years. I have admitted to a personal preference for flash bulbs in under-

water artificial lighting, owing primarily to a need to travel as lightly as possible on professional UW assignments both here and in foreign countries. I once traveled all the way to Australia's Great Barrier reef, lugging one of the most powerful UW amphibious strobe lights, only to have some problem develop in electronics or electrical connections, resulting in a blown strobe tube after only two UW flashes. Fortunately I found flash bulbs in a very small Australian town, which saved the day.

Nevertheless the majority of UW photographers have been turning to strobe lighting for artificial lighting underwater. Strobes have become more dependable and have greater light output in much smaller units. The UW housings and amphibious UW strobe units have been around long enough for the manufacturers to have overcome most of the "bugs" of early UW strobe use.

You can try my own predilection for flash bulbs underwater (see flash bulbs in the Glossary for more on this) or like so many others, you may prefer investing in a strobe underwater. Should you choose the latter, I shall try to give you a fair picture of strobe as a means of artificial lighting for the UW photographer.

Even though this book is based on my own experience with specific photographic equipment, I include opinions about equipment in a few cases from professional UW photographers whose work I admire and whose word I trust.

There are three major manufacturers in the United States producing most of the UW amphibious strobes and UW housings for surface strobes. They have survived, in my opinion, because they have recognized the scope of the UW photography market; they make superior units, which they are constantly upgrading; and they have been in business long enough to have a nationwide network of retail stores handling their products. They include Farallon/Oceanic Products, Graflex/Subsea Products, and Ikelite

Underwater Systems. Graflex/Subsea Products does make some other products (mentioned elsewhere in this book), but its business from the start has been the manufacture of amphibious UW strobes. Farallon/Oceanic Products makes both amphibious strobes and some housings for specific surface strobes. Ikelite Underwater Systems makes a large variety of UW housings to fit more than 133 models from among 12 major surface strobe manufacturers and also an amphibious strobe.

Two major Japanese manufacturers have entered the amphibious UW strobe market as well. Toshiba (sold under the name Philips in Europe) and Sun.

As with most things these days, the cost of UW strobe is high. As a rule of thumb, you get what you pay for. UW equipment is generally more expensive because it must withstand more adverse conditions and is usually produced in more limited quantities. But that does not mean that a more costly unit will necessarily suit you or will fit your own needs underwater. I advise against rushing out and buying the best (or most expensive) before you gain enough experience in UW photography to find out what interests you most, another reason for my advising the use of flash bulbs underwater for the beginner. At today's prices you can take three flash-bulb (FP 26 bayonet-based) or six high-power flash-cube pictures for $1. It would take about 600 flash-bulb photographs before you would pay for one of the less expensive amphibious UW strobes, 2400 flash-bulb photographs before you paid for one of the most expensive Subsea strobes.

The selection of a UW strobe to suit your needs depends on whether your emphasis is on closeup and macrophotography, which can be done very well with less powerful (and thereby less expensive) UW strobes, or whether you have chosen to concentrate on people and larger subjects underwater, which

calls for a much more powerful UW strobe unit—or even two units—for coverage. The most expensive and powerful UW strobe unit will do both types of work; the less expensive and weaker UW strobe will be useful only for the closeup photography.

For these reasons I suggest starting out with an inexpensive flash-bulb gun and flash bulbs until you discover what you need for artificial light underwater and just how much you will use the flash (whether it be bulb or strobe). You can always trade or sell your UW flash gun to another beginning diver when you decide that you need a UW strobe to obtain the sort of photographs that you want.

As with all suggestions, there are exceptions, and the major exception to my advising the beginner to first use flash bulbs underwater would be a beginning UW photographer who already owns a surface electronic flash. Since UW housings are available at a reasonable cost for a great many surface strobe units, investing in a housing for your surface strobe would equal the cost of purchasing a UW flash gun for flash-bulb use. With the costs equal or nearly so, it would probably be wisest to purchase a UW housing for the strobe you already own.

## SURFACE STROBES IN UW HOUSINGS

The least expensive way to utilize strobe lighting in UW photography is to select a housing for a surface strobe unit.

Ikelite Underwater Systems is the largest manufacturer of molded plastic (Lexan) housings for surface strobes. Each year it adds new housings for the new strobe models. A current Ikelite catalog will tell you which models it has UW strobe housings for. Because competition among surface strobe manufacturers is fierce, strobe technology is being updated constantly. The mass market

for strobe purchases is growing so quickly that it is impossible for most of us to keep informed about all the new models being offered for sale—or in fact, all the technical distinctions that make one model different from another.

The other major surface strobe manufacturers are Vivitar, Rollei, Minolta, Capro, Canon, Metz, Braun, Konica, Ascor, Sun (pak), and Strobonar (Strobonar was sold under the brand name of Honeywell up to the middle of 1977; this unit is now handled by Rollei of America, Inc.) A current Ikelite catalog will tell you which models it has UW strobe housings for.

One of the tricky problems of housing a surface strobe is triggering the strobe encased in the housing via a watertight connecting cord and plug system. To understand this problem you must understand that when a strobe is connected by synchronization cord, or "hot-shoe," to a camera, all that is needed to trigger the strobe is the closing of two contact wires inside the shutter mechanism. A very low charge of electricity is carried through the wires, but it is sufficient to cause the strobe to fire.

It has been found that utilizing this surface or direct system of firing a strobe encased in a UW housing is not consistent. Sometimes the strobe will fire and sometimes it will not, because the low level of electrical energy normally used to trigger a surface strobe must travel a much longer distance through a heavier electrical watertight cable. Much of the low-energy electricity seems to be dissipated, and the strobe may not fire when the camera's shutter is activated. A misfiring strobe underwater can be a pain in the neck.

The solid state triggering system, or SST, solves this "synch" problem by utilizing a 22½-volt battery and capacitor located in the UW camera housing which sends a powerful jolt of electricity via the UW connecting (synch) cable to the strobe inside its UW housing, thus activating a solid-state electronic switch in the UW strobe housing. The closing of that SST switch closes the strobe firing circuit, thereby firing the strobe every time.

Farallon/Oceanic Products makes rugged cast-aluminum housings designed for the Strobonar handle mount series of strobe units. It also offers an optional "Sea-Wide Adapter," an optical insert that fits behind the port of its Hydro-Strobe housing, which increases the angle of light coverage from 70° to a full 110°. This is very helpful in wide-angle photography. These housings can be ordered with Ikelite, EO, or Nikonos synch-cord fittings.

It is best to mount the UW strobe housing on a *holding arm* which is attached to the UW camera housing. All the UW manufacturers mentioned make holding arms for their units. Some arms are interchangeable with other brand UW strobe housings, and some arms will fit (without major changes) only equipment made by the same manufacturer who makes the arm.

A number of the UW accessory firms make strobe holding arms also. It is best to examine the various arms available and then check with a diver-photographer who has used a particular arm to get a firsthand report on how it works in the water. UW strobes in housings tend to be bulky and can be heavier than the camera housing itself out of water. In the water you can make them slightly negative or buoyant by taping, glueing, or bolting a little lead weight or styrofoam inside or outside your housing. Because of this bulkiness and weight out of water, the holding arm should be solid enough to keep the strobe in position both above and below the water. Usually these arms are jointed, to enable you to point your strobe at your subject. These joints must be locked into whatever position you desire and not moved from that locked position. The arm must be easily adjustable from one

locked position to another when you are wearing gloves. If you are diving in cold water, you can't very easily take off your UW gloves to turn knobs and levers.

Why not just leave the strobe bolted onto the UW camera housing? You can, and many photographers did in the past. Fewer do now. Any light source bolted near the camera's lens, pointed directly forward, will give very harsh, direct light, like the headlights of an automobile. You will get very black shadows in your photographs. But worst of all, you will get *backscattering* if the water contains any suspended sediment or sand, as explained later in this chapter. All these effects will result in poor, amateurish photographs. A good, movable holding arm will enable you to position the light away from the camera itself. In closeup photography you can place the light directly over the subject matter or at a 45° angle to the subject matter. Both positions will result in much more pleasing artificially lighted photographs.

The next obvious question is: "How do I know when I move the strobe underwater by moving the holding arm where the light is actually pointed?" This is a real problem. It is so easy to say, "experience." For the inexperienced (and the experienced who wants to be sure): Attach a UW battery-powered flashlight to the top or side of your UW strobe housing. To date the best light that I have found for this purpose (because it is so very small and throws a bright spot pattern) is the Super-Q dive light, made by Underwater Kinetics. Some accessory holders are available for mounting flashlights onto strobes, but I have found that gray ducting tape (also called "silver tape") available in most hardware stores, can be used to tape the light to the strobe housing. Be sure that the light is pointing exactly where the strobe flash beam is pointing. Then when you move your strobe underwater, you can lock

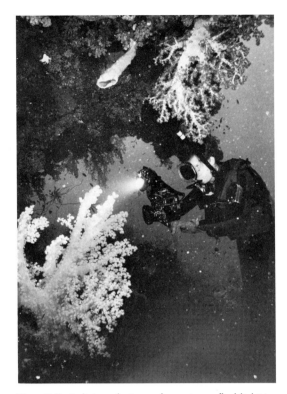

***Illus. 7.5*** A diving photographer using a flashlight to aid in aiming his camera and focusing accurately. The flashlight is taped onto his UW strobe housing. *Photo by Gale Livers/Ikelite*

the arm when the taped-on flashlight beam is striking your subject. This same sort of system is used with a laser beam to point some modern rifles at their target. An aiming light mounted in this fashion is a must for night diving photography.

### Pros of Surface Strobes Used in Housings
- A surface strobe in an UW housing is the least expensive method of utilizing strobe flash underwater.
- You can make use of a surface strobe you already own.

- Housings are available for more than 130 models of surface strobes.
- Any water that might leak into the UW strobe housing can be seen. If this happens, you can swim slowly to the surface, carrying the strobe housing at an angle that keeps the water away from the strobe itself. You may then succeed in getting it back to the boat without wetting the strobe. There you can remove the strobe from the housing before any water damage occurs.

### Cons of Surface Strobes Used in Housings

- The light coverage of a surface strobe is normally quite narrow and is projected by the reflector of the strobe in a rectangular pattern. There are various accessories offered by the surface-strobe manufacturers that make the light coverage more "wide-angle," but at a loss of light brightness.
- The housings are sometimes bulkier when compared with an amphibious strobe flash of the same light-brightness output.
- Except for the Strobonar handle series of surface strobes, there are models of amphibious strobes that are brighter in light output than any surface strobe that can be housed conveniently in a UW strobe housing.

If you already own a surface strobe and you find that a UW strobe housing is available for your particular model of strobe, then I feel it is wisest to house the strobe you already have. If you are starting from scratch, you would be wise to consider the amphibious strobe.

# AMPHIBIOUS STROBES

Amphibious strobes, also known as submersible strobes, are electronic flash units that have been designed primarily for UW flash photography. The body of the strobe itself is the protection against the water and water pressure. All necessary controls are O-ring sealed. Items that may be "add-on" accessories to a surface strobe are an integral water-sealed part of the amphibious strobe.

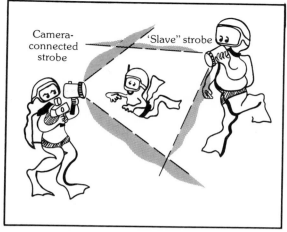

**Fig. 7.2** Slave strobe.
The most efficient method of dual lighting. The diver on the right holds a strobe with a "slave" sensing device built in. When the diver on the left fires her strobe (which is connected by cord to her camera), the light coming from her strobe is sensed by the "slave" unit, and fires the second strobe in complete synchronization so that equal lighting is obtained from both light sources.

Because amphibious strobes have been designed for UW photography, they are rugged and offer a compactness versus power output that surpasses housed surface strobes. Some models offer wide-angle light coverage, and some have varying beams (movable bulb-reflector combinations) to give high light output for closeup or narrow light coverage or a wider coverage for wide-angle photography (at a loss of light output, of course).

Many models offer some sort of slave/synch feature. A slave unit is one that can be triggered by the light of a strobe connected to the camera, thus providing a second light source, or light angle, without having the second (or slave unit) connected by synch cord to the camera housing. Your safety diver can hold the second slave-strobe, or it

too can be attached to your Nikonos or camera housing by means of a holding-arm.

# STROBE BATTERY SYSTEMS

## Disposable Battery Systems

**Low-voltage dry cells** / Usually alkaline, size AA and C 1.5 volt, low-voltage dry cells are used in some amphibious strobes (usually low-light-output units) to form the power for these miniature units. Such batteries are readily available all over the world in drugstores, food markets, gasoline stations, and the like. These cells do lose power, and when they do, your strobe will not throw out the maximum advertised power. An inexpensive battery analyzer will tell you when your dry cells are beginning to lose their energy. Then it's time to change. The cost of new batteries is negligible, but a weak battery will cause underexposed UW flash photographs.

Current amphibious strobes utilizing alkaline flashlight cells are the Toshiba TM-1, known as the Philips PSF 0120 in Europe; the Sunpak Marine 28; and the Oceanic 2000. The light output of these alkaline cell units is the weakest, and they are primarily for closeup or macrophotography. I have had good luck with the Toshiba unit, which uses four AA alkaline penlight cells. I put in fresh batteries each time I go diving. Since AA batteries are also used to power the Canon F 1 and Nikon F, F2 motor drives, I always have plenty of fresh AA alkaline cells on hand. **A tip:** Keeping your cells in the refrigerator will prolong their full power strength. Toshiba states that their unit will give 250 flashes on one set of 4 AA alkaline batteries; however, I think that this is slightly optimistic. I certainly would change batteries after 100 flashes. The recycle time (the time it takes for the unit to store up maximum power from its batteries) is 14 seconds. You must understand that this is true only when the batteries are fully charged and fresh. The recycling time will begin to get longer and longer. I change batteries when the recycling time reaches 20 seconds. **A tip:** If you take one flash picture after another, the batteries will appear to deplete very quickly. You will find that leaving the batteries to rest overnight will bring them back to a faster recycling time.

**High-voltage batteries** / Those such as the 510-volt and 300-volt batteries are used in the amphibious Graflex/Subsea Products and Ikelite amphibious strobe units. The advantage of these high-voltage batteries is the significantly higher number of flashes they can deliver. Their recycling times increase with depletion of the battery, but light output remains constant. It will take longer to draw battery power as the battery depletes. The unit will not fire unless the strobe capacitors (storage units) are at full strength. The disadvantage of the high-voltage battery is its unavailability. Since it is used only in limited battery applications, it is expensive and difficult to find in photographic and dive stores. However, you may choose the high-voltage battery units if you take diving trips in out-of-the-way places, where electricity for charging Ni-Cd (nickel-cadmium) rechargeable batteries is not readily available.

Ni-Cd (nickel-cadmium) are dry batteries that can be recharged time and time again. The high initial cost for these batteries is offset by the elimination of replacement costs. The trend of both surface and UW strobe manufacturers is to incorporate Ni-Cd batteries in their units. Many such units are sealed. If the Ni-Cd battery develops trouble, the unit must be returned to the manufacturer or repair station to correct the battery malfunction.

The advantages are (1) lower overall cost per photograph, if you take a large number of UW flash photographs, (2) shorter recycle times, (3) more compact units.

The disadvantages are:

1. The flashes per charge are limited from 50 to 100 flashes depending upon the particular unit. But with some amphibious UW units, this can be overcome by having a spare Ni-Cd replacement to be used when your first set of batteries is depleted.
2. The recharge time in almost all units is lengthy, often more than 8 hours. This is slowly being corrected by new "fast-charge" Ni-Cd units, which can be recharged in one hour.
3. You must be sure that your charger will operate on foreign electrical current supplies of 220 and 240 volts, as well as on what we consider the normal 110-volt supply. Most new units and chargers have this dual capacity, but it is very important to be sure of your own unit when you travel abroad, especially in Europe where 240 volts is the normal current outlet available. If your unit's charger is not equipped to take 220 volts, you can get a small electric current converter (the Franzus converter model F-11 designed for electric razors). Strobe recharging converters are readily available in most drugstores. They are manufacturered by Franzus Company. The same company makes a set of foreign electrical male and female plugs to enable you to plug into the various foreign female current supply wall outlets. You will be surprised how many different systems are used outside the United States. None of them seems to utilize the flat two-pin male electrical plug we are all so familiar with.
4. Owing to limited use of a Ni-Cd-powered unit problems may develop. Your Ni-Cd batteries must be recharged at least once every 30 days, even if you do not use the unit at all. These batteries slowly lose their charge owing to inactivity. **A tip:** By keeping a chart and recording the time and date of the last recharge, I can consistently keep the energy charge up to full power. It will not hurt the Ni-Cd batteries to have a full charge (10 to 14 hours) even though you have not used the unit. There are quite a few more refinements of this problem, which can be found fully explained in the Glossary under *Batteries*.
5. Hydrogen gas, a by-product of storage battery recharging and discharging, is extremely explosive if ignited by an electrical connection. Though much less from a dry battery than from a wet-cell automobile-type battery, nevertheless, hydrogen gas is emitted. It is very important that you question the seller or manufacturer of any amphibious strobe unit that you may want to buy about how this hydrogen outgassing problem is solved in his particular Ni-Cd UW strobe unit. (See *Batteries, Dangers of*, in the Glossary.) I stress this point because I have had one amphibious Ni-Cd-powered strobe blow up in my hand in test-firing on the surface and another blow up underwater when I pushed the camera shutter release, thereby activating the strobe. Manufacturers are now well aware of this hydrogen-outgassing Ni-Cd-battery problem, and most have made provision to dissipate the gas. But the important thing to remember is to **read the instructions** concerning recharging that come with any strobe so that your unit won't blow up.

In conclusion, amphibious strobes designed specifically for UW photography are becoming more and more popular, for they take care of the special problems caused when a strobe is used in a water environment.

The best advice I can give about the purchase of an amphibious strobe unit is to look at the available units carefully and examine what they will and won't do with an eye to how you will use the strobe in your UW photography. The more powerful the unit in light output (brightness), the more costly it will most probably be. Ask other diver-photographers to make sure the unit really delivers the light output that the manufacturer claims it does. Be sure there is some provision for hydrogen-outgassing protection.

I have found that *all* manufacturers of strobe units, both surface and amphibious, give recycling times that are from 50 to 100 percent faster than I find the units will actually recycle. This is hard to explain, for I have carefully tested new, middle-aged, and old strobe units, all with fresh batteries, and their recycling times were all consistently longer than suggested by the manufacturer. The only real solution is to test-fire your own unit (or one you are considering purchasing) to learn what the true recycling time actually is.

I also find that they overestimate the light output (guide number) by usually one stop. Under controlled lab test conditions the strobe units may give the guide number suggested by the manufacturer; but under real photographic conditions, it doesn't turn out that way. A good estimation of the true light output of any strobe can be metered by a strobe meter, an instrument designed to read strobe light output. A strobe meter can also be used in a UW housing to give an accurate $f$-stop (see below).

If you store your amphibious strobe, be sure that you take it out every 30 days and fire the unit a few times. This will "reform the capacitors" of the strobe. If this is not done on a regular basis, your unit will not give out the power that it is advertised to give.

## UW STROBE ACCESSORIES

### Strobe Slave Units

These are primarily amphibious UW strobe units into which a photoelectric eye has been placed and connected to the synch firing mechanism of the strobe. You switch a control that converts the strobe from synch cable firing—with the cable directly plugged into your camera underwater—to synch firing based upon the photoelectric eye "seeing" another strobe directly connected to your camera "flash." Since light travels so quickly, the first flash will ignite the "slave" flash by its own light intensity—so quickly that for practical purposes both lights go off at the same time as far as the camera shutter is concerned. This enables you to get a second light source in synch with your first, either to add to your total light output (brightness) or to light your subject matter from another angle, giving a different visual affect. Amphibious strobes with both cable synch and slave synch are

manufactured by Graflex/Subsea Products, Farallon/Oceanic Products, and Ikelite Underwater Systems.

## UW Strobe Light Meter

Calculating the proper exposure when using UW strobe units can be difficult, depending on water clarity conditions and distance from subject. Meters that read the light output of a strobe are commonly used in estimating the proper exposure in surface photography. One such meter, quite low priced, but accurate, is the Wein strobe meter or a like model, the Spiratone strobe meter. This meter can be housed in an Ikelite UW housing designed for this particular model of strobe meter. You preset the meter before a UW dive for the ASA of the film that you will be using. Then underwater you place the strobe meter next to your subject and flash your UW strobe. A direct-reading needle in the strobe meter will then point to the proper $f$-stop for accurate color exposure. This is a specialized accessory but is very handy in taking UW color photographs in some exotic diving spot that you may never have the chance to return to.

## Holding Arms, Brackets, and Mounting Bars

You will need some sort of holding device for any strobe underwater. Hanging strobes, light meters, and other accessories to yourself by cords and hook snaps not only makes swimming difficult, but is unsafe for you as a diver. And costly equipment is easily broken when you are getting in and out of a dive boat loaded down with dangling gear. The holding arms that can be easily detached from the UW housing or camera bracket should be your choice if you like to hand hold the flash for better lighting effects.

Each manufacturer offers holding arms, brackets, and mounting bars for its own spe-

cific models. You can adapt some to other manufacturers' strobe units and UW housings if you are handy with small tools.

## GENERAL TIPS ON UW STROBE LIGHTING

**Follow Manufacturers' Directions** / Owing to the great variety of electronic strobe-flash units, you must read the directions that come with your particular unit, surface or amphibious, and follow the instructions and

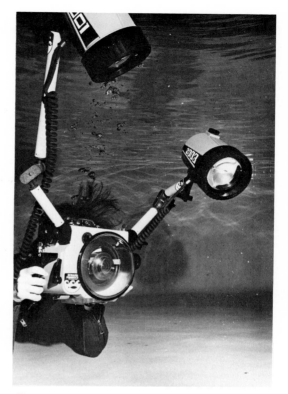

*Illus. 7.7* Two amphibious strobes mounted onto an SLR housing by means of one long and one short ball-joint extension holding arm by Farallon/Oceanic. This system of extension arms enables you to position your strobes exactly where you want them and still keep the lights from being too close to the housing itself, which might result in backscattering.

*Illus. 7.6* Wein WP 500 flash meter in Ikelite UW housing.

*Fig. 7.3* Hand-held flash.
Getting the flash gun's head away from the camera will decrease the effects of backscattering and improve lighting quality. This is most easily done by detaching the flash from the camera and holding it at full arm extension, and at a 45° angle to your subject matter whenever possible.

suggestions. Varying standard operating procedure will not give you the maximum lighting results each unit is designed to give.

## How to Calculate the Proper Exposure /

There is no sure-fire method of estimating the proper *f*-stop (or diaphragm opening) in using strobe underwater. Each manufacturer of amphibious strobes will include a series of guide numbers which you can use as a starting point. You will soon find that the manufacturer obtained these guide numbers in very clear water. Experience will teach you how to vary exposures to compensate for varying UW conditions. The first rule for good exposure, in any case, is to bracket (i.e., expose one full stop over what your guide number tells you, and one full stop under what your guide number tells you). In very difficult water conditions, I even expose two full stops over and two full stops under what I think the proper exposure will be.

First of all, this procedure will insure you one properly exposed photograph; but even when you *are* sure of the exposure (as in macrophotography when the strobe light is so close to the subject that the guide number is always accurate for good exposure) bracketing by one stop over and under (a total of three slides shot for each picture situation and angle) will often show you that the particular subject matter you may be shooting will look better to the eye when slightly underexposed or overexposed from the norm of the guide number. All manufacturers of amphibious strobes explain in their instruction leaflets exactly how to figure the guide number for their strobes, and how to use this guide number underwater.

As a starting point with surface strobes housed in UW housings, you can figure that your UW guide number will be about 1/3 the surface guide number recommended by the manufacturer. For example, the guide number (GN) for a particular surface strobe that I

own is 100 when using 64 ASA film. The UW guide number would be 1/3 of 100, or (rounded off) 35. Since I use 64 ASA films underwater almost entirely, I tape the number GN 35 on the back of the UW strobe housing for this unit. You then divide the actual distance from camera and strobe to subject into 35; the answer is your *f*-stop for an average color subject. In other words, this guide-number-determined *f*-stop for exposure would give you the proper exposure for a subject halfway between black and white, such as gray, medium green, red, orange, or yellow. If the subject is dark, open up (increase) the *f*-stop by one. If the subject is very light, stop down (decrease) the *f*-stop by one.

If you are photographing underwater where there is a reflective surface, such as a white, sandy bottom or light coral, you will be getting reflected light back from your strobe light that will increase the amount of light reaching your subject. It's the same as shooting snow scenes or beach scenes in surface photography, where too often photographers get overexposed (washed-out) color owing to reflected light. Exactly the same thing happens underwater. Generally, you should stop down one *f*-stop in these situations.

Conversely, if you are shooting subjects against black or dark backgrounds, or in open water high off the sandy bottom, you may have to increase your *f*-stop (open up) because you are not getting any added reflective light when you fire your strobe.

There is no real substitute for experience in judging strobe exposures. By bracketing and keeping records of what you did, you will develop your own system for getting the proper exposure for strobe underwater. You can begin by making a test at measured distances in a swimming pool, using a friendly diving partner as the subject. This will give you a general idea of exposure values for your own particular strobe and UW camera

combination. As you dive into waters of various degrees of turbidity (suspended particles) and various color tones, which can run from purple to deep blue and through all ranges of greens, you will gather exposure information that will be the best guide to most of the types of water that you will photograph in, in the future. Be sure to record this information, either underwater with a pencil on a piece of matte-surfaced plastic or as soon as you come to the surface.

**Reading Automatic Exposure Control Strobes** / Most of the present surface strobes come with sensors that can read the flash light intensity. But there are already too many systems to explain here exactly how these sensors work technically. I do know that I have not had even minimally good exposures where I utilized the automatic exposure control systems of these strobes. The primary reason is the lack of backgrounds that reflect the strobe light back to the strobe automatic sensor to enable it to operate automatically. The secondary reason is that the subject matter is often dark or so small that it just does not give an accurate estimation of exposure back to the strobe sensor.

I imagine that the automatic sensors *could* operate successfully in macrophotography, for the light is close enough to the subject in this type of UW strobe photography. However, in macrophotography the distance from subject to camera and the distance from subject to strobe is usually a distance that the photographer knows. Due to the nature of closeup frames, you can quickly calculate an *f*-stop by making one test bracketing, noting the frame numbers and the *f*-stop used for that frame, and later selecting the perfectly exposed slide. You then use *this* slide's *f*-stop as your prime setting, again bracketing up and down one stop depending on subject color, density, and the

mood you want to portray with your UW macrophotograph.

**Determining Angle of Coverage or Beam Angle of a Strobe Underwater** / You will find the diagonal angle of coverage, or beam angle, of any particular strobe in the owner's manual for that strobe. Surface strobe beam angles are usually quite narrow, varying from enough coverage to evenly illuminate a 50-mm lens, to wider beam angles that will cover the 35-mm lens film area. But you lose about a fourth of that surface beam angle when using a surface strobe underwater, again because of the refraction of light through water. A holding arm will affix the strobe light farther away from the subject matter than the lens-to-subject distance in closeup or macrophotography. This moving back of the strobe will increase its beam coverage—just as when you move farther away from a wall at which you point a flashlight, the circle of light (beam angle) increases.

When the strobe and camera are relatively the same distance from the subject, such as in UW photography of people, remember that your strobe will not cover the whole film area if you are using corrected UW lenses (35, 28, 20/21, 17 mm, etc.).

In these situations, if you need even illumination, you will have to resort to using *two* UW strobes mounted on either side of your camera. The only practicable way to determine exactly how to point each light to get the right beam angle for any specific wide-angle lens is to take your camera, lens, and two strobes to the bottom of a swimming pool. Point the lights at the side of the pool, staying from 3 to 5 feet away, and make a test roll. Varying the angle of each strobe (pointed forward), note each change; the resulting test will give you the proper mounting angle for each strobe to get the even illumination that you require for these wide-angle lenses.

*Fig. 7.4* Getting the flash farther away from the camera.
Sunlight can be simulated with flash, if the flash is held directly over the subject. Use of a long flash/synch cord—held by your diving partner—is one of the best methods for accomplishing this.

Alternately, if you only have one strobe, buy a synch cord (to extend from UW camera housing to strobe unit) and let your safety diving partner hold the strobe farther away from the subject than you and your camera are. Like the moving flashlight, as your partner moves farther away from the subject, the beam angle of your strobe will increase and will give even illumination of your subject. This procedure takes an alert diving partner who has an interest in helping you. You can return the favor by holding his light, posing for his photographs, helping him catch fish for his tropical-fish aquarium, or just being an all-around assistant in some aspects of diving in which your partner could use your undivided attention.

I am often asked "who holds your lights" because I use this technique continuously both in flash-bulb, strobe, and constant-light illumination in my own UW photography. First of all, I answer, "My diving partner, and anyone who dives in a safe manner *always*

has a diving buddy on *every* dive." This is the basic rule of safety in all diving. I have found that any diving buddy is intrigued by UW photography, and with a few topside lessons to show him how to hold and aim the light source, along with my own system of UW photography hand signals, the diving buddy turns into a first-rate UW photographic assistant.

Your boy/girlfriend, wife/husband, and/or children, grandchildren, nieces, nephews, and neighbors all make good diving partners, **if they are certified.** Sounds easy, and it is. Just take any one of them diving; let him snorkel and watch you down below with scuba gear, and he always seems to find a way to get certified so he can join you as a scuba diving partner. My wife, Debra, helps me, and I help her. Lotte, the wife of the first modern UW photographer, Hans Hass, has always worked with him in UW photography, and he has always given full credit where it is due.

**Correcting Color Temperature** / Light coming out of a strobe is 5600° Kelvin, or thereabouts. I have found this is too "blue" for anything except closeup and macrophotography (1 foot and closer). This condition can be corrected by placing a color compensating filter inside the strobe housing, for instance, a CC-R (red) 20 to 50, depending on your own particular like or dislike of "warm" UW photographs. You can get CC filters in 3-inch square and 4-inch square gelatin sheets at a modest cost from most camera stores.

Again, in a swimming pool make a color test, which will give you a general idea of the color correction that these filters will provide when used in conjunction with your particular strobe underwater. I suggest purchasing a 4-inch CC-R-20 filter. If this isn't enough, you can double up the filters and get a CC-R-40. Three used together will give you a CC-R-60.

Daylight color films are balanced for 5500° Kelvin, but be that as it may, you are shooting through blue (or blue-green) water, which means that your strobe is really traveling through the water *to* the subject, being colored bluer by the water, and then the light has to travel *back* through the water to your camera, getting a double dose of blue tinting. That is why, even though your strobe is balanced for "daylight" color film, this standard is arrived at because the manufacturer assumes you will be using the strobe in air. You must use a CC-R filter to get good, pleasing UW color.

Many amphibious UW strobe manufacturers have not taken this into consideration either; therefore I suggest placing the CC-R filters inside an amphibious strobe also. You will find manufacturers beginning to make plastic CC-R filters that can be placed directly in front of certain amphibious UW strobes making the rather makeshift CC-R gelatine filter insertion a thing of the past.

**Avoiding Backscatter** / The backscattering effect has been mentioned and explained in other parts of this book, but it should be repeated in this chapter on artificial lighting. The most common fault of flash-lighted UW photographs is caused by a lack of under-

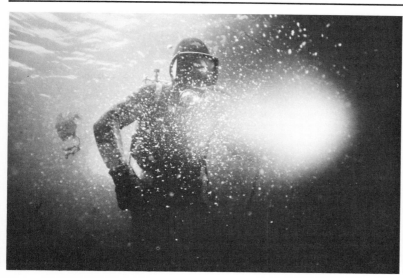

*Illus. 7.8* An example of UW light backscattering can be seen in this photograph of a diver holding a light. When the light was turned off, the water appeared very clear to the eye. With the light on, it is apparent that a lot of suspended matter is actually floating in the "clear" water. Even more light will reflect back at the light itself. *Photo by Flip Schulke*

**Fig. 7.5** Backscattering.
If you use flash close to your camera underwater, the direct light will bounce back off suspended sediment, particles, and plankton. This can be best remedied by getting the flash away from your camera, either by hand-holding it (as in the lower drawing), by using "slave" strobe (see Fig. 7.2), or by using diving-partner-held extension flash (see Fig. 7.3). All these techniques will minimize backscattering.

To avoid as much backscattering as possible, in any type of water, add distance between the light source and the lens of the UW camera. The farther away the better. By using holding arms or by detaching the light source and holding it at arm's length from the camera but still pointed toward the subject matter, the projected light will reflect back toward the light, not the camera's lens, because now they are not near each other.

**A Tip**

It has been my experience that most of the suspended particles in the water are activated by the diver's own flippers. Watch another diver when he or she is on the bottom or near the bottom, and you will see clouds of sediment billowing up. You must learn to practice breath control in ascending and descending when near the bottom and keep your flippers motionless. In the dive boat before a photo dive, warn your safety diving partner or other divers that you may be photographing and they should watch their flippers when near the bottom. We have a UW hand signal for this. You turn your palm down and wiggle your fingers like a spider's legs. This warning means, "You're mucking up the water clarity with your flippers. Stop it!" You will be surprised how much clearer the water remains when all divers practice flipper control.

## Lighting for Natural Effect

Holding a light over or on top of the subject is generally the most pleasing method for lighting underwater, for it approximates sunlight which comes from over us (except at sunrises and sunsets). Light pointed directly at the subject should be attempted only when there is no other way to light your UW subject. Direct light looks artificial. The goal of the capable photographer, whether on the surface or underwater, is to recreate a feeling of naturalness. Yes, we need artificial light to restore the true bright colors that exist under the sea. Yes, we need artificial light to restore colors that even our eye can distinguish underwater but color film cannot. But that artificial light does not have to strike the viewer as unnatural.

The sea and undersea environment are,

standing of backscattering, and/or knowledge on the part of the UW photographer of how to compensate for its effects.

Most water isn't really clear, because it contains suspended particles; these can be plant and animal organisms (plankton) or mineral substances (natural and man-made pollution). They will color the water and are also so small at times you can't see them with the naked eye. This suspended matter can act like tiny reflectors, all reflecting back any light that is directed toward them as it is the nature of reflected light to bounce or reflect directly back toward the source of light. When your car headlights are used at night in a snowstorm, you have a good example of backscattering.

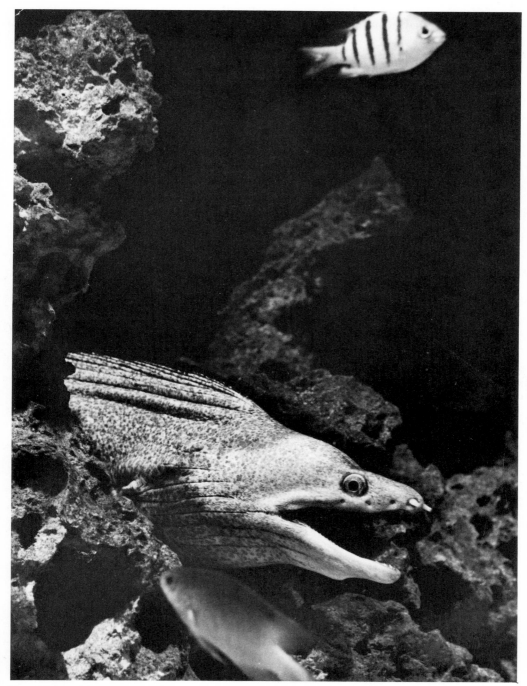

***Illus. 7.9*** One of the most natural-looking artificial-lighting techniques is holding the flash over the subject, so that it resembles sunlight, which also illuminates from directly overhead. *Taken for* Life *magazine by Flip Schulke*

for the most part, nature's realm. It is still fresh and beautiful, the playground of brightly colored animals and of divers or marine scientists who respect inner space. We don't yet have sign boards, hot-dog stands, and the other clutter of civilization. If garish, artificial-looking lighting were natural to the UW world, then perhaps I would accept this type of UW lighting technique.

Many UW photographs are so overlit with strobe and flash that the background of the water becomes black, even in daylight. The resulting photographs, though they show the main subject clearly, could just have easily been made in a fish-tank or aquarium.

In my mind, a truly creative UW photographer is one whose photography reflects the naturalness of the sea, and this can be accomplished only by experimenting with various angles, intensities, and colors of light. A set formula for lighting is fine for the beginner. All too often, the advanced and professional UW photographer remains rigidly bound in formula lighting techniques that are just plain old-fashioned. Many old-fashioned techniques can stand the test of time, but there are many—and many lighting techniques are among these—that were devised because, with primitive lenses, cameras, films, and light sources, they were the *only* means of obtaining a photograph underwater.

Techniques have advanced and much more is understood about the psychology of color and lighting. If you want to improve the art of UW photography— even if only to

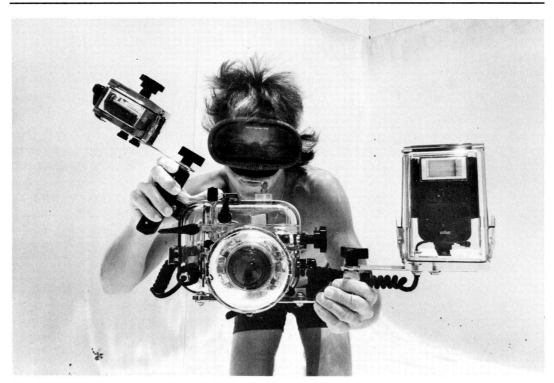

***Illus. 7.10*** A compact commercially available UW SLR system includes left, a surface light meter and right, a surface strobe—both in UW housings attached to the SLR housing. The strobe housing can be detached and held at arm's length to minimize backscattering and obtain more pleasing flash lighting effects.

satisfy yourself when looking at your UW photographs—strive toward lighting techniques that do not smack of artificiality. Forego front lighting as soon as you can to minimize backscattering, and your UW photographs will truly be "art from the sea."

## Suggested Assignments with Flash Underwater

### Flash Bulbs

Try to balance the flash-bulb light with the daylight, or ambient light, so that the flash bulb does not overpower the daylight, resulting in dark daylight areas of the photograph due to underexposure. This can be done by varying the shutter speed in relationship to the *f*-stop and the subject-flash distance. You can get less light falling on your subject by moving the flash away from the subject, and you can increase the light falling on your subject by moving it closer to the subject. The ambient light will remain the same no matter where you move the flash-bulb gun.

Take blue flash bulbs and photograph some brightly colored object, preferably one that will not move, at 6 inches, 8 inches, 12 inches, 1½ feet, 2 feet, 3 feet, and 4 feet away from the object. This test will enable you to discover at what distance blue flash bulbs begin to color the scene too blue for your own particular visual taste. I suggest this test because there is considerable argument among UW photographers about the cut-off point in the distance from subject when using blue flash bulbs. I feel that it is a matter of both visual taste and water coloration. If you dive regularly in one type of water, as I do (the Florida Keys in the Atlantic Ocean), you will be able to standardize your procedure of when to use blue flash bulbs and when to use clear flash bulbs.

### Strobe

Balance strobe light with ambient light by moving the strobe in and away from your subject. You need both UW light meter and strobe for this exercise.

Use a holding arm to position your strobe directly over the subject. Try other positions: at a 45° angle to the subject or frontally (just to see whether you feel that frontal light looks as "bad" to you as it appears to me). Stir up the bottom, so that you get more suspended particles in the water; the resulting strobe-lighted photographs will give you good examples of backscattering.

Try detaching the strobe from its bracket or holding arm and hand hold it in various positions relative to your subject matter. In this way you can practice pointing it in the right direction, since aiming a light underwater is slightly confusing owing to water refraction.

Make an exposure test of your particular strobe unit underwater so that you can discover the true guide number of your strobe and camera system.

Get a large enough gelatin CC-R filter (Kodak CC-R-20) to insert inside your strobe housing or amphibious strobe to see if you like the resulting warmer-toned color photographs. Double and triple the filter if you want warmer light. The brightness of your strobe will be lessened by the addition of the CC-R filter or filters. Take this into consideration when determining the proper *f*-stop (exposure).

Make a series of macrophotographs, moving the strobe into various positions relative to the subject. Besides frontal light, try 45° top, side, and back (the strobe behind the object being photographed) light.

Try moving the strobe away from the subject (while keeping the camera nearer) when using a UW wide-angle lens, to determine full coverage of the strobe's beam angle.

# 8·SHOOTING MOVIES UNDERWATER

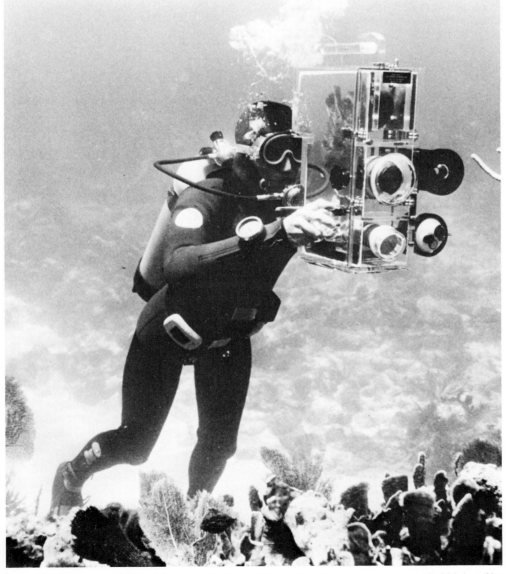

**Illus. 8.1** Filming on a Virgin Islands' reef with my 16-mm Beaulieu movie camera with 200-foot film magazine attached, custom-made Plexiglas housing by Harrison/Atlantic Plastics, dome port, 5.9-mm Angenieux T/2 lens, Schulke/Klein 180° optical viewfinder. *Photo by Paul Dammann*

It is not an exaggeration to say that most people have been introduced to the undersea world via film. The early films of Cousteau and Hass, shown in theaters and on television in the 1950s; the adventures of Mike Nelson (actor Lloyd Bridges) in the TV series *Seahunt*; the UW TV documentary series of the *National Geographic* and Cousteau; and recent movies such as *Blue Water—White Death, Orca,* and *The Deep* have shown us both fact and fiction underwater.

There is a big difference in quality between most amateur and sport diving films and professional UW films, which are extremely expensive to produce and shoot. Even amateur UW filming is very costly.

In a 1977 survey by *Skin Diver* magazine 90 percent of all divers surveyed owned one or more cameras. Of this number, 30 percent owned UW cameras, and of those who owned UW cameras, 10.2 percent owned 8-mm or super-8-mm movie cameras and 1.5 percent owned 16-mm movie cameras. Though in 1977, only about 12 percent of divers are filming underwater, amateur interest in UW movie making has grown as the income level of the hobby diver has risen.

Many of today's professional cinematographers started by first doing UW still photography or small amateur films, shot first for personal interest, then for UW film festivals, and finally for professional screening.

Many of the technical explanations in previous chapters about still photography apply equally to UW filming, therefore I will not duplicate them. Since still photography is just that, *still,* and filming shows movement, there are some tools and techniques that pertain specifically to filming underwater. There are also direct visual differences.

Still photography shows one subject at a time. You may or may not look at one picture in conjunction with another. You may arrange pictures in a sequential order to show to friends with a slide projector. Since each slide is separate, it is easy to eliminate inferior photographs and sort them about into different sequences, depending on your audience and the length of time you have to show your slides or black-and-white photographs.

Film, on the other hand, is continuous. Objects move in film. You can arrange the sequences or film scenes by editing, but this technically is a time-consuming operation and is not practical.

Here are a few good, inexpensive books on beginning film making:

1. *Home Movies Made Easy* (AD-5) Eastman Kodak, 1974. 8 mm and super-8 mm.
2. *Underwater Movies* (AD-15) Eastman Kodak, 1975. 8 mm and super-8 mm.
3. *Guide to Film Making** by Edward Pincus, New American Library. An elementary guide to all aspects of film making. The basic beginner's handbook (for 16 mm) from choosing the camera to screening the movie—a complete and practical production manual for the student, the teacher, and the independent film-maker.
4. *Film-Making** by Barry Callaghan. Van Nostrand Reinhold. For amateur film-makers or newcomers to professional film units.

The books referred to are primarily about film making with 8 mm and super-8 mm, which is the film size most commonly used by amateur photographers. It's a simple matter of economics. The smallest acceptable film size in professional work is 16 mm. The costs of everything when shot in 16 mm more than double when you consider the expense of film and processing. The 16-mm cameras and lenses will cost anywhere from 4 to 10 times more than comparable super-8-mm gear. Because super-8 mm has become the dominant size in the smaller format, super-8 mm will be discussed most in this chapter.

*These two books can be obtained from the publisher or Birns and Sawyer, Inc., 1026 N. Highland Ave., Los Angeles, California 90038.

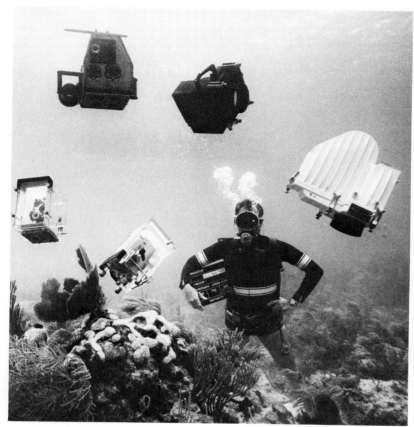

**Illus. 8.2** Professional UW filming can become very expensive. Jordan Klein poses on a reef surrounded by just a few of the specialized movie housings that he needed to shoot the UW sequences for the feature film *Hello Down There*. A professional UW cinematographer like Jordan Klein usually owns his own UW movie gear and, in Jordan's case, designs all the housings as well himself. The housings here are three 35-mm/16-mm aluminum housings, and two Plexiglas 16-mm housings. These housings with their enclosed cameras can weigh up to 100 pounds on the surface, but Jordan weights his so that they float weightless when underwater. It is important with larger housings to have them properly weight balanced so that you can move the camera about with ease. These housings are so perfectly balanced that he can let one go and it will just hang right where he put it (when there is no UW current). *Taken for* Life *magazine by Flip Schulke*

As in the earlier chapters on still photography, I shall first discuss the easiest types of UW movie making and then proceed to some explanation of semiprofessional and advanced amateur UW film making. So that you understand my terminology, when I speak of "film" or "filming" I mean using a movie camera. When I say "photograph" or "photographing" I mean still photography.

Lighting must be continuous for filming, and therefore when artificial light is needed in UW film making, some sort of continuous light source must be used.

First I shall acquaint you with current camera and UW housing combinations.

## SUPER-8-mm CAMERAS, HOUSINGS, AND FILM

Your selection of a super-8-mm movie camera for UW filming is dependent on the availability of a UW housing to fit it. Compared with still photography, there are a very limited number of "off-the-shelf" housings available in the United States for UW movie cameras. Farallon/Oceanic Products and Ikelite Underwater Systems make custom equipment for super-8-mm cameras. If you write to them, they will let you know whether your particular camera will fit into their custom housings.

8-mm cameras are manufactured with close-up, or macro, capability, more UW lens correctors should become available. These correctors for super-8-mm cameras when used underwater will provide for greater angle of coverage as fully described in the discussion of UW optics in Chapter 2.

## Kodak XL Super-8-mm Movie Cameras

The XL series of Kodak movie cameras can be accommodated in Ikelite Underwater Systems molded plastic housings. Both the zoom or non-zoom models work well underwater. All the XL cameras have a 230° shutter opening, yielding 40 percent more exposure than conventional shutters, which combined with the camera's $f/1.2$ lens, enables it to film in very low levels of light. These are the cameras that pioneered the low-light super-8 camera trend and that have consistently provided exceptional results even compared with more sophisticated cameras. They have automatic CdS exposure control. Composition is aided by use of an optical viewfinder.

Designed for the Kodak XL cameras, two housings fitted with special wide-angle lenses as part of the UW housing are sold by Aqua-Craft and are known as Novatek optical housings. One model permits a 90° angle of coverage and the other a 130° angle of coverage underwater. Both units yield movies that are sharp and clear from a few inches in front of the lens to infinity. But note: zoom control is not compatible with the wide-angle lenses in this Novatek system. The Novatek lens, in conjunction with the Kodak XL lens, exhibits some barrel distortion, but not enough to be distracting in UW filming. The same two optical housings are designed to take the Minolta XL movie camera also. Since these housings give such a wide angle of coverage—and it is difficult to see the whole viewfinder frame directly through your face mask and UW housing—I suggest

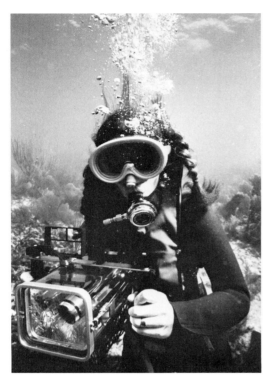

*Illus. 8.3* The Kodak super-8-mm model XL 330 movie camera in Ikelite housing. Focusing can be done through the lens-integral-camera viewfinder. Viewing the full format must be done through an open-type sports finder (as in picture) or more accurately through an optical viewfinder. *Photo by Flip Schulke*

All movie camera housings call for an external viewfinder, the best for UW filming being an optical viewfinder. An optical viewfinder will show you action outside the camera's format, enabling you to preplan the entrance of a fish or diver into your camera's frame.

The UW housings currently sold offer lens-refraction correctors (dome correctors or other lens-widening systems) only as custom installations. The off-the-shelf housings for super-8-mm cameras come with flat ports as standard equipment, with the resulting loss in angle of coverage due to water refraction. As more and more super-

accessory optical viewfinders as an aid in accurate composition.

## Canon Super-8-mm Cameras

Other popular super-8-mm cameras for which you can obtain suitable housings from Ikelite Underwater Systems, or Farallon/ Oceanic Products are the Canon series. The 512XL and 814 electronic model cameras add the capability of macrophotography 1 inch from the lens. UW controls are provided for shutter, focus, and power zoom. Bolex 350 and 233; Eumig Mini 2, 3, and 5; and the Minolta XL 250 and XL 400, are other cameras for which off-the-shelf housings are available.

An excellent super-8-mm camera-housing combination is available in Europe, the Silma Nautilus designed specifically for the Italian Silma line of macro movie cameras. This is an example of a housing that was designed completely around one manufacturer's movie cameras. Robert Bosch makes a similar housing for the German Bauer C5 XL macro and the C 107 XL models of super-8-mm cameras. Again, as with the Silma units, these Bosch/Bauer UW rigs are available only in Europe. These UW housings are known as the Bauer Aquarius.

## Fujica AX 100 8-mm Movie Camera

This camera and housing were designed for each other and are readily available for purchase in the United States. This Japanese import has a wide shutter and a very fast $f/1.1$ taking lens. It is a CdS EE automatic exposure movie camera, with a range from $f/1.1$ to $f/16$. It comes with an accessory closeup lens, so that you must decide on closeups or longer shots before starting your dive. It also comes with an "open-type" sports viewfinder. Purchasing an accessory optical viewfinder would be an improvement for more accurate viewing and composition.

## Super-8-mm Films

Movie film for super 8 mm is quite limited. Kodak makes

- Kodachrome 40 (40 ASA). This film is balanced for tungsten artificial light. It can be used with an 85 filter (built into many super-8-mm cameras) with a resulting ASA in daylight of 25.
- Ektachrome 40 (40 ASA). This film is balanced for tungsten artificial light. It can be used with an 85 filter with a resulting daylight ASA of 25.
- Ektachrome 160, type G (160 ASA). This film is balanced for daylight.

I prefer to use Ektachrome 40, giving me an ASA of 25 when I use the 85 filter for shallow clear-water and bright-sunlight filming. When going deeper (below 15 feet), I use Ektachrome 160, type G, daylight-balanced. The Ektachrome 160 type G is extremely fast, and with the 230° shutters available on many newer models of super-8 movie cameras, one can take films underwater in quite dim light. Remember, because you lose the warm colors below 15 feet, in order to restore accurately the color of tropical fish and coral below this depth, you need artificial light. This calls for the constant type of flood lighting, which will be discussed later in this chapter.

For those of you who want to shoot black-and-white super-8-mm movies, Plus-X reversal 7276 with a daylight ASA of 50, and Tri-X reversal 7278 with a daylight ASA of 200 are manufactured by Kodak, but you will probably have to have your photo store special-order it for you, as there isn't much call for super-8 black-and-white film these days.

## 8-mm Film

Movie film in 8 mm is even more limited.

Kodak makes

- Kodachrome 25 (25 ASA). This film is balanced for daylight.
- Ektachrome 40 (40 ASA). This film is balanced for tungsten artificial light. It can be

used with an 85 filter, with a resulting ASA in daylight of 25.

Fuji makes

- Fujichrome RT 200 (ASA 200). This film is balanced for tungsten artificial light. It can be used with an 85 filter, with a resulting ASA in daylight of 160.

But note: Kodak, Fuji, and other film companies make sudden changes in their films, so it is best to check with a reliable photo store to see the latest super-8 and 8-mm film offerings from these film companies. Fortunately, they seem to make new films compatible with the automatic ASA settings of most movie cameras.

# 16-mm CAMERAS, HOUSINGS, AND FILM

## 16-mm Cameras and Housings

The 16-mm cameras considered to be advanced amateur to semiprofessional and units generally considered to be completely professional are described in the following pages. Professional units usually cost more than the amateur units do. The lines of usage are blurred, however, for sequences in professional theater and TV films have been filmed with the less expensive "amateur" units. These units are less versatile, and usually do not have provision for film loads in excess of 100 feet. On the other hand, they are often smaller, more portable, and easier to fit with UW commercial housings, rather than the one-of-a-kind or custom housings.

**The Bolex marine housing** / Manufactured by Bolex-Switzerland, it is a long-time favorite of UW movie makers. Though I could not obtain information on current manufacture of this housing, a great number have been made, many of which are on the used-housing market. They are beautifully manufactured with great technical care and have stood the test of time. They were designed

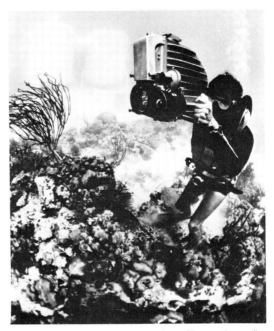

**Illus. 8.4** Aquanaut Frank Pugliese films with Arriflex 16-mm camera, 400-foot film magazine, in a Birns and Sawyer cast-aluminum housing. 16-mm aluminum housings that contain surface movie cameras often are quite bulky, owing to configuration of camera and film load. The cameraman was photographed at a depth of 50 feet in the U.S. Virgin Islands. A UW laboratory called Tektite can be seen in the background. *Photo by Flip Schulke*

for the Bolex H-16 cameras and have flat lens ports. Most H-16 models will fit into these housings, perhaps with a little modification of housing controls. One is limited to 100-foot film rolls, and although the housing comes with an open-type sports viewfinder, an optical viewfinder can easily be fitted in place of the open type. The camera is spring-wound, and in this day of dependence on batteries, it's nice to be sure that the film will move forward, as mechanical spring winding is almost fail-safe. As the Bolex cameras have a rather short wind, you cannot shoot long scenes. Look in your dive shop and camera store for one of these reliable housings.

Ikelite Underwater Systems makes a stock housing for the Bolex H-16 cameras. But

owing to the assortment of lenses and models, Ikelite, in order to do the fitting, must have your Bolex camera with its lens or lenses for five days. The standard installation comes with a flat port, but custom dome-corrector installations can be made to accommodate wide-angle lenses (10 mm and wider).

**Kodak K-100 camera** / This 100-foot load-spring-wound 16-mm camera was manufactured in large numbers by Eastman Kodak until the early 1970s. It came in a three-lens-turret and a single-lens model. Since it did not have reflex viewing, it was not as popular as cameras with through-the-lens viewing. There are still many of these K-100 cameras in existence, and since they are very easy to get repaired, they make an excellent 100-foot-load UW camera when combined with a 10-mm or even wider lens. The K-100 is a favorite among spring-wound 16-mm cameras because one can get 40 feet of film on one winding of the motor.

Farallon/Oceanic Products still manufactures a very good cast-aluminum housing for the K-100 camera. Since lenses and models vary, this housing is a custom installation. Both flat and corrected dome ports are available. Oceanic offers an optical UW viewfinder for the 10-mm lens mounted in their housing.

I purchased a K-100 housing from French Underwater Industries (no longer in business). It is aluminum and similar in size and shape to the current Farallon/Oceanic Products unit. I then bought a used turret K-100 for about $200 and had French install an *f*-stop gear and control arm for a C mounted T/2 Angenieux 5.9-mm wide-angle lens. A corrected-dome port was fitted to the lens. This gave me an extremely small UW 16-mm camera rig, which was a significant factor in successful filming of action and wide-angle UW TV sequences. I mounted one of my own 180° optical viewfinders with a masking frame corresponding to the angle of coverage of the 5.9-mm lens, which is 94° when used in conjunction with a corrected dome port. It is still my favorite UW movie camera, since it is so maneuverable and easy to swim with.

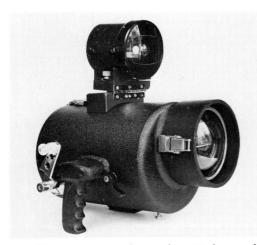

*Illus. 8.5* My custom-made cast-aluminum housing for the Kodak K-100 16mm (100 foot capacity) camera. This camera-housing combination is extremely compact and easy to swim with. I designed a method of parallax control for the optical viewfinder so that almost perfect framing is possible even in fast-moving action scenes. My favorite lens with this system is the 5.9-mm Angenieux T/2 wide-angle. With the dome port I get an effective 94° angle of coverage underwater. *Photo by Flip Schulke*

### A TIP ON EXTREMELY WIDE-ANGLE LENSES FOR 16-mm CAMERAS

Besides the 5.9-mm Angenieux lens, a much less costly American-made lens of very high quality is now available. Century Precision Cine/Optics manufactures and sells directly a 5.7-mm *f*/1.8 Century extremely wide-angle lens for 16-mm movie camera use. It, like the 5.9 Angenieux, exhibits no pincushion or barrel distortion and fills the 16-mm format film frame without vignetting. This Century lens comes in C or Bolex RX mount and has a universal fixed focus from 12 inches to infinity; no focusing underwater is necessary. With a corrected dome port, the angle of coverage would be 100°. Underwater this extremely wide-angle lens is as good as the Angenieux at a great monetary saving.

**Canon 16-mm Scoopic movie camera** / A lightweight camera with a 100-foot load capacity and fully automatic exposure with manual override. It has a built-in 12.5 to 75-mm $f$/1.8 macro zoom lens and shoots at speeds of 16, 24, 48, and 64 fps. It has automatic film loading, SLR viewing, and uses NiCd rechargeable batteries. It costs about $2000 or more. The disadvantage of this particular camera is that the zoom lens is built in (cannot be exchanged for an extremely wide-angle lens), and therefore one is limited to the angle of coverage of an $f$/12.5 lens behind a flat port. (I don't suggest trying a corrected dome port with this particular zoom lens.) Ikelite Underwater Systems stocks a housing for the Canon 16-mm Scoopic, but your camera must be custom-installed, which takes five days at the factory. Because your face mask will keep you from seeing more than a small part of the SLR viewfinder through the housing and camera's viewfinder system, an accessory optical viewfinder is advised.

**Beaulieu R16B movie camera** / It has a 100-foot load capacity (200-foot daylight load in separate accessory film magazine), SLR viewing, and variable speeds from 16 fps. The light meter is built in (needle is read in SLR viewfinder system). But note: The light-meter needle cannot be seen through the SLR viewing system underwater, so it is best to set the $f$-stop manually by measuring exposure with a UW light meter. It uses NiCd rechargeable batteries to operate the film advance motor and will take any C mounted lens. This camera is considered to be a "semi-professional" camera and with a wide-angle lens will cost $1500 to $2000, depending on the equipment purchased.

I own one and find it a good camera with the 200-foot magazine, for use with a 10-mm or longer lens, for medium-distance and closeup filming underwater, since I can see just enough through the SLR viewfinder

to focus these longer lenses. The camera with the 200-foot magazine is large, necessitating a large housing. Ikelite Underwater Systems offers a custom housing for the Beaulieu. As usual, you must send your camera and lens to the factory for installation.

## 16-mm Film by Kodak*

- Ektachrome MS 7256 (65 ASA). This film is balanced for daylight. I feel that this film is the best choice for UW 16-mm color photography. It has the added contrast and color saturation needed for bright UW color filming.
- Ektachrome EF 7241 (160 ASA). This film is balanced for daylight. Best for use in very dim light, the color saturation balances well with Ektachrome MS, but this film, owing to its fast speed (ASA) is considerably more "grainy" when projected.
- Ektachrome EF 7242 (80 ASA). This film is balanced for tungsten artificial light. It is the best choice for UW night filming, in which the only light source is tungsten artificial "constant" movie lights.

## PROFESSIONAL UNDERWATER CAMERAS

These cameras and housings can cost from $5,000 to $20,000, depending on camera and housing combined. I will list those cameras and housings that I am acquainted with, along with one amphibious 16-mm UW movie camera originally designed for the U.S. Navy. A detailed description of these units is beyond the scope of this book, but I would like to give thumbnail sketches for those of you interested in what the small group of UW movie specialists use.

**Eclair ACL 16-mm Camera** / This extremely professional 16-mm camera, with a 200- and 400-foot magazine capability and

---

*16-mm movie film is loaded in different lengths (100, 200, 400 feet) by the factory and on different spools and windings (inside wind or outside wind). You must check the instructions with your own 16-mm camera or film magazine to be sure to purchase the proper length, spool, and wind.

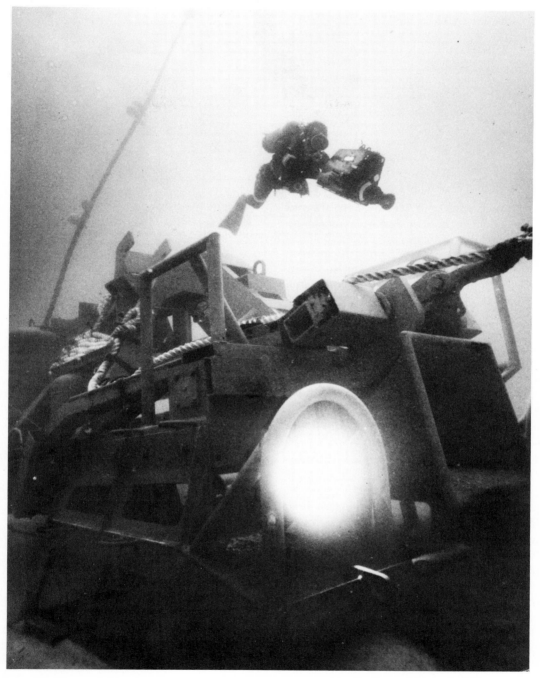

***Illus. 8.6*** *(A cropped portion of a fisheye 180° wide-angle lens photograph)* A UW A.T. & T cable-laying machine is typical of the large objects that a professional cinematographer is called upon to document on film. Jordan Klein uses one of his Mako 35-mm Arriflex rigs to make a television commercial. *Taken for* Life *magazine by Flip Schulke*

lens interchangeability operates on rechargeable NiCd batteries. A sturdy cast-aluminum housing pressure tested to a 200-foot depth is manufactured by Image Devices, Inc., who offer the following accessories: magnified reflex viewfinder, optical viewfinder, corrected dome optics for wide-angle lenses, UW leak detector, out-of-synch warning light, and pressure release port. This rig is one of the smallest camera and housing units for UW photography, considering the 400-foot film capability.

**Arriflex model 16M 16-mm camera and Arriflex 35 mm** / The Arriflex movie cameras are fully professional units with fully professional prices, since they have been designed for surface theater, documentary, and TV filming. Custom housings are manufactured by Jordan Klein-Mako Engineering. Accessories include full-frame magnified reflex viewing, the largest image optical viewfinder on the market today, corrected dome optics customized for any specific wide-angle lens, and corrected dome optics for Panavision lenses. For anyone considering a camera and housing of this type, it is tailor-made to his own particular needs and specifications by the factory.

**Teledyne DBM 9-1 16-mm amphibious UW movie camera** / The 9-1 is a superior-quality 16-mm motion picture camera for professional UW filming, the current Rolls Royce of UW movie cameras. This camera was originally designed and manufactured for the U.S. Navy and is currently sold by the manufacturers, Teledyne Camera Systems, on special order. It is truly a "dream" UW movie camera since it was designed specifically for that purpose. It features a 400-foot film magazine contained in quick-change plug-in units—16, 24, 32, and 48 frames per second. It has an adjustable shutter from 18° to 140° and NiCd rechargeable batteries, with state-of-charge indicator. It is *not* a reflex viewing camera and is designed around one lens, a Leitz/Canada Elcan

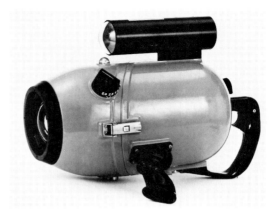

*Illus. 8.7* The DBM 9-1 is one of the best examples of an amphibious UW movie camera designed specifically for UW filming. Manufactured by Teledyne Camera Systems, this 400-foot-film-load, 16-mm camera comes with a Leitz/Canada Elcan water-contact 6.6-mm $f/2.4$ lens giving a UW angle of coverage of 76°. Of cast-aluminum construction, designed to stand up to rough-water conditions. *Photo courtesy Teledyne Camera Systems.*

water-contact 6.6-mm $f/2.4$ UW designed lens, giving an angle of coverage of 76°. Both 13 mm and 28 mm UW Elcan lenses are also available on special order. It is equipped with a leak detector and automatic footage indicator visible underwater. Accessories include an optically matched viewfinder. It is certified for operation at depths from 300 down to 450 feet.

## ARTIFICIAL LIGHTS FOR UW FILMING

The same problems of needing additional light for both exposure and color-balance correction exist with movie cameras underwater as with still photography. The problem is more difficult in one way as it takes a lot of electricity or battery power to give constant illumination to carry even the shortest distances underwater. There is a plus factor with movie lights, though, for you can see what effect the light will have on your subject—something that cannot be

done with flash or strobe since the light emitted from those sources is of too short duration for your eye to see its effect.

As a professional UW photographer I find that I prefer to use the constant movie light whenever I can (in my still photography also) because of the great advantage of seeing exactly where and how the artificial light should be placed for the lighting quality I want in my finished still photographs. Of course it also makes switching from still photography to filming underwater on the same dive quite simple, and, even better, the constant lighting enables the photographer to determine his exposure by consulting his light meter alone, just as he would do if he were shooting photographs and filming under ambient light alone. I shall add a few more advantages of constant light in creative UW photography at the end of the following list of movie lights.

## Portable or Battery-Powered Movie Lights

The handiest and least expensive type of UW movie lights is the battery-powered models. They range in power from 100 to 350 watts of illumination. Running power

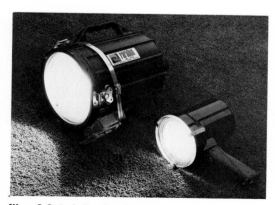

*Illus. 8.8* Left, Farallon/Oceanic Model ML 350 NiCd-battery-powered UW movie light. Right, 100-watt Ikelite modular movie light, NiCd-battery powered.

(full illumination) on one battery charge ranges from 10 to 30 minutes. Running time is much like figuring gas consumption in an automobile. It all depends on how you use the power. Continuous running will yield much shorter time than short on/off usage of the battery powered light.

**100-watt modular movie light** / Manufactured by Ikelite Underwater Systems, this light provides 3400° Kelvin cinema lighting coverage for a standard camera lens. Two modular lights can be used to obtain 100 watts of lighting power, and can be held or adjusted on a light bar to fill the angle of coverage of wide-angle lenses. It is powered by a rechargeable NiCd battery. Additional NiCd batteries can be purchased for this unit and exchanged between dives to increase the lighting time. The normal running time of one fully charged battery is 12 minutes. Recharging a battery pack takes 15 hours.

**100-watt PML movie lights** / Manufactured by Farallon/Oceanic Products models 100 and 200 provide 3400° Kelvin cinema lighting. The model PML 100 unit has a special battery pack of NiCd cells, which charge in 16 hours and provide 24 minutes of running time. The PML 200 unit uses a battery pack of D-size NiCd cells. These batteries reach full charge in 5 hours and run for 12 to 14 minutes per battery charge. Battery modules for each model are replacable and feature an internal hydrogen absorber, providing hydrogen outgassing explosion protection.

**350-watt Farallon/Oceanic UW movie light** / Provides 3400° Kelvin cinema lighting. Its adjustable beam width from a 20° spot to a 90° floodlight will cover most normal and wide-angle lenses underwater. It has a removable rechargeable NiCd battery pack, and a battery-charge meter visible underwater. The construction is cast aluminum and there is catalytic protection against hydrogen outgassing of the NiCd batteries.

It will run 16 minutes with the 350-watt bulb on one battery charge.

**350-watt IDI model UWL 1 UW movie light** / Manufactured by Image Devices, Inc., it provides 3200° Kelvin cinema lighting. A truly professional portable UW light, it is designed and built by a professional movie equipment manufacturer. The NiCd battery power supply cannot be interchanged in the unit. The unit will run up to 30 minutes if not run for long periods of time. The battery can be recharged overnight. The unit is of cast-aluminum construction and has been depth-tested to 600 feet. The angle of coverage of the light's beam is controlled by separate reflectors. The light reflector head is connected to the battery power pack by a UW connecting cord, with EO connections, that can be plugged and unplugged underwater.

## What You Can and Can't Do with UW Battery-Powered Movie Lights

These lights are quite portable and the batteries are easy to recharge, though most take 10 to 24 hours to reach full charge after being depleted. This problem can be solved by having more than one battery pack, so that you can replace batteries when one runs out, during a day's diving. But the major problem is their very weak illumination. They are excellent for illuminating night-diving filming, however, because there is no ambient daylight then and you can expose for the artificial lighting alone.

Filling in to restore colors in ambient light (daylight) situations is not successful except at very close light-to-subject distances, because the ambient light is so much stronger than the light output of a 150 to 350-watt movie light that you do not see the movie-light effects when your light is 2 to 3 feet away from the subject. Therefore it is good for macro-, or closeup photography, but for larger objects more than 2 to 3 feet away from your camera, movie lighting under-

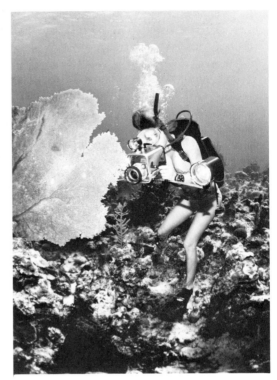

*Illus. 8.9* You can increase your movie-light intensity by using two lights. Mounting them on extension holding arms on each side will also give you more even coverage of the subject when you are using wide-angle lenses. The angle of beam of the movie light has not been designed for wide-angle use, but using two will give you the necessary wider angle of beam. *Photo by Gale Livers/ Ikelite*

water is a wasted effort. When using a movie light as a daylight fill, use a UW exposure meter to obtain the proper speed and *f*-stop, for close exposure. **Remember,** it is nearly impossible to bracket when filming, so it is important to arrive at the optimum exposure settings before you begin shooting underwater.

## 120-Volt UW Movie Lights

These lights give enough illumination (1000 watts) for use as fill and color-balance units 10 to 12 feet away from your subject matter. The 120-volt light itself isn't any more ex-

*Illus. 8.10* Diving partner Paul Dammann holds my favorite UW movie light, the Birns and Sawyer 1000-watt, 110-volt Snooper light. *Photo by Flip Schulke*

pensive than the most powerful battery movie lights. Then why aren't they more widely used? Wouldn't anyone prefer 1000 watts over 350 watts—with the added distance range of the more powerful light? Of course. But these lights, drawing 120 volts as they do, must be powered through thick waterproof cables connected to a portable electric generator in your dive boat, rated for 1500 watts or more. If you are a serious UW film-maker, and perhaps still photographer at the same time, as I am, then this is the ultimate solution to most UW lighting problems. Portable generators are not that expensive. You do need a strong back to carry the generator from home, to car, to boat, and back again, but the resulting UW photographs lighted in this manner are worth all the added work as far as I am concerned.

**A word of warning:** You are dealing with enough voltage to kill or injure someone if the lights and cables are not specifically designed and manufactured for UW use. I do not advise experimenting with or using "home-made" 120-volt lights and cables underwater!! I find the following equipment particularly satisfactory:

**1000 watt, 120 volt, Snooper light head and UW cable** / Manufactured by Birns &

Sawyer, Inc. The "DXW" bulb is color-balanced at 3200° Kelvin and is rated for 150 hours of illumination. It is contained in a cast-aluminum light head, with a thick glass dome port for a more even and wide angle-of-coverage beam. The light head is equipped with a handle or yoke for mounting. The manufacturer also offers a light head with both handle and yoke, so it can be either held by another diver or mounted on a camera holding arm (light bar).

The 14-gauge connecting cable has been rated to carry the power to two 1000 Snooper light heads. It is made of a tough, oil-and-corrosion-resistant material that retains its flexibility even after years of exposure to salt water. I have used Snoopers and this cable for more than 12 years without problems of any sort.

**500-watt, 115-volt, Hydroquartz model HQ 500 light head and UW cable** / Manufactured by Hydro Products. Utilizes a quartz iodide bulb, with a color balance of 3000° Kelvin and features a reflector design that provides an even and uniform wide-

*Illus. 8.11* Hydro-Products Model HQ 500, 500-watt, 115-volt UW quartz-iodide light. *Photo courtesy Hydro Products.*

angle illumination pattern of 100° x 100°, with no hot spots. Will operate to a 1000-foot depth. It is small and easily hand-held or mounted on a camera lighting bar. The bulb life is 500 hours.

**1000-watt, 115-volt, Hydroquartz model LQ 1000 light head and UW cable** / Manufactured by Hydro Products. This unit also utilizes a quartz iodide bulb, with a color balance of 3000° Kelvin and an illumination pattern of 90° x 90° with no hot spots. The bulb life is 2000 hours.

## Using Movie Lights Underwater

Whether to mount the movie light/s onto the UW camera housing using a camera holding arm (light bar) or to have your diving partner/s holding and aiming the movie lights at your subject is the major choice to be made when using movie lights for UW fill or as the main source of illumination. Mounting your movie lights on the UW camera is the easier, but not necessarily the better, of the two methods.

### Advantages of Mounting Movie Lights

1. You have direct control over the lights, since they are attached to your UW movie housing.
2. By mounting and aiming them you know they will always be pointing at your subject matter, no matter how you turn or aim the camera.
3. You can turn them off and on to conserve batteries (in portable units) at will.
4. You can mount lights on either side of your housing to illuminate a wider area; by the overlapping of the two beams, this coverage will remain constant.

### Disadvantages of Mounting Movie Lights

1. Backscattering of suspended sediment is the greatest negative factor of mounting movie lights directly onto your UW movie housing. Except for closeup movie photography, where the extension arms of the movie lights enable you to keep them at a 45° angle to your subject, the mounted lights will shine directly ahead like the twin mounted headlights of an automobile and reflect off particles in the water.
2. Since f-stop selection (exposure) is determined by the amount of light falling on your subject, the exposure and the color balance effect of

the movie light will vary as you move in and back from your subject. Therefore with mounted lights you are not able to use one of the best features of UW movie camera work, that is, the ability to smoothly swim in, around, over, and through a scene, with the movie camera running all the while. In surface movie photography this is called a "dolly shot." A dolly is a wheeled vehicle on which the camera is mounted, allowing smooth movement of the camera. Underwater you "dolly" by swimming. When you dolly underwater, with mounted lights, objects in the distance will appear blue. As you get closer and your movie light begins to illuminate the scene, the subject will intensify into actual colors (red, yellow, and shades of blue and green), but as you get too close the subject will "white out" from too much light. Then as you move away it returns to the blue water color again. Such sequences look as though a flashlight is moving over a scene, lighting up one thing at a time. This will look very artificial to the viewer of the film. How can you avoid it? Have your diving partner or partners hold and aim the movie lights. This is a more difficult method because you do not have direct control over the lights. It takes cooperation and practice for the dive partners to aim the lights where you are filming on a consistent basis. But this technique has many filming advantages.

### Advantages of Diving Lights Being Held by Diving Partners

1. You can position the movie light or lights exactly where the light looks best, and where backscattering is minimized. Preferably the combination diving partner and lighting man can hold the lights at a 45° or 90° angle to the subject's side or above the subject to simulate sunlight. The diving partner can keep a constant, known distance from the subject (even if it is moving), freeing the photographer to swim in and out. This method keeps the exposure ratio constant, since the light remains the same distance from the subject no matter how close or far away the camera is. With a little practice a good UW lighting partner can anticipate the photographer's turns and moves and keep a steady light on the subject. Using this method the lighting effect is not noticeable on the finished film, but the subject is illuminated and the colors remain constantly bright as long as your "swim-through," or dolly, doesn't take your camera more than 10 feet away from your subject in daylight-fill

situations. At night, when the artificial light is the only illumination, I have found that the light color will remain balanced when I film 15 to 20 feet away from the subject, even swimming right up to it and then away.

2. Since the lights are not attached to your camera, you can make better use of the intensity of the illumination given off by the movie lights. You can position the lights 5 feet away from your subject. Your camera can roam from 10 feet to 1 foot away from it, and your color exposure and balance will remain constant. With the lights mounted on the camera, when you are 10 feet away, even with 1000 watts of UW movie lighting, the light will have little effect in daylight-fill filming; it just will not carry that distance through the water.

3. You can get more even beam coverage when you are using wide-angle lenses, for the movie light can be moved farther away from the subject than your camera lens can. The farther away you move—within reason, remember that you will lose the effect of the light if you move it too far away—the wider the beam of light becomes. You can see both the width of the light and the amount of illumination it is giving to the subject, because you can *see* the artificial light. If you do move it too far back, you will see the light fade out and the colors of the subject turn to blue. Then you know to move the light closer. In fact you move the light with regard to the subject until the color looks right, the shadows are the way you want them, and the exposure intensity is correct. It is for this reason that I prefer to use movie lights in my still photography underwater also—I can see, beforehand, exactly what the light is doing to my subject. On the other hand, you cannot see the effect of strobe light until your still photographs are processed.

4. In the hundreds of instances in which I have used the diver-holding method I have not experienced any disadvantages. Why, then, is the mounted-movie-light method so common? I think it started because of the ease of handling mounted light(s) and housing by one diver-photographer. I have advised mounting other accessories such as the light meter and viewfinder onto the housing to keep them from getting in your way when swimming, as they would if attached to your person by tether cords. But the movie light(s) can always be held by your diving partner(s), and it is not a difficult technique for your diving partner to

master. All they have to do is keep the movie light pointed at your subject. They can see the light emitted from the movie light they are holding; therefore it takes no great experience or talent to keep it aimed properly. You can work out signals before a dive to let your partner know what the subject of your film is. **A tip:** In case your buddy misunderstands when underwater, just swim over, twist the movie light in his hand so it is aimed the way you want it, and your partner will quickly catch on to how he should aim the light.

## A Few Further Thoughts on UW Movie Lighting

I feel quite strongly about not mounting movie lights onto the UW camera housing. The reason is primarily the quality of UW photography. You are photographing something that exists, and you want to show it and its beauty in your film. Anything that intrudes as artificial looking will detract from the reality and beauty of the UW world. Natural and realistic lighting is one of the signs of the truly perceptive photographer. This naturalness in lighting has been slow to come, even in theater movies. Part of the reason is the purely technical problems of early film, lenses, and cameras. You just couldn't get an exposure without pouring high-intensity light directly onto the subject matter. I am speaking now of movie photography in general, not just UW filming.

As the design of lights, film, cameras, and lenses progressed, it was no longer necessary to pour light into the scene being filmed and get all those harsh shadows on the subject and the background. Naturalness of lighting has become a fine art in contemporary film making. One can go to a movie today and not be aware at all of lighting. It is toward this contemporary lighting naturalness that UW photographers should strive also.

You may remember when home movie making meant using a movie-light bar, which had the 8-mm movie camera mounted in the center of it and four to six high-intensity

movie floodlights inserted in it. You may also remember if you were ever a subject how hard the light was on your eyes and how much the resulting movies looked as if they were lighted with the headlights of an automobile. It was impossible for subjects pinned down by this blinding type of light to appear very natural.

Now, with the advent of the adjustable shutter for home movie cameras, beginning with the Kodak XL super-8-mm models and quickly followed by many other super-8-mm cameras, lighting bars are no longer suggested by manufacturers; instead you are told that you can take "natural" films with room lighting. You can do this because of the combination of the adjustable shutter and the new fast ASA color films. Just as the lighting bar has nearly disappeared from home-movie technique, this old-fashioned and unnecessary technique can be eliminated underwater. Just have your diving partner hold the lights.

## UW FILMING TECHNIQUES

### Camera Steadiness

The movie camera is designed to show movement, which can be subject and/or camera movement. If the subject is moving, either you can keep the camera in one place and film the subject moving through the scene, or you can move along with the subject. In either case, it is hard for the eye to follow any subject if the camera frame is jerking up and down. Camera movement of this sort ruins more home movies than any other single cause. On the surface the movie camera is placed on a tripod whenever possible, to minimize the camera movement caused by hand-holding the camera. Just as camera movement causes blurred photographs in still photography, camera movement causes blurring in a finished film and severe eye strain in watching it.

Actually, it is much easier to avoid camera movement underwater than on the surface. First of all, the UW camera in its housing is quite large, and any large object is retarded in movement through the water by the weight and resistance of the water environment. Second, you are swimming, not walking. Underwater swimming is a smooth movement, whereas walking when holding a camera is a jerky movement.

Hold the UW movie housing with arms slightly extended in front of you. Keep your eye (face mask) close enough to the viewfinder to see the proper framing but without touching it. This way the water will cushion slight movements of your body from the camera. If it touches your mask, any movement of your head will also move the camera, which may mar the film.

You should also practice smooth breathing, so that sudden inhalations and exhalations of air will not jerk your body enough to be transmitted through your arms and cause camera shake.

### Shutter Speed

If you have a movie camera with a variable shutter speed, try using one shutter speed slower than normal. This will slightly speed the movie action when viewed. Since movement underwater is slow, if you film at the normal feet per second (fps) your projected sequences will seem to take too long and eventually become boring to your viewers. The thing to remember about movie filming is that you get faster projected action when you slow the fps of the shutter. Conversely, when you speed the shutter, you will get slow-motion sequences when projected. You should use some discretion when using a slightly slower shutter speed. If your subject is a fast-swimming scuba diver, it may be best to use normal fps shutter speed, or the swimmer will look like Charlie Chaplin underwater. Slowing your shutter speed will

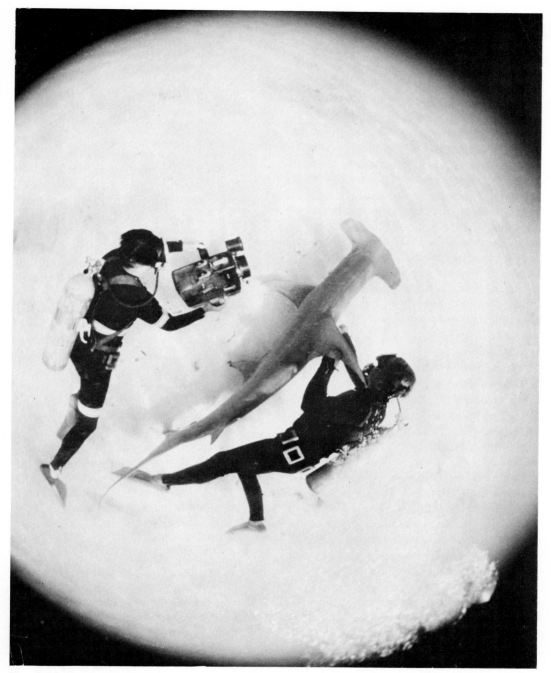

**Illus. 8.12** Handling large sharks, such as this hammerhead should be left to the professional UW stuntman. Jordan Klein films shark-handling expert John "Big John" McLaughlin for one of the *Flipper* TV shows. *Taken for* Life *magazine by Flip Schulke*

also give you a bit longer running time for your load of film.

## Framing— the Viewfinder Underwater

Framing for most UW movie cameras, especially super-8 mm, can be done only with accessory viewfinders. I have written at length about framing for still photography, about the advantages of optical UW viewfinders over the open-type sports viewfinder. Optical viewfinders are especially helpful in movie photography, because you are able to see the moving action outside the viewfinder frame. This way you can plan your camera movement while viewing and film fish and divers as they swim into the camera's frame, because you can see them in the optical viewfinder before they enter the lens-coverage area delineated by the viewfinder's reticule.

## Planning a Movie

For a movie film, no matter how short, to be interesting to the viewer, it must be preplanned. Otherwise you end up with a series of filmed scenes that jump from one subject to another, or from one angle to another that, when viewed on a continuous basis, just don't make any visual sense.

A film should have some sort of logical development. Since it is always viewed in order—one scene after another—because of the very nature of film projection—the photographer must bring some sort of order to his scenes, or everything appears disjointed. Since the UW world is alien to most viewers anyway, it can appear even more disjointed if shooting is not preplanned, since the viewer has little previous visual experience to relate to when looking at your UW film.

This preplanning takes the form of a script, or a listing in some sort of logical order of what you are trying to show underwater. The books that I have mentioned

earlier in this chapter will give you full details of scripting, and you can apply them to your own particular stage of film development when filming underwater.

You can film by the "seat of your pants" and hope to bring some sort of logical or visual order to your film in editing (selecting) scenes after shooting and when putting your film together. Professionally, this is known as cinema verité, or pure documentary filming. To get an acceptable finished film, it is generally conceded that one must shoot 10 times the amount of film that will end up in the finished, edited film. I have filmed this way, but someone else was paying for all the film I was shooting. Most of you will be paying for your own film, so by preplanning, or scripting, you can cut your ratio of shooting-to-finished viewing film to nearly 1 to 1.

In short, this means thinking about the who, what, why, when, where, and hows of your intended UW filming. List them, and follow the list so that you get as much as you feel is necessary to tell the story. The primary method of doing this is to vary subject and scene selection and then use the following camera angles in capturing these subjects and scenes:

When scripting you can note the camera angle (which refers to subject-camera distance) alongside the sentence describing the shot, such as:

1. LS (long shot)
2. MLS (medium long shot)
3. MS (medium shot)
4. MCU (medium close-up)
5. CU (close-up)
6. ECU (extreme close-up)

Varying these camera-distance angles makes the film visually more interesting and exciting. It also enables you to show the viewer the setting or scene and then close in on shots of the objects in the scene. We have all been visually influenced by both theater films and television, which use these techniques constantly. If you film only long or only medium shots, your film will put your

audience to sleep, because they have been conditioned to expect the visual contrasts of distance changes in movie film.

It is extremely easy to vary these camera-distance angles in UW photography because you are able to move up and down and in and out effortlessly by floating and swimming in the water. That is why a zoom lens is so valuable in surface filming, it enables you to move in closer to your subject without moving the camera. Underwater, however, you can use one set focal-length lens and glide your camera in and out, gaining the same visual effect as zooming without a zoom lens.

The problem of using a zoom lens underwater is that by zooming a lens underwater you do come in closer to your subject on film, but your camera remains away from the subject. Therefore you are shooting through a lot of water, both degrading your image and ruining color balance. Whereas by gliding in and out with the camera you also get closer to the subject, but as you get closer you are filming through less and less water separating the camera from the subject. Therefore your image remains sharp, color balance is bright, and you have one less control (the zoom control) to worry about as you are filming.

One wouldn't need zoom lenses in surface film making if one could somehow become weightless and could float in and out, to and fro from the subject. Underwater you are weightless, gravity has no effect, and a novice or amateur UW filmmaker understanding this complete freedom of camera movement with regard to angle and subject distance can film scenes that look as if they were taken by a professional surface cinematographer.

As a still-photographer primarily, I wouldn't dream of trying to film a professional surface subject without the help of professional film cameramen. But I have been able to jump directly into successful UW TV filming projects because the weightlessness of water does away with so many of the difficult professional surface movie filming techniques.

## Tips on Movie-Making

Watching television, with an eye to how sequences or shots are cut and put together will teach you more about editing than any words can.

Don't try to conserve film by taking very short sequences. Count at least 10 seconds every time you depress the camera's start button. It takes time for the eye and mind to comprehend what is being flashed on the movie screen. The biggest single error that novice film makers make is taking many shots in very short spurts. When viewed, it is impossible to understand what is being shown before the spurt is over, and another spurt appears. You can always shorten a filmed sequence by cutting it down in editing, but you cannot add onto a sequence after the fact.

Make your first UW film on the natural beauty that you see when you are diving in a good area; this can be done without scripting. Shoot at random. Such a natural-beauty film does not necessarily need a scripted, logical sequence. Then select specific subjects, research them (perhaps with a dive in the location before your filming dive), make a rough script, and you will produce an informative film that is a joy to look at and fun to project. More important, you will have a film that you can look at for years to come, bringing back all the memories of that diving trip.

Get a good book on film editing, because that's how good films are fashioned. By cutting out extraneous footage, then cutting and splicing the rest, you will end up with a film that you will be proud to project for family and friends, and you won't get groans of "Oh, no, not another home movie!!!"

# 9· THREE IMAGINARY PHOTO-DIVES

**Illus. 9.1** "Pieces of eight" from a sixteenth-century Spanish treasure shipwreck (1579) found near Grand Bahama Island, Bahamas. These early Mexican minted silver coins are called "cobs" because of their uneven edge shape, caused by shaving portions away until the coin weighed correctly. *Taken for* Look *magazine by Flip Schulke*

There are UW photographic tools and techniques that do not fit neatly into categories or chapters in this book. So that I can give you the benefit of a great deal of trial-and-error learning on my own part—to keep you from having to stumble along making the same mistakes, which can be very costly in terms of damaged equipment, cameras, lights, and other photo gear that won't work when you get to your diving site—I want to take you along with me on a series of imaginary dives.

Our journey will start with the general preparations before leaving home for a dive. Then we will proceed on an ocean-reef daytime dive, an ocean-reef nighttime dive, and a fresh-water (typical lake) dive. In my narration of these dives, the photographic situations described will be real, gathered from my own UW photographic assignments and experiences. But they are imaginary in that I shall compress many experiences into each dive. I shall be mixing shallow and deep diving experiences together. It will be obvious that it would be impossible to combine so much photography at so many depth levels in one dive. **In all diving below 33 feet, decompression safety tables should always be followed.** The dives described are only fictional as far as time underwater, depth, and decompression problems are concerned—all actual situations and UW photographic equipment and skills described are fact.

In these photo dives you will be my diving partner. This will give me a way to show you how diving partners cooperate. We will be using many methods described already in this book, plus a variety of new techniques and tips. Let's begin with the pre-dive preparations.

# PREPARATIONS FOR A PHOTO DIVE—Getting ready the night before

Since so much UW photography is done in saltwater and in the ocean, I make the following preparations the night before for such a dive.

## Check All Diving Gear

Check mask, flippers, scuba-regulator, air tanks, dive suit, BCV or safety vest, spare O rings for air tanks, small tool kit, and all other personal diving gear.

---

A note about diving masks. Many people need corrective eyeglasses to see. I'm quite nearsighted myself, and without my glasses everything 5 feet to infinity is a hazy blur. There are two major ways to achieve visual correction in face masks.

- Have your prescription lenses bonded to the inside of your face mask. This can be done by some opticians, especially those who have an interest in diving. *Skin Diver* magazine prints ads by opticians who offer to bond your lens prescription to masks they supply or to your own mask.

- Buy a Cressi-Sub mask. These Italian-made masks are the only masks in which plus or minus corrections are ground directly into the face-mask plate itself. I have used these masks for 10 years and have found them to be the best solution to eye-glass correction underwater. Until recently one had to get these masks by order from Cressi-Sub in Italy. Now, however, an American importer and dive store has taken over exclusive American importation of these masks, and they have more than 5000 masks with various corrections in stock. For further information about the Cressi corrective mask models, the "Lince," "Super-Lince," and "Pinova," write U.S. Aquanauts. If you have a particularly difficult prescription they can order your exact correction requirements from Italy.

One further tip for those of you who have bifocal problems. As you get older, you cannot focus your eye on things held close to your face. Photo equipment numbers such as $f$-stop, speed, and frame counters, are notoriously small and very difficult to read underwater with the Cressi optical mask. I have had my optician glue a very small magnifying lens at the base of the face-mask plate on the outside of the mask—one eye only. If you decide to do this, so that you can hold your UW cameras close to your mask to read the numbers through this magnifying "bifocal," be

sure that the optician installs a lens that is *twice* as strong as the one you need on the surface. The water coming in contact with this magnifying bifocal will cut its strength exactly in half. A small detail, but since I have had this magnifying bifocal glued in place, I can easily read all the numbers on all my UW photo gear—shutter speeds, *f*-stop, and the number of pictures I have left on a roll via the frame counter. The reason that the bifocal is mounted outside the mask is that, when it is mounted inside the mask, the edges will collect water bubbles when you rinse out your mask, distorting the vision through the lens.

## Check UW Photographic Equipment

- Check O rings of housings, Nikonos cameras, and strobes for any grit that might keep the unit from sealing. Check for cuts and scratches on the O rings. *Lightly* grease the O rings with a UW silicone lubricant. **Do not use spray silicone lubricants on any plastic, Plexiglass, or Lexan housings,** it will "craze" the clear plastic. Use only silicone lubricants from a tube. **Do not over grease,** it will only cause grit to stick to the O ring, causing future trouble.
- Operate all controls to see that they are moving smoothly. Use silicone tube grease on the control rods to make them turn smoothly.
- Mount your SLR inside your housing, to see that all controls are working properly.
- Mount the housing *f*-stop and focus gears on whatever lenses you plan on using with the SLR, and check to see that they are working correctly when the housing is all buttoned up. I store extra lenses, when I plan on using more than one, in self-sealing rigid plastic refrigerator storage containers. You can find round ones that will just fit around a lens snugly. These containers will keep all salt air and moisture from touching your surface lens until you are ready to put it on your SLR camera just before a photo dive.
- Run a flash-connection test by hooking up your strobes and/or flash gun to the camera housings and the Nikonos cameras. This will check all batteries and also confirm that all connections are in working order. Salt air and water can corrode electrical connections, and you can remedy this by sanding the connections with an emery board.

- Check all other batteries with a battery-tester, especially the batteries that power a motorized camera. If you don't have a tester, use new batteries, it is better than running out of "juice" while underwater.
- Recharge all Ni-Cd batteries. Always start a photo-dive expedition with freshly charged Ni-Cd batteries.
- Confirm that you have sufficient film for your planned dive, take the film out of the boxes and mark the type of film directly on the film-storage can. This will take up much less room and will cut down one more operation to be done in the boat at the scene of the dive.

I do not normally load my UW cameras with film the night before a dive. Film choice depends on weather conditions and needs to be done when I am on the scene for the best lighting and clarity. If the seas are very rough, I do try to load the cameras before leaving the dock on the day of the dive, especially if the dive boat is small.

Ocean diving almost always calls for working out of a dive boat. Some are big and roomy, some medium, and some are just skiffs with any available space at a premium. Storing and keeping your fragile photographic equipment safe from damage or saltwater—either from the rocking of the boat or the clumsiness of another diver—is a major concern.

I have tried many containers and methods of packing my UW photographic gear for dives. The more successful are listed below.

**A Large Heavy-duty Plastic Garbage Can with Tight-fitting Top** / This is my favorite container for use in a medium or large dive boat. I place a thick piece of foam rubber (2 inches thick) against the inside bottom of the garbage can. Then I wrap each piece of photographic equipment in separate color-coded terry-cloth bath towels, which cushion the gear. Since the SLR housings are the heaviest, I place the aluminum ones at the bottom of the cans; next in are the SLR plastic housings and strobes, and on top the Nikonos camera gear. I place

other circular pieces of foam rubber between the layers of photo gear. The film I am going to use I put into separate clear-plastic bags, separated by type of film, including extra bags for the exposed rolls that I will eventually remove from the UW cameras after each dive. I mark all equipment-storage garbage cans clearly on the sides and top FRAGILE—CAMERA EQUIPMENT so that fellow divers don't use them for trash.

I use a second garbage can for all of my diving gear: mask, flippers, weight belts, scuba regulators, BCV's, dive suit, and backpack. This one is clearly marked DIVE GEAR. These cans are easily placed in the back seat of my car when I am driving to a dive location from home.

When away on trips, I ship all the photographic gear in very heavy-duty fiberglas and wood photographic equipment cases that are foam-rubber-lined. These have been designed for the shipment of movie camera equipment and manufactured by Fiberbuilt. To be shipped efficiently in such cases most of the gear must be broken down into component parts. Once at the dive site I purchase (or borrow from the dive shop) a plastic garbage can or two—inexpensive insurance against equipment damage. All plastic garbage cans containing equipment must be tied down securely in the dive boat to avoid damage or loss in rough seas.

I am often asked "Why don't you just use the heavy-duty camera equipment shipping cases on the dive boat?" Salt water is the major reason. The salt spray, salt air, and crashing salt waves will corrode the metal parts of the regular camera cases. Then too, salt water will inevitably get inside the cases, permeate the foam rubber, later crystalize, and could scratch your equipment and lenses in days to come.

Many photographers make their own wooden camera equipment cases and line them with foam rubber. Wooden cases are a good solution, if you are a handy wood-worker—but you must be able to remove all the foam rubber after each dive, and wash out all the saltwater and salt crystals with fresh water.

My plastic garbage cans are easily washable, as are the foam rubber and the towels that wrap the equipment.

**A Medium-Sized Soft Dive Bag** / Normally used to transport dive gear, this is my compromise solution for use in a very small boat. Again, I wrap the equipment in color-coded towels, and separate them with pieces of foam rubber. You can stash a soft dive bag such as this in the nooks and crannies found in a small boat. If the seas are rough, I sit with the photo-gear dive bag held on my lap, so that my body will take up the shocks of the waves and sea pounding against the boat as it moves through the water. Again, as with my plastic cans, I have the dive bag for photo equipment well marked and I keep it in constant view so it won't be tossed about by fellow divers who tend to be rough on their gear.

Since I often share a dive boat when ocean diving with other divers, I find it useful (and good conservation of my valuable photo equipment) to talk to each one before embarking, telling him of my photo dive plans, and asking him to be careful when throwing wet dive jackets and shaking salt water from his hair, if I am changing film in the dive boat. During film changing equipment is highly vulnerable to water since the housing is open, exposing the surface camera or insides of the camera to the elements. I always give a good, loud shout to one and all when I am about to open a UW camera or housing or change film when other divers are entering or climbing sopping wet out of the ocean.

Most divers are happy to cooperate in protecting your UW photo gear. But it's up to you to explain *how* they can help.

# DIVE 1. OCEAN-REEF DAYTIME DIVE

Today is a sunny day, with good underwater visibility, at least at the beginning of our dive.

You and I suit up. A full dive suit and gloves are necessary even in tropical waters. Lengthy diving, in which you remain quite still as one often does in UW photographic diving, even in warm waters, will lower your body temperature. You need the insulation and abrasion protection of the suit. Coral can cut badly.

Check long, dangling straps. UW gear is designed to be worn by divers of all different sizes so straps come in one length—long. On all my personal gear I have cut the straps down, so only a small end sticks out of the buckles. Dangling straps can also be safely tucked out of sight behind other gear. I always carry my own weight belt—not the weights themselves, just the belt—cut just right for me in length. I can always rent the lead weights at the dive shop at my destination. I also carry with me my own tank back pack. Again, I can rent bare air tanks at the dive destination. Using this method, all dive gear will fit well, and there will be no dangling belt ends to ruin picture composition.

It is a calm day, so I unravel my equipment drop cord. This is a 20-foot piece of nylon rope that has brass snaps affixed about 2 feet apart, starting from the bottom of the cord. I tie this cord onto a safe place in the boat, and one by one lower the camera equipment that you and I plan to use on our dive—a separate piece of gear attached to each brass snap—into the water. You can buy this type of drop cord at Glenn Beall Industries, or you can make up your own drop cord from parts purchased at a boating store. The advantage of a drop cord is to free your hands to put on your diving gear. It is also dangerous to jump into the water holding photographic gear in your hands.

On a rough day I get one of the other divers to hand me my equipment after I am already in the water.

One word of warning about the use of a drop cord on a calm day. Be sure that the photo gear on the end of the cord will not touch the bottom or a reef underneath the boat. Take into consideration the rise and fall of the tide also. You don't want your costly gear bumping along coral or bouncing off the bottom. If your housings are weighted almost to neutral buoyancy in the water, attach a lead weight to the bottom of the drop cord and this will keep the photo gear from slowly drifting around or floating up and knocking against the bottom of the dive boat. And remember to tell other divers where your rope *is* so they won't dive on it and pull it up when the boat begins moving.

Just to make this dive easier, imagine that all different sorts of UW photographic gear are already attached to the drop cord and hanging beneath the dive boat; it will keep us from having to go back into the boat until the end of our dive.

## Subjects in the Ocean

**Divers Entering the Water** / Since they hit the water in many different manners, seen from underneath—looking up—divers will give you action silhouettes endless in their variety. This works well in either black and white or in color. Shoot it with your 28-mm UW lens and the Nikonos camera, or perhaps use a wider-angle lens (24, 20, 17 mm) with your SLR in a UW housing. Expose for the surface light if you want a silhouette of your subject. The more you stop down your lens, or use a faster shutter speed, the darker the sky will get in black and white and the deeper blue in color. If you expose for the subject (diver), you will completely overexpose, or wash out the color saturation of the water and sky showing down through the water. You may *want* to

*Illus. 9.2* A large grouper peers from his lair in an Indian Ocean reef. When possible, try to get fish photographs that place a particular fish in its environment. Constantly coming in very close in fish photography can result in photographs that look as if they were taken in a large aquarium tank, not in the open sea. Taken with Calypso camera, 21-mm Nikkor *f*/4 lens, Schulke dome adapter, Tri-X 400 ASA black-and-white film, sunlight exposure determined by UW exposure meter. *Photo by Flip Schulke*

have detail in the subject matter, and though this exposure technique can work successfully in black and white, it just won't produce a colorful slide.

**Sun in the Frame** / Another "looking-up" subject is the inclusion of the sun in the frame of your camera. This can be done with any UW lens and camera. The sun streaming through the water, reflecting off the suspended particles, resembles sunlight shining through fog, or through a humid forest of trees in surface photography. This technique (shooting up) is one of the most beautiful UW photographic effects. It can be used with any UW subject matter: swimmers, boats floating overhead, fish, coral formations, and underwater vegetation. When uti-

lizing this technique it's good to bracket exposures. Color film will see the sun's rays in a different manner than your own eye does. A lighter or darker exposure can sometimes be more dramatically effective than the "proper" light meter exposure.

## Reef Photography

At the shallower depths (1 to 20 feet) we find a chance to take overall reef shots, or shots of schools of fish. No artificial light is needed here on a bright sunny day. I note that you are using a CC-30 R filter for this ambient light photography. I'll take the same subjects without that filter, and we can compare the difference in color tone and

***Illus. 9.3*** The UW 28 mm on a Nikonos camera caught one of Cousteau's divers, Bernard Delmotte, exploring a virgin reef in the Indian Ocean. I liked the fish on the left and the diver on the right of the composition—though better separation of the diver from the coral would have been obtained had I been just a bit lower, so that his legs were framed against the water rather than the reef. One does not usually have control over all the moving objects underwater, so quick recognition of good composition and smooth operation of the camera's controls increase your chance of getting an outstanding photograph. *Photo taken for* National Geographic *magazine by Flip Schulke*

correction when we get the slides back from the lab.

Now you are using a fisheye lens on your Nikonos. Since the water is very clear today, using the fisheye lens (or a fisheye removable supplementary lens) will give you an extremely wide angle, and at very shallow depths (1 to 10 feet) you can convey through your projected color slides just how beautiful a sunlit reef can be, with the myriad corals and multicolored tropical reef fish. On a bright sunny day, it is possible to use Kodachrome color slide film, either 24 or 64, depending on your personal favorite of

the two. At 10 feet you will find all sorts of subject matter. Be sure you place yourself and your UW camera as low (hugging the bottom) as you can. Shoot up at a 20° to 45° angle. This will place the outline of the subject matter (reef, coral, fish, or diver) against the plain blue water background. In photography this is called "separation" of the main subject from the background. If your background is "busy" (full of detail and contrasting objects), it will tend to eclipse your foreground subject. Conversely, you will find that your photographic foreground subject will "pop out" at you when your

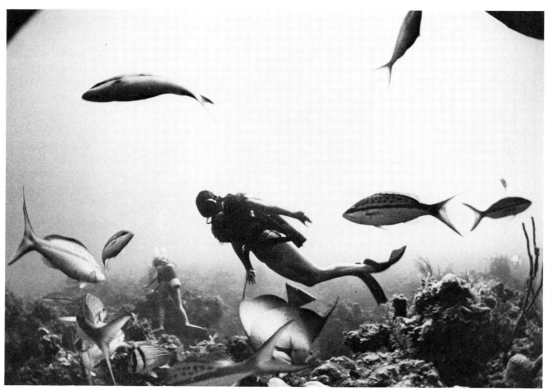

*Illus. 9.4* By cropping a 12-mm Spiratone fisheye lens photograph, nearly all the fisheye circular format is lost, and the extreme wide-angle view of fish and diver is retained. Many photographers react negatively to fisheye photographs because we are all more accustomed to a rectangular image. Careful cropping can remove the distracting circular frame, and the resulting rectangular photograph will still give an extremely wide-angle view of your UW scene, wider by far than the widest nonfisheye lens. *Photo by Flip Schulke*

background isn't fighting for the attention of the viewer's eye.

With your UW meter take a reading of the brightest subjects and the darkest subjects, selecting an *f*-stop exposure and corresponding shutter speed so the exposure will fall about halfway between the lightest and darkest areas of your scene. You will learn to refine your choice of *f*-stop and shutter speed as you gain more UW photographic experience. Until then, the safest way to insure good exposures is to bracket.

We call photographs that are darker in exposure "low-key" photographs. Brighter color slides are called "high-key" photographs. You will find, as I have, that slightly low-key color slides will have much richer (saturated) colors. Minute shades of color are lost in high-key slides. Sometimes, though, this bright look is what you want. Other times you may want dark, moody UW color slides. As you take more and more UW photographs—if you experiment with high- and low-key exposures, you will learn which subject matter—and what situations—lend themselves to more pleasing finished color slides.

Don't lay your photographic equipment down on the bottom or on a handy piece of coral. Any slight water movement will cause the equipment to move around, which can easily cause scratches to lens ports and other damage. Dome ports are especially vulnerable. Sand can also lodge around the

silicone-greased O-ring seals and control shafts. This sand won't cause any problem to the watertight seals of the housing, amphibious camera, or strobe on *that* dive, but there is a good chance that some of the grains of sand will work themselves in between the O ring and the O-ring-groove when you open the unit after your dive. On subsequent photo dives, these sand granules could keep the O ring from making a watertight seal, and your unit will begin to admit water. You risk permanent camera, lens, or strobe damage if such a leak occurs. Since sand is also suspended in water at times and other divers can kick up sediment with their flippers, it is always a good idea to check and clear the major O rings on your gear after each day's diving.

## Wide-Angle-Lens Subject Matter

Try using your Nikonos with its UW 28-mm lens for some medium wide-angle photographs. Remember that the Nikkor UW 28-mm lens gives you a UW angle of diagonal coverage of about 62°—what you would normally get with a 35-mm lens in surface photography. Your composition will be more accurate if you use an optical viewfinder with this Nikonos-28-mm lens combination.

Wide-angle lens subjects can include:

- Other divers
- Fish larger than 6 inches
- Larger pieces of coral
- Schools of fish
- Objects lying on the bottom, such as anchors, cannon, etc.
- Large plant life, such as kelp.

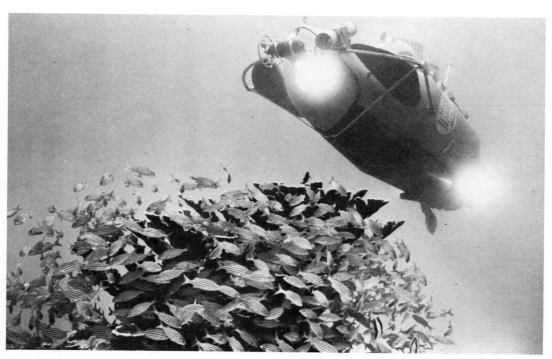

***Illus. 9.5*** Large objects such as submarines require the UW photographer to use the widest-angle lens at his disposal. The great inherent depth of field of a 20-mm lens (with a corrected UW angle of coverage of 94°) enables me to get the sub and school of fish in one photograph with both widely separated objects sharply focused. *Taken for* Ebony *magazine by Flip Schulke*

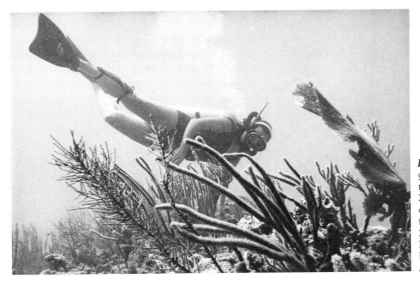

*Illus. 9.6* Filling a photograph's composition elements throughout the full 35-mm film format is accomplished most satisfactorily with the SLR camera. 24-mm wide-angle lens, Nikon-F camera, dome port, housing by Giddings/Felgen. *Photo by Flip Schulke*

The list is truly endless. In all my years of diving I have never run out of new and varied shallow reef subject matter to capture on film utilizing wide-angle lenses.

Now I'll use my UW shallow-reef favorite— a 35-mm SLR camera-housing-dome corrector UW unit, with a 24-mm lens. This combination will give me a UW angle of diagonal coverage of about 84°, or the same angle that I would get with the 24-mm in surface photography. I will have plenty of depth of field with this wide-angle lens.

Use your strobe or flash gun for artificial "fill-in" light; it is the most practicable and convenient artificial lighting method for most UW photographers. You may want to try a constant-light source as a means of lighting with still photography UW also.

Let's go back to the dive boat to change film in the cameras and rig for closeup macrophotography. **Take care not to leave your photographic equipment lying about the boat in direct sunlight.** The heat from the sun can cause moisture to condense inside the UW housing, causing droplets that can obscure the clarity of the housing's port, and even form a fine layer of tiny droplets over the camera lens itself. Shooting subsequent photographs through this "mist" of droplets will guarantee fuzzy photographs. Excessive heat build-up will also damage both camera and film. Check the information sheet that comes with the particular roll of film you are using. You will find warnings about heat causing color shift, and loss.

## Back to the Reef for Closeups

As we slip back into the water, with both Nikonos close-up systems and SLR housings with macro-lens attached, our photographic options are endless.

**Closeups with the Nikonos Systems /** Inanimate or very slow moving subjects abound by the thousands on a typical reef. This type of UW closeup photography will always give you a full roll of beautiful pictures (see *Plate 5*) if you look closely for subjects. Try staying in a very small area of a reef, perhaps 3 to 5 feet square. You could shoot dozens of colorful UW slides within such a small area and never repeat yourself. First there are the obvious corals, brittle and as soft as vegetation, endlessly varied in

graph (left) is the complete circular frame just as the lens put it on the 35-mm color film. This lens is so wide that it makes the diver appear to be quite a few feet away from me, when in actuality he was so close I could reach out and touch him on the shoulder from the same position the photograph was taken. The photograph (right) is a cropped version of the same fisheye photograph, getting rid of the circular format. *Taken for National Geographic by Flip Schulke*

cleared up, we are now deeper (about 75 feet) and the sunlight's colors are absorbed, leaving only blue. We need to use a flash bulb or strobe to light up this scene. I want to get as much depth-of-field as possible, so that I can come in very close on the coins and still see the treasure hunters in the photograph (see color insert, *Plate 13*). A fisheye lens will take in all of the scene. If I had my 15-mm Nikkor UW Nikonos lens it would do almost as good a job.

Here, you take the flashgun, hold it off to the left, so the sand the divers are kicking up won't backscatter light as much. Be sure you keep it out of the 140-degree range of the fisheye area of coverage. By your holding the light off to the side, and away from the subject matter, the light will throw a wide enough light beam to cover the whole 140-degree lens coverage area, and be relatively equidistant from the coins and diver with air-lift, so that the color exposure on both will be the same. Think that I will bracket anyway, who knows when I will ever get the chance to photograph real 16th century Spanish "Pieces of Eight" again. Using the flash or strobe will reintroduce natural colors, so that the whole photograph will not look "blue." I balance off the artificial light exposure with the daylight exposure so that the artificial light will not overpower the scene, and make it look like night, another reason for bracketing. At 75 feet and in cold water, making accurate exposure calculations is difficult. Remember, when you see a "once-in-a-lifetime" subject, shoot plenty of exposures and different angles. Film at this point is cheap.

Don't be afraid to motion to your subject to position himself for good photo composition. I find it difficult at times to communicate in these situations, so I place myself in exactly the pose I want my subject to assume, and then move over, motioning him to pose as he has just seen me do.

Dropping much deeper through the blue-green water, to 150 feet, we spot a 2,000-year-old Roman wreck, and piles of large clay amphora (jars). University UW archeologists are surveying the wreckage area. It is obvious that the pile of amphora is too large to light artificially. Lighting up just one or two in the foreground will leave all the rest in the background a different color, so the resulting picture will look very artificial. Using the light meter, I expose for high-speed color film and shoot with a 28-mm UW Nikkor lens on my Nikonos. The end product will be an eerie blue-green, but it

will show the whole pile of amphora (*see color insert, Plate 18*)—a compromise in color technique. It *would* be possible for a UW Hollywood movie crew, with a Hollywood budget, to artificially light the whole area, but such an idea just isn't practical for most of us.

I seem very happy and excited as we continue photographing the 2,000-year-old wreck, then I realize that I am beginning to think quite erratically. Ideas for different photograph angles are drifting into my brain at slow-motion speed.

At 150 feet we are being affected by *nitrogen narcosis* (NN), and this potential diving danger is something that underwater photographers must always be aware of, for safety reasons and because nitrogen narcosis will also affect your reasoning ability at depths, and thus affect the quality of your UW photographs.

NN affects each of us in different ways, but at 150 feet it *will* affect your brain and reasoning power. "Tunnel thinking" is very common, therefore when you are planning deep-water photography, try to simplify all of your photographic equipment, and only plan on taking a few photographs. Concentrate before the dive on these photographs, and how, technically, you are going to do them. Don't plan on being able to figure out all sorts of exposure and lighting variables at depth. I have found it best to list with indelible marking pen on gray tape affixed to my housing, those picture situations I can anticipate before the dive along with projected exposure, and/or flash *f*-stop information. Keep from having to deviate too much from your pre-dive photographic plans. You may be one of the rare ones, but I find all divers think and react very slowly at nitrogen narcosis depth. Always remember to keep track of your dive time, and don't let "just one more beautiful photograph" keep you down longer than your pre-planned deep-dive safety time table. I stress this for it

is *very* easy to do. For this reason, I do not recommend deep diving photography for any diver unless he or she has had a lot of diving and deep-diving experience and has been certified or trained for diving in the NN level. Remember too, nitrogen narcosis hits different people at different depths. I can feel the unmistakeable effects of NN at 125 feet, though most books say effects are first felt at 150 feet.

**No photograph is worth hurting yourself or your diving partner/s.**

So let's go back up to the boat; it's getting dark, and we can prepare for a night-dive.

# DIVE 2. AN OCEAN NIGHT DIVE

I am often asked what is the most exciting type of scuba diving. My reply comes with no hesitation—night diving. The ocean is alive with night creatures, for they have much less fear of predators swimming in the darkness. The sea takes on a different personality. Dark, foreboding, yet irresistible in its fascination. Completely different from the day, night diving has its own special photographic problems.

*Preparations*: This is not a scuba-diving instruction book, but I would be remiss if I did not mention a few safety considerations concerning night diving. Do not try to go night diving unless you go with other divers who all have experience in night diving. The best suggestion I can give to the diver who wants to try night diving is to get certified by NAUI, PADI, NASDS, or YMCA in night-diving techniques. A certified dive master will give you the added safety edge that can contribute to your personal confidence when you find yourself surrounded by pitch-black water. Night diving certification will teach you the special problems involved. It is easiest to go night diving when the event is organized by a dive shop. They will supply

the needed lights both to illuminate your way underwater and give you enough light to compose through the viewfinder and focus your camera.

Generator powered night-diving lights give off the maximum amount of light, but they restrict your diving to whatever length of cable the dive boat carries. Battery powered hand-diving lights are the most mobile light source.

Your diving partner should hold the diving light, so that you can either use a movielight or flash for artificial lighting.

Close-up/macro photography is the easiest to do at night, since with the Nikonos and its focus-viewing-distance frames, you have a known f-stop setting with this combination.

I like to use movie lights at night, for they act both as guide lights and exposure lights. I use Tungsten-balanced film with the movie lights at night when I want to get accurate colors of the fish since there is no ambient sunlight to contend with.

It is especially important to brief all the divers in your party so that everyone completely understands the plan of the dive. Your own diving partner should know when he will hold the light and when you will hold it for him, if he is also an underwater photographer. It is more difficult to signal at night; that is why a good understanding of what you are planning to do is necessary before entering the water.

*The dive:* As soon as you enter the water you will see it alive with a mass of swimming creatures of all sizes. I was able to make a tape recording during a few night dives. Excerpts from one made off St. John in the Virgin Islands will give you an idea of the excitement and photographic possibilities that confront you at night.

"I can see hundreds of fish, all swimming around in a frenzy because they can see in our dive lights the tiny fish that they live on, prey on, gobble up. There go 12 to 15

tarpon, it would drive a game fisherman nuts to see so many, swimming back and forth feeding. It's beautiful to see them swimming and eating in their own home, better than on the end of a hook. . . . Here come some more tarpon, with their low underslung jaws, shooting up and nipping at the little fish, rushing about in twos and threes chasing the same fish. With each movement of their bodies the tarpons' scales reflect a different color from our dive lights, the silver turns to purple, to green, to orange, blue, every color of the rainbow as they swim and turn. . . . I can count the scales on their bodies as they flash within a foot of me. One is coming by right now, there he goes, you can see each scale, you can see his tail fin, you can see his eye as it glows in our lights. I hope my pictures will show the luminosity of the tarpon's scales. They're bright glistening silver, the silver has a shade of gold in it, as they turn they look like animals made of beaten sterling, no exaggeration.

"There goes an amberjack snapping at a small fish, grabbing him, sucking him in . . . another one, right into his mouth. . . . All around the diving lights themselves are little yellow reef fish, hundreds of them. I'm sure they are attracted to the microscopic organisms which are themselves attached to our lights. They look like French grunts or blue-striped grunts. . . . I wonder how many people have ever seen snapper in their night haunts, getting their food. The yellow grunts ebb and flow with the movement of the water, all schooled together.

"It's so fantastic and unreal at night underwater, it's nothing like going to an aquarium, it's nature on the loose. I could stay down here for hours watching the fish. They swim in different ways. I watch how they use their fins, how they suddenly wheel, turn, and remain motionless for an instant. Our lights are giving them a chance to see their prey a lot better; they wheel and turn like a pack of jet airplanes. . . . Hey, look, there's some

squid, about 3 to 4 inches long. There are about five of them.

"As my diving partner swims up with the underwater lights I can see some beautiful images in the viewfinder as the squid change color in front of my eyes. First a transluscent white, then orange, ending up bright red. . . . Thousands of tiny bait fish have descended on us; I can hardly see Paul. The bait fish move like a giant cloud, back and forth; they all move as if they were one, couldn't be more than an inch long each. . . . The dive lights seem to slow down the fish, even to the point of dazzling them, making them tame. . . . The dive master is signaling that the dive is all over, got to get back to the boat, still have plenty of air, wish I could stay down all night, know I can't, wish I could!"

Probably the biggest problem in night diving is that there are so many subjects at which to point your camera that you can begin to shoot too fast, and in all directions, without taking care to check exposure, distance, focus, etc. You must discipline yourself to take time, set your camera and lights properly, and don't let the wealth of subject matter and breathtaking beauty overcome your need for practicing good UW photo techniques.

Because of the difficulty in working in the darkness—the dive lights cannot be turned on you whenever you desire to see the control numbers of your UW camera—you need to have your own small flashlight, to enable you to see and set your camera controls. Helmet-type lights that can be worn on the head are available, thereby freeing your hands for the camera and its controls. Write distance vs. exposure settings down on grey tape, with a sharpie pen (it's indelible) before you dive. It will make exposure figuring simple when underwater.

Night diving is another good place for utilizing two artificial light sources. Use either a camera strobe and a partner-carried slave strobe for this, or two movie lights. As men-tioned in Chapter 8, movie lights (battery) powered) will only give from 10 to 15 minutes of continuous light, but they will last for a much longer time, at very near full-light output, if you turn them on just before photographing, and turn them off right after snapping the shutter. I easily get an hour's worth of night-photography light from battery powered movie lights using this "off again," "on again" method. With movie lights, since they are a constant light source, you can see what you are going to get on your film, I can't stress this point enough.

Back to the dive boat, pack up your gear carefully for the return trip back to the dock. Don't try to change the film in your cameras now. There will be plenty of time once you get back home or to your motel if you are on a dive vacation.

## Back Home, After a Dive in Salt Water:

I have covered in great detail the need to *soak* all of your UW camera gear in *fresh-water*. Do it, and you will insure a much longer life to your gear and substantially lower the risk of salt-water and moisture damage to your housing's metal parts. Don't let your photo gear sit all night without the fresh-water soak. You'll be dog-tired from the day's dive, but you will save yourself a lot of money and grief in housing and camera repair if you don't go to bed before getting all that ocean salt off your photo gear.

## DIVE 3.  A FRESH-WATER DIVE IN DAYLIGHT (lake or river)

This will be a fresh-water dive, the preparations of your camera (and diving) gear should be the same as outlined at the beginning of this chapter.

I have described operating out of a boat, but now we shall just walk right off the lake's

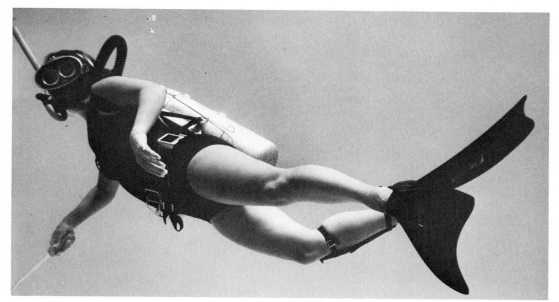

*Illus. 9.12* The human body assumes so many different positions while scuba diving, and there is such a variety of diving gear, that diver photographs never seem to look the same. Taken with Calypso camera, 28-mm UW Nikkor lens, Tri-X 400 ASA black-and-white film, sunlight exposure determined by light meter. *For* Life *magazine by Flip Schulke*

shore into the water on this dive as is the case in most fresh-water diving.

Don your scuba-gear safety equipment, including a full-wet suit—lake diving often is in very cold water. I find that I cannot concentrate on photography underwater when I am chilly or cold. Go over hand signals, especially photo hand signals.

It's a sunny day as we begin, so you carry the Nikonos with an extension tube for close-up/macro work, and I'll take along a 35-mm SLR housing, with 24-mm wide-angle lens and dome corrector port. Both of us have UW light meters, one a Seconic Marine II and the other a surface meter in a UW housing. Ektachrome 64 is in the SLR housing and Ektachrome 200 in the Nikonos.

Since we plan on shallow-water photography, we have not brought any artificial lighting units with us. We note that the water is very clear as we walk in. Both UW cameras are held in our hands—no tether cords,

or neck straps to get tangled up with our BCV's.

Drifting slowly, I get you to pose for me after taking a meter reading and setting the shutter for 250th of a second. You swim by me, over me, and alongside me as I take your portrait. The shutter speed should insure stopping your swimming movements, so we should get photographs with no camera or subject movement.

I give you the hand signal for, "Don't look at the camera, proceed about your business." Lying on my back on the 15-foot-deep bottom, I can take silhouettes of you swimming and looking around, by catching your dark shape against the brighter midwater or surface background. I see that I need to keep a certain distance from you, otherwise the 84-degree angle of the corrected 24-mm lens will exaggerate your body shape giving it an unnatural look, a gross example of forced perspective.

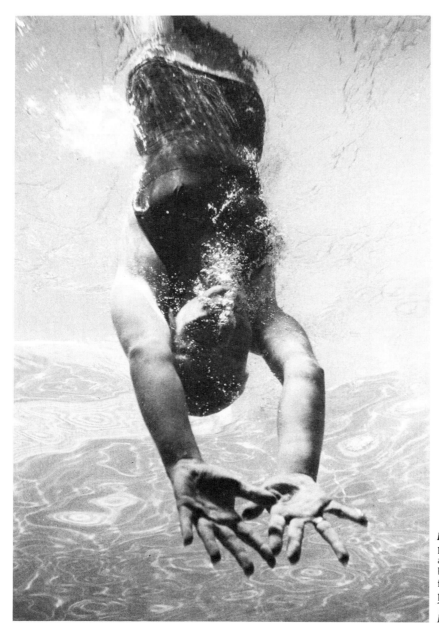

*Illus. 9.13* Fresh-water pools have their divers, and catching one as she breaks through the surface makes an arresting photograph. *Taken for* This Week *magazine by Flip Schulke*

I look around for other subject matter that a wide-angle lens such as the 24-mm can do justice to. A few of the objects that I have found in lakes and streams and shot with a wide-angle or fisheye lens are: schools of fresh-water fish, junk cars, old tires, re-frigerators, underwater vegetation, animal skeletons, fossils, a complete skeleton, in-cluding tusks, of a 5,000-year-old Great Hairy Mammoth, Indian artifacts such as a large broken Indian pot complete with painted designs, other swimmers and divers, chil-

dren diving and sliding into the lake, and by looking up through the water, boats and water-skiers zooming over my head. Don't overlook frogs, tadpoles, salamanders, minnows, snakes, insects, swimming, diving and wading water fowl.

Since you are doing closeup photography with the Nikonos closeup attachment and framing device, all you have to do is place the subject matter right in the wire-framing device, take a meter reading, select a slow shutter speed because you can brace yourself on the bottom thereby giving you a small $f$-stop and increasing your depth of field. Some of the subjects that you find to take closeups of are: golf balls from the nearby golf course, beer cans and bottles, a large fishing lure from the big one that broke the fisherman's line and got away, a closeup of that Indian pot. You find that the coloration of the plant life growing underwater varies in hue from very dark green, through light green, and even yellow. By placing yourself with the sunlight shining through the leaves of the vegetation, you take some very beautiful nature pattern pictures. In this particular lighting situation bracketing your exposures assures you of a slide that will draw "Oohs" from viewers at your next slide show.

Some of the silhouette shots that we both shoot might look better in black-and-white, but we can decide that after we get the color slides back from the processing lab.

Fresh-water UW photography is easier than ocean diving for the simple reason that you can usually work right off the shore, and your photographic gear does not have to be soaked in fresh water after you finish the day's diving, for obvious reasons: no salt build up in most lakes, rivers and streams. I have lumped lakes, rivers, and streams together under the general heading of fresh-water diving.

Some lakes are clear, and others muddy. Generally, if a lake or river is surrounded by sand or hard rock (such as mountain lakes), it will be clear. If it is surrounded by earth, especially cultivated earth, it will probably be muddy, resulting in poor underwater visibility. There isn't much difference in river and stream diving except for current problems in many rivers. I have found most rivers too clogged with suspended sediment for very good photography.

On the other hand some small streams, away from the industrial and population centers, can be very clear and it is possible to get good photographs of fresh-water fish in these situations.

Water clarity is always a matter of personal experience. Divers who spend most of their time in lakes and rivers become used to the limited visibility. But living near the Florida Keys, as I do, has badly spoiled me since the ocean water there is often extremely free of suspended matter, and therefore the water is very clear. I have seen very good photographs taken in quite murky water, both in fresh and salt environments, so if you can see an object with your eyes, underwater, you probably can photograph it. A variety of UW conditions adds spice to your diving and produces a versatile portfolio of photographs.

A personal word about cave diving. I have not and will not discuss UW photography in caves. Living in Florida for much of each year, I have seen the increasing number of deaths of both professional and novice divers while exploring caves and sinkholes. Besides the many equipment problems involved in cave diving, one cannot come directly up to the surface when lights or equipment failures develop, and panic is often the result. If you are seeking photo advice for cave diving you will have to find it somewhere else.

# 10·CREATIVE SEEING UNDERWATER

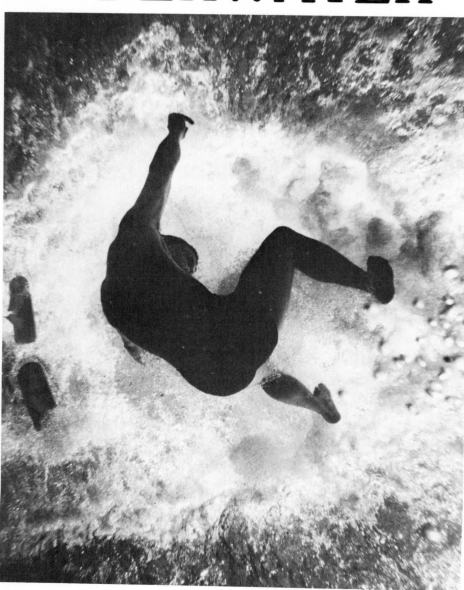

**Illus. 10.1** As you advance your UW photographic technical abilities and gain shooting experience, you should be searching for a wide variety of subjects and situations. Otherwise before long your UW photographs will begin to have a sameness that will ultimately bore your viewers and even yourself. Just think for a while of all that can happen in the water and you may come up with such things as what a water skier looks like when he falls off his skis. *Taken for* Life *magazine by Flip Schulke*

Previous chapters have dealt with the craft and technique of UW photography. Clearly, understanding equipment and methods will widen the scope of what you are able to photograph. Technical know-how is the first skill necessary to bring good photographs back from a dive.

On the other hand effective UW photography requires a second, equally important, skill—harder to learn than the first; a sense of the aesthetics of photography as it manifests itself in the underwater world. Aesthetics is defined as "pertaining to beauty, sensitive to shape and form, and showing good taste." The whole technique of artistic visual communication enters into your search for a personal aesthetic in underwater photography.

The following criteria contribute to an aesthetically pleasing (good) photograph as I see it:

## SELF-SATISFACTION

When you see your newly processed photographs *you* should be pleased with your efforts. Though it will help bolster your ego when your fellow divers and friends applaud the results, it's *your* opinion that counts.

The "tools" that you have to work with to get pleasing UW photographic results are selection of subject matter, composition, camera angle, use of illumination, action and movement, and separation of subject elements by shades of black and white or by color tones. These aspects of good photography can overlap. *Composition* can embrace one or all of the above elements.

## EFFECTIVE COMPOSITION

I do not believe in hard and fast "rules" of composition. You can find such rules listed ad infinitum in textbooks on painting and photography. Each rule does have its place in a given situation, but adhering to rules leaves you no room to experiment with composition in visual situations that just *look better* by breaking the rule. Besides, I doubt if many of these rule-makers have ever experienced the underwater environment.

I do believe in looking about you, becoming acutely aware of the shapes and objects that make up the undersea locale. One way to develop and sharpen your picture-taking "eye" is to look for pleasing compositions as you go about work and play—without a camera. You can also do this when you are diving without a camera. You can quickly see and discard "pictures" or retain images that look good for the time when you have your camera. You develop a picture-taking sense by clicking off hundreds of possible compositions with a blink of your eye instead of the snap of the camera shutter. It saves a lot of film and is very convenient because you always have your "eye-shutter" with you.

Look also at the work of other photographers, as well as paintings or drawings; this will help you to discover varied possibilities in subject choice and placement (composition), which you can apply to UW work. There is nothing wrong with copying the work of those you admire. At first, the copies may be similar, but you will soon find that your photographs diverge into your own seeing style. Since every UW photo is different identical copying is almost impossible.

## RESEARCH

If there is one "secret" in producing good photographs, it is to *use your eyes* to perceive more than the obvious. Don't just glance at the subject matter you encounter underwater. Try to see and understand what it is you are looking at. A visit to your local library or bookstore can give you background information on undersea flora and fauna. If you have some knowledge of what you may see underwater beforehand, then you can look for it, and perhaps recognize it when

*Illus. 10.2* Shooting directly up will give you good black-and-white silhouettes. Here four divers hold onto the anchor rope, as they stop for decompression after a deep dive. *Taken for* Life *magazine by Flip Schulke*

you do see it. Besides this "rational" or intellectual approach to UW photography, your emotions will also help you to discover good pictures. I have never gone diving with anyone who is not emotional and excited by what they have seen in the deep. Your best photographs will result from shooting those things that interest and excite you most.

Try to avoid constantly using the same UW photo techniques. This will force you to learn more about photographic methods that will enable you to operate your UW photo gear so you can get what you see onto film.

When your UW photography pleases you and others and you feel that you are portraying and communicating visually what

*you* see that excites or interests you underwater, you will be on the right road to discovering your own personal underwater vision.

## CREATIVITY

This is a difficult word to define. There are those who say "you either have it or you don't." I disagree. Nearly everyone "has it." The problem is discovering it in oneself, and then letting it out through the medium of camera, lens, and film.

There is only one *you* and your personal interests and vision deserve cultivation. Photographic tools and techniques will continue to grow and expand; the manufacturers will see to that. All diving photographers who can pay the price have an equal opportunity to avail themselves of existing gear. It's the fact that you have a very personal and individual way of seeing that makes you and your photographs unique. The following are some of the ways you can help yourself achieve more creative UW photographs.

### Creative UW Camera Techniques

**Look for Different Angles from Which to Shoot Your Subject** / Floating in water, as you are, enables you to quickly change your angle or camera position relative to the subject. You can shoot from directly under, directly over, and at high, low, and middle angles with very little exertion. Don't be limited by your surface angle techniques—make the lack of gravity as experienced underwater move you into angles that are more interesting than shooting everything head on.

**Choose a Lens That Gives the Best Angle of Coverage to Suit Your Subject** / Shoot closeups with a lens that can move in close, fill the frame, and focus sharply. Larger subjects demand wide-angle lenses, unless you happen upon the diver-photographer's nirvana—truly crystal clear water. If you want

both background and foreground sharp in the same photograph, again the wide-angle lens is the best choice. If you want to have the background all out of focus, so the viewer looks at only one subject, a longer lens will do this.

**Use Light—Either Ambient Sunlight or Artificial Light—to Emphasize Your Subject** / It is obvious that a brightly colored fish should be illuminated so that the film will capture the bright colors. Conversely, a stretch of interestingly shaped coral might look better in a back-lighted, black-and-white photograph. The subject matter itself very often cries for one technique or another to

show it to its best advantage. Know your options so that you can achieve the most creative visual impact.

**Pose Your Subject When You Can** / Photographing in water is not the same as shooting on the surface. Good, creative *candid* UW photographs are the rare exception. You are severely limited by the length of time you can stay underwater. It is almost impossible to "wait around" for things to happen, with both you and your subject in the right place, for a good picture. Once again, remember to keep your eyes open and remain aware of your diving partner's underwater behavior. You will get the best

*Illus. 10.3* The coral-and-plant encrusted framework of a metal shipwreck makes a dramatic framing device in UW photography. *Taken by Gale Livers/Ikelite*

*Illus. 10.4* On a reef, the various types of corals are a never-ending source of UW frames. Catching the diver in photographs exhaling air bubbles also adds to the "underwater" look of your photographs. *Taken for Dentsu Advertising Agency by Flip Schulke*

UW "people" pictures if you choose someone beforehand who *wants* to be photographed. Take that person along as well as your regular partner, then the two of you can concentrate on featuring the third diver in your photographs.

**Use Natural UW Frames to Outline Your Subject** / Shooting the mouth of a cave, an opening in coral, or plant life will add underwater scenic interest to your "people" pictures.

**Try Infrared Color Film** / This will give very strange color shifts (i.e., what is actually green will photograph red). You get a surrealistic view of the underwater world.

**Use Slow Shutter Speeds** / You can get artistic effects by setting your shutter at slow shutter speeds (1/15, 1/8, and 1/4 of a second). They will give you blurred-movement photographs. Oftentimes, purposely blurring your subject will give the viewer a feeling of movement.

**Use a Fisheye Lens, or Fisheye Supplementary Lens** / Make use of these lenses' inherent curvature (barrel) distortion to dramatize the composition of your picture.

**Hold a SLR Housing Half In and Half Out of the Water** / The water-air interface bisects the center of the camera's lens giving you a view of what's on the surface and what's below at the same time. This technique works best with wide-angle lenses. If you use a dome corrector on your housing, you will get the same actual or "real" distance from both the underwater and overwater objects. See illustration on page 7. Since the focus scale is different underwater, due to the action of the water and the dome corrector, a plus-5 "split" diopter supplementary closeup lens screwed onto the front of the camera's lens, with the diopter half underwater will help to equalize the UW and surface focus points. Since you need one *f*-stop less exposure on the surface half of the photograph, a split 2x neutral density filter covering the top half of the camera's lens will equalize the surface and underwater exposure. A specialized sort of photograph, but it's a lot of fun to show your dive boat and underwater diver in the same photograph. You can actually see what you will get by composing through the pentaprism viewfinder of the SLR. I find this works best if you set up the split closeup lens, and the split ND filter, for a vertical photograph. It works only in a very flat, calm sea.

## Creative Darkroom Techniques

I must point out here that *some* creative photographic techniques border on a less-than-realistic visual experience. They are part of what photographers call an art-oriented approach. Indeed, the negative word "gimmick" is often used to describe some of them. I do feel, however, that in order to encourage your own creativity you should be aware of these darkroom "tricks." Then you can apply them to your own UW photography or not as you please.

Since the same techniques are used in both surface and UW photography, I refer you to the following books:

- *Photography,* by Charles Swedlund
- *Photography—adapted from the Life Library of Photography,* by B. and J. Upton
- *Photographic Printing,* by Ralph Hattersley.

In these books you can find explanations and illustrations of the following darkroom techniques:

1. Solarization (both color and black-and-white).
2. Composite images—photomontage—color slide sandwiches.
3. Posterization (both color and black-and-white).
4. High-contrast (Kodalith) printing.
5. Texture screens.
6. Reticulation.
7. Diazo color prints from black-and-white negatives.

All of the above techniques are methods of expressing yourself visually. They have the advantage of turning a "common" subject into a less common finished photograph.

My career as a professional photojournalist has afforded me access to uncommon subject matter. These opportunities are rare for most UW photographers. Search out those that you might have the chance to photograph. For the "cliché" UW photographic situations, consider some of the alternative camera and darkroom techniques. UW photography will never become visually uninteresting to you.

## My Own Search for Creativity in UW Photography

**Finding a New Angle** / There are *always* new angles; it is simply a matter of finding them. A few years ago I was told that there were no new ways to photograph waterskiing, that everything interesting had already been done on this much photographed sport.

I like a challenge so I thought a bit, and then took a friend who was a very good water skier to a clear spring-fed river in central Florida. I knew that a lot of foam and bubbles along with ski tracks form in the water in the wake of water skiers. I also knew that they moved at a fairly fast rate of speed, so I got a Plexiglas UW housing made up for what was then a rare item, a motorized 35-mm camera—giving me 5 frames a second capability. We found the right site at Rainbow Springs, Florida. I perched myself on a sunken log about 25 feet down and pointed my camera upwards. We mounted a couple of floats above me to direct the skier so that he would always pass directly over my head. He spent the day skiing over me, and I came up only to change film or air tanks. The patterns thrown by the moving skis were as visually exciting as I had imagined them to be. We also had a bit of luck, as the skier fell off his skis directly over me while he was trying to ski barefoot, and with the motorized camera I was able to get a sequence of him crashing down through the

water. I used a 28-mm wide-angle lens, shooting through a flat port, which was all I had at the time. The fresh water in the spring was clear enough so that the angle of coverage of 62° was sufficient for my purpose.

I shot black-and-white film, because I wanted to enhance the contrast of the clear water and the skier's bubbles, through high-contrast enlarging in the darkroom. This set of photographs (see Plates 45–48) ran in *Life* magazine and has been reprinted dozens of times in magazines all over the world. No one had ever looked at water skiing from underneath before!

**Adventures with a Fisheye** / Photographing a 30-foot-long living, moving creature is the ultimate in wide-angle photography, especially when the water clarity allows one to see only about 15 to 20 feet with any photographic definition. But this assignment gave me the first real challenge to do 180° fisheye-lens photography.

It all began with a phone call in 1965 from Bob Gilka, the director of photography of *National Geographic* magazine. He knew that I was experimenting with UW extremely wide-angle and fisheye lens photographic techniques. Was I up to photographing a whale underwater, queried Gilka. I asked what sort of whale and he replied that it was 30 feet long, about 5000 pounds in weight, alive and a member of the Orca family. It meant going to Puget Sound, in the state of Washington. The whale had a pet name, "Namu," and a young aquarium owner, Ted Griffin, was keeping him in a large lagoon—blocked off from the rest of Puget Sound with submarine nets. In fact, it was the first Orca ever held in captivity. To his knowledge no Orca had ever been successfully photographed underwater.

Thirty feet didn't sound like too large a whale to photograph; I knew that blue whales often exceed 100 feet in length, so 30 feet would be "tiny" as whales go. I asked the editor no further questions, jumped on the

first airplane bound for Seattle, with my Nikon-F and Plexiglas SLR housing with fisheye dome attached.

Somewhere in the flight, my seating companion inquired about my purpose for flying to Seattle. I had previously told him that I was an underwater photographer. I said that I was going to photograph a whale named Namu.

"The killer whale? How exciting!" he exclaimed.

So *that's* what an Orca was! In those days killer whales were thought to be on a par with the great white shark as the number-one man-eating creature in the underwater world! What had I got into?

Ted Griffin met me at the airport. On the drive to his lagoon, he filled me in on the background of killer whales. In his view, the man-eating stories were false, or at least exaggerated. Indeed after six months of getting to know Namu, he had dived into the lagoon and swum about with the killer whale. This was just two weeks before my arrival.

"He's a big teddy-bear," Ted said, "just as long as he is fed enough!"

Griffin had found that if he fed Namu 400 pounds of salmon a day, he was as playful as a kitten; 300 pounds wasn't enough, Namu would be surly; 500 pounds would make him fall asleep.

"There's nothing to fear. Namu never opens his mouth underwater when I'm near him," Ted told me.

Bolstered by Ted's confidence and egged on by the thought of taking the first UW photographs of a killer whale, I donned my dive suit and scuba gear, grabbed my Nikonos and 28-mm lens, and plunged into the lagoon.

Ted was feeding Namu on the surface, and I was standing on the bottom of the lagoon, which was only 15 feet deep, peering into the murky water trying to catch a glimpse of the whale.

Suddenly a huge head appeared, and Namu looked me over with his eye (the one facing me), squeaked some sounds from his blow-hole, and opened his mouth.

Although I was the only thing eatable in sight, I managed to snap off a frame of Namu displaying his mouth full of sharp, 2- to 3-inch-long teeth. At the time they looked like elephant tusks to me. Then I shot to the surface, climbed out of the lagoon, and confronted Ted with Namu's behavior.

"Oh yes," Ted said, "I forgot to tell you that Namu is used to my feeding him in the water. He was only "begging" for salmon.

I spent a week photographing Namu. The murky water presented my greatest difficulty, for by then Namu and I were great friends. As I stood on the bottom, barely able to see, I would suddenly feel a brushing on the top of my head. It was Namu running the whole length of his underside across my scalp, all 5000 pounds of him, without ever exerting any downward pressure on me. I guess that he was using me as a "tickling board."

In the murky water I discovered that I could take only portions of his body with the normal wide-angle lenses then available. As soon as I moved back far enough to get more than about a quarter of him in my frame, I could no longer see him distinctly. So all I could do with the Nikonos and 28 mm was concentrate on his head, as he ate, swam about, and made sounds underwater by blowing air from his blow-hole.

Looking through my fisheye, I discovered that I could see Namu on the surface quite clearly—in silhouette—if I lay on my back on the bottom of the lagoon, directly underneath him. Ted would hand-feed Namu, so that the whale would remain directly above me. These photographs turned out to be the most effective in showing the tremendous size of Namu. It is an axiom of photographic illustration that in order to communicate a very large object (or very small, for that matter), something that the viewer can relate to with regard to size should also be in the photograph. Ted's body, swimming and

feeding Namu, gave the viewer an idea of the enormous size of this undersea mammal.

The resulting photographs in *National Geographic* were the first ever published of a killer whale underwater; and whenever I am asked about my most memorable UW photographic experience, I always say, "photographing Namu, the killer whale." (See Plates). As things turned out, that assignment opened up the whole area of extremely wide-angle UW photography of large, moving subjects.

**Exploring Submersibles** / After the Namu experiences, I tried various lenses with my SLR-dome housing. At various times I used the full-frame-fisheye Minolta-Rokkor-OK MC 16-mm *f*/2.8 lens. This gave me quite a bit more exposure latitude, since my original Nikkor fisheye lens was only *f*/8. I also felt restricted by the circular format of the original Nikkor fisheye lenses. I found the Sigma-Filtermatic Multi fisheye lens 16-mm *f*/2.8 lens to be more versatile than the Minolta since it was designed to be fitted onto many SLR cameras via adapters. It too was a full-frame format lens.

I then fitted the Nikkor *f*/8 fisheye, Nikkor *f*/5.6 fisheye, and Pentax-Takumar SMC fisheye 17-mm *f*/4 lens to the Nikonos amphibious camera via UW lens adapters of my own design. To get a full-frame-format photograph *without* the barrel distortion of the fisheye lenses, I also adapted the Nikkor 21-mm *f*/4 lens (no longer manufactured) for use with my Nikonos cameras. For wide-angle use with the SLR housings with dome correction, I utilized the Nikkor 20-mm *f*/3.5 lens, the Canon 17-mm *f*/3.5 lens, and the Sigma 18-mm *f*/3.2, all three of which give full-frame format without barrel distortion. (See *Lens, Underwater,* in Glossary).

Shortly thereafter, I photographed the Perry Cubmarine research submarine in the Florida Keys, using the Nikkor fisheye *f*/8-mm lens. The submarine was about 20 feet

**Illus. 10.5** The Perry Cubmarine, research submersible. *Taken for* Ebony *magazine by Flip Schulke*

along, and I was able to photograph it in 30 feet of water, which was very clear.

Another time I photographed the Perry "Shelf-diver" research submarine in the open ocean—the Gulf Stream, about 50 feet down. The water is usually crystal clear in the Gulf Stream; again I used the Nikkor fisheye *f*/8-mm lens.

More recently, I called upon the extremely wide-angle coverage when photographing two mini-subs. These were one-man submersibles, used by Jacques Cousteau in exploring and filming the depths of Lake Titicaca, Peru/Bolivia. I wanted to get both mini-subs—which always dived in pairs—together in one photograph, and the fisheye lens on the Nikonos in my own lens adapter proved to be the only way to accomplish this. Since they were oval in shape, the inherent barrel distortion of the fisheye did

not apparently change the true shape of the subs.

The last big moving things that I have had quite a bit of experience in photographing are sharks.

**Tackling Sharks—If You Must/**Sharks have been so overpopularized by maga-

**Illus. 10.6** Perry Shelf-diver submersible. *Taken for* Encyclopaedia Brittanica by *Flip Schulke*

zines, books, movies, and television stories, that the greatest fear I seem to run into with new or prospective divers is the fear of being attacked. It is a fact that thousands of sharks inhabit the world's seas. It also is a fact that very seldom does a diver ever see a shark. Actually, I have rarely seen a shark unless I was "chumming" (throwing fishbait without hooks into the water). We do this only when we are trying to attract sharks to photograph them. I doubt whether the beginning diver and occasional diving photographer would see a shark while underwater—or be bothered by one. Though I suggest leaving shark photography to the professionals, I know of no recorded mortal shark attack upon an underwater photographer. More people die, the world over, of bee stings than shark attacks. The number of recorded *deaths* of cave divers far exceeds recorded shark attacks.

Australian diver Rodney Fox is one of the few men known to have survived a great white shark attack. And even though Rodney Fox is unbelievably lucky to have survived the attack, he has continued diving in the 15

**Illus. 10.7** A double exposure with a Calypso camera produced this diver seemingly menaced by *two* sharks. Double exposures can also be done by placing two color slides together, called a "sandwich." This technique shouldn't be overdone, but in moderation it adds sparkle to an evening's slide show. *Photo by Flip Schulke*

years since. With regard to the odds of a shark attack I would like to repeat a story that Rodney tells.

There is a large rock, in the middle of a desert in Australia. It is a few hundred feet high, round, and quite smooth. It is quite easy to climb, and tourists are flown in to see this lone red rock sticking up out of the desert. It is also an aborigine holy place, and is called now Ayers Rock, for its European discoverer. *More people are injured, or die each year from falling off the smooth sides of this Australian tourist attraction, than are injured or die from shark attacks the world over. . . .* The fear of shark attack, if one follows common safety rules, is highly exaggerated.

Sharks are more common in deep water, since they are a wide-ranging fish. The exception is the nurse shark, which is very common in reefs, but its mouth is tiny, it is not aggressive, and it is not included among the sharks dangerous to man. Of course, *any* animal will attack when hurt—even house pets—though usually most animals will try to escape, if an *escape* route is open to them. Therefore all large undersea animals should be treated with caution. Moray eels are timid, but I would not stick my hand

under a rock or in a hole in a reef unless I was sure no moray had made its home there.

Barracudas have vicious teeth with which they can do a lot of damage, but they are more inquisitive than aggressive underwater. They will come very close and watch your every movement, but I have never had one make an aggressive move toward me or another diver. Local Florida divers treat barracudas with respect, but they do not leave the water when they come around.

Divers do generally leave the water when sharks are in the vicinity, and I think that this is a good practice. My photography of sharks is done with a great deal of professional experience and back-up diver protection. To be on the safe side, always ask the opinion of local dive-shop guides about sharks and predators in the area in which you are going to dive, if you are not personally acquainted with that particular dive area. Spearing fish is one of the quickest ways to attract predators. They come in to grab the bloody fish on your spear and may grab a piece of you too.

Spearfishing today is too "easy" to be

***Illus. 10.8*** A black-tipped shark photographed at a depth of 175 feet. The light was quite dim, so the Tri-X film was "pushed" in development to an effective ASA of 1600. The film's granular structure is greatly magnified by this forced development. *Taken by Paul Dammann*

viewed as sport. Because of this and the general regard on the part of divers for environmental protection, we see it less and less in the United States. Spearfishing for food has its place however in areas in which it is legally allowed, and when done by experienced spearfishermen. Spearing fish should *not* be done by others in your diving party while you are photographing unless you are specifically photographing spearfishing. Caution should be practiced when photo diving in areas where other diving parties are spearing fish. As previously mentioned, speared fish often spread their blood in the water, which can attract sharks. Please note that I am not saying that all spearing *will* cause sharks to come into the area, but it *can* do so. You should be aware of this possibility when you dive in the same general area with others who are spearing fish. I mention this because I know full well how much we begin to concentrate on finding a good photograph or stalking a prettily colored fish with our UW cameras—a concentration that must be split if the probability of predators is increased by nearby spearfishermen.

A note about shark behavior: You are safest in clear water. It has been my own experience, and that of some of the major shark photographers worldwide, that sharks are extremely cautious in clear water. They will swim about you in very wide circles, moving in a very slow spiral toward you. Ron Taylor, Valerie Taylor, Peter Gimbel, and Stan Waterman, who filmed many types of dangerous sharks while making probably the most authentic documentary film *ever* made on sharks—*Blue Water, White Death*—

*Illus. 10.9* My diving partner and safety diver, Paul Dammann, protects both of us from any unexpected lunge from a black-tip shark with his "bang-stick." *Taken for* Stern *magazine (Germany) by Flip Schulke*

sharks on the nose, with a short, heavy billy-club carried along for just that purpose. In each case, the shark would retreat, and leave the divers alone. This is one method that I have observed that works. I leave the practice of "clubbing" to divers with a lot of shark experience. But it is something to remember in case of such an emergency.

Whenever I photograph the sharks that we attract by chumming, I work with safety divers well armed with "bang-sticks," and any sharks that appear aggressive are dispatched with the "bang-sticks."

The safest procedure for filming and photographing sharks is from what are known as "shark cages." The more elaborate are free-floating, and rise and lower underwater of

**Illus. 10.10** Rodney Fox of Port Lincoln, Australia, uses one of my Nikonos cameras to show how he photographs from inside the shark cages he designed for movie and still filming of great white sharks. Fox, who survived a massive great white shark attack 14 years ago, is the world's expert on locating great white or pointer sharks so that they can be filmed. He found great whites for the documentary film *Blue Water, White Death*, and again for the scenes of the *real* live whites in *Jaws*. A cage such as this is a must for attempting photography of these sharks. *Taken for* Triton *magazine (UK) by Flip Schulke*

**Illus. 10.11** Shark filming cages are usually used in pairs. Here you can see a great white shark trying to get at the UW film-maker inside one of these shark cages. *Photo by Rodney Fox*, copyright 1976.

reported this behavior pattern time and time again, even when surrounded by hundreds of sharks. They would approach the divers in ever decreasing circles, until the sharks were close enough to actually bump the divers with their noses. These divers, and Cousteau's divers when I was diving with them in the Indian Ocean, would club the

**Illus. 10.12** A black-tip shark looms close to my Nikon-F SLR and 24-mm lens. *Photo by Flip Schulke*

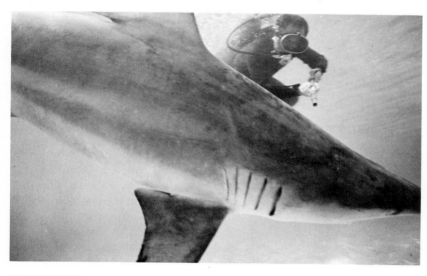

**Illus. 10.13** We work without cages with these sharks. Fellow-diver Dammann holds his "bang-stick" at the ready to dispatch the shark if he should get too "friendly." In my few shark photographic expeditions we have not had to kill a shark during filming. *Taken for Stern magazine (Germany) by Flip Schulke*

their own power. Cage design of this type has been pioneered by Peter Gimbel. Many diver-photographers have used cages attached by cables and hung beneath their dive boats. The cages restrict your movement and your choice of camera angle, but they do keep the sharks away from you while you snap pictures.

The opportunity to photograph sharks in a planned and organized way doesn't come along that often, so I use a motorized 35-mm camera, so that I can take as many photographs, as quickly as possible, when the shark appears, for they do not often stay around divers for very long.

I have done all of my shark photography on shallow reefs—never more than 30 feet deep. I can then dispense with artificial light, thus achieving a much more "natural" and authentic look. My work has been done on

the reefs that border the Gulf Stream, so we can chum them in the shallower water with bait.

I prefer to use a 35-mm SLR camera in a housing because I want to be perfectly sure of both sharpness of focus and composition, which I can do by looking through the Canon Speed-finder or Nikon Sports-finder enlarged viewfinder prisms. Though it is always important in UW photography to make each frame as good as possible, in shark photography each frame can be a "one time only" situation. The SLR enables you to get the composition you desire, while sharply defining the shark.

A slight movement of either subject—when you have both shark and diver in one photograph—can completely change your composition. If the shark had been a bit farther forward, or the diver a bit lower, the shark's body would have blocked the diver from the camera's eye. Given the speed of the action, working with sharks is more than a bit nerve-wracking. Being able to see exactly what will appear on the film the instant before you depress the shutter release is a distinct advantage.

In summary, sharks are one of the more exciting subjects in the sea. Just remember to take care, follow all safety rules, and dive with a partner and other divers who have experience diving with sharks. Use a cage, and/or safety divers who have, and learn how to use "bang-sticks."

**Choosing a Diving Partner** / All through this book I have mentioned diving partners. Though I dive frequently, I do not consider myself a professional diver. There are many diving situations that I have studied and read about, but have not actually experienced.

I do have the good fortune to have a partner who acts as both my safety man and diving partner in any situation in which I feel I need a professional. He is Paul Dammann, a member of the City of Miami Fire Department, and he is a diver's diver. I respect his

***Illus. 10.14*** Paul Dammann, the best photographer's diving partner in the business.

knowledge, prudence, experience, and guidance. If the pursuit of a particular photograph is likely to get me into trouble, Paul will discourage me from attempting it in the first place. If something does go wrong underwater, he helps me to overcome the problem that presents itself.

Paul doubles as a model in many of my UW photographs. We have developed a series of high-pitched squeaks (imitating the porpoise) which enable us to communicate during a dive even more quickly than by the constant use of hand signals. (Hands filled with camera gear make hand signals difficult at times.)

He has appeared in so many UW still photos and movies that he is known in the

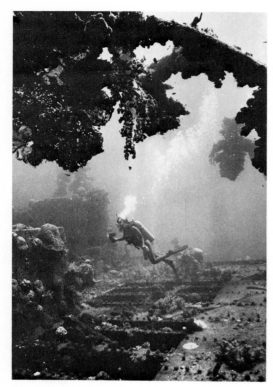

***Illus. 10.15*** Sometimes you are rewarded with extensive underwater clarity. Spend these elusive times taking long shots or UW scenic shots. It will give you the chance to photograph the grandeur of a large steel shipwreck lying on the ocean's floor. It is best to include a diver somewhere in this type of photograph so that his body can give scale to the other picture elements. This is a good example of such a photograph. *Photo by Gale Livers/Ikelite*

industry as "the world's most famous unidentified diver." Widely known as a dive master and photographer's diving assistant, he has been called upon to work with many of the outstanding professional UW photographers of our time.

Thus you can see that it is very important to choose a diving partner who can help you in your photography rather than merely look on or be just along for the ride.

Whenever I must work without Paul, I carefully interview my would-be diving partner, paying particular attention to his experience and his general attitude toward diving. If he appears to be a "hero" type, bragging about how deep he has been and how well he can handle "narcing," I look for someone else. No one needs a UW partner who must continually prove his manhood by being reckless. The care with which I choose diving partners isn't a personal idiosyncracy with me. The diving photographers I admire most are just as careful—and they are still alive.

When diving with Cousteau's team onboard the *Calypso* in the Indian Ocean and again at 12,000 feet up in the Andes at Lake Titicaca, I found *every* diver on the team to be a safe, thoughtful, and serious diver. For the thousands of dives that this team has done over the years, their UW accident record is amazingly small. Even though much of the professional diving that they do is extremely difficult and dangerous, I always had a strong sense of security and well being when diving with them.

Throughout this book I have spoken primarily about male partners and divers. The reason for this is that very few women took up scuba diving in the early years. In the past 5 years, however, one sees nearly as many women as men diving. The marine biologist Sylvia Earle, one of the first U.S. female "aquanauts,"* is an outstanding diving partner. Now more and more divers are teaming up with their wives or women friends as diving partners. My wife, Debra, and I dive together in all my sport diving, and as a result she is rapidly gaining the experience necessary to be my dive partner on working dives. She started out holding the lights for me; now I often hold the lights while she does the photographing. Ron and Val Taylor

*Those who have lived in open, underwater, nitrogen-saturated conditions and who must undergo decompression in a chamber before their body adjusts again to the surface atmosphere.

of Australia have a good UW working partnership—he shoots film (cine) and she shoots still photographs on their professional diving assignments.

More and more, diving photography has become a full-family activity.

**Photographing Wrecks** / Who hasn't read about sunken pirate treasure ships? Such tales, often described in children's books, help to form some of our earliest daydreams. Any sunken ship is exciting to come upon underwater, and offers innumerable photographic possibilities. It can be anything from a sunken row boat on the bottom of a freshwater lake, a freighter that has sunk in the ocean, a battleship lying on the bottom of Truk lagoon—a victim of World War II—to an ancient wreck with cannons and buried treasure.

I've had a lot of fun photographing wrecks. Experience has taught me that a wide-angle lens is a necessity on all wreck sites. Because any wreck is going to be large, the wider your lens, the more you can include. It is impossible to artificially light a wreck; therefore you will have to be happy with an overall blue or a dramatic black-and-white photograph. You can vary your photographs of wrecks a bit by lighting some recognizable object in the foreground and letting the background (the rest of the wreck) go blue.

The greatest problem with a very old ship wreck is that there is little or nothing visible of the ship itself. Undersea currents and storms will have carried away all the ship's superstructure. Parts of the ship itself are found only by uncovering the timbers with an "air-lift." I think most people have the impression that if they happen upon an old ship wreck, it will be lying on the bottom, masts still erect, tattered square sails still attached. Unfortunately for the photographer this is not the case.

About the only way you can photograph "treasure" and artifacts being uncovered

underwater is to make friends with a treasure-hunting group who have already found a wreck. These people are *very* secretive, but it is possible to get taken on their treasure dives by agreeing to trade your UW photographs for their permission to watch them work at their wreck site. Your better opportunities, however, will be photograph-

10.16

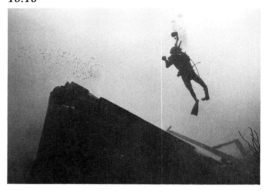

10.17

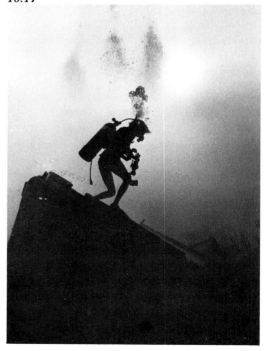

ing cannons and perhaps an anchor from an old ship. In many parts of the world, at the most popular diving areas, local guides may be able to direct you to one of these wrecks.

Wreck sites contain fewer artifacts than one would imagine, because the locations of most wrecks are known and are partially salvaged soon after sinking, especially if on a shallow reef. Fortunately, most governments have strict rules about removing artifacts, for they prevent all these undersea sights from being removed.

Modern wreck diving is somewhat easier. Contemporary sunken ships are usually well marked or known by local divers and guides. The superstructure will probably be intact. This type of wreck can range from large ocean-going ships wrecked on reefs to smaller pleasure-craft, to hulks deliberately sunk to form the basis for an artificial fish reef.

Be cautious about swimming inside a large sunken ship. You can get lost in the maze of ship's passageways. Diving lights are a must. I would always advise being

10.18

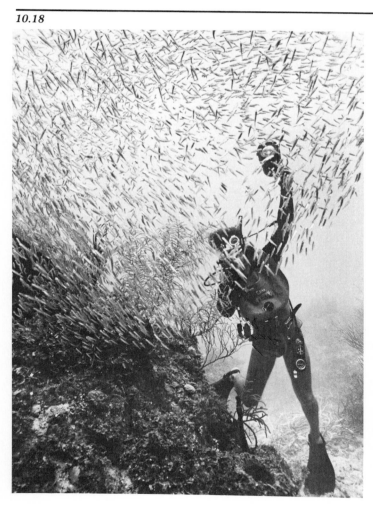

*Illus. 10.16, 10.17, 10.18* What does a professional photographer do on his day off? Take UW photographs for fun. Diving guide Bruce Nyden led my wife Debra and me to a recently sunken fishing boat, and I couldn't resist spending most of my time photographing it. Top, facing page, Illus. 10.16, Debra descends onto the bow of the boat. Below, facing page, Illus. 10.17, Debra, poised on the bow to adjust her camera, is silhouetted against an eerie backdrop. Note the rising air bubbles and the effect of sun shining dimly through the deep water. Left, guide Bruce Nyden photographs a school of small fish near the wreck. Sunken small craft become natural havens for all sorts of marine life and offer unlimited subject matter in a very small area. Taken with Nikonos III, 15-mm *f*/2.8 UW Nikkor lens, Tri-X 400 ASA film, exposure determined by light meter. I used black-and-white film for the wreck is too deep (40 feet) to retain any colors other than blue when taking wide-angle shots. It is impracticable to light it artificially—it's too big. The shapes of diver, fish, and wreck lend themselves to silhouettes. I can emphasize the gradations of black and white in darkroom printing, so black and white seemed the natural choice for this particular wreck dive. *Photos by Flip Schulke*

shown through a large shipwreck by a knowledgable guide. The bow, stern, propeller, wheel house, and deck equipment all make good underwater subjects, and good props for photographing exploring divers. If the name of the ship is still legible, take turns posing on it. This will provide a good souvenir of your wreck dive, and perhaps the title slide for a slide show.

Small pleasure craft—which seem to sink quite regularly—also offer good subjects for UW photographs, because they are small enough to encompass in one shot. Debra and I dove on one sunk by the owner in about 50 feet of water off Freeport, Grand Bahama Island, because it was too old to repair. As the craft is wood, it will probably break up entirely in a few years, but for now it is a photogenic undersea subject. Having already made it their home, schools of fish abound in and around the wreck, providing good subjects for close-ups and other shots.

Illus. 10.16, .17, and 18 are photographs taken on my "day off," so that I was shooting without any preconceived photographs in mind. Often I shoot in black-and-white on such occasions because I like to make my own enlargements in the darkroom, and black-and-white does not necessitate artificial light at that depth.

**Posing People Underwater** / Posing photographs that involve another diver or divers begins with inspecting your diving partner(s) before the dive. Some face masks photograph better than others—a matter of personal taste. Long hair on a female diver looks beautiful when floating about weightless underwater, but it can easily get caught in the regulator attached to the air tank. Often it is best for a woman to wear her hair in one long braid or in pigtails. If you want the long-hair look, try placing a small plastic bag over the protruding parts on the top of the air tank.

A word about diving suits and other dive gear that will enhance your UW photographs.

Classic black dive suits tend to look somber. However, a few years ago I discovered that dive-suit nylon-neoprene material was also made in colors. I selected what is known as international orange and had brightly-colored suits made for myself and my diving partners—an idea which caught on quickly. You will now find orange jackets generally manufactured. Blue is also common, but is less effective in UW color photography against the blue-water background. My own preference is for orange jackets and hood with black or blue pants. A completely orange outfit tends to make the diver look as if he were diving in long underwear. International orange is preferable to red, for red tends to darken more quickly, in as little as 15 feet of water.

Red or yellow dive masks jazz up portraits of fellow divers, and yellow flippers also stand out better than black or blue ones. When possible, select orange fishing gloves instead of white canvas work gloves; the white gloves photograph like two bright white spotlights in a color photograph. Though *every* diver need not be dressed in colorful dive gear, a few really spark up the color of your photographs.

Have a checklist of planned poses before entering the water. Then you and your subject can quickly respond underwater to situations as they arise, allowing good composition, accurate settings and effective artificial light techniques.

Watch out for reflections in the face mask of your subject; they can be desirable or distracting, depending upon the particular pose, and UW situation. The weightlessness of the water environment causes subjects to dangle their arms and legs. I remind divers to keep their arms and elbows close to their sides, when I am photographing them. Hold objects very close to the body. Because wide-angle lenses tend to elongate, if arms, hands, legs, or feet are spread and dangling, your subject can end up looking like a human octopus! Moving through the water is a

graceful action. See that your photographs reflect this. Again, take care that flippers do not stir up sand and sediment when you are photographing near the bottom.

Wait for your subject to exhale bubbles. Many UW artificially lighted photographs look as though they could have been taken at night anywhere. Including bubbles in UW photographs of people effectively establishes the UW environment.

*Newsweek* magazine recently assigned me to illustrate a cover story on the recreational aspects of diving, called "Life Underwater." We took the model, wearing a special backpack, to a shallow UW reef. The photograph was lighted with a 1000-watt movie light held up and to my left by my wife, Debra. There were hundreds of tropical reef fish milling about the sea, but they would not come close enough to the model so that I could get them in the composition. We all waited and waited. Patience is a prerequisite for a photographer; waiting does pay off. Suddenly a yellow and silver reef fish darted in, and I was able to get diver, coral, and fish all lighted in the one photograph. If there is a lesson here, it is "don't quit until you have

done everything possible to get the picture you want; good UW photographs don't come easy—they come from a combination of hard work and patience."

In sport and hobby diving, there are a few "sure-fire" poses that should give you good UW photo-portraits of other divers.

- Divers using their photography equipment. The camera prop shows them doing something rather than gazing at your camera in a self-conscious manner.
- A diver framed with coral—it's like looking through a natural picture frame. This shows both the beauty of the underwater reef and a recognizable person.
- A diver framed in the entrance to a UW cave. You get inside the cave and shoot out at your subject who is in the entrance.
- Exploring with UW light. The light as a prop in the photograph leads the viewer to understand that the diver is involved in a search. Moreover, the redness of the UW cine lights adds a touch of dramatic color to the overall blue of the photograph.

## A CLOSING WORD

One of the most exciting things that UW photography has taught me is the interrelationship between water and space. It happened like this:

Often, when we see astronauts on film and TV, weightless—floating inside their spaceship or out on a space walk—we wonder how they can fulfill their work tasks in this alien environment. How do they learn to work while weightless? What conditions on earth can simulate the weightless conditions of outer space? The answer is the underwater world. Because of this parallel between the UW and space environment, I was asked years ago by NASA to film and take still photographs of our first SKYLAB astronaut crew.

So off I went to the Marshall Space Flight Center, Huntsville, Alabama, to dive and photograph in their UW test tank, called the "neutral buoyancy simulator." The tank is five stories high, about 70 feet in diameter,

*Illus. 10.19* Exhaled air bubbles emphasize the underwater setting of photographs. Taken with Nikonos II, 28-mm UW Nikkor lens, Tri-X black-and-white 400 ASA film. *Photo by Flip Schulke*

and is filled with crystal-clear filtered fresh water—a UW photographer's dream come true. A mock-up of the actual SKYLAB, at its full scale of almost 70 feet in length, rested inside the test tank.

Three astronauts, including Pete Conrad, who had been to the moon, entered the water, fully dressed in their space suits. I worked for hours filming and photographing their space-walking techniques. As I snapped away, memories of Namu, the killer whale flashed through my mind—an animal that had lived in the sea for millions of years. Here, framed in my camera's lens were the first space men, learning how to live in space by moving in the water where all life began—a symbolic merging of man's future and past.

Whales and spacemen are just two subjects that can be captured on film, as we have seen in this book. You need only pick up your camera; then let your mind flow with the water, and become one with it. The underwater world may be only a transitory home, but it merits your creative energy and spirit. Join the whales, astronauts, and me in making photographs of this planet's other "atmosphere."

**Illus. 10.20** My daughter Maria makes a good subject as she returns to the surface carrying her UW camera. Converted from color slide. *Photo by Flip Schulke*

**Illus. 10.21** Underwater photography can be the documentation of our new activities in the sea. Here, marine scientist Sylvia Earle, one of the world's first woman aquanauts, examines algae near St. Johns Island, U.S. Virgin Islands, as part of the Tektite II UW habitat living experiments. Sylvia set records for length of scientific exploration dives and data gathered unsurpassed by other Tektite aquanauts, male or female. *Photo by Flip Schulke*

**Illus. 10.22** Diver Bob Farrelly maneuvers a diver propulsion vehicle (DPV) through the coral reef off Freeport, Grand Bahama Island, in the Bahamas. Taken with Nikon-F SLR camera, 18-mm Spiratone/Sigma lens in Ikelite housing, dome port, converted from color. *Photo by Flip Schulke*

**Illus. 10.23** Astronaut Pete Conrad practices space walking underwater in NASA's giant water-filled neutral buoyancy simulator. *Taken for the National Aeronautics and Space Administration by Flip Schulke*

# GLOSSARY

This section includes both general photographic and underwater-photographic terms. It combines brief definitions for the novice with expanded technical and scientific explanations geared to the more advanced photographer.

As you gain more experience in photography, you will find that certain words and terms may have multiple meanings. Underwater photography is a relatively new field and diver-photographers have borrowed or coined much of their working language. Usage differs by regions as well. In spite of these variations, the following definitions and cross-references should acquaint you with the basic terms you need to know. All italicized words are further defined elsewhere in the glossary.

My thanks to Charles Swedlund for permission to draw on general photographic terms and definitions from his book *Photography—A Handbook of History, Materials and Processes;* Holt, Rinehart and Winston, Inc., 1974.

- **ABERRATION, LENS** / Optical defects in a *lens* that cause it to mar images by blurring or some other type of distortion. Defects that commonly affect UW photography are distortion and chromatic aberration.
- **ABSORPTION** / In photography, the assimilation of light rays by the medium they strike, the effect of which is to block light so that it travels no farther. The complete absorption of light results in black. This is the opposite of reflection.

    Light is absorbed in water by any dark-colored particles which are floating in the water and by living organisms, such as plankton, which make use of light energy for photosynthesis. In general the amount of light that is absorbed underwater is minor when contrasted with the amount of light lost through scattering.
- **ACTUAL DISTANCE** / *See* Apparent distance.
- **AIR EMBOLISM** / A traumatic and potentially deadly condition in which the rupture of alveoli (air sacs in the lungs) walls forces air into the bloodstream and results in the plugging of blood vessels by air bubbles which enter the circulatory system directly from the lungs. This happens when the swimmer approaches the surface too rapidly when underwater. Embolism is easily avoided by ascending slowly and maintaining a normal breathing rhythm. If a diver has to come up quickly he should exhale continuously, particularly near the surface, thereby allowing the expanding air to flow harmlessly away.
- **AMBIENT LIGHT** / *See* Sunlight.
- **ANGLE OF COVERAGE** / The area "seen" by a lens. It is usually calculated on the diagonal from the two farthest corners of the film format. The longer the focal length of the lens, the smaller the angle of coverage. As an example, a 300-mm telephoto lens will perceive a very narrow angle of coverage, while a 28-mm wide-angle lens will "see" a large area. The angle of coverage, therefore, is inversely proportional to the focal length of the lens. Because of the magnification caused by refraction underwater, the effective focal length of a lens is increased. A 50-mm lens, which would be considered normal on a standard format 35-mm camera above water, becomes a telephoto lens under the surface. A 35-mm lens, which, in the air, is a wide-angle lens, becomes a normal lens underwater. Diagonal angle-of-coverage data for some commonly used lenses underwater can be found under Lens, Underwater. *See also* Port.
- **ANGLES** / *See* Angle of coverage, Camera angle, Concentric dome lens, Port, Flat port, Port.
- **APERTURE** / The lens opening that admits controlled amounts of light into a camera, its size variable but regulated by an iris diaphragm and expressed as an *f*-number.
- **APPARENT DISTANCE** / A mile is a mile—except underwater. This seemingly nonsensical phrase takes on meaning when the photographer carries his equipment beneath the waves. Undeniably, a fish that is 10 feet away from a photographer remains 10 feet away whether it is in the water or in his neighborhood seafood restaurant. However, the magnifying effect which divers and cameras must cope with underwater distorts actual distances and relationships in such a way that a whole new series of focusing calculations must be brought into play. The refractive indices of water and air are significantly different. This causes light rays to bend as they pass from the water through the lens port of the camera housing. The effect of this bending or refraction is to increase the focal length of the lens. As a result the lens will behave as though its focal length were one-third greater than it actually is. The angle of coverage of the lens is decreased, and objects appear to be about 25 percent close than they actually are. Our fish that is 8 feet away will appear to us to be only 6 feet away. Because both the camera and our eye are subject to the same optical deception, setting the camera at 8 feet, where we know the fish actually is, would yield a photograph that is strikingly out of focus. The camera must be focused at the apparent distance. If we are using a reflex viewfinder, this is a relatively simple undertaking—we simply get the subject in focus in the viewfinder as we normally would. However, with other cameras, we must either rely on our senses to gauge the apparent distance and make the appropriate setting on our camera or, if we are able to measure actual distance, we must be careful to

subtract the 25 percent that is lost because of refraction.

- **ARTIFICIAL LIGHT** / Any source of visible illumination not originating from the sun. To the UW photographer this means two major types of light.

    1. Flash illumination: provided by flash bulbs, flash cubes, or strobe (electronic) flash, and powered by batteries.

    2. Constant illumination: provided by bulbs and tubes emitting a constant light, and powered by 110/220/240-volt electrical current or by storage batteries. Commonly referred to as movie lights.

- **ATTENUATION** / Attenuation is the reduction of the intensity or brightness of light as it shines through any medium over a distance. Light shining through water is attenuated or reduced much more rapidly than it is when it shines through the air. There are two principal causes of this attenuation: light absorption and light scattering.

- **BACKSCATTER** / This is the effect caused when light from the flash travelling toward the subject underwater hits and is reflected by the millions of tiny particles which surround the subject in the water. The light reflected from these particles, which include microscopic organisms like plankton and bottom sediment, is then reflected back into the camera lens.

- **BARREL DISTORTION** / Magnification of an image at its center, caused by a lens aberration.

- **BATTERIES** / A means of storing electrical energy for portable power, batteries that UW photographers are concerned with come in major types:

    1. Nonrechargeable types. These batteries must be replaced when all the stored electrical power has been used up. Alkaline batteries of this type will give the longest energy capacity. Eveready Powercells and Mallory Duracells are two examples of this type of low-voltage disposable battery. High-voltage strobe units use 300-volt and 510-volt "dry" storage batteries.

    2. Rechargeable types. These batteries are known as NiCd batteries, from their nickel and cadmium composition. They come in low-voltage models, purchased at stores. Most Ni-Cd battery systems are used to power portable strobe-flash units and UW movie lights. The major advantage is that these batteries can be used repeatedly—after recharging—which can range from 1 to 16 hours, depending on the battery-unit system design by the manufacturer. Most Ni-Cd batteries require the longer recharging times.

    Ni-Cd batteries have some drawbacks which the UW photographer should be aware of.

    Outgassing can occur with Ni-Cd batteries in UW usage. (*See* Batteries, dangers of.)

    These rechargeable Ni-Cd batteries also have a use "memory." Even though a Ni-Cd battery may be designed to power a strobe unit for 100 flashes—after a 16-hour charge—if you repeatedly use only 36 flashes, you will set up a memory pattern and the battery will no longer fire off 100 flashes. This memory pattern can be broken either by manually firing the strobe unit up to 100 flashes or by leaving the power switch on for a few hours so that the strobe's capacitors will drain the full power from the Ni-Cd battery. Then recharge for varied periods. **Be sure to heed the manufacturer's warning concerning overcharging.**

- **BATTERIES, DANGERS OF** / A potentially dangerous but little-known problem may arise when any type of battery is used in the same underwater housing with a lamp or electrically driven camera motor. This is perilous hydrogen outgassing. All batteries in conventional use as power sources can give off hydrogen if they are in the least bit faulty. If this hydrogen is ignited by a spark from a motor or the heat from UW light, a potentially fatal explosion can result.

    Even many diver-photographers who have been diving for years are apparently unaware of this danger. Any type of battery gives off hydrogen gas. Ni-Cd rechargeable batteries emit very little, but it *can* be enough for an explosion if one of the Ni-Cd cells happens to be faulty.

    The hydrogen explosion danger can be eliminated by inserting in the battery section of the housing a hydrogen catalyzer made by Hydro-Catylator Corp. It has a IRI-9 catalyst cone or a 3/4-inch (19-mm) catalyst cube for lead-acid batteries or else a 3/4-inch catalyst cube for alkaline batteries.

    These catalyzers convert any outgassed hydrogen into harmless water. By inserting one in the housing for a battery-operated, motor-driven camera, a diver can also protect himself against the possibility of an explosion due to defective camera batteries. Though such explosions are rare, the author has witnessed the explosion of an unprotected UW light with a Ni-Cd battery. *See also* Outgassing, hydrogen.

- **BENDS, THE** / *See* Decompression sickness.

- **BLACK-AND-WHITE FILM** / *See* Films, black and white.

- **BRACKETING** / As a margin for error, the technique of making in addition to a "proper" exposure several exposures that are both over and under the norm.

    Since there is no absolute assurance that you are going to get consistently ideal exposures, even with the best of light meters, bracketing is a sensible and inexpensive method of ensuring a good photograph.

    *See also* Exposure bracketing, Shutter speed bracketing.

- **BREATH CONTROL** / An important element in good underwater photography is camera steadiness. At the moment you release the shutter or roll the film, you want to become as firm a camera platform as possible. One way of adjusting your buoyancy and steadying the camera is through breath control. By inhaling or exhaling slightly a few seconds before you take your picture, you can control your position in the water so that you remain almost motionless for the short period of time necessary. Inhale slightly if you are a little heavy in the water and tend to sink. Exhale if you are a little light, tending to rise. After

you have taken the picture, release your breath. Be especially careful not to hold your breath if it makes you bouyant and causes you to rise, otherwise you will be in danger of an air embolism.

- **CAMERA** / From the Latin for "room," a light-tight box fitted with a lens to admit, by the action of a released shutter, a selection of light rays so as to cause them to form an image on a field of light-sensitive material—film. *See also* Rangefinder camera, Single-lens reflex camera, Twin-lens reflex camera, Viewfinder camera.
- **CARTRIDGE** / A roll-film carrier, sometimes called "cassette," that completely encloses the light-sensitive material.
- **CASSETTE** / *See* Cartridge.
- **CHROMATIC ABERRATION** / Broadly speaking, an aberration is any defect in the optical or lens system of a camera. Aberrations, as the name suggests, cause the photographs taken through these lenses to fall short of optimum quality. One common defect is called chromatic aberration. All lenses are, in effect, prisms. When normal, or white, light enters a lens, the seven rainbow colors which make up this light are bent or refracted. Because this refraction or bending takes place at a slightly different angle for each color, we are able to see the different colors that make up white light when we pass the light through a prism. A side effect of this phenomenon is that a single lens will bring each color into focus at a slightly different point. As a result, in both black-and-white and color photography, a photograph taken with a lens that is chromatically aberrant will be slightly blurred or out of focus in all color wave lengths but one—obviously an unacceptable situation. To resolve this difficulty, the color-corrected lens was devised. This lens is made up of several lens elements, each of which has a different refractive index. In combination, the varying refractive indices cancel out each element's chromatic aberration and bring all colors into sharp focus at the same point on the film plane.
- **CINE LIGHT** / *See* Movie light.
- **CLOSEUP PHOTOGRAPHY** / A photograph which has been focused by optical or mechanical means at a distance of no more than 1½ feet in front of the *camera.*

    Closeup photography or macrophotography is generally regarded as any subject photographed at a distance of 1½ feet or closer. The image of a photographic subject recorded on film grows larger as the camera-to-subject distance is reduced. Since the shooting distances for close-ups are less than 3 feet, you can almost always count on getting a clear picture. Framing and focusing are critical in close-up photography, and accordingly, a single-lens reflex camera is best. Flash is usually necessary for close-ups since you will almost always want to boost the light so that you can use a small aperture that gives you an adequate depth of field. Subjects for close-ups are infinite underwater. You need only to look under rocks or coral ledges or poke around in the sea grass to find sea anemones, miniature sponges, snails, tube worms, star fish, and coral polyps. Sponges, coral, and tropical fish are particularly good for close-ups because they have interesting shapes, unusual textures, and bright colors. *See also* Diopter.

- **COLOR** / *See* Films, color, Color temperature, Dispersion.
- **COLOR BALANCE** / Color film records color that the photographer's eye does not always see. The human brain records colors of the world as it remembers they should look, automatically compensating for a certain degree of color change. Color film records the light wavelengths it was designed to record. It cannot automatically compensate for light shifts in color as the brain does.

    Therefore color films are designed primarily to accurately record color balance, measured in a quality known as color temperature. Temperature serves as a gauge because the spectrum of wavelengths of light varies as it heats up. "Warm" color is red, "cool" color is blue.

    Color temperature is measured on the Kelvin scale, which serves as a standard comparative measure of wavelengths present in the light we see.

    Daylight film is balanced for the color temperature of midday light (about 5500° on the Kelvin scale). Tungsten film (indoor film) is balanced for artificial light sources which are quite a bit "warmer" than daylight, or about 3200° to 3400° Kelvin.

    If one takes a photograph under lighting conditions that are not matched to the film, unbalanced, or "wrong," color will result in the finished photographs.

    Color film must be chosen to match the illumination conditions. If the illumination conditions are not balanced (matched), then this can be corrected with the use of either color-compensating, color-conversion or color-correcting filters.

    The photographer can also choose to unbalance or change the colors rendered by choosing color filters that will exaggerate or distort the "true" color of the existing object or scene being photographed.

    Therefore true color balance can be obtained by choosing color film balanced for the particular light source you will be using—or you can change the color balance to render it more accurate or to render it exaggerated by the utilization of color-compensating, color-conversion or color-correcting filters.
- **COLOR-COMPENSATING FILTERS (CC filters)** / *Filters* are usually made of gelatin, optically corrected, and produced in six colors of various intensities for use in balancing the color of the light available for exposing film and photographic paper.

    The filters most used in UW photography are the Kodak CC-R series.

    *See also* Conversion filters, Filters.
- **COLOR RENDITION** / *See* Color balance.
- **COLOR REVERSAL FILM** / Films which produce a positive transparency are called reversal films. This film reproduces color accurately on the

material that is actually exposed in the camera. Blues are rendered as blues, yellows as yellow, etc. Color reversal film stocks are the material we use when we want slides, or super-8-mm motion pictures, and as a result they are normally projected on a screen, rather than viewed directly. It is technically possible to have color prints made from color reversal originals, although the result is generally not quite so good as prints made from color negative stock.

- **COLOR TEMPERATURE** / A means of describing the color of light in terms of its relative warmth (dominance of red wavelengths) or coolness (dominance of blue wavelengths), which can be measured in degrees Kelvin. Applicable only to light sources, such as the sun or a tungsten lamp, emitting a continuous spectrum. *See also* Color balance.)

- **CONCENTRIC DOME LENS, PORT** / Because of the many optical problems inherent in the use of flat ports in UW photography several different approaches have been tried to resolve them.

One of the most elementary and least costly methods of restoring the full coverage angle of an "in-air" lens used underwater and of avoiding many of the aberrations of a flat underwater port is to use a hemisphere with concentric inner and outer surfaces. The majority of these domes are made of Plexiglas, which has very good optical properties. The main suppliers for such domes are the manufacturers of Plexiglas covers for marine compasses. Glass domes are also used and can be obtained from optical supply houses. Before we speak of the advantages and disadvantages of each, let us consider the general optical principles on which they work.

In order to gain the full correction that the dome port affords, the in-air lens and the dome must be so placed that the entrance pupil of the lens and the center of curvature of the dome coincide. From Fig. G.1 it can be seen that the image-limiting center rays, which establish the *angle* of coverage, meet the dome port perpendicularly along a radial path after passing through the center of the lens. Now any ray incident on a surface at an angle perpendicular to that surface, i.e., any ray traveling along the normal, continues without deviation and is not refracted. The original in-air coverage angle of the lens is thus preserved.

As we have seen, a flat port reduces the apparent object distance by 25 percent from the actual object distance. A dome port in conjunction with an in-air lens reduces the apparent object distance o' still more (Fig. G.2) owing to the fact that the dome in contact with the water forms a strong negative lens element. Just as a rough example: with a dome of radius approximately 4⅓ inches (110 mm) and an actual in-water distance from object to a dome of 8 feet (2438 mm), the dome port alone may give an apparent object distance o' of approximately only 15.6 inches (396 mm). The exact apparent object distance varies, depending on the radius of curvature of the particular concentric dome used and the

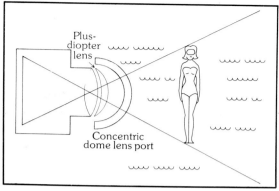

**Fig. G.1** Restoration of the original object space coverage angle of an in-air lens by means of a concentric dome port.

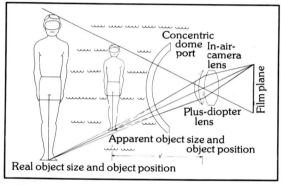

**Fig. G.2** Real and apparent object size and object position with an in-air lens in conjunction with a concentric dome port.

reduction in apparent distance is greatest for the smaller domes. What the photographer is confronted with in effect is closeup photography, as far as focusing the lens is concerned. Closeup photography, of course, can be managed either by using a plus-diopter supplementary lens or by using an extension shim or adapter to move the film plane farther from the lens. Which of these means is used depends on the particular camera and in-air lens combined with the dome-port system.

The following are examples of supplementary plus-diopter lenses to be utilized with specific domes:

| Radius of Curvature of Dome Port | Diopter Lens |
| --- | --- |
| 3.5 in. ( 89 mm) | +5 |
| 6 in. (152 mm) | +3 |
| 8 in. (203 mm) | none, if the in-air lens in use can be focused to within 2 ft (610 mm) |

From all we have said, it is evident that the dome port as such, used with or without a plus-diopter lens, will affect the accuracy of the camera lens's engraved focus or footage scale. This scale cannot be used accurately in dome-port underwater application. It must be refigured, either through optical mathematics or by trial and error using a reflex camera underwater. Naturally, if focusing is done via the ground glass of a reflex-type camera, one does not have to refer to the footage scale at all.

Although the dome port makes the footage scale even more inaccurate than the flat port does, it does give good correction of the underwater magnification effect. The object is seen by the system not only at a much shorter apparent object distance but also at a proportionally smaller size (Fig. G.2). As the object distance shrinks, the apparent object size shrinks in exactly the same proportion. The camera sees a nearer object of a smaller size, and one effect compensates for the other to keep the angular dimensions constant. Not only is the object's in-air coverage angle maintained by the dome-port system but also nothing is lost of the object. There is no cropping, and the object is reproduced on the same scale as it would be reproduced by the same lens at the same actual distance with in-air photography.

The dome-port system also gives good correction of such refraction defects as coma, astigmatism, distortion, and chromatic aberration in comparison with the minimal corrections of the flat-port system, according to the author's experience.

The dome-port combination also exhibits very good correction of pincushion distortion as can be seen in a test-pattern slide taken under water (see Illustration 2.6). Edge sharpness is not completely corrected. But in actual underwater filming no loss of edge resolution can be detected. Dome-port correctors do exhibit a slight difference in focus from the center of the frame to the edge of the frame. This is because the dome-port focuses on a curved aspheric surface, but the camera's film plane is flat. It is completely compensated for, however, by the depth of field of wide-angle in-air lenses. Illustration 2.7 is a comparison photograph made with the same focal length (20 mm) and at the same actual object distance (3 ft) 91 cm as Illustration 2.6, but with a flat port. Note the corrected magnification and improved pincushion distortion and other refractive defects in Illustration 2.6 thanks to dome-port use.

Illustration 2.8 shows as a further comparison a photograph of the test chart, made again at the same distance of 3 feet, but using a fisheye lens in conjunction with a dome port. The lens was the Minolta Rokkor OK MC fisheye 16 mm, f/2.8, with a pickup angle of 180°, filling the 24 x 36 mm format. The extreme curvature (barrel distortion) is caused by the fisheye lens design, not by the dome port, which conserves the lens's in-air angle.

Let us now briefly consider the merits and drawbacks of Plexiglas and real-glass domes. Glass ports, fabricated to the proper shape, size, and thickness, can have good strength and rigidity. However, glass domes are much more costly, and they are difficult to cut to the proper size for a housing. Moisture (fogging and droplets) forms more readily on the inside of a glass dome, especially in cold water. Plastic, on the other hand, is cheaper and more easily fabricated, but it scratches more easily. Plastic domes when not in use can be protected from scratching by lens covers. They show almost no fogging or interior condensation of water vapor. All in all, plastic domes seem best at the depths we have been working at.

*See also* Condensation, Lens.

- **CONDENSATION** / Condensation is the reduction of a gas to a liquid. Warm air contains moisture (humidity). This warm air condenses into water under certain conditions. Condensation can become a real problem to the UW photographer when the surface humidity is high and air temperature is warmer than the water you will dive in. This warm, humid air enters the UW camera, or UW camera housing when it is opened to adjust the camera or change *film*. When the camera or housing is then submerged in cold water, the temperature differential is transmitted quickly through the glass or plastic port and the enclosed air begins to condense into water droplets, often covering the inside of the port. Resulting photographs taken under these conditions look as if the picture were taken in a thick fog.

  Some useful tips: When condensation is forming on the interior of any type of UW port, the heat from an underwater movie light can be used to warm up the port, and often the condensed droplets will evaporate. Inserting a silica-gel packet in the housing before diving may also help to eliminate excessive condensation. If at all possible, try to change film in a dry location on the dive boat—a cabin is a better place for this than the open sections of the boat. Anti-fog solution—sold for defogging divers' face masks—can also be carefully applied to the inside surface of the port, thereby inhibiting moisture condensation.

  *See also* Concentric dome lens, Port, Movie light.

- **CONVERSION FILTERS** / Filters designed to help correct *film* sensitized to one type of light (daylight, for instance) for use in a different type of light (tungsten, for example).

  Conversion filters differ from color-compensating filters (CC) in that conversion filters are designed for converting specific color films from balance with one type of light source to another. Color-compensating filters (CC) compensate for color balance by varying one color.

  *See also* Color compensating filters, filters.

- **DECOMPRESSION SICKNESS** / The most common serious diving disorder is the bends, or decompression sickness. The amount of nitrogen, which is always present in a dissolved state in the body tissues, increases under pressure during long or deep dives. If the diver ascends too rapidly, the increased pressure of nitrogen in the body's blood

and tissues cannot be eliminated fast enough through the lungs. The gas forms into bubbles that lodge either in the lungs or in the heart, causing symptoms of suffocation, or more commonly in the nerves, brain, or spinal cord, causing not only excruciating pain but also severe stiffness and even paralysis. To completely eliminate excess nitrogen from saturated tissues can take from nine to twelve hours, which an afflicted diver usually spends in a decompression chamber if he is lucky enough to be near one. Even so, he can still experience violent convulsions. Divers should follow a controlled ascent, rising at such a rate that the excess gas can be safely expelled through his lungs. Decompression tables have been formulated giving the time to be spent at different depths.

- **DEFINITION** / The fineness and clarity of detail in an image or the capability of a lens or an emulsion to yield fine detail.

    *See also* Resolution.

- **DEPTH OF FIELD** / The zone extending in front of and behind the point of sharpest focus throughout which focus seems acceptably sharp and unblurred.

    Depth of field varies significantly from one type of lens to another and, for any individual lens, depending on the aperture setting and upon whether the photographer is attempting to focus on an object which is very close to him or which is at some distance from him. Taking the significant factors in order, the first element which governs depth of field is the focal length of the lens. Because of inherent design characteristics, wide-angle lenses have proportionately a much greater depth of field than telephoto lenses do. Extreme wide-angle lenses sometimes have such a great depth of field—from a matter of a few inches outward to infinity—that the designers do not even incorporate a focusing capability in the lens. Telephoto lenses, on the other hand, inherently have a very narrow depth of field. When photographing with an extremely long lens, focus becomes an extremely critical factor, as the nearest and most distant point of acceptable focus may be separated from each other by a matter of feet, or even inches.

    The second factor governing depth of field is the aperture, or *f*-stop, at which the lens is set. For any given lens, a wider aperture will yield a shallower depth of field than will a small aperture. This characteristic is constantly borne in mind by the creative photographer and is used to impart maximum impact to his photographs. As an example, let's say you want a photograph of a particularly beautiful and unuusal fish. This fish, however, insists on positioning itself in front of a jumbled, cluttered background of coral, rocks, and debris. You might consider opening your lens to its widest aperture setting and then compensating for the exposure by using a faster shutter speed. The result, in your finished photograph, would be that the shallow depth of field had knocked the unwanted background sufficiently out of focus so that it no longer detracted from the beauty of the fish which was your principal subject. Conversely, let's say you wanted to photograph the same fish, but with as much of its natural habitat as possible included in the picture. You might then set your camera to the narrowest aperture, again compensating for exposure by using a slower shutter speed, so that you would increase your depth of field to the greatest extent possible. The third factor affecting depth of field is the subject-to-camera distance. For any given lens, the depth of field will be greatest for subjects which are at, or close to, their maximum acceptable distance from the camera.

- **DIAGONAL ANGLE OF COVERAGE** / *See* Angle of coverage.

- **DIAPHRAGM—*f*-stop** / In a camera, usually placed in the lens barrel or shutter mechanism, a device for regulating the size of the light-admitting aperture by means of leaves that overlap to expand and contract in circular order.

- **DIFFUSION** / The scattering of light rays in all directions, as a result of their reflecting off a rough surface or passing through a translucent medium.

- **DIOPTER** / A unit of measure employed in optics to express the refractive power of a lens, usually applied to supplementary close-up lenses to indicate their capability for magnification.

    The term "diopter" is most commonly heard applied by opticians to the lenses in eyeglasses. Plus diopters allow for closer eye focus, and minus diopters allow for distant eye focus. For example, a nearsighted person will need a minus-diopter lens correction in eyeglasses. A far-sighted person will need a plus-diopter lens correction. Since we are not concerned with distant focus in UW photography, only plus-diopter supplementary lenses are of concern here.

    *See also* Close-up photography.

- **DISPERSION** / In the definition of the spectrum we explain that a ray of normal light that appears white or colorless to the eye is actually composed of seven major colors, which can easily be seen when the light is passed through a prism. When that happens, each of the seven colors in the visible spectrum is refracted or bent to a somewhat different degree and is thereby made discernible. This characteristic of light is termed dispersion, and the fact that each of these different colors, having a slightly different wavelength, emerges from the prism at a visibly different point is a vital factor in the design of any optical systems. This is true because *every lens* is, in fact, a prism. Therefore, when light is refracted through the prism (or lens), the various colors of which it is composed tend to *focus* at a different point. The effect of this divergence of focus is more fully discussed in the section on Chromatic aberration.

- **DISTORTION** / A major *aberration* encountered when a flat port creates an interface between air and water. Distortion affects the shape of the image. Pincushion distortion results when magnification of the outer portions of the picture is greater than that of

the center portions and barrel distortion results when it is less. A flat port produces primarily pincushion distortion—again more noticeable with wide-angle lenses. Such distortions are less distracting, of course, if natural subjects with no straight lines or square corners are being photographed.

*See also* Concentric dome lens, Port.

- **DOME PORT** / *See* Concentric dome lens, Port.
- **ELCAN UW LENSES, LEICA** / *See* Lens, underwater, and Water contact lens.
- **ELECTRONIC FLASH** / *See* Strobe.
- **EXPOSURE BRACKETING** / Taking a picture at the *aperture* indicated by the *light meter*, taking a second picture with the *lens* opened one *f-stop* wider than the meter indicates, and taking a third shot with the lens closed down one *f*-stop smaller than the meter indicates. Everything else, including *shutter speed, ASA, camera*-to-subject distance, remains the same.
- **EXPOSURE LATITUDE** / The effect that *light* has on photosensitive material; also the product of light's intensity and the time during which it affected the photosensitive material.

  Exposure depends on two factors—the strength of the light and the length of time it is permitted to act on the *film*. In a *camera* each of these factors can be controlled independently or in combination.

  The strength of the light reaching the film is determined by the *lens aperture*. The length of time is dependent on the *shutter speed*.
- **EXPOSURE METER** / *See* Light meter.
- **EXTENSION TUBES** / Light-tight tubular rings designed to extend the distance between the lens and the focal plane inside the camera and thus to effect image magnification.

  In order to practice the art of macrophotography, the UW photographer must be able to place his camera almost on top of the tiny objects he will photograph and *focus* his lens sharply at the very short distances at which he will be working. Adapting a standard lens to work at these close ranges can be accomplished in two basic ways. The first is by the use of diopters, or supplementary, lenses.

  The second method is by the use of an extension tube. The extension tube increases the focal length of the lens by physically moving the lens further from the film plane. In this way, it permits the lens to be focused crisply at a distance of just a few inches. Extension tubes are available for most popular camera and lens systems. As they are, in essence, a simple tube with a mount that will fit the camera on one end and a mount that will accept a lens on the other, they are comparatively inexpensive. Extension tubes come in a wide range of reproduction ratios, so the photographer can select the tube or tubes which will mate most effectively with his existing lenses and yield the photographic results in which he is most interested.
- **FILMS, BLACK AND WHITE** / *Film* rendering the shades and colors found in nature as shades on a gray scale, ranging from intense black to pure

white. Because it is a negative film, it responds to those tones in the opposite manner to the way they actually appear, that is, black appears as white on the film, white as black, light gray as dark gray, etc. When used with a suitable negative printing paper, the process is reversed, so that an object that was originally black again appears black, and so on down the tonal range.

TRI-X-PAN (TX) ASA 400 black-and-white negative film, Kodak
    Film sizes: 135 (35 mm) cassette, 20 and 36 exposures
        120 (2¼/2¼–6/6 cm or 2¾ by 2¾–6/7 cm) roll film.

VERICHROME PAN (VP) ASA 125 black-and-white negative film, Kodak
    Film sizes: 110 cartridge, 12 exposures
        126 cartridge, 12 exposures

PLUS-X-PAN (PX) ASA 125 black-and-white negative film, Kodak
    Film sizes: 135 (35 mm) cassette, 20 and 36 exposures

PLUS-X-PAN PROFESSIONAL (PXP) ASA 125 125 black-and-white negative film, Kodak
    Film sizes: 120 (2¼/2¼–6/6 cm or 2¾ by 2¾–6–7 cm roll film.

PANATOMIC-X (FX) ASA 32 black-and-white negative film, Kodak
    Film sizes: 135 (35 mm) cassette, 20 and 36 exposures

PANATOMIC-X PROFESSIONAL (FXP) ASA 32 black-and-white negative film, Kodak
    Film sizes: 120 (2¼/2¼–6/6 cm or 2¾ by 2¾–6/7 cm) roll film

- **FILMS, COLOR** / Comes in two major types; Color reversal (slide) film, and color print (color negative) film. In most cases I do not advise the use of color print (color negative) film in UW photography.

  Ektachrome films are supplies in two forms (in some sizes): amateur films and professional films.

  This is a new distinction with Ektachrome films. Amateur films can withstand higher storage temperatures, but color will shift with aging of the film. Professional films are said by the manufacturer to remain constant in color balance, but they must be kept under controlled temperature conditions, and processing must be performed soon after exposure of these films. If you are diving in hot areas, and keeping your film cool would be difficult to achieve, then it would be better to use the amateur films. As the needs of the amateur and professional photographer expand, film manufacturers (and camera manufacturers also) add more and more products to choose from. I have found it best to select one medium-speed and one fast-speed color film that seems to work well for me, and learn how to use those films in all situations. Too many choices will only lead to poor results. Various color films will give different tones of color; and since every person's eye varies, what may be pleasing color to my eye may not be so pleasing to yours. Stick to color film that gives results that are pleasing to your eye.

You will only get into trouble if you try to use many types of color film on a dive, trip, or professional UW photographic job.

*AMATEUR FILMS* (Ektachrome E-6 process)

EKTACHROME-64 (ER) ASA 64 E-6 lab process positive color slide film, Kodak

Film sizes: 110 cartridge, 20 exposures
126 cartridge, 20 exposures
135 (35 mm) cassette, 20 and 36 exposures
120 (2¼/2¼–6/6 cm or 2¾/2¾–6/7 cm) roll film

EKTACHROME-200 (ED) ASA 200, E6 lab process positive color slide film, Kodak

Film sizes: 110 cartridge, 20 exposures
126 cartridge, 20 exposures
135 (35 mm) cassette, 20 and 36 exposures
120 (2¼/2¼–6/6 cm or 2¾/2¾–6/7 cm) roll film

*PROFESSIONAL FILMS* (Ektachrome E-6 process)

EKTACHROME-64-professional (EPR) ASA 64 E-6 lab process positive color slide film, Kodak

Film sizes: 135 (35 mm) 36 exposure
120 (2¼/2¼–6/6 cm or 2¾ by 2¾–6/7 cm) roll film

EKTACHROME-200-professional (EPD) ASA 200 E-6 lab process positive color slide film, Kodak

Film sizes: 135 (35 mm) 36 exposures
120 (2¼/2¼–6/6 cm or 2¾ by 2¾–6/7 cm) roll film

Both Ektachrome-200 ED and EPD film can be developed for an effective ASA rating of 400. But this takes special development by the processing lab. Kodak sells special "Pushed Development" (Kodak Special Processing Envelope, ESP) envelopes, and most processing labs can "push" these two films to ASA 400, thereby giving you either one further *f*-stop, or one faster shutter speed when shooting underwater. *Remember:* once you deside to shoot at the higher film speed (ASA rating), you must shoot the whole roll at that higher film speed. You can't change horses in midstream.

KODACHROME-25 (KM) ASA 25 positive color-slide film

Film sizes: 135 (35 mm) 36 exposure cassettes

KODACHROME-64 (KR) ASA 64 positive color-slide film

Film sizes: 110 cartridge, 20 exposure
126 cartridge, 36 exposure
135 (35 mm) 36 exposure cassettes

SPECIAL FILMS

Ektachrome slide duplicating film 5071 E-6 lab process positive color-slide film

Film size: 135 (35 mm), 36 exposure

Color-reversal film for making duplicate color slides from original Ektachrome and Kodachrome transparencies. *See* Duplicating color slides.

- **FILM SPEED (ASA)** / A term for the relative light sensitivity of photographic materials; also for the light-admitting capabilities of lenses.

- **FILTER FACTOR** / The number by which correct exposure prior to filtration must be multiplied in order to maintain the same effective exposure once the filter has been added. The factor increases exposure to compensate for the light withheld by the filter.

- **FILTERS** / A piece of transparent material, such as gelatin, glass, or acetate, that when placed in front of the light source can, through its color or structure, affect the exposure of photosensitive materials by blocking some wavelengths while passing others. *See also* Color compensating (CC) filters, Conversion filters.

- **FISHEYE LENS** / An extremely wide-angle lens covering a field of about 180° and reproducing a circular image with pronounced barrel distortion.

- **FLASH** / A light source that is coordinated with the camera's shutter mechanism to provide, for purposes of exposure, a brief, intense flash of light.

- **FLASH BULB, FLASH CUBE** / Expendable photoflash lamps (bulbs and cubes) containing metallic foil or wire in a pure-oxygen atmosphere. When ignited by an electrical trigger (battery), they provide a high-intensity, short-duration light pulse. Color temperatures range from about 3800° to 3950* Kelvin for aluminum and zirconium, respectively. Most flash bulbs are also available with a blue coating that filters the light to approximately daylight color film balance.

Flash bulbs provide a convenient and fairly inexpensive light source for still photography.

Relatively large and powerful strobe units are required to equal the light output of the commonly used flash bulbs.

Flash cubes (high power) are sufficient for flash photography with inexpensive cameras used underwater (such as some models of the Instamatic camera). They will also provide sufficient light for macrophotography.

For most other UW flash photography purposes, the bayonet-based or "peanut" flash bulb is preferred because of its much greater light output.

*Synchronization advantages of flash bulbs:* Focal-plane flash bulbs are designed for use with cameras with focal-plane shutters; this includes almost all 35-mm cameras, and the Nikonos models of amphibious UW cameras. You will get the maximum amount of light output from a flash bulb when your camera shutter is set at 1/30 of a second. You will cut the light intensity in half each time you double your shutter speed. This enables you to combine natural (ambient) light underwater with the light from the flash bulb, by varying the speed and *f*-stop.

This combination of ambient light and flash light enables you to let the ambient light light up the water and background of your photograph while the flash bulb lights up your foreground subject matter and reestablishes the proper color rendition of your subject also.

Strobe cannot synchronize with the focal-plane shutter at speeds higher than 1/60 of a second. (A

few cameras will synchronize strobe to 1/125 of a second, but they are rare).

The "speed" when using a strobe light is in the duration of the strobe light itself, not in the speed of the camera's shutter. You get the same light output from a strobe at any shutter speed from 1/60 and slower.

Since one of the main sources of "balancing" exposure is in being able to vary both shutter speed, and *f*-stop (diaphragm), you can see that you have lost one major variable with the strobe, since you cannot utilize your camera's shutter to cut down background light by using a shutter speed higher than 1/60.

Flash bulbs enable you to choose both the shutter speed and *f*-stop variable.

This combination is known as "synchro-sunlight." Figuring the proper exposure utilizing both flash and daylight in combination takes a little juggling. First use a UW light meter to determine a normal exposure without flash. Then choose an *f*-stop and shutter-speed combination where the *f*-stop is one or two stops smaller than the one you would use if you were relying on the flash bulb alone to light up your subject matter. This way you will get just enough light from the flash to restore the proper colors, especially the reds and yellows, and still get the background—or blue water—properly exposed. It takes some practice, but the resulting photographs do not have that harsh front-lighted or over-lighted look that flash alone can give.

- **FLAT PORT** / The flat port is the most commonly used port in UW photography. It consists of a port made of glass or clear plastic (i.e., Plexiglas), with the surface sides of the port flat and parallel to each other (plane parallel).

Fig. G.3 illustrates what happens when a flat port is used in conjunction with an "in-air" lens in UW photography. Underwater, any lens with a flat port produces an image equivalent to that which would be obtained by in-air photography on the surface with a lens having a focal length 33 percent greater. The angle of coverage of the lens behind a flat port is reduced. Why?

The angle of coverage of a lens is determined by those limit rays which can be traced backward from the edge of the image aperture (the film-frame border) through the center of the lens and straight outward into the object space. (Rays passing through the center of a lens are not refracted.) This is usually determined with the lens focused at infinity. In air, the outward-bound limit rays would travel along the broken lines as shown in Fig. G. 3. However, at the transition at the flat port from air into water or water into air, these rays are refracted, and the solid lines show their path within the water. The effective angle of coverage can be calculated from $(\sin a/2)n - \sin b/2$, where $a$ is the coverage angle in air and $b$ the effective coverage angle in water. It turns out that the effective angle underwater with a flat port is roughly only 66 to 75 percent of the coverage angle that the same lens would have in air.

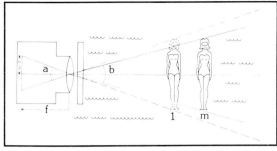

*Fig. G.3* Image space coverage angle (*a*) and object space coverage angle (*b*) with a flat-port UW camera housing ($h/2f = \tan a/2$).

To clarify this, consider a person at an object position *1* (Fig. G.3) such that the person would just fill the whole picture height in air. That person's image would appear cropped as indicated in the figure by the solid lines of the underwater pickup angle *b* (in addition to appearing closer to the camera). To avoid this cropping, the person must be placed at a greater distance, as seen in *m*.

To summarize the refractive effects of using a flat port: It produces an apparent shift of the object toward the camera, to 3/4 of its true distance without any change in the size of the object. This apparent reduction of object distance makes the object appear larger by 4/3. In addition, the coverage angle of the camera is reduced to about 3/4 of its in-air angle.

*See also* Port, Concentric dome lens port, Water contact lens, Refraction, Lens, underwater, Angle of coverage.

- ***F*-STOP** / The numerical expression of the relative size of the light-admission opening in the lens, an expression derived from the lens's focal length divided by the effective diameter of the lens. Each lens is capable of a series of apertures, often termed *f*-stops.
- **FOCAL LENGTH** / The distance from the lens to the plane of focus when the lens has been focused at infinity, usually stated in terms of millimeters (mm) i.e., 50-mm lens, 35-mm lens, 21-mm lens, 15-mm lens, etc.
- **FOCAL-PLANE SHUTTER** / A light-controlling mechanism installed along and just forward of the camera's focal plane that allows film to be exposed progressively through a slit of adjustable size formed by one or more roller blinds moving parallel to the focal plane.
- **FOCUS** / The point inside the camera where light rays converge to form a clear and sharply defined image of the subject in front of the camera. To adjust the camera to achieve this result.
- **GUIDE NUMBERS (GN)** / The GN is a rating supplied by manufacturers for different combinations of flash and film. When flash (either bulb or

strobe) is to be used, the correct exposure can be determined by measuring the distance in feet from flash to subject and dividing it into the guide number. The result is the *f*-stop setting to be used for average exposure.

As an example:

$$\text{Flash-to-subject distance} = \frac{GN80}{10 \text{ ft}} = f\text{-stop } 8$$

Guide numbers are only approximate and should be used as "guides" only, because shooting conditions vary widely, affecting the finished exposure. Remember that in UW photography, guide numbers supplied by manufacturers for use in "surface" photography cannot be used underwater. Manufacturers of UW strobes supply guide numbers that conform to use underwater and can be relied upon to give you a starting point for good exposure.

Good flash exposure will result from using guide numbers as a general guide, and *bracketing exposures* both over and under. You will soon learn what are accurate guide numbers for correct exposure for the UW conditions in which you work.

- **HOLDING ARM** / *See* Mounting bar.
- **INCANDESCENT LIGHT** / Illumination generated by a heated substance, such as the glowing filament of a light bulb, which derives its energy from electric current.
- **INCIDENT LIGHT METER** / *See* Light meter.
- **INFINITY (∞)** / In photography, the area farthermost from the camera in which objects are seen by the lens in sharp focus. This usually commences at 40 or 50 feet in front of the camera and continues into the distance as far as some 300 yards. Infinity focusing derives from the phenomenon of light rays seeming to travel parallel to each other over great distances rather than at angles to one another as in the near environment.
- **IVANOFF CORRECTOR, PORT** / One of the first optical designs to reduce the aberrations inherent in the flatport, originally invented and manufactured in France. It is basically a reversed Galilean telescope, in which the front plano-concave lens is used as the water-tight port. This negative element is combined in the corrector with a positive lens positioned behind it. Manufacturing and patent rights to the Ivanoff corrector are held by (Rebikoff) Underwater Products, and the device can be obtained only through this company as a complete camera-plus-corrector unit.

This corrector has been designed to be afocal, and it therefore can be used in conjunction with an in-air camera lens of any focal length as long as no vignetting of the corners of the film frame occurs. It completely corrects for the UW magnification effect, and thus the focal length, image scale, and field of coverage of the camera lens is the same in water as in air. Pincushion distortion, chromatic aberration, and other flat-port aberrations are fully corrected. Although the Ivanoff corrector is afocal, in practical applications, due to the varying diameters of in-air lenses, a separate Ivanoff corrector must be de-

signed for, and matched for, each individual in-air lens it is to be used with.

- **LEAF SHUTTER** / A mechanism for controlling exposure, usually located in the lens or just behind it, whose assembly is a concentric arrangement of overlapping metal leaves that, when activated, rotate toward the outer rim of the circle, thus admitting light, and then closing. Sometimes called diaphragm shutter.

*See also* Focal plane shutter.

- **LENS** / A solid-shaped piece of transparent material (glass or plastic) or an assembly of such pieces capable of gathering and selecting light rays reflected from a subject, and of modifying their behavior so that they enter the camera and travel toward the focal plane to form there an image of the subject from which they emanated.

*See also* Concentric dome lens port, Flat port, Diopter, Fisheye lens, Ivanoff Corrector, Telephoto lens, Wide-angle lens, Zoom lens, Water-contact lens, Lens, underwater.

- **LENS, UNDERWATER** / Data for surface lenses, and underwater lenses for still and cine photography:

The following table lists some of the common lenses used in UW photography. Lenses of equal focal length and aberration correction manufactured by other lens companies will exhibit similar diagonal image angles of coverage.

| Lens Identification | | In-Air* | UW Flat Port* | UW Dome Port* | UW Water Contact* |
|---|---|---|---|---|---|
| *16-mm FILM* | | | | | |
| Century † | 3.5 mm f/1.8 | 165 | 123 | 165 | na |
| Century | 5.7 mm f/1.8 | 100 | 75 | 100 | na |
| Angenieux | 5.9 mm T/2 | 94 | 66 | 94 | na |
| Angenieux | 10 mm T/2 | 64 | 47 | 64 | na |
| Leitz Elcan water-cor tact lens | 6.6 mm f/2.4 | na | na | na | 76 |
| *24 X 36 STILL* | | | | | |
| Nikon-Nikonos water-contact lens | 15 mm f/2.8 | na | na | na | 94 § |
| Leitz-Elcan water-contact lens | 15.3 mm f/2.8 | na | na | na | 90 + |
| Minolta-Rokkor-OK MC fisheye lens † | 16 mm f/2.8 | 180 | na | 180 | na |
| Sigma-Filtermatic fisheye lens Multi † | 16 mm f/2.8 | 180 | not practical | 180 | na |
| Canon FD | 17 mm f/4 | 103 | 72 | 103 | na |
| Pentax-Takumar SMC † wide-angle | 17 mm f/4 | 120 | not practical | 120 | na |
| Spiratone-Sigma-wide-angle | 18 mm f/3.2 | 100 | 70 | 100 | na |
| Nikon-Nikkor auto | 20 mm f/3.5 | 94 | 66.5 | 94 | na |
| Nikon-Nikkor ‡ | 21 mm f/4 | 92 | 65 | 92 | na |
| Nikon-Nikkor auto | 24 mm f/2.8 | 84 | 60 | 84* | na |
| Nikon-Nikkor auto | 28 mm f/2 | 74* | 54 | 74 | na |
| Nikon-Nikonos UW water-contact lens | 28 mm f/3.5 | na | na | na | 59 # |
| Nikon-Nikonos lens | 35 mm f/2.5 | 62 | na | na | 46.5 ¶ |
| Nikon-Nikkor auto | 35 mm f/2 | 62 | 46 | 62 | na |
| Nikon-Nikkor auto | 50 mm f/1.4 | 46 | 34 5 | 46 | na |

*Coverage angles generally calculated in relation to the image diagonal.
† Image fills full frame of format, but lens is of fisheye design, therefore much inherent barrel distortion.
‡ This 21-mm lens is no longer manufactured, but it is included in this table because it is readily available used. Due to the novel design of this lens, it forms an excellent combination with a dome-port correction system.
§ Effective focal length underwater is 20 mm.
+ Effective focal length underwater is 22 mm.
# Effective focal length underwater is 38 mm.
¶ Effective focal length underwater is 50 mm.
na = Not applicable

- **LIGHT METER** / An instrument for measuring the intensity of the light falling on or reflecting from a subject and for indicating this in terms of camera exposure settings for the speed of the film used.

  There are two major types. The incident light meter measures the amount of light that actually falls upon the object or scene to be photographed. This meter is favored by professional cinematographers, since it can be a better judge of exposure judgment when many artificial light sources are illuminating the subject matter. However, the incident meter does not work well in reading ambient light underwater.

  The second type is the reflected light meter which measures the intensity of the light being reflected by a subject. This type of meter is most commonly used in UW photography.

  The reflected light meter, either a separate piece of photographic equipment or incorporated directly into the camera body itself, reads the amount of light that passes through the camera lens. When built into the camera itself, it is known as a through-the-lens light meter.

  There are so many varieties of reflected light meters built into cameras that it is pointless to try to explain how all of them work. If you operate a light meter correctly, according to the manufacturer's instructions, you should be able to rely on it to give you a very good indication of proper exposure settings for either the shutter speed or the lens diaphragm (f-stop).

  See also Reflected light meter.
- **MACROPHOTOGRAPHY** / See Close-up photography, Diopters.
- **MOVIE LIGHT** / A high-intensity incandescent light, with a medium-to-wide beam, used to illuminate movie photography scenes where there is insufficient or no ambient light available.

  It differs from flash illumination in that the light source remains constantly on until the battery supply runs out or the light is turned off.

  Movie lighting units are known as "constant" lights, because they can be used to illuminate still photography subjects, with a constant form of lighting.

  Movie-lighting units draw a huge amount of electricity because they must be bright enough to expose film correctly. They are powered by 110/220/240 electrical current or by groupings of Ni-Cd rechargeable dry-cell storage batteries.
- **MOUNTING BAR** / A device for mounting the light head of a strobe or movie light onto an amphibious camera or UW camera housing. Mounting bars vary widely in design, but are usually some form of tubular arm that not only mounts the light head to the UW camera but extends the head away from the camera. The mounting bar should be adjustable in some manner, so that the light head can be directed at the discretion of the photographer.

  Mounting bars are also known as "arms," "strobe-arms," "ball-joint arms," "holding arms," and "flexi-arms."

- **NATURAL LIGHT** / See Sunlight.
- **NITROGEN NARCOSIS** / Nitrogen narcosis is the medical term for the condition which Jacques Cousteau has aptly described as "rapture of the deep." The effects of nitrogen under pressure are very similar to those of a variety of gases used in anesthesia, and it is fairly well established that nitrogen has the same properties they do although in much weaker form. You can get a good idea of how nitrogen narcosis feels by going to a dentist and having nitrous oxide for a tooth extraction. The effects can also be compared to something a lot more familiar—alcoholic intoxication. The first symptoms usually become apparent at depths in excess of 150 feet, depending upon the individual. The diver feels elated and loses coordination. He behaves as if he were intoxicated and may become irresponsible. This sense of euphoria can be fatal. Two people are unlikely to be affected at exactly the same depth; therefore it is important to watch your buddy carefully when diving deeper than 75 feet. You may not notice any impairment unless you try to do something which requires quick thinking or accuracy of thought or motion, like reading a depth gauge, figuring decompression, or handling an emergency.

  Symptoms disappear immediately as the diver rises above his susceptible depth and have no known aftereffects.
- **OPTICAL UNDERWATER VIEWFINDERS** / One of the most vexing problems facing the UW photographer has been the scarcity of accurate optical UW viewfinders.

  Reflex cine cameras, in some housings, permit direct UW viewing through the normal reflex system, and this is partially successful. The resulting finder image is quite small, however, because the diver-photographer cannot get his face close enough to the finder. It may be used for focusing, but even with reflex cameras underwater an optical viewfinder giving a large image is often needed also to see small details in the subject matter being filmed. The shape of a housing and the ease with which the diver can apply his face mask to the viewfinder determine just how and where the finder should be bolted to the housing. Simple parallax correction may be accomplished by including a hinge and an adjustment screw, but intuition and experience are necessary here. Field-limit masks may be obtained by etching a reticle (frame) or grid on a clear plastic disk, which then must be screwed down on the finder objective.
- **OUTGASSING, HYDROGEN** / See Batteries, dangers of.
- **OVEREXPOSURE** / Caused by too much light striking photosensitive (film) material.

  Using a light meter and flashguide numbers will help you to obtain properly exposed photographs, thereby avoiding overexposure.

  Today's black-and-white and color films have some exposure latitude, therefore you can be off in your exposure by one full f-stop overexposed or

underexposed and still have an acceptable black-and-white negative or color slide.

When in doubt about exposure settings on your camera, a professional photographers' rule of thumb is:

Lean toward overexposure when using NEGATIVE film, either black-and-white or color print film (Kodacolor, etc.).

Lean toward underexposure when using POSITIVE film, all color slide (transparency) materials.

Overexposure can be used as a means of visual impact, and slightly overexposed photographs are often called "high-key" photographs.

- **PARALLAX** / The discrepancy between the view presented to the eye through a camera's sighting device or viewfinder and that recorded by the camera's lens.

The term parallax identifies a defect inherent in the viewfinder that prevents it from revealing with accuracy the area actually seen by the camera lens. This discrepancy occurs because the viewfinder and the lens do not sight from the same position. Usually the viewfinder is located slightly higher than the lens and off to one side.

- **PORT** / The short form of the term "porthole," meaning a circular window in a boat, used by underwater photographers to describe the "window" through which a camera lens is both protected from the water and through which the lens "sees" an UW image. Most UW housing lens ports are also circular.

The term has been expanded to mean any window in a UW housing, such as a window to see controls or a window to look through the camera viewfinder, but in all cases the covering of the port, whether it be glass or Plexiglass, transmits light clearly.

*See also* Flat port, Concentric dome lens port, Fisheye lens, Water-contact lens, Lens, underwater, Refraction.

- **RANGEFINDER CAMERA** / Essentially, the rangefinder camera is a viewfinder camera with the added capacity to focus the image by eye. Some rangefinder cameras make use of a split image, so that the photographer has to bring two halves of the image together. other systems use a double image, which requires that the photographer superimpose one image over the other so that they are perfectly matched. Both systems use a pair of matched mirrors, which are linked to the focusing ring of the lens. When these mirrors are brought into coordination with each other, either by superimposing a dual image or lining up the split image, the camera is automatically focused at the range of the object being observed. Rangefinder camera systems suffer two principal disadvantages underwater. The first is that, when the camera is placed in a watertight housing, it is usually very difficult to get the face mask close enough to the rangefinder viewing port to observe the image clearly and focus the camera properly. The second disadvantage is common to all viewfinder cameras, of which this is a form: The system is subject to parallax error.

- **REAL IMAGE** / An image capable of being projected, as by a positive lens, upon a surface, such as the ground-glass screen at the back of a view camera, and there made visible to the naked eye. *See* Virtual image, Apparent distance.

- **REFLECTED LIGHT METER** / The reflected light meter measures the amount of light bouncing off the subject and reaching the photographer's position. For most photographic purposes, reflected light readings are acceptably accurate, and their use is faster, more convenient, and much less intrusive. There are two types of reflected light meter:

1. The selenium photoelectric cell which produces a current when light falls on the cell which activates an indicator needle on the meter dial.
2. The cadmium sulfide (CdS) cell powered by a battery. The cell functions as a resistor, blocking the flow of electricity from the battery. Light striking the cell reduces its resistance, resulting in a current which activates an indicator needle on the meter dial. CdS meter can usually measure lower light levels than selenium meters can.

- **REFLEX CAMERA** / A reflex camera is a camera which allows the photographer to observe his subject, compose his photograph, and focus the image through a lens which is either the same as, or identical with, the lens which will actually take the photograph. There are two types of reflex camera. The older type is called the twin lens reflex (TLR). The newer version is the single lens reflex (SLR).

- **REFRACTION** / The bending of light rays caused by their passing obliquely from one transparent medium through another of different density, as from air to water.

Light rays which are not reflected penetrate water, but they undergo a change of direction: They are refracted. This accounts for the observation that an oar appears to be bent at the place where it enters the water. Since any light ray passing from a low-index-of-refraction medium such as water or glass is bent or refracted toward the normal (and any ray passing the other way is bent away from the normal), it is obvious that the water itself acts like an additional very poor and very changeable lens in an UW photographic system. This ultimately is the source of most of the problems of UW photography—the need to compensate for the refractive effects of the water. Plastic or glass ports and special lenses may be used to partially compensate for these effects.

There are four main categories of optical problems in UW work, all due to refraction by the water in the object space in contrast to the air in the object space in surface photography. They are (1) an apparent change in object position; (2) an increase in image size (a magnification of the image relative to the image which would be obtained by the same lens at the same actual object distance by in-air photography, (3) a reduced angle of coverage or lens pickup

angle, and (4) some increase in general optical aberrations.

Camera lenses used under water are usually protected (as is the whole camera) from contact with the water by a housing with a window consisting of a flat or curved piece of glass or Plexiglas, called in UW terminology a "port." The most common port is a piece which is plane-parallel (both sides flat and parallel). The flat port is simple and useful, but it also creates the optical problem in its most serious form when it is used in conjunction with an in-air lens designed for surface photography.

*See also* Concentric dome lens.

- **RESOLUTION** / Also known as "Resolving power," and in slang usage, "sharpness." The ability of a lens to record or of a film emulsion to reproduce fine detail. The higher the resolution of a lens, the greater detail in subject matter it can record. We say, "We have a sharp lens." Lens resolution is usually based upon price. The higher the lens price, usually the higher the lens resolution.

Conversely, different films are rated by their resolution. Most film is made up of black-and-white or color "grains." The smaller these grains, the higher the resolution of the film. Generally the lower the ASA or the "slower" the film speed, the finer the grain and the higher the film resolution.

You can expect higher revolution from films with lower ASA film ratings and larger grain, and poorer resolution (or reproduction of fine detail) from films with high ASA film ratings. You sacrifice film quality and resolution as the film speed increases. Pushing film by forced development beyond the film's rated speed enables the photographer to make photographs in situations in which normal exposure is impossible owing to low light levels. Both film quality, resolution, and color balance will suffer though by "pushing" film speed ratings.

*See also* Definition.

- **SHUTTER SPEED** / The length of time the shutter is open, thereby the length of time that light is allowed to enter the camera. On most cameras shutter speed ranges from 1/1,000 of a second to 1 second. Most cameras also have a mechanical means of keeping the shutter open as long as the photographer desires.

- **SHUTTER SPEED BRACKETING** / Bracketing the shutter speed is an alternative to bracketing the *f*-stop. In other words, you leave the *f*-stop the same and vary the shutter speed. For example, if the meter indicates that the proper setting is *f*/8 at a shutter speed of 1/125 of a second, you can shoot additional photographs at 1/60 of a second and 1/250 of a second. In the first instance the exposure time is increased the equivalent of one *f*-stop. In the second, the exposure time is decreased by one full *f*-stop. Bracketing is particularly important in shooting flash. To be on the safe side, always bracket flash exposures by shooting at least one *f*-stop below and above the estimated exposure.

- **SINGLE-LENS-REFLEX (SLR) CAMERA** / The single-lens-reflex (SLR) camera is a newer form of reflex viewing system in which the image to be photographed is viewed through the lens which actually will take the picture. As is the case with the twin-lens-reflex camera, light is reflected through a mirror onto a ground glass. However, when the shutter is tripped, the mirror very quickly snaps out of the way of the lens, and the light rays are permitted to fall on the film plane. Focusing and composition are exact, and there is no problem of parallax error, as there is absolutely no offset between the image which the photographer sees and the image which is seen by the taking lens of the camera. In the SLR viewfinder, the image is properly positioned left to right, so that panning to follow a moving object is a natural and instinctive act. A mental effort to reverse the direction of movement is not required, as is the case with the TLR. The final major advantage of the single-lens-reflex camera is the fact that most SLR systems will accept a wide variety of lenses from wide-angle to extreme telephoto. This gives the photographer an immense range of visual possibilities and increases his versatility underwater significantly. It should be borne in mind that all camera systems are a compromise, and even the highly popular SLR camera systems do present certain disadvantages underwater. First, they are considered by many photographers to be noisy, as there is a great deal of mechanical activity taking place when the shutter lever is depressed. A mirror pops up, shutter leaves click, and in some brands of camera, a considerable racket is generated. Second, after the camera is mounted in a watertight housing, it is frequently difficult to get the eye close enough to the viewing aperture to focus and frame the picture properly. This is particularly true in conditions of limited ambient light where the image in the viewfinder may be extremely dim. Some camera systems have attempted to compensate for this problem by creating a prism reflex viewfinder which shows a larger and brighter image and which is therefore easier to work with underwater.

- **SST (solid-state-triggering) SYSTEM** / An electronic system of providing positive triggering of both electronic and flash-bulb lighting in UW use, utilizing a 22.5-volt battery/capacitor. When the camera-shutter-release button is depressed, this action closes the SST circuit, sending 22.5 volts to the solid-state-triggering device in the strobe housing. The solid-state-triggering device does electronically what an old-fashioned relay would do mechanically (see illustration). In an old-fashioned relay, as current passed through *a* it would act as a magnet. The magnet field created would pull down on lever *b*, making contact at point *c*, which is part of the electronic-flash-synchronized circuit. As contact is made at *c* the synchronized circuit is closed, thus firing the electronic flash. The SST system works the same way, except parts a, b, and c are miniaturized electronic parts instead of mechanical parts as in the older type of mechanical relay. In this way the electronic-flash-synchronized circuit travels a mini-

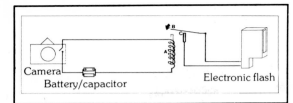

**Fig. G.4** Relay system (see SST system).

mal distance and is totally isolated from the 22.5 volt circuit and the water. The SST is a design of Ikelite Underwater Systems.

- **STOP DOWN** / To reduce exposure by adjusting the camera to a smaller aperture.

- **STROBE** / Short for stroboscopic, an electronic flash whose capability to fire repeatedly and rapidly, for the purpose of producing a high-intensity exposure light, derives from energy stored in a charged condenser.

  Invented by Dr. Harold Edgerton of Massachusetts Institute of Technology in the 1930s, the strobe stores up energy drawn from an electrical power source—in the case of modern strobes for most photographic use, dry batteries, or rechargeable Ni-Cd batteries—in a high-voltage capacitor. This energy is discharged when triggered through a gas-filled flashtube. The energy stored in the capacitor is discharged very rapidly, and thus the light pulse has very high peak intensity and duration (from 1/500 of a second to 1/10,000 of a second in modern strobe units). The color temperature of most photographic strobe units approximates the color temperature of daylight, 6000 Kelvin. A common method for judging light output is "watt-seconds." Units of 50-, 100-, and a few 200-watt second units can be obtained in relatively compact size for diver's use. The watt-second rating can be misleading, though, for the size and shape of the strobe's reflector throws the light in various angles. A 50-watt second strobe with a very narrow angle of "throwing light" due to its reflector design will give much more light in that specific area than will a 50-watt second unit with a wide-angle "throw."

  It is easiest to judge competing strobe units by looking at the angle-of-coverage that the unit gives (this will be in the specs of the unit) and also at the suggested surface guide number (GN).

  The design and operation of strobe units has been undergoing a change recently, and various systems of automatically limiting the amount of light have pretty well become the norm in commercially available surface strobes.

  The advantage of the automatic strobe unit is that it will emit the proper amount of light when strobe and camera are set according to the strobe manufacturer's instructions, thereby doing away with having to figure out the proper exposure (f-stop) by use of guide numbers.

This is done, usually, by using a sensor in the strobe unit, which measures the amount of light reflected from the subject and compares the light output with the nominal value. When the required light output for good exposure is reached, the strobe cuts off its light output. In other words exposure control is obtained by reducing the illumination time of the flash.

In the newest automatic units, the residual energy not required for exposure is stored up, ready for the next flash.

The problem with automatic strobe in underwater photography is that your subject matter underwater just does not reflect sufficient light to cause the light output to compute automatically. In most cases gross underexposure will result. One can also get overexposure if there is a large amount of particles suspended in the water, for the particles will reflect back the strobe flash, again giving a false reading to the automatic "brain" of the strobe. These automatic units can almost always be used underwater, however, for all have provision to switch the unit from automatic to manual. In the manual mode, the diver/photographer resorts to the normal method of utilizing the corrected-for-underwater guide number, as described in Chapter 7.

- **SUNLIGHT** / Visible wavelike pulsations of energy emitted by the sun. In underwater photography, film is exposed by sunlight, by artificial light sources, or by a combination of both, i.e., mixed-lighting techniques.

  In mixed-lighting techniques, the photographer chooses to use the sunlight surrounding the scene (ambient light) and one or more artificial light sources to illuminate his subject matter.

  *See also* Artificial light, Movie lights.

- **SUPPLEMENTARY LENSES** / *See* Diopter.

- **TELEPHOTO LENS** / A long lens, one whose focal length exceeds 200 millimeters, which causes it to produce a larger image on the negative than would a normal lens and optically to reduce the depth of the space separating objects located in the field before the camera. Such a lens has the capability to render a clear and large image of subjects relatively distant from the camera.

- **TWIN-LENS-REFLEX CAMERA** / As the name indicates, the TLR has two lenses, a viewing lens for observing, composing, and focusing the picture, and a taking lens which actually transmits the image to the film. The most important advantage of any reflex camera over the viewfinder camera is that the photographer actually sees his photograph before he snaps the shutter. As a result, his composition and focus are usually much better than they would be through the second-handed arrangement of viewing his subject through a separate viewfinder. In the twin-lens reflex, the image which the photographer observes is projected from the viewing lens, onto a mirror, and then onto a ground glass screen. The distance that the light travels from the viewing lens to the screen is identical to the distance the light must travel from the taking lens to the film plane.

The two lenses are mechanically linked together. Consequently, when the photographer focuses the image on the ground glass, he automatically focuses the taking lens as well. The TLR camera has a number of advantages over other cameras, and some excellent underwater pictures have been taken with it. However, it also has a number of significant disadvantages. First, the distances between the viewing lens and the taking lens, though small, does introduce the possibility of parallax error, especially when shooting extreme close-ups. Second, most TLR cameras do not have interchangeable lenses, and the lenses with which they are usually equipped are regulated for photography on the surface. Therefore, using them underwater means that the photographer is, in effect, forced to use a moderate telephoto lens. This disadvantage is compensated for somewhat in the more sophisticated TLR systems by the possibility of using diopters (supplementary lenses) to partially overcome the telephoto effect. Perhaps the most irksome disadvantage to the underwater photographer of the TLR is that the image, as seen on the ground glass, is reversed from left to right. As a result, the photographer, in attempting to follow action, will very often inadvertently pan the wrong way, thereby losing his subject rather than keeping it in the frame. A good deal of practice and familiarity with the TLR tends to help overcome this problem. However, in the midst of all the other stresses and concerns of underwater photography, keeping this additional factor in mind is simply too troublesome for many photographers.

- **UNDEREXPOSURE** / Too little light admitted to the camera to form a sufficiently bright image. In black-and-white photography this will result in a thin negative and thus a dark enlargement (positive-print).

    When color-slide (positive image) film is underexposed, you will get darker colors. One to two f-stops of underexposure can add richness to existing colors, because you will be making them darker. With color-slide film it is always safer to lean toward underexposure. It is possible to increase brightness of a dark positive color-slide. If a color slide is overexposed, the colors on the original slide will be washed-out and there is nothing that can be done to darken up an overexposed color slide. *See also* Overexposure.

- **VIEWFINDER** / A general term for an optical or mechanical device on or in a camera for sighting and framing (composing) the image to be photographed.

    *See also* Viewfinder, open type; Optical underwater viewfinder; Viewfinder, SLR prism type.

- **VIEWFINDER, open-type (sportsfinder)** / "Sportsfinder" is a generic name for any relatively large wire frame fitted to a camera body or housing that allows the photographer to observe and compose his scene quickly, easily, and without having to resort to the camera's own smaller viewing system. Though the word "sportsfinder" is used generically, Nikon uses the word to identify its brand of enlarged SLR viewfinder prism accessory. Therefore some con-

fusion can result when divers/photographers are using the word, "sportsfinder." I have found I must define it when discussing it with other photographers.

As the name implies, sportsfinders were originally developed for use in following the fast-moving action of athletic events, sports-car races, etc. Sportsfinders come in a wide variety of shapes, sizes, and configurations, and a number of photographers take the trouble to build their own units to meet their individual technical and creative needs. Most sportsfinders, however, share certain characteristics. They utilize a fairly large rectangular frame in the front to define the outer limits of the picture area. In the rear, they will frequently have a dot, a smaller rectangle, or a rifle sight to guide the photographer's eye so that he does not position himself too far to the right or left, thereby framing a photograph which his camera does not "see." Most sportsfinders are quite adequate for medium and distant shorts. However, as they are offset from the taking lens by a considerable distance, they all suffer serious parallax problems when photographing close-ups. The photographer must learn the parallax error of his sportsfinder and teach himself to compensate for that error in shooting closeup photographs. Once he learns to cheat his shots upward and possibly to one side or the other, he will find that the sportsfinder will yield quite acceptable results in most situations. Care should be taken when purchasing or building a sportsfinder to assure that it has some form of positive alignment device that locks it into a rigid position in relation to the camera body. This will prevent the sportsfinder from shifting in action and causing an unexpected parallax problem that will ruin the cameraman's picture.

- **VIEWFINDER CAMERA** / In the viewfinder camera, a small optical viewfinder completely independent of the camera lens, allows the photographer to view the subject approximately as it is seen by the lens in order to compose his photograph. The simple viewfinder has no provision for focusing the lens. To focus, the photographer must estimate the subject-to-camera distance and adjust the lens-focusing ring accordingly. On most viewfinder cameras the small viewfinder which is adequate for surface photography is totally inadequate underwater. When the camera is inside a housing and the face encased in a mask, the distance between the eye and the viewfinder is enough to make it impractical. However, an auxiliary sportsfinder is a help in this situation. When approximating the subject-to-camera distance in order to focus the viewfinder camera, it is important to remember that the camera focuses at the same distance as the eye, the apparent distance and not the actual distance. In other words, if you took a tape measure underwater and set your focus by the measured distance, the picture would be out of focus. You have to use three-quarters of the measured distance.

- **VIEWFINDER, SLR PRISMS** / The most common method of viewing (focusing. composing, and metering) with a single-lens-reflex (SLR) camera is by means of a penta-prism. This 5-sided prism is situ-

ated directly over the focusing and viewing screen of the SLR, and presents the scene being viewed as it is, with top and bottom being in the same place in the prism viewfinder, and left and right sides of the photograph corresponding to the left and right sides of the actual scene.

Nearly all SLR viewfinder prisms are designed for the photographer's eye almost to touch the viewfinder window in order to see the full aspect of the focusing and viewing screen. This is a disadvantage when using SLR viewfinders in underwater housings, since both your diving facemask and thickness of the UW housing viewfinder port keep the photographer's eye much farther away from the viewfinder. This causes an inability to see the complete viewing-screen format. You can still see enough to focus, but not enough to compose to the extent of the full 35 mm film format. Often it is also very difficult to see SLR built-in-meter match-needle and LED displays.

Canon camera's 35 mm F-1 series offers an accessory enlarged viewfinder prism called a "Speedfinder," and Nikon camera's F series offers a similar enlarged viewfinder prism called an "Action-finder." These two accessory prisms enable the UW photographer to see the full format of the focusing and viewing screen, as well as the built-in-meter match-needle and LED displays.

Pentax camera's 6 cm by 7 cm (model 6 x 7) series offers an accessory Underwater Magnifier/Viewfinder. This is not another enlarged prism to replace the standard camera's prism, but an eyepiece that screws into the rear window of the 6 x 7 penta-prism. This UW eyepiece reduces the size of the image from the focusing and viewing screen presented to the diver, but you can see the full frame aspect for accurate composition.

- **VIRTUAL IMAGE** / The image formed in a negative lens and, although clearly visible, perfectly focused and oriented like the original subject, not capable of being registered on a flat surface.
  *See also* Real image.

- **WATER-CONTACT LENS** / The ultimate in correction of aberrations, distortion, and magnification can be found only with camera lenses designed, from the beginning, for underwater usage. Utilizing high-speed computers and glass that meets the requirements of total underwater optical correction, lens manufacturers are beginning to produce fully corrected water-contact lenses. These lenses cannot be used for in-air (surface) photography, since the front element of the total lens formula is designed to be in direct contact with the water in order to obtain the desired optical properties.
  *See also* Underwater lenses.

- **WIDE-ANGLE LENS** / A lens of short focal length that allows both broad viewing coverage and, in addition, great depth of field.

- **ZOOM LENS** / The zoom lens is a lens whose image size can be varied by moving one of its elements with respect to the others. It can thus give the effect of a wide-angle lens, a normal lens, and a telephoto lens, all in one, with the added ability to change its focal length while a picture is being taken.

# APPENDIX 1
## Addresses of Manufacturers and Other Firms Mentioned in the Text

**Actsfilm** (*see* Guppy)
**AGFA-Gevaert, Inc.** (Agfa pocket 110 cameras, Guppy marine housing)
275 North St.
Teterboro, NJ 07608
(201) 288-4100
**Aqua-Craft** (retail and mail-order store specializing in UW photographic products, distributor for Green-Things, Underwater Kinetics)
3280 Kurtz St.
San Diego, CA 92110
(714) 298-9351
**ASCOR** (strobe units)
Berkey Marketing Co.
25-20 B'kln-Queens Expwy W.
Woodside, NY 11377
(212) 932-4040
**Glenn Beall/Industries** (Sekonic meter holders, brackets, lens controls, etc.)
887 South Route 21
Gurnee, IL 60031
**Birns and Sawyer, Inc.** (Snooper UW flood lights, for cine and still photography)
1026 N. Highland Ave.
Los Angeles, CA 90038
Bill Sutphin, Supervisor
(213) 466-8211
**Bolex** (*see* EPOI)
**Robert Bosch G.M.B.N.** (Aquarius UW housings for Bauer super-8-mm cameras)
Geschaftsbereich
Photokino
Postfach 109
7000 Stuttgart 60
Germany
**Braun North America** (strobe units)
55 Cambridge Parkway
Cambridge, MA 02142
(617) 492-2100
**Canon USA Inc.** (35-mm cameras)
10 Nevada Dr.
Lake Success, NY 11040
(516) 488-6700
**Capro** (strobe Units) *see* EPOI
**Century Precision Cine/Optics** (wide-angle lenses for 16-mm movie cameras)
10661 Burbank Blvd.
North Hollywood, CA 91601
(213) 766-3715

**Cressi-Sub** (factory-prescription-ground corrective face masks—prescription ground directly into face plate)
Via M. Mastrangelo, 4
16166 Genova-Quinto
Italy
**U.S. *importer*; U.S. Cressi-Sub**
971 S.W. First St.
Miami, FL 33130
(305) 545-9000
Attn. Jesus Otero

**Edmund Scientific Co.** (optics, simple lenses, prisms)
300 Edscorp Bldg.
Barrington, NJ 08007
(609) 547-3488

**Electro Oceanics, Inc.** (EO electric connecting cords and plugs for flash and strobe units)
2000 S. Santa Fe Ave.
Compton, CA 90221
(213) 537-2430

**Elmo Mfg Corp.** (U.S. distributor of Toshiba UW strobe)
*see* Toshiba

**EPOI—Ehrenreich Photo-Optical Industries, Inc.** (Nikon, Nikonos cameras, Bolex movie cameras)
623 Stewart Ave.
Garden City, NY 11530
(516) 222–0200

**EWA-Marine** (soft plasting UW housings)
Goedecke & Co., G.M.B.H.
Postfach 831703
D-8000 Munchen 83
Germany
*U.S. Distributor:* **Pioneer Co.**
209 Harvest Rd.
Cherry Hill, NJ 08002
(609) 667-8951
Attn: Wolfgang Harms
*see also* Spiratone, who handles some EWA-Marine housings in the U.S.

**Farallon Industries** (350-watt portable UW floodlight)
*See* Oceanic Products, which has taken over manufacture, repair, and sales of Farallon Industries equipment.

**Fiberbilt Photo Products** (camera and equipment cases)
601 W. 26 St.
New York, NY 10001
(212) 675-5820

**Franzus Company** (electrical power voltage converters and adapter plugs)
239 Park Ave. S.
New York, NY 10003

**Graflex, Inc.** (manufacturer of Subsea strobe lights, and other Subsea products)
210 Brant Rd.
Lake Park, FL 33403
(305) 844-8937
Attn: Brad Ganther

**Green Things** (wide-angle and closeup correction lenses for Nikonos)
*see* Aqua-Craft

**Guppy Marine Housings** (housing for AGFA cameras, models 2000, 3000, 4000, 2008, 3008, 4008, including matching strobe flash)
Actsfilm
Unterwasser-Optik
Schutzenhausstrasse 13
CH 8618 Oetwil a/See
Switzerland
Attn: A. Cramer

**Hasselblad** (cameras, marine UW housings)
*U.S. Distributor:*
Braun North America
55 Cambridge Parkway
Cambridge, MA 02142
(617) 492-2100

**Helix Limited** (camera equipment store specializing in all types of UW photographic equipment; owner Paul L. Schutt accomplished diver-photographer)
325 West Huron St.
Chicago, IL 60610
(312) 944-4400

**Hydro-Catylator Corp.** (manufacturers of hydrogen catalyzers to protect against explosion of outgassed hydrogen from storage, and rechargeable batteries)
Box 3648
3579 E. 10 Ct.
Hialeah, FL 33013
(305) 696-2504

**Hydro-35 Housing**
*see* Oceanic Products

**Ikelite Underwater Systems** (complete line of molded plastic UW housings, for all types of photographic equipment, Nikonos attachments)
3303 North Illinois St.
Indianapolis, IN 46208
(317) 923-4523
Brigham Kepler, Technical Adviser

**Image Devices Incorporated** (Eclair ACL housings, UW lights)
1825 N.E. 149 St.
P.O. Box 610606
Miami, FL 33181
(305) 945-1111

**Konica** (strobe units)
*U.S. Importer:*
Berkey Marketing Co.
25-20 B'kln-Queens Exprwy W.
Woodside, NY 11377
(212) 932-4040

**Leitz, E., Inc. (U.S.A.)** (Leica cameras)
Rockleigh, NJ 07647
(201) 767-1100

**Leitz, E., Ltd. (Canada)** (ELCAN corrected UW lenses)
122 Ellen St.
Midland, Ont.
Canada
For Elcan UW lens information: W. G. Kluck
(705) 526-5401

**Mako Engineering** (Jordan Klein) (16-mm cine housings, viewfinders)
P.O. Drawer 1630
1634 S.W. 17 St.
Ocala, FL 32670
(904) 732-2268

**Metz** Photo Products Division (strobe units)
EPOI
101 Crossways Park
Woodbury, NY 11797
(516) 364-8030
(212) 895-9191

**Minolta Corp.** (strobe units)
101 Williams Drive
Ramsey, NJ 07446
(201) 825-4000

**National Camera, Inc.** (small tools and repair aids for cameras)
2000 West Union Ave.
Englewood, CO 80110

**Niko-Mar Housings** Manufactured by Giddings/Felgen and GF, San Francisco. Discontinued manufacture. Parts and service taken over by Oceanic Products.

**Nikon**
*see* EPOI

**Nikonos**
*See* EPOI

**Oceanic Products** (complete line of metal housings for cameras and flash, Giddings/Felgen and Farallon Industries UW photographic products)
1333 Old County Rd.
Belmont, CA 94002
(415) 592-8484
Bob Hollis, president

**Pentax, Asahi, Corporation** (35–mm cameras, 6/7 cm cameras, marine 6/7 housing)
9 Inverness Dr. E.
Englewood, CO 80110
(303) 798-8113
Masa Tanaka, Vice-President

**Professional Camera Repair Service, Inc.** (Calypso and Nikonos repair, expert camera repair)
37 W. 46 St.
New York, NY 10036
(212) 246-7660
Martin Forscher, Technical Manager

**Rollei of America, Inc.** (Rollei 35-mm cameras, Rollei strobe units, and Strobonar strobe units)
P.O. Box 1010
5501 South Broadway
Littleton, CO 80120
(303) 794-8200

**Rolleimarin** (UW housing for the Rolleiflex twin-lens-reflex cameras)
*U.S. Importer:* Photo Products Division
(Rollei Professional Products)
EPOI
101 Crossways Park W.
Woodbury, NY 11797
(516) 364-8030
(212) 895-9191

**Seacor, Inc.** (corrected 21-mm lens for Nikonos viewfinders)
Box 22126
San Diego, CA 92122
(714) 453-7933

**Sekonic** (UW light meters)
*U.S. distributor:* Copal Corporation of America
85-25 Queens Blvd.
Woodside, NY 11377

**Silma** (nautilus UW housings for Silma super-8-mm cameras)
P.O. Box 26
Corso Francia 98
10098 Rivoli Torinese
Italy

**Spiratone** (filters, plus diopter lenses, soft vinyl plastic UW camera housings)
136-06 Northern Blvd.
Flushing, NY 11354

**Strobonar** (strobe units—formerly known as Honeywell Strobonar)
*See* Rollei of America, Inc.

**Subsea Products, Inc.** (UW strobe-flash units, close-up adapters for Nikonos)
*See* Graflex, Inc.

**Sun** (pak) (strobe units, and amphibious strobe unit)
Berkey Marketing Co.
25-20 B'kln-Queens Expwy W.
Woodside, NY 11377
(212) 932-4040

**Teledyne Camera Systems** (16-mm UW amphibious cine camera)
131 North Fifth Ave.
Arcadia, CA 91006
(213) 359-6691

**Toshiba** U.S. Distributor: (UW strobe flash)
Elmo Mfg. Corp.
32-10 57 St.
Woodside, NY 11377

**Tropic Isle Dive Shop** (repair specialists for flooded camera equipment)
P.O. Box 755
Key Largo, FL 33037
(305) 451-1063

**Underwater Kinetics** (UW lights, water-detection system for UW housings)
P.O. Box 2125
La Jolla, CA 92038
(714) 270-1000

**Vivitar** (strobe units)
*U.S. importer:* Ponder and Best
1630 Stewart St.
Santa Monica, CA 90406
(213) 829-3672

**Viz-Master Systems** (Viz-Master 20 wide-angle auxilliary lens for Nikonos 35-mm lens)
59 Wellington Rd.
Hatch End
Middlesex HA5 4NF
England
Geoff Harwood, President

**Wein Products, Inc.** (strobe flash meter)
115 W. 25 St.
Los Angeles, CA 90007
(213) 749–6049

**Weston Euromaster Light Meter** (successor to the Weston-5 light meter)
Dist: Quality Light-Metric Co.
6922 Hollywood Blvd. Suite 210
Hollywood, CA 90028

# APPENDIX 2
## Underwater Magazines

### UNITED STATES:
*Skin Diver*
Paul Tzimoulis, Editor/Publisher
Connie Johnson, Managing Editor
Peterson Publishing Co.
8490 Sunset Blvd.
Los Angeles, CA 90069

*Sport Diver:* The Journal of Sport Diving
Steve Blount, Editor
Suite 120
103 Century 21 Dr.
Jacksonville, FL 32216

*Undercurrent*
Roger Craver, Publisher
Ben Davison, Editor
P.O. Box 1658
Sausalito, CA 94965

### UNITED KINGDOM:
*Triton* (the magazine of the British Sub-Aqua Club)
Bernard Eaton, Editor
Eaton/Williams Publications
40 Grays Inn Road
London, WC1X 8LR

**Underwater World**
5 Cedar Court, Cedar Road
Sutton, Surrey, SM 25DH

### FRANCE:
*Oceans*
Yves Baix, Editor
4, rue Luce
La Pointe-Rouge
13008 Marseille

*L'Oventure Sous-Marine* (Techniques et Exploration)
Jean-Albert Foex, Editor
10, rue de la Bourse
Paris-2

*Etudes et Sports Sous-Marins*
(Organe officiel de la Federation Francaise d'Etudes et de Sports Sous-Marins
Jacques Dumas, editor
34, rue du Colisee
75008 Paris

### GERMANY:
*Submarin*
Jurgen Claus, Editor
Ortlerstrasse 8
8000 Munchen 70

*Der Taucher*
Gerherd Binanzer, Editor
Augustenstrasse 50
7000 Stuttgart 1

### ITALY
*Mondo Sommerso*
Antonia Soccol, Editor
via Carlo Alberto 65
10123 Torino

*Fotosub* (published by collaboration of Mondo Sommerso, and Fotocamera)
Salvatore Gajas and Antonia Soccol, Editors
via Carlo Alberto 65
10123 Torino

*Il Subacqueo*
Calogero Cascio, Editor
Via della Maratona 66
00194 Roma

# APPENDIX 3
## Procedures for Treating UW Photography Equipment (Cameras, Metal UW Housings, Light Meters and Strobes) That Has Been Flooded by Salt or Fresh Water

Most leakage of UW equipment is caused by sand, grit, or crystalized salt between the O ring and the O-ring groove, which keeps the O ring from making a watertight seal. The outside pressure of the water forces water to enter the unit.

The single most common cause of UW unit flooding or leaking when using gear in salt water, is the improper (or complete lack of) cleaning of the large O rings by the diver-photographer after each diving trip. Proper cleaning is even more important if the gear is not used for several weeks.

Carefully (do not use sharp objects—you might scratch the O ring) remove the O ring after each diving excursion, clean out the O-ring grooves with a soft fresh-water wet cloth, paying attention to removing any caked or solidified salt and silicone lubricant. Cotton swabs work very well also for cleaning O-ring grooves. Wipe salt and lubricant off the O ring itself with a clean, soft dry cotton cloth and *lightly* relubricate with manufacturer recommended O-ring lubricants. **Never use spray lubricants around UW units with any plastic parts.** Use O-ring lubricant sparingly, for too much will only attract more sand and grit on your next dive. Too much lubricant can also cause an O ring to *extrude* partially from the groove, causing massive leakage.

Should your UW housing or other equipment flood, or your amphibious camera develop a leak, the following procedures have been suggested to me by two repairmen both recognized as the tops in their field.

## PROCEDURE FOR A FLOODED CAMERA*

1. Rinse out the camera by submerging completely in fresh, cool tap water. Change the water when sediment or dirt appear in the wash water. This procedure should also be followed with the lens. The soaking and rinsing should be done for at least half an hour.

2. After soaking, use compressed air to *gently* blow out the rinse water and dry up (evaporate) all the visible water. You can "crack" the K or J valve of your scuba tank *very slightly* to get a gentle stream of compressed air for this purpose. **Caution:** Do not open the valve so that a hard stream of compressed air comes out. You can damage your camera and shutter curtain by blasting compressed air at it. Remember you are using the compressed air only to quicken the evaporation time.

3. Place the camera and lens in an oven. Monitor the temperature so that it is between 100° and 120°, **no hotter.** Leave it in the oven, checking constantly until all the rinse water is evaporated.

4. Mail to a reputable professional camera-

repair service station as quickly as possible. This can be done by the following services:

- U.S. Postal Service, registered, insured, airmail parcel post
- Federal Express
- UPS (United Parcel Service) priority service
- U.S. Postal Service, B label, express mail, insured
- Check your local post office to see if they offer this B-label service. If they do, your package is guaranteed to be delivered at its destination the next day. Don't get this service mixed up with A-label express mail. A label costs less, but your package must be picked up at the addressee's zip code post office, and the addressee is not notified of the A-label package's arrival by the post office. B label will cost more, but it is delivered directly to the addressee the day after you mail the package.

## PROCEDURE FOR A FLOODED NIKONOS CAMERA OR LIGHT METER †

1. Rinse twice in fresh water, working the shutter.

2. Soak once in a 50/50 alcohol and freshwater solution. **Caution**: Do not use straight alcohol, for at full strength it can damage plastic parts in the newer models of Nikonos.

3. Wrap in a damp towel and place the camera, damp, in a plastic container or strong plastic bag.

4. Enclose note describing problem.

5. Wrap in package, tape securely, insure and ship, **as fast as possible.**

Crawford favors the damp 50/50 alcohol-water shipment for he has found that drying out Nikonos parts can damage them if the whole camera isn't first dismantled.

Neither repairman advises mailing a flooded camera inside a water-filled container. I only mention this because it seems to be a common misconception among divers that this is the best shipping procedure. Because saltwater can quickly corrode metal parts beyond repair, shipping the unit to be repaired fast is your only chance of saving the unit. I do not advise you to dismantle either a camera or a lens. Leave the repairs to an expert.

---

*As suggested to me by Marty Forscher of Professional Camera Repair.

† Capt. Bill Crawford, Tropic Isle Dive Shop.

# BIBLIOGRAPHY

Kodak, "Bibliography on Underwater Photography and Photogrammetry," Pamphlet P-124, 1972, 35¢. Order from Department 454, 323 State Street, Rochester, NY 14650. This is the most extensive bibliography available of books and articles written in the United States and abroad on the subject of underwater photography. Most of the listings are technical and scientific articles. The pamphlet contains a subject and author index, which is handy when looking for technical information on a particular underwater photographic problem. Kodak revises and updates this pamphlet on a regular basis.

Cooper, Joseph D. *Nikon/Nikkormat Handbook,* 1974. American Photographic Book Publishing Company, Inc., East Gate & Zeckendorf Blvds., Garden City, NY 11530. Section on UW photography; pages 15-3 through 15-40 covers in detail Nikonos I and Nikonos II cameras.

Craig, Walt, *Learning Photography: A Self Directing Introduction,* rev. ed., 1975. Grid, Inc., 4666 Indianola Ave, Columbus, OH 43214. A soft-cover work book; this is the best self-learning work-textbook for anyone wanting to learn the basics of photography, cameras, and darkroom technique. You will probably have to write directly to the publisher to obtain a copy, as it is primarily sold as a classroom college supplemental text and therefore not usually found in book stores.

Dobbs, Horace, *Camera Underwater,* 2nd ed. The Focal Press, London, and Amphoto, Garden City, N.Y., 1973.

Feininger, Andreas, *Basic Color Photography,* Prentice-Hall, Inc., Englewood Cliffs, NJ, 1972. A good, easy-to-understand photography learning book on color photography. Though written in simple, technically uncluttered language, it still covers the techniques and technical problems of color photography, most of which can be applied to underwater color photography.

Frey, Hank, *Hasselblad Underwater Photography,* Victor Hasselblad, Aktiebolag, Goteborg, Sweden, 1972. Pamphlet in English, outling equipment and techniques of utilizing the Hasselblad 6/6-cm cameras underwater.

Greenberg, Jerry and Idaz, *Water-Proof Guide to Corals and Fishes of Florida, the Bahamas and the Caribbean,* Seahawk Press, 6840 SW 92 St., Miami, FL 33156, 1977.

Hattersley, Ralph, *Photographic Printing,* Prentice-Hall, Inc., Englewood Cliffs, NJ, 1977.

McNeil, Gomer T., *Optical Fundamentals of Underwater Photography,* 2nd ed. Mitchell Camera Corporation, Photogrammetry Division, Rockville, MD, 1972. A difficult book to find, because of its specialized subject matter, but it should be included in a large library. The only complete book on underwater corrected optics systems from a scientific standpoint.

Mertens, Lawrence E., *In-Water Photography: Theory and Practice,* Wiley-Interscience, a Division of John Wiley & Sons, New York, 1970. The most extensive scientific book on UW photography.

Schulke, Flip, "Filming the Ways That Skylab Astronauts Train Underwater," *American Cinematographer,* June 1973, pp. 718–719, 758–760, 773–777.

Schulke, Flip, "Some Technical Aspects of Underwater Cinematography," *Journal of the Society of Motion Picture and Television Engineers,* Vol. 82, No. 12, December 1973, pp. 983–991.

Swedlund, Charles, *Photography: A Handbook of History, Materials and Processes,* Holt, Rinehart and Winston, Inc., New York, 1974. I recommend this as a good overall photographic textbook.

Strykowski, Joe, *Divers and Cameras,* Dacor Corporation, 1974. 161 Northfield Rd. Northfield, IL 60093.

Upton, Barbara and John, *Photography: Adapted from the Life Library of Photography,* Educational Associates, a Division of Little, Brown and Company, Boston, 1976. Another excellent textbook on basic, intermediate, and advanced photographic techniques, including darkroom processing and printing.

Wallin, Doug, *Basics of Underwater Photography,* Amphoto, Garden City, N.Y., 1975.

# INDEX